Bright Stars
American Painting and Sculpture Since 1776

Bright Stars
American Painting and Sculpture Since 1776
Jean Lipman and Helen M. Franc
Introduction by John I. H. Baur

E. P. Dutton & Co., Inc. New York

First published, 1976, in the United States by E.P. Dutton & Co., Inc., New York. / All rights reserved under International and Pan-American Copyright Conventions. / No part of this book may be reproduced or transmitted in any form or by any means, electronic or mechanical, including photocopy, recording, or any storage and retrieval system now known or to be invented, without permission in writing from the publishers, except by a reviewer who wishes to quote brief passages in connection with a review written for inclusion in a magazine, newspaper, or broadcast. / Published simultaneously in Canada by Clarke, Irwin & Company Limited, Toronto and Vancouver. / Printed and bound by Dai Nippon Printing Co., Ltd., Tokyo, Japan. / Library of Congress Catalog Card Number: 76-25791. / ISBN 0-525-07147-4.
First Edition

Contents

Note on the Comments

In the dimensions height precedes width; a third dimension, depth, is given for some sculpture. Measurements are given in inches up to 6 feet, and thereafter in feet and inches.

Sources for the quotations cited in the comments will be found on pages 202-206.

Acknowledgments

Grateful acknowledgment is made to the respective private collectors and public institutions for providing documentation of works in their collections and granting permission to reproduce them. We are also indebted to many others who have answered inquiries and facilitated our research, particularly to staff members of the Frick Art Reference Library and The New York Public Library at Forty-second Street, and of the libraries of The Boston Athenaeum, The Museum of Modern Art, The New-York Historical Society, and the Whitney Museum of American Art.

Can You See?

Classified ads offering houses or apartments for rent or sale frequently declare that these properties "must be seen to be appreciated." This seemingly self-evident recommendation might even be made for American art, for until recently most of us have been too little aware of our country's legacy in the visual arts. It is appropriate that on the occasion of our Bicentennial, as we revaluate our history as a nation, we should also look hard and critically at some outstanding examples of painting and sculpture produced in the United States since 1776.

This book is not intended to be a historical survey. Instead, it presents a relatively small number of works that seem to the authors to offer an especially rewarding experience to anyone who looks at them attentively. The selection has been made by two people who have spent their entire careers looking at and writing about art of many periods and cultures, as well as editing art publications. We have included here no work that did not seem to both of us of outstandingly high quality. Each example, whether familiar or relatively unknown, major or minor, has given us the excitement of confronting splendid art—an experience we have been eager to share with the reader. Although the sequence of the illustrations is roughly chronological, works related by subject, visual similarities, or their artists' shared concerns have often been grouped together irrespective of date.

From the galaxy of paintings and sculptures produced in the past two centuries, we have chosen what seem to us singularly Bright Stars. The star idea is like that of the *Guides Michelin*, pointing out what is "worth a special visit." Most emphatically, it does not imply that these are the 150 "best" or "most significant" works of American art. The choice among so many possibilities has been a difficult one and has obliged us regretfully to omit many alternates. We admit to having been guided in the last analysis by our personal tastes; and, in fact, we shall be delighted if some of our readers vehemently denounce the omission of their particular favorites, for that will indicate they know those works well and care deeply about them.

No artists, as such, have been either included or omitted, nor are they necessarily represented by their best-known examples, for we were choosing each painting and sculpture on its own merits as a memorable image. It is incidental to our initial premise that some are historically significant, and that taken together they add up to a minihistory of American art. We should, however, explain that we have omitted artists whose basic attitudes and styles had essentially crystallized before they came to the United States, although several of them have significantly affected the course of American art—Hans Hofmann and Josef Albers preeminently by their teaching, and perhaps most notably Marcel

Duchamp by his concepts. Although he influenced only a small circle while he was first resident here during World War I, since the 1950s Duchamp's ideas have been the catalyst for a growing number of American artists.

Beyond that restriction we made no a priori assumptions. Above all, there was no effort to prove that the works presented here are more "American" than others or that they share common denominators. American art is part of the mainstream, constantly reacting to and adapting foreign influences, while developing in certain ways of its own on this side of the Atlantic. A pluralistic society has, logically, given birth to a pluralistic art; America's art, like her people, is characterized chiefly by diversity. This is evident not only chronologically throughout our two-hundred-year history, but also in the simultaneous coexistence of entirely different tendencies; we need only cite, for instance, the present-day polarity between Photo-Realism and Minimal art.

The inclusion of many examples from our rich heritage of folk arts reflects a growing recognition that, judged from the standpoint of expressive power and aesthetic quality, they can no longer be relegated to a secondary rank. It becomes increasingly difficult, moreover, to segregate from the others the artists (often anonymous) who created these works by describing them as "naïve," "primi-

7

tive," or "self-taught." Many others in this book, as well as they, stood apart from the prevailing academic tradition, although surely more aware of it; certain of their own inner vision, they chose to pursue it in ways of their own. It is also surprising to note how many of our artists, right down to the present, have been self-taught—either lacking any formal training or else inventing their own techniques, and thereby contributing notably to the language of art: among the cases in point are Calder's mobiles, Oldenburg's soft sculptures, Pollock's "drip" paintings, Stella's shaped canvases.

If, indeed, one can discern any distinctively American characteristic among our artists, it is a pragmatic attitude toward their materials, an artisanlike delight in handling them, and the same kind of "can-do" spirit that has been evident in many other facets of our life as a young, pioneering nation. When the great art historian Erwin Panofsky first came to the United States, he announced after a few months that he considered most revealing the expression he frequently heard here: "Why not?" Unburdened by the tradition of long-established salons, unawed by the authority of art academies, and often uninhibited by lack of training, American artists have pursued their careers with sublime self-confidence, at times stubbornly persisting despite harsh strictures. Charles Willson Peale turned from saddlemaking to painting after seeing some pictures so indifferently executed that he decided he could certainly do better; Benjamin West and John Singleton Copley defied the precepts of the Royal Academy by their unconventional choice of subjects and manner of rendering contemporary events; Hiram Powers—with the full concurrence of his sitter—ignored advice to mitigate the unsparing realism with which he portrayed President Jackson; Thomas Eakins resigned the directorship of the Pennsylvania Academy of the Fine Arts rather than abandon his practice of teaching from the nude; James McNeill Whistler quixotically instituted a costly lawsuit against the formidable John Ruskin in order to defend the rightness of his own aesthetic ideas; the Ashcan School painters flew in the face of accepted canons of taste by the "vulgarity" of their subjects—as the Pop artists were later to do, compounding their impertinence by adapting to their purposes commercial-art techniques; using heavy construction machinery and the earth's raw materials, Robert Smithson dared to impress his visions large on the face of the American landscape.

The American public, for its part, has almost from the beginning displayed what is generally regarded as a national trait by responding with lively curiosity, if not always with complete understanding, to new developments in art; with characteristic openness, it has rarely raised chau-

vinistic objections to welcoming foreign art at least as eagerly as our own. From Paris, where he had gone to negotiate the treaty of peace with Great Britain, John Adams wrote to his wife Abigail in 1780: "It is not indeed the fine arts which our country requires; the useful, the mechanic arts are those which we have occasion for in a young country as yet simple and not far advanced in luxury, although perhaps much too far for her age and character. . . . I must study politics and war, that my sons may have liberty to study mathematics and philosophy. My sons ought to study mathematics and philosophy, geography, natural history and naval architecture, navigation, commerce, and agriculture in order to give their children a right to study painting, poetry, music, architecture, statuary, tapestry, and porcelain." His countrymen, however, were by no means disposed—either as artists, patrons, or spectators of art—to wait three generations to satisfy their taste for the arts. Peale's museum, opened in 1786, quickly drew a large and enthusiastic public; today, the number and wide dispersal throughout the country of American museums, and their attendance figures, are a constant source of astonishment abroad, and there is no estimate of the number of private collectors. (It turns out that our Stars have been drawn from 77 public and private collections, from California to Massachusetts, in addition to two foreign institutions.) Unfortunately, despite this activity, only a handful of our artists during the past two centuries have been enriched by their profession; even today, there are relatively few who are not obliged to supplement their earnings from sales by teaching or in other ways. It has seldom been the artists themselves who have profited the most from the intense appetite Americans have shown for painting and sculpture; it is an ironic development, which would surely have astounded their predecessors, that growing numbers of artists today are protesting the overcommercialization of art by producing works that are intentionally made "uncollectible."

To point out changing attitudes toward art in America since 1776 was one of the purposes we had in mind when writing our comments for this book, although our emphasis has been on the importance of looking—taking the time, notwithstanding our harried lives, to look intently and not just on the run. Every painting and sculpture is, among other things, a primary source bearing witness to the times that brought it forth and to the personality of the artist who created it. No matter how interesting the piece may be as a document, however, nothing can elevate it to the status of a work of art if it lacks inherent quality. The information contained in each of our comments is provided simply to add an extra dimension to visual enjoy-

ment: for example, setting the work of art in context, discussing its style and subject, the circumstances that brought it into being, and giving some relevant facts about the artist. We have often selected quotations that allow the artist to speak for himself; we have also frequently cited contemporary critics—sometimes sympathetic, sometimes hostile—who often afford insight into the climate of opinion in which the respective artists worked. As Mr. Baur has observed in his thoughtful introduction, it is only in our century that such statements have been couched in terms of formal analysis; and it is only very recently that artists themselves have taken over the critics' function by providing their own elucidations. It is our hope that, taken together, our comments may illuminate various currents of American thought and contribute to a better understanding of what may at times seem puzzling or arbitrary developments.

On the eve of the American Centennial, one of our self-taught artists, Erastus Salisbury Field, filled a canvas nine feet high by thirteen feet long with a unique composition, the *Historical Monument of the American Republic* (described on page 63). Pridefully saluting the Constitution, episodes in our history, and our national heroes, it also celebrated the country's growing industrial progress. Today, at our Bicentennial, we find such innocent optimism and total faith in the blessings of unlimited industrial expansion superseded by a sober awareness of many problems; the prevalent mood is one of questioning rather than of unqualified self-assurance. We can nevertheless take courage from those sensitive barometers of society, our artists. They do not counsel despair but continue to demonstrate new attitudes not only toward art, but toward life. Seeking to break down the barriers between art and nonart and make them more interchangeable, they place less value on the art object and more on new concepts of life-style. As our earlier artists have done, artists today continue to find new kinds of beauty where others have perceived only ugliness, opening our eyes to aspects of our urban environment and our landscape that we may have despised or merely disregarded. They continue also to embrace new materials, new technologies, and adapt them to their needs. Above all, they teach us that we should not fear chance, change, and uncertainty, but welcome them as not only inevitable, but even as essential to life itself. However different their modes of expression, our contemporary artists, like those of the past, are still making strong, affirmative statements and, in doing so, are adding to our national heritage.

Grateful for the creativity and diversified achievements of American artists since 1776, most proudly we hail our Bright Stars.

Broad Stripes

John I. H. Baur

A quiet revolution is taking place in our attitude toward American art of the past. We have been told so often that, until fairly recently, our painting was a provincial echo of European movements, emerging here after a time lag of about a generation, that we have tended to see it exclusively in those terms. One result is that we have neglected what did not fit into the pattern of European developments—such as the major part of our folk art—as well as those more sophisticated works that, although obviously related to European traditions, broke into strange or unexpected areas and said something fresh and often startling.

This book attempts a new approach—pragmatic, nonhistorical, aesthetic. Its authors have selected as their Stars works that they find visually rewarding, whether the artists were famous or not, whether they played significant roles or none at all in the development of major movements. By responding to manifestations of our art that appeal to the modern eye—from New England gravestones to abstract fantasies for which Surrealism has finally prepared us—the authors have given us a new understanding of the richness and variety of our artistic heritage.

But dangers beset a purely aesthetic approach. Edouard Roditi, for example, singled out Raphaelle Peale's *After the Bath* (page 41) as a proto-Surrealist picture. He did not know that it was painted as a practical joke on the artist's wife, which renders rhetoric on its Surrealist qualities of dubious value. The present authors, as their comments make clear, have sought out the facts that have kept them from falling into traps of this sort. It may nevertheless not be irrelevant to place their Stars in a broad historical perspective, which is the purpose of this essay. In short, it seems advisable to trace the main stylistic currents and aesthetic beliefs of American art in order to understand even those works which altered or flouted them.

Considering the criteria of selection, which the authors have explained in their preface, it may be coincidence but it is not without significance that virtually every major movement in American art is represented in these 150 illustrations. By "main currents" and "major movements," I do not necessarily imply schools of art in the European sense. We had few acknowledged arbiters—like Sir Joshua Reynolds and John Ruskin in England, or Jean-Auguste-Dominique Ingres and Eugène Delacroix in France—and few ateliers, few master-pupil axes. But we did have groups of artists with shared concerns. Sometimes these were concerns with subject, such as the Hudson River School's involvement with the meaning of American landscape. Sometimes they were concerns of style, such as those of the luminists in the nineteenth century or of the precisionists in the twentieth. In many cases there is little evidence that artists working in the same vein knew one another, or even knew each others' work—although of course they may have. It seems, rather, that certain attitudes were prevalent at certain times and were widely shared.

From its beginnings to the end of the nineteenth century, the American aesthetic was dominated overwhelmingly by a philosophy of realism, despite the efforts of Washington Allston to implant the Romantic style. Delight in painted illusion was as strong in the eighteenth century, when Charles Willson Peale is reported to have fooled George Washington into bowing to his *Staircase Group* (page 40), as it was in 1841 when an anonymous critic in *The Dial* wrote that "the power of Nature predominates over the human will in all works of even the fine arts. . . . Nature paints the best part of the picture."

But realism had different meanings at different times. The prevailing deism of the eighteenth century, with its faith in the rational and the practical, produced an artist such as Peale, who was as proud of his ability to make false teeth, design a bridge, or classify birds as he was of his skill in painting. When deism waned in the nineteenth century, however, and transcendentalism emerged, the artisanlike concept of art became suspect and even seemed to threaten the creative spirit. As Nathaniel

Hawthorne put it in his short story "The Artist of the Beautiful": "Thus it is that ideas which grow up within the imagination and appear so lovely to it . . . are exposed to be shattered and annihilated by contact with the practical."

Beginning as early as Benjamin West, the concept of realism changed from a relatively uncomplicated appreciation of illusion as a skill to a more romantic attitude that saw it as a means to a moral and aesthetic end. This end was often identified by the term *idealism*—endlessly argued in nineteenth-century criticism and fraught with a number of different meanings. Our artists were praised in the *Analectic Magazine* (1815) for "their acuteness in observation, in truth and accuracy," but were found deficient "in variety and grace, and in generality and grandeur of conception." On a more sophisticated level *The Dial* (1841) suggested that "the delight which a work of art affords seems to arise from our recognizing in it the mind that formed Nature again in active operation." In other words, the artist's function was to reveal the presence of God in nature, and no understanding of nineteenth-century American landscape painting is possible without a realization of the deep and genuine pantheism of the period. John Ruskin's insistence (in his "Cambridge Address," as reported to Americans in *The Crayon* in 1859) that "wherever art has been used . . . to teach any truth, or supposed truth—religious, moral or natural—there it has elevated the nation practising it, and itself with the nation" sanctioned the doctrine of the moral and didactic nature of art, already preached by the transcendentalists.

In the last third of the nineteenth century this lofty attitude waned, as national expansion, growing materialism, and a new sophistication brought the old certainties into question. But realism itself was too deeply ingrained to be dislodged at once. Its nature changed: from descriptive to visual (Impressionism) and from the relatively impersonal to the personal, the idiosyncratic, the individual. A new emphasis on personal style was born, together with a concept of art as a vehicle to create mood through a freer manipulation of nature. But in spite of the efforts of certain eccentric individualists (to be considered later), it was not until the twentieth century that realism itself was questioned. Certainly no one considered abstract form to be the means and end of art. Abstract design was present in the nineteenth century, as the patterns of American quilts attest, but until recently no one would have called these anything but decoration.

Similarly, our unsophisticated folk painting and sculpture of the eighteenth and nineteenth centuries were scarcely considered art at all, until modern eyes recognized the formal strength and expressive qualities that the best of the naïve artists instinctively possessed. A good case could be made, however, for the realist intent of these artists and for the largely unconscious nature of their designs (and for those of their twentieth-century successors), which were derived at least in part from the necessity of finding shortcuts around their technical limitations. All in all, realism continued to dominate American art before 1900 in spite of the scattered exceptions that can be found.

Portraits of people primarily, and portraits of places—these were the concerns of most American artists in the eighteenth century and of a lesser but still considerable number in the first two thirds of the nineteenth. English portraiture was plainly the source from which our artists drew, both for style and pose, but these borrowings often went through a strange sea change when they came to America. Thus William Williams's *Deborah Hall* (fig. 1) is set in a formal garden complete with niches and statuary, unlike anything to be found on this side of the Atlantic and also quite unlike its English prototype. It has an unreality, an air of fantasy, that is doubtless unintentional but is singularly appealing today.

On a more sophisticated level, painters like John Singleton Copley, Ralph Earl, and Gilbert Stuart disavowed Sir Joshua Reynolds's "Grand Style" and turned the elegance and social rhetoric of English portrait painting into a more sober art that seemed, partly by suppressing the trappings of class, to emphasize the human character of their sitters. The very starkness of Copley's *Paul Revere,* (page 26) Earl's *Roger Sherman* (fig. 2), or West's *Colonel Guy Johnson* (page 29) give them an intensity of expression seldom found in Romney or Reynolds. The same unadorned directness makes some of our folk portraiture (such as the *Gravestone of Polly Coombes,* page 46) so memorable, in addition to its decorative qualities. And although Gilbert Stuart went even further toward fashionable English ideals than Copley had after his removal to London, he managed in such a painting as *Mrs. Richard Yates* (page 35) to preserve an equally vivid sense of his sitter's identity. His assured and fluent style, verging on impressionism, influenced two generations of American portraitists, from Thomas Sully and Samuel F. B. Morse to Henry Inman and John Neagle.

In portraying places, until the early nineteenth century artists generally relied on a technique that combined drawing and watercolor, handled in a rather dry, topographical manner of little aesthetic interest. Their technique, however, was adopted by several later folk artists with unpremeditated results. Edward Hicks's *Cornell Farm* (page 60), J. F. Huge's *Burroughs* (page 80), and Paul A. Seifert's *Residence of Mr. E. R. Jones* (page 61) turn a dry formula into wonderfully decorative arrangements of buildings, people, and animals.

But it was the Hudson River School that constituted America's first real landscape-painting movement. Inaugurated by Thomas Cole in the 1820s, it grew rapidly, both in number of artists and in popular favor. Breaking with the topographical approach of the past, it combined realism and romanticism in about equal measure. Most of the artists had studied or traveled in Europe and drew freely on European sources—especially in their preference for panoramic views and the romantic paraphernalia of blasted trees, crags, precipices, and the like. Yet their work had its native aspects. In his *Autobiography* Worthington Whittredge expressed his despair when faced for the first time by "a mass of decaying logs and tangled brush . . . no well ordered forest, nothing but the primitive woods with their solemn silence reigning everywhere."

As Asher B. Durand's *Kindred Spirits* (page 69) makes apparent, there was a close bond between their paintings and the extensive nature poetry of the day. Both poets and painters shared the belief that God's presence was manifest in nature, and

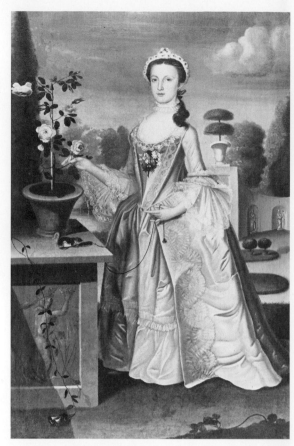

1. WILLIAM WILLIAMS. *Deborah Hall.* 1766. Oil on canvas, 71¼″ × 46½″. The Brooklyn Museum, Brooklyn, New York (Dick S. Ramsay Fund).

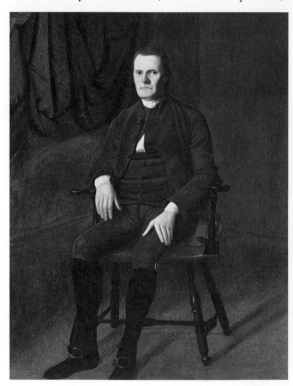

2. RALPH EARL. *Roger Sherman.* 1777–1779. Oil on canvas, 64″ × 49⁹⁄₁₆″. Yale University Art Gallery, New Haven, Connecticut (Gift of Roger Sherman White).

that the artist's function was its revelation. This effectively limited the liberties that the artist permitted himself, even though Emerson had encouraged him to show in man "the suggestion of a fairer creation than we know." And since "sublimity" was the quality perhaps most highly prized in nature and in art, the painter sought it where he

could best find it, even if it led him to Labrador, the Andes, or tropical jungles, as in Frederic Church's *Rainy Season in the Tropics* (pages 78–79). While painters such as Albert Bierstadt and Thomas Moran took as their subject the spectacular scenery of the Rocky Mountains, George Inness, by contrast, under the influence of the Barbizon School produced lyrical landscapes imbued with personal feeling, blurring the objective clarity of the Hudson River School with an atmospheric, impressionistic haze.

By mid-century, however, another group of landscape painters—generally identified today as the luminists or tonalists—were exploring a different direction. They avoided the grandiose, the sublime, and were chiefly concerned with subtle nuances of light and atmosphere rendered in a precisely realist technique. Early figures in the movement were two English-born artists, Robert Salmon and George Harvey, the latter of whom undertook a series of watercolors that he called Atmospheric Landscapes of North America. But the artists who carried this kind of painting to its purest expression were Fitz Hugh Lane and Martin J. Heade (pages 74, 76–77).

Both Lane and Heade captured with mirrorlike clarity changing effects of sunlight, mist, rain, or approaching storms. Lane's predominant note was one of serenity (fig. 3). Henry James might have been describing a Lane canvas when he wrote in his story "A Landscape Painter" (*Atlantic Monthly*, 1866): "I shall never forget the wondrous stillness which brooded over earth and water. . . . How color and sound stood out in the transparent air. . . . The mossy rocks doubled themselves without a flaw in the clear, dark water. . . . There is a certain purity in this Cragthorpe air which I have never seen approached,—a lightness, a brilliance, a *crudity*, which allows perfect liberty of self-assertion to each individual object in the landscape." Heade went even further than Lane in his concern with light. In the 1860s, for example, he painted a series of haystack views at different times of day and under different conditions of weather—a theme that Monet, independently and with a different technique, was to explore some twenty

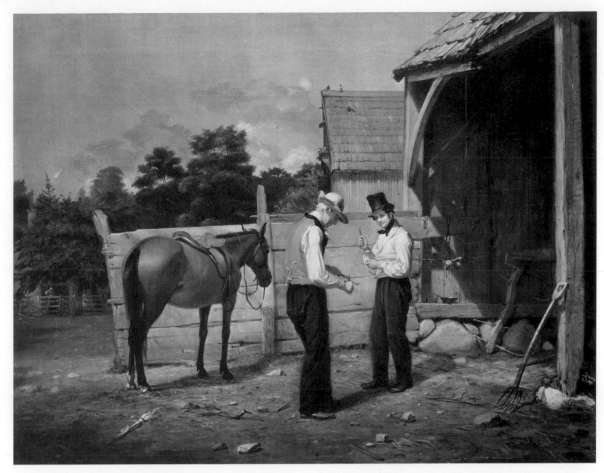

4. WILLIAM SIDNEY MOUNT. *Bargaining for a Horse*. 1835. Oil on canvas, 24″ × 30″. The New-York Historical Society, New York.

years later. Heade was fascinated with the drama of storms (page 76), and with exotic tropical effects that he encountered in Brazil (page 77).

In their concern with light, the luminists forecast the central preoccupation of the Impressionists

3. FITZ HUGH LANE. *Owl's Head, Penobscot Bay, Maine*. 1862. Oil on canvas, 16″ × 26″. Museum of Fine Arts, Boston (M. and M. Karolik Collection).

a generation or more later, although there was of course nothing impressionist in their handling of it. Perhaps their most notable accomplishment was their transformation of realism into a tool for poetic expression. Their intensity of observation imparts, in some strange way, an intensity of feeling. Yet their visions have a frozen, almost trancelike quality; they are oddly impersonal.

Something of the same indefinable magic crept into the work of certain naïve painters, such as the anonymous author of the *Meditation by the Sea* (page 75). Obviously he was not technically equipped to paint the subtleties of light and atmosphere, but he shared with the luminists an ability to isolate the moment, to freeze the scene.

At about the same time that American painters began to portray our landscape, others turned to genre, recording incidents of daily life. There had been earlier essays in this direction in the eighteenth century, such as John Greenwood's *Sea Captains Carousing in Surinam* (page 25). And early in the nineteenth century Charles Willson Peale had painted himself exhuming the bones of a mastodon (page 42), while Henry Sargent had preserved the look of a sophisticated dinner party of the 1820s (page 54).

But it was only after 1830 that genre painting became a widespread movement, and its unquestioned leader was William Sidney Mount. Mount expressed his distrust of "ideality and the grand style" and announced that his aim was "to copy nature . . . with truth and soberness." His crisp realist style was not unlike that of the luminists, and, indeed, his *Eel Spearing at Setauket* (page 72) has all the reserved poetry of a luminist landscape. Mount's commoner vein was one of rustic anecdote (fig. 4), and his popular success in this area established a mode that prevailed in American genre

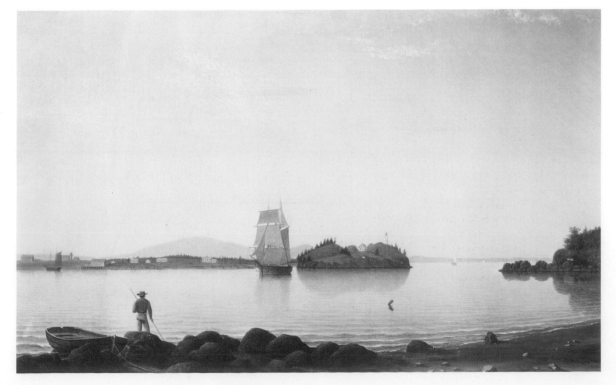

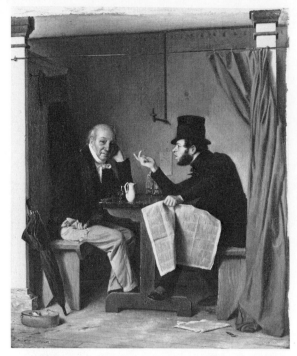

5. RICHARD CATON WOODVILLE. *Politics in an Oyster House.* 1848. Oil on canvas, 16″ × 13″. Walters Art Gallery, Baltimore.

painting until the Civil War, although urban life had its chroniclers, too, as in Richard Woodville's *Politics in an Oyster House* (fig. 5).

Western genre painting departed more radically from Eastern when it came to portraying the American Indian. A sense that the Indians' way of life was doomed and should be recorded before it was too late motivated several artists in a quasi-scientific study of their society and customs, much as Audubon was impelled to record the birds of America before they should vanish from their primeval haunts. George Catlin, Alfred Jacob Miller, Seth Eastman, and Karl Bodmer were only a few of those moved to some degree by documentary aims. Paradoxically, Catlin, who gave us the most extensive record of Indian life, was the least realistic, perhaps because the pressure of recording everything he saw led him to adopt a kind of sketchy shorthand. But in his portraits of Indians, like the

sardonic *Pigeon's Egg Head Going to and Returning from Washington* (page 44), he could be as precisely realistic as any of his contemporaries.

It was in still-life painting, however, that American realism found its most extreme expression. In the beginning (early in the nineteenth century) it was much influenced by Dutch still-life conventions. Raphaelle Peale, for instance, was following Dutch examples when he arranged his objects in the shallow space of a tabletop set against a plain wall, with the edge of the table a dark band, as a kind of visual base, across the bottom of the canvas. But Peale departed from Dutch precedent in the homely nature of his materials and the simplicity of his designs—a cupcake and a few raisins, some carrots and a red pepper (fig. 6), or a spray of blackberries on a china saucer. These he painted with a closeness of observation that gives us a heightened sense of their existence, as if we were seeing their miraculous forms and textures for the first time. The poetry of things—that things have a poetry not of association but in themselves—is, as George Santayana pointed out, a philosophical concept of antiquity. Even before the luminists found it in landscape, Peale showed that it existed in the most commonplace objects, although he was not above using his great skill for less elevated purposes, as in his mischievous *After the Bath* (page 41).

The work of Raphaelle and his uncle James Peale affected American still-life painting for many years. In the last quarter of the nineteenth century, however, a new kind of still-life painting emerged, embodying an even higher degree of illusionism. William M. Harnett (page 84) was the leading practitioner of this trompe-l'oeil (fool-the-eye) realism. He was soon followed by John F. Peto (page 85), John Haberle, Alexander Pope (page 91), and others. These artists—Harnett and Peto especially—composed their paintings with a much more developed sense of color and design than the Peales had evinced. Indeed, the revival of interest in trompe-l'oeil art (once thought fit only for bourgeois consumption) stems largely from the appeal it has to modern eyes for its abstract qualities. But perhaps because of this very concern with design, these artists lost some of the "poetry of things"

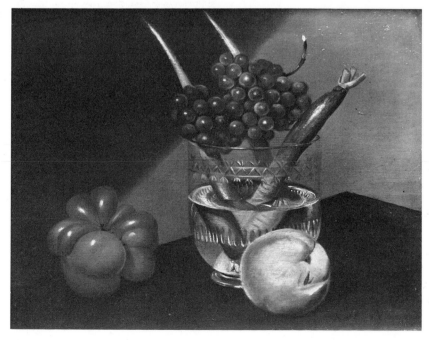

6. RAPHAELLE PEALE. *Still Life with Red Pepper.* c. 1810. Oil on canvas, 11¾″ × 15″. Wadsworth Atheneum, Hartford, Connecticut (Ella Gallup Sumner and Mary Catlin Sumner Collection).

that Raphaelle Peale had demonstrated. It is his unselfconscious, less illusionistic, but more penetrating art that now seems the truer expression of American realism.

Aesthetically speaking, the culmination of American realism came only after the Civil War; it manifested itself in the work of two of America's greatest nineteenth-century painters—Thomas Eakins and Winslow Homer. Of the two, Eakins was closer to the tradition established by Copley in portraiture and by Mount and Bingham in genre. There was, in his work, a sobriety, an analytical approach to anatomy and perspective, a painstaking attention to detail, an aversion to romanticizing. His portraits, such as *Miss Van Buren* (page 94), have the ring of a truth that goes deeper than appearance, although they were often distasteful to his sitters. His scenes, such as *Max Schmitt in a Single Scull* (page 92), have an absolute clarity and firmness of structure as well as a sensitive rendition of light and atmosphere. It is not just the similarity of subject that links this picture with Mount's *Eel Spearing at Setauket* (page 72); it is perhaps the final expression of the luminist vision before it broke into Impressionism.

And Impressionism, in its various forms, was, of course, the movement that replaced the old descriptive painting with a new visual realism during the last third of the century. The transition appears in early work by Winslow Homer, such as his *Croquet Scene* of 1866 (page 89), and in the slightly later paintings of Nantucket by Eastman Johnson (page 88). Although still close to the earlier realism, in these pictures a new freedom in the handling of paint is apparent: highlights are scumbled on, contours broken, forms suggested rather than analyzed, details blurred by sunlight or obscured in shadow. In his later seascapes, such as *West Point, Prout's Neck* (fig. 7), Homer went on to a much bolder style that owed little to European sources and may be considered our first truly native Impressionism.

Other artists were more indebted to European developments. The dark Impressionism of the Munich School affected Frank Duveneck (fig. 8) and William Merritt Chase, and through them, as teachers, a whole generation of younger Americans. John Singer Sargent (page 97) and James Abbott McNeill Whistler (page 96) spent most of their lives abroad and made their own contributions to international Impressionism. Mary Cassatt (page 93), Theodore Robinson, John H. Twachtman (fig. 9), Childe Hassam, and others were directly influenced by such French Impressionists as Claude Monet and Edgar Degas. But they did not go so far as the French in pointillism or in the dissolution of form in sensuous color, which may again be attributed to the persistence of the more sober form of American realism.

That realist tradition was indeed so powerful throughout the nineteenth century that it is easy to overlook certain maverick artists who flouted it—often to their sorrow insofar as material success was concerned. From John Quidor's robust fantasies, based on the writings of James Fenimore Cooper and Washington Irving (page 55), to Ralph Blakelock's moonlit landscapes and Albert P. Ryder's dark visions, such as *Jonah* (page 100), there stretch some sixty years during which various

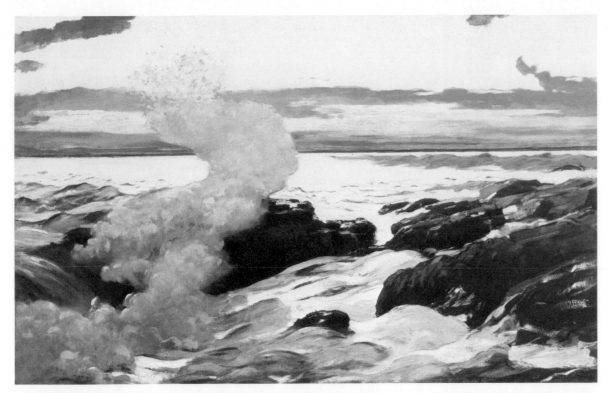

7. WINSLOW HOMER. *West Point, Prout's Neck*. 1900. Oil on canvas, 30¹⁄₁₆″ × 48⅛″. Sterling and Francine Clark Art Institute, Williamstown, Massachusetts.

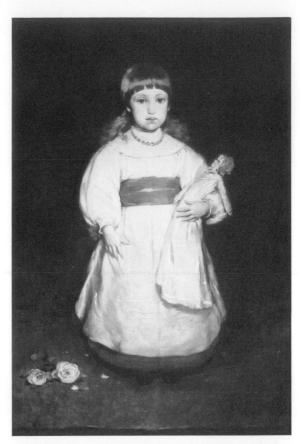

8. FRANK DUVENECK. *Mary Cabot Wheelwright*. 1882. Oil on canvas, 50³⁄₁₆″ × 33³⁄₁₆″. The Brooklyn Museum, Brooklyn, New York (Dick S. Ramsay Fund).

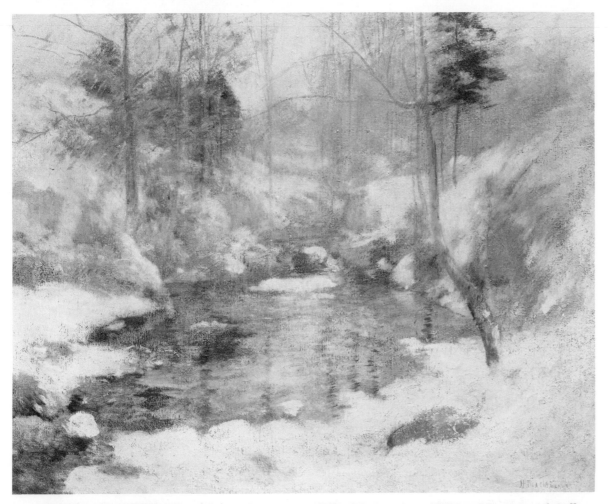

9. JOHN H. TWACHTMAN. *Winter Harmony*. c. 1900. Oil on canvas, 25¾″ × 32″. National Gallery of Art, Washington, D.C. (Gift of the Avalon Foundation, 1964).

artists explored on occasion the private worlds of their imagination. The subject might be ostensibly biblical but its embodiment as fanciful as Edward Hicks's *Peaceable Kingdom* (page 62) or Erastus Salisbury Field's *Israelites Crossing the Red Sea* (page 63). In Thomas Cole's *The Architect's Dream* (pages 70–71), Elihu Vedder's *Lair of the Sea Serpent* (page 98), and William Rimmer's *Flight and Pursuit* (page 99), we meet a more private imagery, sometimes close to nightmare. But these were all exceptions in an era firmly wedded to fact. Quidor was accused by a contemporary critic of painting a horse that "is not a horse . . . being unlike to anything in the heavens above, the earth beneath or the waters under the earth," while Ryder's *Jonah* was described as being "chiefly remarkable for the bad taste in the attempt to represent the Almighty." So Quidor was forced to paint banners and fire-engine panels for a living, Blakelock became insane and spent years in a state hospital, and Ryder lived on a pittance in his crowded, untidy rooms, ever more reclusive in the face of critical neglect. Realism was too firmly entrenched to be abandoned without some allegorical or biblical sanction—and even that was not always enough. As a certain Dr. Samuel Webber complained in the *New England Magazine* in 1835, artists' angels were anatomically impossible. "How then," he asked, "shall these heavenly existences be represented fittingly . . . ? Truly," he answered, "it does not appear necessary that they should be at all."

American sculpture, through most of the nineteenth century, suffered from the overwhelming bane of Neoclassicism. On rare occasions this produced some charming and decorative figures, such as William Rush's allegorical *Schuylkill Freed* (page 47), which benefits from French influence, probably transmitted by Houdon. Most professional American sculptors, however, studied in Italy, like Hiram Powers and Horatio Greenough; there, long after Canova's death in 1822, his chilly sentimentalizations of Greek sculpture—perpetuated by Thorwaldsen—still seemed the acme of perfection. The best work of the Neoclassicists was their portraits; in these, despite lip service to antiquity through togas and similar trappings, they sometimes carved heads of forceful realism and sculptural strength, as in Powers's *Andrew Jackson* (page 51). But it

was not until the end of the century that classical ideals were really understood and—principally by Augustus Saint-Gaudens (page 95)—were blended with a greater naturalism and Renaissance influences into a Beaux-Arts tradition that revitalized American sculpture. A more pedestrian realism had produced endless Civil War monuments, Frederick Remington's illustrative Western bronzes, and the small Rogers groups in plaster that became ubiquitous in middle-class American homes.

For the greater part of the nineteenth century, however, the most interesting sculpture—to modern eyes—was that of the craftsmen: the naïve makers of portraits and trade signs, the figurehead carvers, the whittlers of toys and decoys, and the weather-vane makers. Mercifully unaware of Neoclassicism for the most part, they worked with an instinctive feeling for expressive form and a natural decorative flair (pages 49, 67, and 82), and some of their works uncannily forecast modern sculpture. Others are masterpieces of powerful carving, like the New England figureheads (pages 48 and 50) and the somber, impressive cigar-store Indian attributed to a New Jersey slave named Job (page 66). We are just beginning to recognize the variety and richness of these creations.

Early in the twentieth century, American art was shaken by two revolutions that profoundly changed its directions. The first—and least radical—was a new attitude toward the permissible subjects of art. It is hard to realize today the bathos into which the National Academy's exhibitions had slipped by the early 1900s (although scarcely more so than those of the Paris Salons and the Royal Academy); they were studded with pictures entitled *Dream Life, Divinity of Motherhood, Love's Token,* and the like. Genre painting had for the most part descended into cloying sentimentality, while a maiden in a Grecian robe could be posed on a haystack for an allegorical picture called *Autumn.*

But new forces were stirring. As early as 1880, W. Mackay Laffan wrote in the *American Art Review* that there would be more cause for rejoicing "over one honest and sincere American horse pond, over one truthful and dirty tenement, over one unaffected sugar refinery, over one vulgar but unostentatious coal wharf than there shall be over ninety and nine mosques of St. Sophia, Golden Horns, Normandy Cathedrals and all the rest of the holy conventionalities and orthodox bosh."

The call for a straight look at the realities of American life was sounded more effectively by Robert Henri early in the twentieth century. With others—including John Sloan (fig. 10), William Glackens, Everett Shinn, and George Luks (page 103)—he founded a group called The Eight, which held one memorable exhibition in 1908. Conservatives called them the Black School, the Revolutionary Gang, and eventually the Ashcan School, the name that has stuck. Other critics welcomed their exhibition as a challenge to the Academy and the beginning of a more truly national art.

The Eight were soon joined by others, including Eugene Higgins, Jerome Myers, and George Bellows (page 102), all of whom turned their attention to the teeming street life of New York, to prostitutes, foreign immigrants, nickel movies, prizefights, and McSorley's Bar. Stylistically they remained within the acceptable realist tradition of dark Impressionism, which both William Merritt Chase and Henri taught. But by turning it to new purposes, they revitalized it for a time.

The more radical revolution by far was that of international modernism, which emerged in Europe during the first two decades of the century, and in which Americans took part from very nearly the beginning. Its two main branches were expressionism and Cubist-based abstraction, both of which challenged the basic assumptions of the American realist tradition. As a nation we were far less prepared for such innovations than Europe, since we had developed no real Post-Impressionist movement to pave the way for expressionist distortion or Cubist analysis of form, as Cézanne, Gauguin, Seurat, and Van Gogh had done abroad. Maurice Prendergast came closest to filling that role here, but his lyrical watercolors (page 104) and modest oils were not widely appreciated until years later.

It was therefore predictable that American critics, academic artists, and the public were shocked by the modern art that most of them saw for the first time in the so-called Armory Show of 1913 (see page 105). Charges of charlatanism were common, and the critic Royal Cortissoz consigned all French art from Cézanne on to the rubbish heap. In 1910 Gelett Burgess had been equally taken aback by the paintings by Henri Matisse, André Derain, and the other *fauves* ("wild beasts") that he saw in Paris. "If you can imagine," he wrote in the *Architectural Record* that year, "what a particularly sanguinary little girl of eight, half crazed with gin, would do to a white-washed wall, if left alone with a box of crayons, then you will come near to fancying what most of this work was like."

Nevertheless, many young American artists working in Europe were immediately drawn to the new movements. A class taught by Matisse, starting in 1908, was popular, and his *fauve* influence is clearly apparent in early paintings by Alfred Maurer, Morton L. Schamberg, William and Marguerite Zorach, and others. Patrick Henry Bruce (page 109) and Arthur B. Frost, Jr., allied themselves with the French painter Robert Delaunay and his Orphist movement—an offshoot of Cubism that, by exploiting the receding and advancing qualities of color, created the appearance of motion in depth. Morgan Russell (fig. 11) and Stanton Macdonald-Wright explored similar effects in a rival movement that they called Synchromism. Under the influence of Italian Futurism, Joseph Stella (fig. 12) created even more dynamic abstract compositions. The presence in New York of Marcel Duchamp and Francis Picabia at the time of World War I also influenced a number of artists, among them Morton Schamberg and Man Ray (pages 106–107), to work in a style like that being evolved independently by the Dadaists abroad.

Marsden Hartley studied not only in Paris but also in Germany. Expressionism in that country was heavier in its forms and at least as violent in color as *fauve* painting. Hartley's Berlin canvases of 1914 and 1915 (fig. 13) are among the most powerful abstractions by an American at that time, and some of the German influence persisted throughout his career (page 114). John Marin, on the other hand, developed a lighter, tenser expressionism, mingled with Cubist formulas, which he refined into a personal shorthand well adapted to stating the dynamic forces he felt in his world (page 115).

10. JOHN SLOAN. *South Beach Bathers.* 1908. Oil on canvas, 25⅞" × 31⅞". Walker Art Center, Minneapolis, Minnesota.

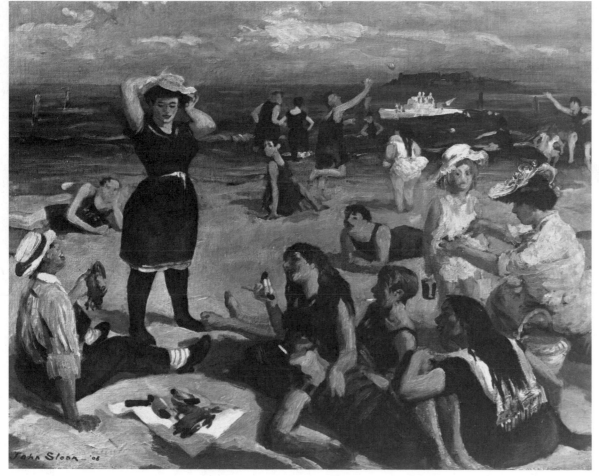

certain sardonic comment on the cult of brushwork.

In general, however, the Pop artists drew on the signs, the symbols, and the techniques of popular culture—on such sources as comic strips, billboards, trademarks, and advertisements. This imagery had been tentatively explored before. As early as 1924 Gerald Murphy painted a razor, a fountain pen, and a box of safety matches (page 110)—machine-made icons of popular use—although he composed them much as a Cubist artist would have done. Stuart Davis also drew on the city's vulgar aspects, especially the lettering of its signs, but like Murphy he was as much interested in a kind of Cubist design as in the nature and associations of the elements he used (page 116).

True Pop art was more ironic in tone and more concerned with the levels of meaning in objects—and often with the actual objects themselves. Like Rauschenberg's *Canyon* (page 160), Jim Dine's *Double Isometric Self-Portrait* (page 171) is an assemblage of three-dimensional things and painted surfaces, but its cool impersonality is in direct contrast to Rauschenberg's expressionist implications.

Pop art explored many other approaches to the symbols of our culture. Often its artists used extreme enlargement—as in Lichtenstein's exaggerated benday dots, a device that emphasizes both the essential nature of the image (a reproduction) taken as point of departure, and its abstract quality. This process of transformation is even more striking in the immense paintings of James Rosenquist (pages 166–167), which utilize billboard technique and advertising images but fragment the latter to create virtually abstract compositions.

The multiple images of Andy Warhol and his use of—among other things—popular cult figures, from Marilyn Monroe to his own self-portrait (page 170), represent other aspects of the movement. Style itself becomes the subject of some Pop art, as in Lichtenstein's ironic transformations of Art Deco, Monet's Cathedrals, and Abstract Expressionist flourishes (pages 168–169), or in Tom Wesselmann's series of Great American Nudes—some with oblique reference to Matisse (page 172).

A movement so diverse is hard to summarize. Although when it first emerged it was called New Realism, Pop art is not primarily realist. It is indebted to both Abstract Expressionism and the hard-edge abstraction of the 1960s, but it is not predominantly abstract. Rather, it is an art that deals with the accretion of meanings in our daily visual experience and that wrings a certain sardonic poetry from this rich source in a variety of ways.

Twentieth-century sculpture made a more uncertain start but caught up with painting (some would say surpassed it) after 1950. The early modernists of consequence can be numbered on one hand: Elie Nadelman, Alexander Archipenko, and Gaston Lachaise, soon followed by Alexander Calder and Jacques Lipchitz. Indeed, Nadelman (about 1907) seems to have preceded Picasso in the Cubist treatment of a human head, and his slightly later figures with their elegant, interlocking, and reciprocal curves (pages 126 and 127) were, in his own words, "nothing but a pretext for creating significant form." Lachaise was trained in the tradition of Rodin and French academic sculpture but soon evolved his own style of sinuous lines and simplified volumes (page 125).

11. MORGAN RUSSELL. *Four-Part Synchromy, Number 7.* 1914–1915. Oil on canvas, 15¾" × 11½". Whitney Museum of American Art, New York (Gift of the artist in memory of Gertrude Vanderbilt Whitney).

13. MARSDEN HARTLEY. *Portrait of a German Officer.* 1914. Oil on canvas, 68¼" × 41⅜". The Metropolitan Museum of Art, New York (The Alfred Stieglitz Collection).

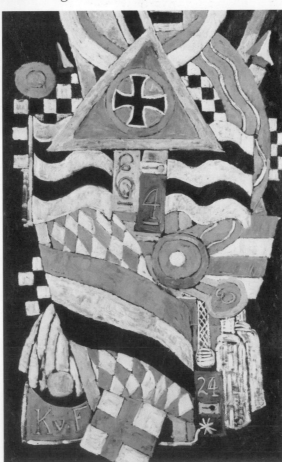

These are only a few of the pioneer modernists in America; many other artists, less well known today, experimented with abstract or expressionist styles

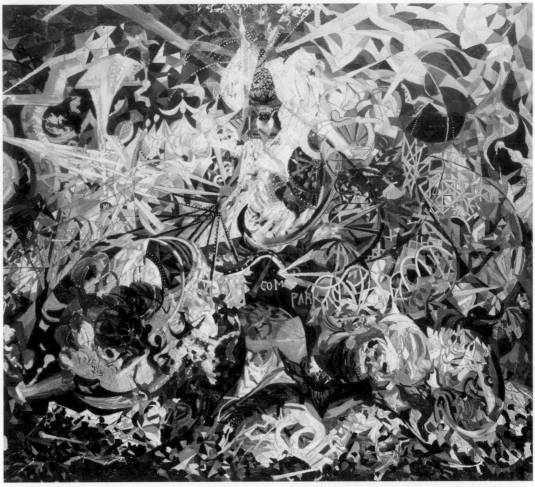

12. JOSEPH STELLA. *Battle of Lights, Coney Island.* 1913. Oil on canvas, 6' 2" × 7'. Yale University Art Gallery, New Haven, Connecticut (Gift of Collection Société Anonyme).

in the first two decades of the century, and some produced work of lasting interest. In the 1920s, however, a widespread reaction set in, and there was a general retreat from the extreme positions of modernism, both in this country and in Europe. A number of the pioneers found pure abstraction inadequate for their needs and moved toward various forms of semiabstraction that permitted them to say more specific things about nature and man. Thus Arthur Dove—one of the first Americans to practice abstraction—evolved fluid patterns that, despite their abstract look, are recognizable symbols of trees, moons, the sea, or boats (page 105). Somewhat later, Milton Avery worked out a similar way of translating nature into strong, flat designs (page 153). Stuart Davis, who had been swept into Cubist experiment by the Armory Show, soon found that he needed concrete elements of American life, from gas pumps to billboards, to express the dynamic tempo of the American city (page 116).

Still another group of painters were the precisionists, who used the sharp contours and flat areas of color characteristic of late Cubism to create semiabstract paintings of familiar subjects that can be sensed both as design and as reflections of American life. The spare and functional aspects of our civilization especially appealed to them and were well adapted to this kind of precisionist treatment, as in the fine three-dimensional geometry of Niles Spencer's *Two Bridges* (page 113). Charles Demuth infused precisionism with elegance and wit in his symbolic portrait of William Carlos Williams, *I Saw the Figure 5 in Gold* (page 111). Charles Sheeler, more than any other, explored the intrinsic beauty of machine forms, as in his *Upper Deck* (fig. 14). Georgia O'Keeffe eliminated extraneous detail to delineate architecture, flowers, and the desert with clean, bold contours (page 112).

Expressionism required less modification than abstraction to deal with aspects of American life.

14. CHARLES SHEELER. *Upper Deck.* 1929. Oil on canvas, 29⅛" × 22⅛". Fogg Art Museum, Harvard University, Cambridge, Massachusetts (Purchase—Louise E. Bettens Fund).

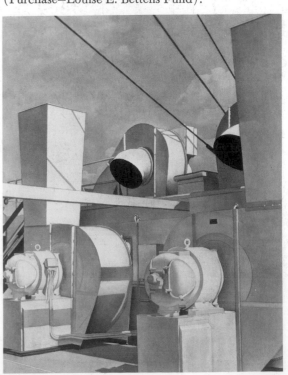

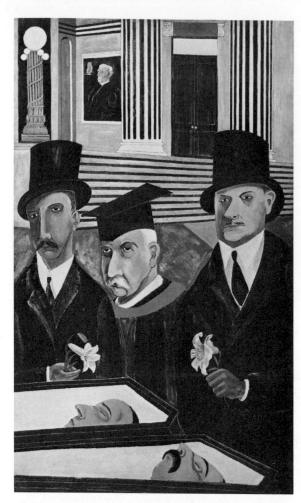

15. BEN SHAHN. *The Passion of Sacco and Vanzetti.* 1931–1932. Tempera on canvas, 7' ½" × 4'. Whitney Museum of American Art, New York (Gift of Edith and Milton Lowenthal in memory of Juliana Force).

It was adopted, especially during the 1930s, by a number of artists who were concerned with the human suffering of the Depression years. Ben Shahn

17. CHUCK CLOSE. *Phil.* 1969. Synthetic polymer on canvas, 9' × 7' 10". Whitney Museum of American Art, New York.

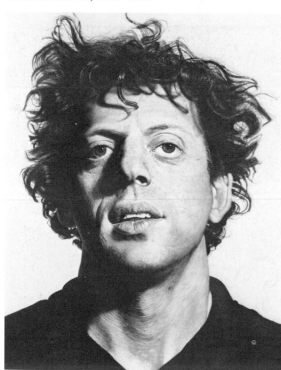

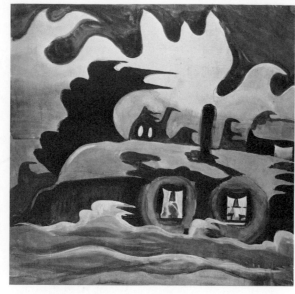

16. CHARLES BURCHFIELD. *The Night Wind.* 1918. Watercolor and gouache, 21½" × 21⅞". The Museum of Modern Art, New York (Gift of A. Conger Goodyear).

in his series of pictures attacking the injustice of the Sacco-Vanzetti trial (fig. 15), Philip Evergood, Jacob Lawrence, Jack Levine, and others used various kinds of expressionist distortion to give a cutting edge to their social protest. The style persisted even in later works, like Shahn's *The Red Stairway* (page 120) and Lawrence's *Cabinet Makers* (page 121). Expressionism could also convey a wide range of private emotions, as in Louis Eilshemius's *Jealousy* (page 101) or Charles Burchfield's *Night Wind* (fig. 16).

Despite the profound influence of modernism, the old realist tradition never totally died out and was never completely submerged. Edward Hopper, more than any other artist, was responsible for its long persistence. His unflinching view of man's pervasive loneliness was imparted by exact observation and an immensely subtle use of light to emphasize the isolation of people, as in his *Nighthawks* (page 117). In Parker Tyler's apt phrase, he was a master of "alienation by light."

As the century has worn on, more and more younger artists have reexplored the possibilities of realism. Although Andrew Wyeth is the best known (page 119), others of a still newer generation have utilized the unselective vision of the camera and the random nature of the snapshot to create effects of immediacy and an almost impersonal reality. Chuck Close (fig. 17) and Richard Estes (page 173) are two among many in the current movement of Photo-Realism, which has its parallel in the work of such ultrarealist sculptors as John de Andrea and Duane Hanson (fig. 18).

Another form of earlier art that has survived with little change in the twentieth century is that of the naïve or folk artist. America's transition from a rural, craft-oriented culture to an urban, machine-oriented one obviously diminished the number of artisans producing handmade objects for use and decoration. Still, we have always had our untrained and unsophisticated artists with an innate feeling for expressive design. Sometimes their works are nostalgic images of a more innocent past, like Joseph Pickett's *Manchester Valley* (page 81).

Sometimes they are priv[...] Hirshfield's *Nude at the* [...] rare occasions they rise t[...] personality, as in the [...] John Kane (page 122). [...] have not entirely disappe[...] charming *Adam and Eve* [...] Dolores Lopez (page 128[...]

While the social fermen[...] haps the normal pendulu[...] ment) turned many artist[...] modes of expression, there[...] if not very visible curren[...] through that decade. Me[...] goyne Diller, Hans Hof[...] George L. K. Morris, and [...] only some of the most fa[...] ploring various kinds of a[...] to expressionist in those yea[...]

Early in the decade and [...] which challenged tradition[...] nature of art, reached A[...] anti-aesthetic movement o[...] and the subconscious—wa[...] Breton in Paris in 1924. [...] Paris, was an early conv[...] Sage, who was also associa[...] in the 1930s, continued t[...] to paint her haunted imag[...] (page 139).

Orthodox Surrealism did [...] American adherents, but i[...] on American art and was [...] which Abstract Expression[...] The Surrealists' theoretica[...] tism and distrust of conscio[...] liberating influences on a [...] York who had already abs[...] of abstraction, from Picasso[...] Gorky was among the first[...] realist theory and to exper[...] Although he consistently [...]

18. DUANE HANSON. [...] 1973. Polyester and fiber g[...] size. Collection of Morton N[...]

21. HELEN FRANKENTHALER. *Flood.* 1967. Synthetic polymer on canvas, 10' 4" × 11' 8[...] Museum of American Art, New York (Gift of the Friends of the Whitney Museum of Americ[...]

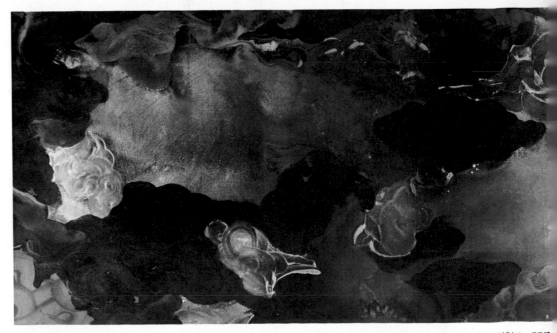

22. WILLIAM PETTET. *Buff.* 1969. Synthetic polymer on canvas, 6' 5" × 12' 5¾". Wh[...] seum of American Art, New York (Gift of the Larry Aldrich Foundation).

Pop art, as Lawrence Alloway has pointed out in his book *American Pop Art*, emerged "as an alternative to an aesthetic that isolated visual art from life and from the other arts"; it was rooted in "a new willingness to treat our whole culture as if it were art." In this respect it was the antithesis of

Abstract Expressionism with its elitism, [...] —as in the transitional work of Jasper Joh[...] 161, 162–163) and Robert Rauschenb[...] 160)—it sometimes utilized the free, pai[...] niques of that movement, and in Roy Lic[...] *Big Painting #6* (pages 168–169) eve[...]

It was Calder, however, who made the most radical contribution to modern sculpture. Starting as an illustrator, he developed, in the late 1920s, wire sculpture that was a kind of drawing in space (page 132). Volume and mass, the characteristics of sculpture for centuries, were destroyed in favor of contours, or more accurately were implied by the contours. And instead of sitting solidly on their bases, in the manner of traditional sculpture, these wire structures were hung from the wall or the ceiling or were poised on tenuous supports so that they often moved slightly, as if a tremor of life ran through them.

From this start Calder advanced to his abstract mobiles (page 134), creating the first extensive body of work by any sculptor based on an aesthetic of motion. These and the big stabiles of later years (pages 196–197) established him as one of the most creative innovators on either side of the Atlantic. With the exception of George Rickey (page 135), few artists have successfully followed him in the realm of mobile constructions.

Most American sculpture in the first forty years of the twentieth century adhered to conservative lines. The Rodin tradition of modeling in clay as a basis for figures to be carved in stone or cast in bronze was strong throughout the period. A small revolt took place when carvers like William Zorach, Robert Laurent, José de Creeft, Chaim Gross, and John Flannagan (page 129) tried to establish the primacy of direct carving with its special concern for the nature of the material, the shape of the original stone or log of wood, and the frank expression of carving techniques by leaving on the finished work the marks of the tools used in its creation. But this cult of "truth to materials" was less an innovation than it was a return to an older tradition; it soon developed its own conventions and eventually passed into academic formulas.

Even Surrealism, which had leavened American painting in the 1930s, had little effect on sculpture, although David Smith went through a Surrealist phase. The only exception was Joseph Cornell, whose magical boxes with their dreamlike allusions to the Renaissance (page 138), to alchemy, astrology, and a highly personal ornithology had no successful followers. Cornell's technique of creating three-dimensional works by the assemblage of miscellaneous parts, however, had many subsequent practitioners. At a later date the spirit of Surrealism did reappear occasionally, as in H. C. Westermann's constructions, the fantastic chairs of Lucas Samaras (page 178), or Ernest Trova's robotlike Falling Man (page 179). Perhaps there is even a final echo of it in the grotesque tableaux of Edward Kienholz (page 177), although his intention is social comment rather than exploitation of the subconscious.

It was only after 1940 that American sculpture really began to explore the paths opened by modernism. The concept of drawing in space, pioneered by Calder in his wire sculpture, was developed in a more delicate and totally abstract vein by Richard Lippold, who stretched filaments of metal into webs that are studies in poised tension, yet glitter romantically (page 137). But it was David Smith who made the most brilliant use of sculptural calligraphy. Welding strips of steel together in linear compositions, as in the *Hudson River Landscape* (page 133), he created a monumental effect. Here the voids suddenly become as important as the

lines that define them, and the line itself takes on a greater variety of weight and rhythm. Such work is not unrelated to Jackson Pollock's skeins of paint and has a similar spontaneity of feeling (although actually based on careful preparatory studies).

Smith went on in later works to reexplore Cubism (pages 154 and 155) and to range through a wide variety of more open forms, which fall somewhere between the linear pieces and the solid geometry of his Cubi series. His *Zig IV* (page 154) is constructed entirely of sheets of metal welded to form a dense design of curves and squares. In all his work there is a craftsmanship, a respect for his intractable, even brutal, materials, and an instinctive rightness of proportion that make him unquestionably one of the leading figures of our time. His influence has been enormous.

Two other sculptors of Smith's generation have contributed greatly to the range of abstract sculpture in the last thirty years: Isamu Noguchi and Louise Nevelson. Noguchi enlarged the role of stone carving—that most traditional of techniques—with a modernist vocabulary. His slab constructions, such as *Kouros* (page 130), suggest totemic figures or assemblages of biomorphic forms, yet are totally abstract. His monolithic carvings, such as *Black Sun* (page 131), bring into focus his feeling for stone and his immense skill in handling it. His works combine flat and round, fluid surfaces and sharp angles, in an abstract counterpoint of high tactile appeal.

Louise Nevelson has done more than anyone to make sculpture a complete environment, a total experience. Working in modules—generally shallow

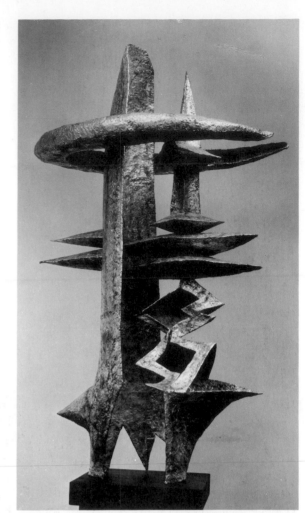

24. SEYMOUR LIPTON. *Sorcerer*. 1957. Nickel-silver on monel metal, 60¾″ high. Whitney Museum of American Art, New York (Gift of the Friends of the Whitney Museum of American Art).

wooden boxes filled with a rich variety of carpentry—she builds walls that overwhelm the viewer by their sheer size and sometimes literally surround him. Painted always in monochrome—white, gold, or black—these assemblages take on an impressive unity that belies the small scale of their parts. The black walls especially, with their mysterious depths and shadows, have a romantic quality rare in abstract sculpture (pages 158–159). Although wood was for a long time her chosen material and the one she has seemed most at home with, she has also worked in painted aluminum, plastic, and recently in steel for outdoor monuments (pages 198–199).

Abstract Expressionism had only a few analogies in sculpture, perhaps because the method of gesture painting was not really adaptable to the medium, and color fields were inapplicable. Nevertheless, some artists, such as Barnett Newman, did work in both painting (fig. 20) and sculpture (page 149), while others, such as Theodore Roszak, Reuben Nakian, Ibram Lassaw, Herbert Ferber (fig. 23), and Seymour Lipton (fig. 24), were not only friends of the Abstract Expressionists but also created forms that were approximately equivalent in their rough vigor and nongeometrical, sometimes biomorphic, shapes. Frederick Kiesler's work in wood (fig. 25) and the wooden constructions of Mark di Suvero (page 148) have an even more pronounced expressionist quality, which allies them stylistically, if not historically, with Abstract Expressionism. Kiesler, like Nevelson, is among the sculptors who have wished to make works that

23. HERBERT FERBER. *Sun Wheel*. 1956. Brass, copper, and silver, 56¼″ high. Whitney Museum of American Art, New York.

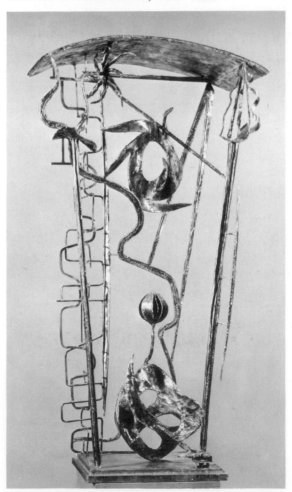

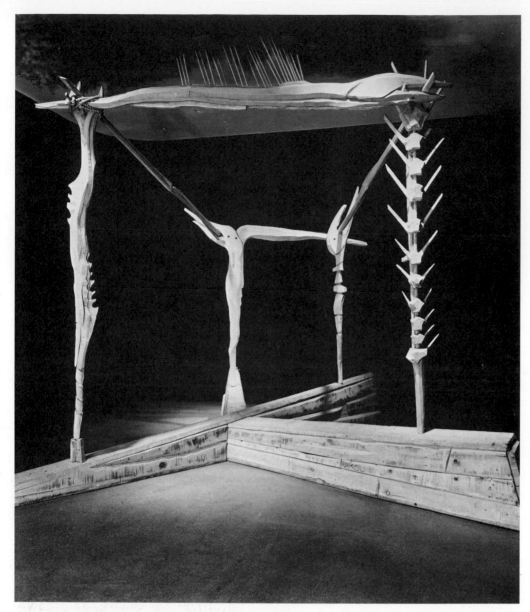

trasting ways of treating the same subject. His soft style (page 193) is his most original contribution to American sculpture and perhaps the most radical innovation since Calder's mobiles. The translation of normally hard objects into vinyl or canvas stuffed with kapok or foam rubber transforms the image from realism to a kind of wild and often very funny fantasy. As Barbara Rose points out in her monograph on Oldenburg, these soft works are never twice the same, since gravity alters them whenever they are moved. Thus accidents of process, which were sought but became frozen in gestural painting, are a constant, ever-recurring element in Oldenburg's works. Beyond this, their content is purely obsessional.

Oldenburg's hard constructions, such as *Giant Saw—Hard Version* (page 193), are not unrelated to the Minimal abstract sculpture discussed below; but since each deals with a recognizable object,

26a. MEL BOCHNER. *Ten to 10: Relation of Interior to Exterior Circles*. 1972. Ink and pencil on paper, 7½" × 9¾". Collection of Mr. and Mrs. Victor W. Ganz.

26b. MEL BOCHNER. *Ten to 10*. 1972. Pebbles on floor, 11' in diameter. Collection of the artist.

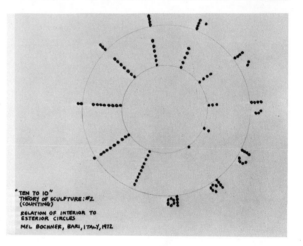

25. FREDERICK J. KIESLER. *Galaxy*. 1951. Wood, 12' high. Collection of Nelson A. Rockefeller.

would function as environments. And John Chamberlain, assembling fragments of automobile bodies or crushing them in a hydraulic press (page 156), devised the closest sculptural equivalent to the action painters' creative use of accident.

Just as American painting in the 1960s swung from expressionism to Pop art and to more geometrical forms of abstraction, so sculpture followed a very similar course. And just as the early painting of Johns and Rauschenberg leaned heavily on Abstract Expressionist technique, so the early Pop sculpture of Claes Oldenburg—the objects for his famous Store, made of muslin soaked in plaster stretched over a chicken-wire frame and painted with enamel (page 164)—had a strong Abstract Expressionist look. But Oldenburg's intentions, like those of the Pop painters, were different. "I am for an art," he wrote in 1961, ". . . that does something other than sit on its ass in a museum. I am for an art that grows up not knowing it is art at all. . . . I am for an art that embroils itself with the everyday crap & still comes out on top."

As his art developed in the 1960s, Oldenburg moved away from expressionism and worked in two opposed styles—one soft and one hard. He has used these simultaneously ever since, sometimes as con-

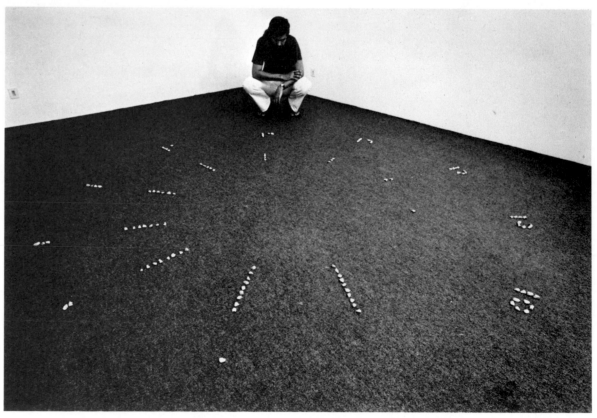

there is an inevitable tension between the realism and the abstract design—a tension heightened by the exaggerated scale, the texture, and the unexpected conformations.

The abstract sculptors (and painters of related tendency) who reacted against expressionism in the 1960s moved, for the most part, toward a much simplified geometry, sometimes called Minimal art. Among its leading figures are Robert Morris, Larry Bell, and Donald Judd, whose "specific objects" (as he once called his works) are severely simple forms, often arranged in equally simple progressions (page 190). "A shape, a volume, a color, a surface is something itself," he wrote in *Perspecta* 11 in 1967. "It shouldn't be concealed as part of a fairly different whole." It is apparent that such an art, severe and impersonal, is not only antiexpressionist; it also breaks with the more "designed" abstract sculpture of the past, such as Cubism or Constructivism.

The Minimal aesthetic appealed to a number of artists in the 1960s, although their means have differed widely. Dan Flavin has made spare creations of light, using standard fluorescent tubes in simple configurations (page 192). Tony Smith's constructions (page 195) have some analogies with Minimalism, although he arrived at them through his experimentation with modules and architecture, which may explain the great size of many of his pieces, their monumentality, and the impression they give of powerful, enclosed volumes. Like Nevelson, these artists conceive of their works as creating environments. This inclination, and the strength of gigantic scale and mass, reached its ultimate expression in the earthworks of Robert Smithson (pages 200–201) and others—whole landscapes altered not for charm or utility, as in gardens or parks, but purely to create basic forms on a hitherto unprecedented scale.

As we enter the last quarter of the twentieth century, American painting and sculpture present an exceptionally wide spectrum of styles, many of which have developed simultaneously in a number of countries as opportunities for international cultural contacts have continued to expand. In addition to those tendencies already referred to, we should mention Conceptual or Anti-object art (see figs. 26 a and b and page 200); the abstract serial imagery practiced by such artists as Agnes Martin, Carl Andre, and Sol LeWitt (fig. 27); and art utilizing electronic technology, such as video tape, pioneered by the Korean Nam June Paik, the Canadian Les Levine, and the American Vito Acconci (fig. 28), among others. This is a medium whose possibilities are only beginning to be realized.

These, then, in brief summary, are the main currents in American art, from those distant Colonial days—so much farther behind us than the years alone indicate—to our own uneasy present. It is a span of art split into two nearly unrelated parts by the advent of modernism. This is not entirely true, because the realist tradition of the eighteenth and nineteenth centuries has recently reemerged with considerable strength. But it is basically true, because the modern movements have proposed different values and different concepts of reality, and finally convinced us (with some help from science) that the nature of truth itself has changed.

The entire history of modernism, in this country

27. SOL LEWITT. *3 4 3 4 3*. 1974. Painted wood, 24″ × 40″ × 24″. John Weber Gallery, New York.

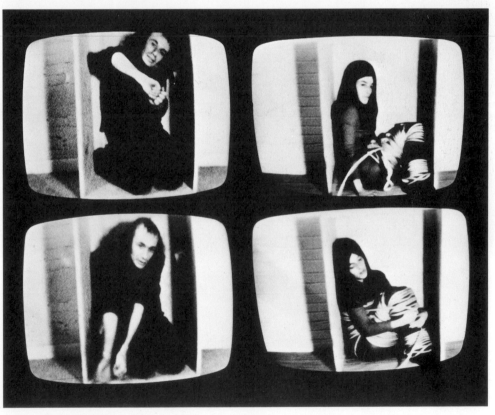

28. VITO ACCONCI. *Remote Control*. 1971. Two video tapes, one hour each, played simultaneously. Sonnabend Gallery, New York.

and abroad, has been one of successive challenges to previously accepted ideas, resulting in a constant enlargement of our definitions of art and shifts in the criteria by which it is judged. But these challenges have probably never been more radical than they seem to be at present, especially with the rise of Conceptual art and the increasing interest in electronics and video tape. What is involved is not only an extensive use of nonart materials and a merging of previously distinct mediums, but also a conscious effort to break down the barriers between art and life. The very notion of a work of art as a physical entity with some degree of permanence, which can be judged by aesthetic standards of quality, is being called into question. The relations among artists, critics, dealers, patrons, art institutions, and society at large are all being reexamined.

Gone forever are the simple faiths of the past. We no longer trust the evidence of our senses to reveal the nature of matter or to separate fantasy from fact. Nor can we believe totally in either. The ambiguity of truth is our discovery, and with it has come, inevitably, the accelerated search for new verities that especially characterizes our time.

Dawn's Early Light

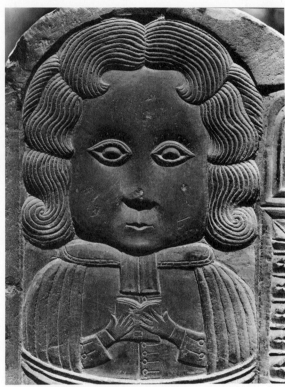

The year 1776 did not have the same significance in the arts as it did politically, that is, by marking a sudden rupture in tradition. Although independence intensified a sense of national pride and stimulated a demand for portraits of America's heroes, there was more continuity than change in the arts, and a persistence of certain characteristics that had developed during the Colonial period.

Chief among those characteristics were a straightforwardness of approach and an inclination toward the specific rather than the general. In a sense, a revolution in the arts was effected in England, rather than in America, with a body of theoretical writings on aesthetics by Edmund Burke and others from the mid-eighteenth century on; the founding of the Royal Academy in 1769; and Sir Joshua Reynolds's introduction of the Grand Style, with its emphasis on an intellectual ideal of beauty based on the antique and the Italian Renaissance. Americans, however, remained relatively unaffected by these developments. Both by temperament and by the nature of their social institutions, they were not prone to indulge overmuch in philosophical speculations and were quite averse to accepting authoritarian dictates on what art should be like. This spirit of robust independence—with an international melting-pot mix to adapt to their new purposes—is perhaps the most significant and durable aspect of American experience and art throughout their history. It was well after the Declaration of Inde-

29. UNIDENTIFIED ARTIST. Detail of the Reverend Jonathan Pierpont gravestone (initialed "N.L.," possibly standing for Nathaniel Lamson). 1709. Slate, 27½" high. Wakefield, Massachusetts.

pendence, however, that a free native style began to develop strongly.

Our seventeenth- and early-eighteenth-century portraits were more closely related to Elizabethan and Dutch prototypes than to the portraiture that was to develop in America. Yet one feels that the spirit of the rigorous pioneer life of the first settlers in New England and New York is reflected in these early likenesses. There are in many of them, as in the early gravestone carvings, a primitive candor and a fresh energy that reveal, within the shell of old, established traditions, the promise of a sturdy new style.

Although early-eighteenth-century painting, like the society, was for the most part literally Colonial, the forces that were leading to the Revolution were also inherent in the arts. At that time a number of talented painters broke away from English traditions to create our first native art: Joseph Badger, John Greenwood, Winthrop Chandler, and John Durand, who all made strong advances in this di-

rection. The works of Robert Feke, John Singleton Copley, Matthew Pratt, Benjamin West, and William Williams provide classic examples of the continuity of the English tradition in American art. Their best work, however, branches off vigorously from that tradition, rather than continuing in a direct line. The difference—in strength as well as in style—between the portraits Copley painted in America and those done after he settled in London in 1775 is most significant, as is also the fact that both West and Copley introduced a radical innovation into British art by departing from convention to represent contemporary events in contemporary dress.

The pre-Revolutionary works reproduced on this and the next four pages—covering the period from the late seventeenth century to 1776—present a visual prologue to our Bright Stars. They also provide some provocative comparisons (we name a few, but the reader is invited to find others): John Durand's *Children in a Garden* and Sheldon Peck's *Anna Gould Crane and Granddaughter Jennette* (page 39); Winthrop Chandler's portraits of the Reverend and Mrs. Ebenezer Devotion, painted just before the Revolution, and his portraits of Captain Samuel Chandler and his wife done shortly after it—the latter pair (page 33) being of particular interest in comparison with Ralph Earl's double portrait of Judge Oliver Ellsworth and Mrs. Ellsworth (page 32).

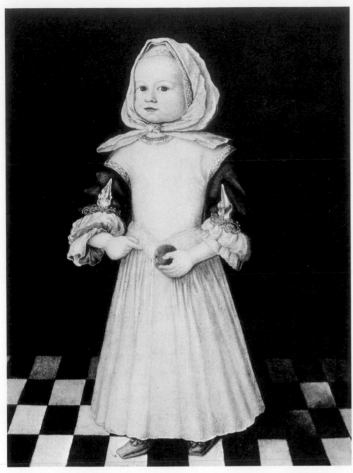

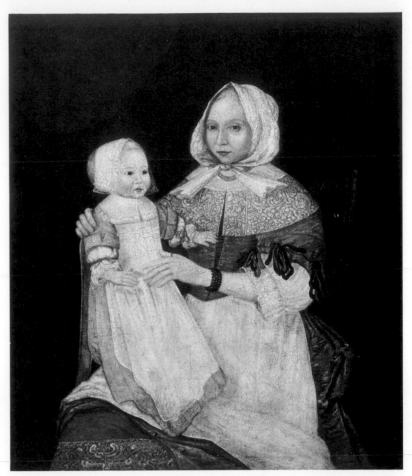

30. UNIDENTIFIED ARTIST. *Alice Mason.* c. 1670. Oil on canvas, 33¼″ × 24⅞″. Adams National Historic Site, Quincy, Massachusetts.

31. UNIDENTIFIED ARTIST. *Mrs. Elizabeth Freake and Baby Mary.* c. 1674. Oil on canvas, 42½″ × 36¾″. Worcester Art Museum, Worcester, Massachusetts (Gift of Mr. and Mrs. Albert W. Rice).

32. UNIDENTIFIED ARTIST. *Ann Pollard.* 1721. Oil on canvas, 28¾″ × 24″. Massachusetts Historical Society, Boston.

33. JOSEPH BADGER. *Mrs. John Edwards.* c. 1750. Oil on canvas, 47″ × 36″. Museum of Fine Arts, Boston (Gift of Dr. Charles W. Townsend).

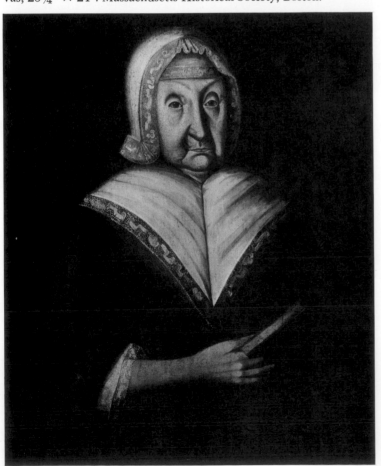

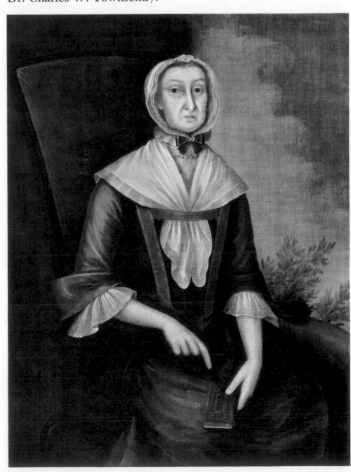

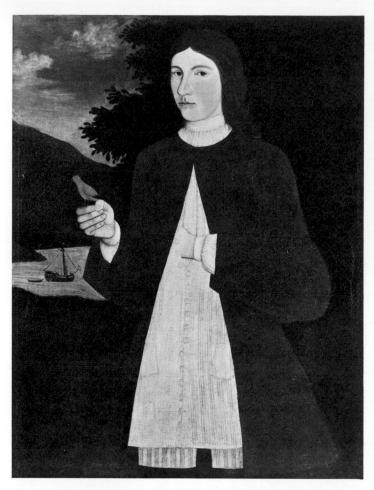

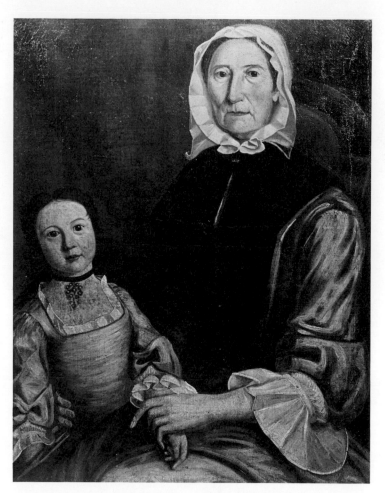

34. UNIDENTIFIED ARTIST. *Pau de Wandelaer*. c. 1725. Oil on canvas, 44¾″ × 35¼″. Albany Institute of History and Art, Albany, New York.

35. JOHN GREENWOOD. *Abigail Gerrish and Her Grandmother*. c. 1750. Oil on canvas, 28½″ × 27½″. Essex Institute, Salem, Massachusetts.

36. WINTHROP CHANDLER. *Reverend and Mrs. Ebenezer Devotion*. 1770. Oil on canvas, 53″ × 43″. Brookline Historical Society, Brookline, Massachusetts.

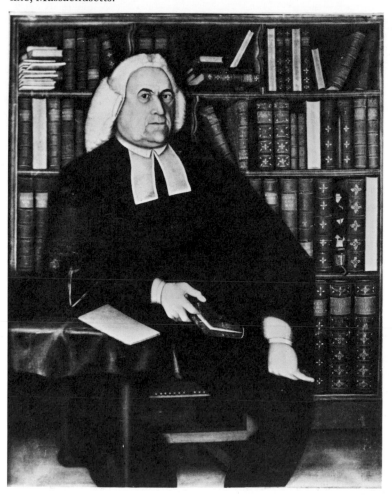

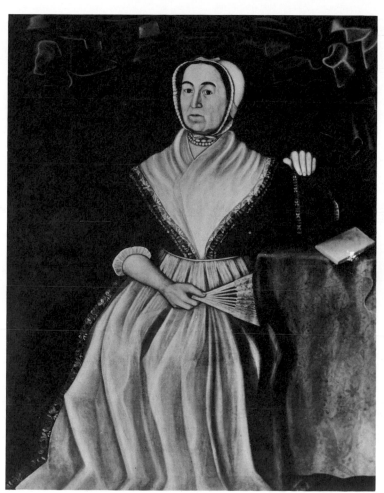

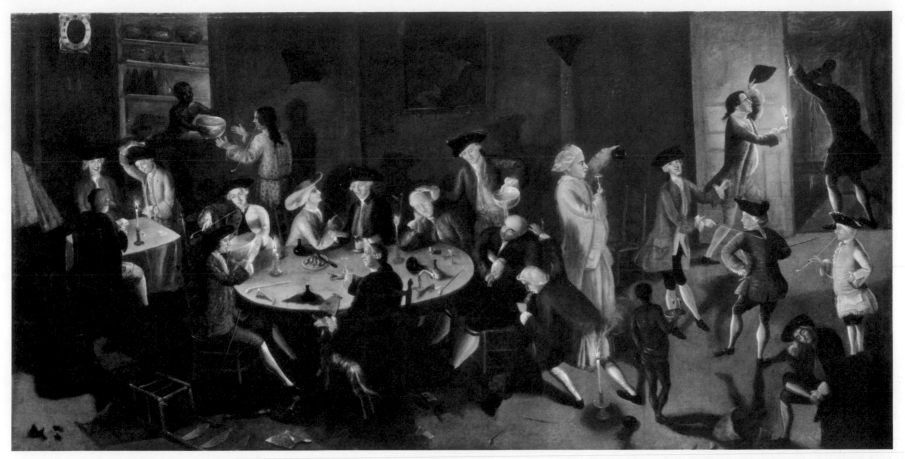

37. JOHN GREENWOOD. *Sea Captains Carousing in Surinam*. 1757–1758. Oil on bed ticking, 3′ 1¾″ × 6′ 3¼″. The St. Louis Art Museum, St. Louis, Missouri.

38. MATTHEW PRATT. *The American School*. 1765. Oil on canvas, 36″ × 50¼″. The Metropolitan Museum of Art, New York (Gift of Samuel P. Avery, 1897).

39. JOHN DURAND. *Children in a Garden*. c. 1770. Oil on canvas, 42¼″ × 44¼″. The Connecticut Historical Society, Hartford, Connecticut.

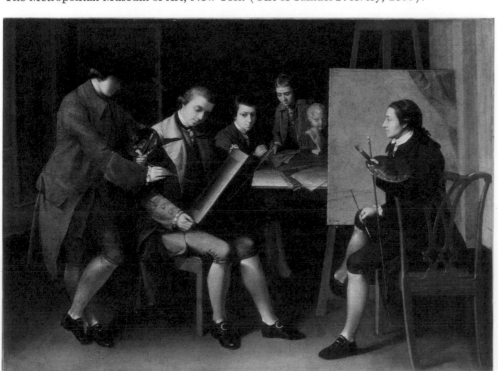

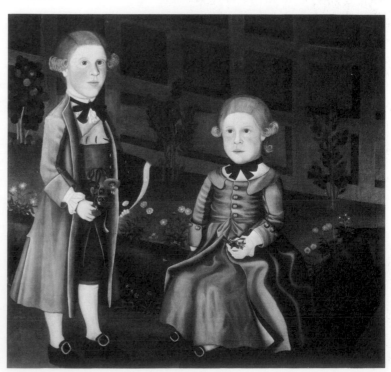

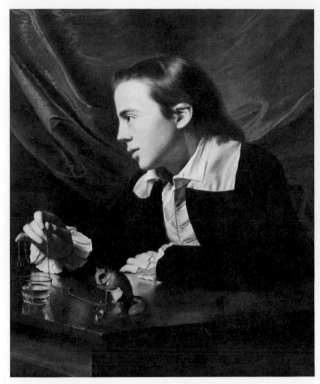

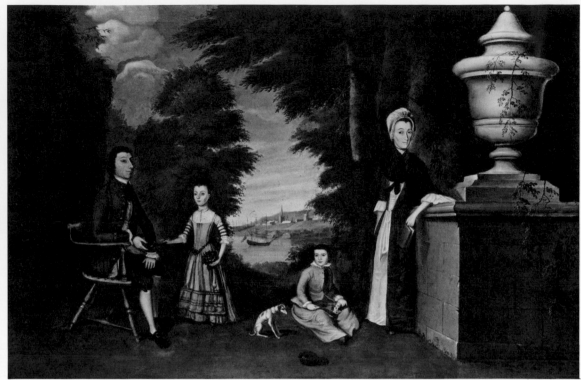

40. JOHN SINGLETON COPLEY. (above, left). *Henry Pelham (Boy with a Squirrel)*. c. 1765. Oil on canvas, 31¼″ × 25″. Private collection.

41. WILLIAM WILLIAMS. (above, right). *The William Denning Family*. 1772. Oil on canvas, 34½″ × 51″. Collection of Mr. and Mrs. W. Denning Harvey.

42. JOHN SINGLETON COPLEY. (below, left). *Paul Revere*. 1765–1770. Oil on canvas, 35″ × 28½″. Museum of Fine Arts, Boston (Gift of Joseph W., William B., and Edward H. R. Revere).

43. JOHN SINGLETON COPLEY. (below, right). *Mr. and Mrs. Thomas Mifflin*. 1773. Oil on canvas, 61½″ × 48″. The Historical Society of Pennsylvania, Philadelphia.

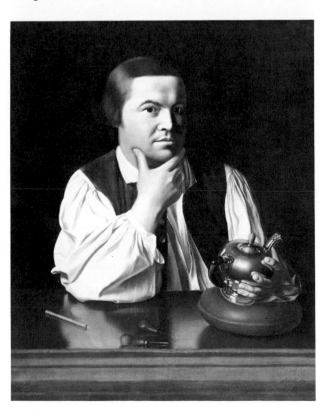

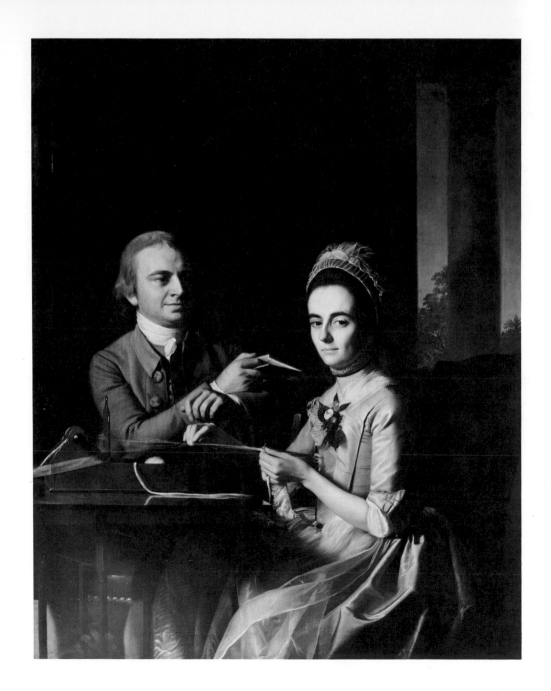

What So Proudly We Hail

BENJAMIN WEST. Born Springfield Township, Pennsylvania, 1738; died London 1820. *Colonel Guy Johnson*. 1776. Oil on canvas, 6' 7½" × 4' 6½". National Gallery of Art, Washington, D.C. (Andrew Mellon Collection).

In the spring of 1776, Colonel Guy Johnson, who two years before had succeeded his uncle, Sir William Johnson, as Superintendent of the Six Nations and other Northern Indians, came to London to seek aid and advice in counteracting the increasing militancy of the colonists in upper New York. During his visit he sat for his portrait to the American artist Benjamin West, who had settled in London in 1763 and had quickly risen to eminence.

In keeping with West's moralizing tendencies, this handsome picture is as much an allegory as a conventional portrait. Slung over the colonel's military red coat is an Indian blanket, and his belt, moccasins, garters, and the headgear in his hand are ornamented with Indian beadwork. The rifle he holds at rest parallels the peace pipe to which the chieftain beside him points in a gesture that also draws attention to the scene at the left—an Indian encampment, with the distinctive horseshoe of Niagara Falls in the distance. The chieftain is an idealized figure, rather than representing, as is frequently said, Johnson's assistant Joseph Brant

—the young Mohawk warrior named Theyenega, whose quite different features are known to us from portraits that George Romney and Gilbert Stuart painted of him during his visit to London.

West had known and admired Indians since his boyhood in Pennsylvania. Soon after he arrived in Rome from America in 1760 he astounded the cognoscenti who had taken him to see the Apollo Belvedere by exclaiming, "My God, how like it is to a young Mohawk warrior!" True to his Quaker heritage, West in his portrait of Colonel Johnson seems to have been motivated much as he had been five years before when he painted *Penn's Treaty with the Indians* (Pennsylvania Academy of the Fine Arts, Philadelphia), of which he later wrote: "the great object I had in forming that composition, was to express savages brought into harmony and peace by justice and benevolence."

Although he had had no formal training, West's youthful talent was so evident that after a brief period as a portrait painter in Lancaster, Philadelphia, and New York, he was sent abroad at the age of twenty-one by a wealthy patron to study the old masters and attain his desire of becoming a painter of mythological and historical subjects. During three years in Italy, West absorbed the aesthetic theories of the archaeologist Johann Winckelmann, who declared that antiquity provided the noblest

models for artists to emulate. Arriving in London in 1763, it was West, the provincial American, who introduced Neoclassicism into England, anticipating by more than a decade Jacques-Louis David's propagation of that style in France. West's respect for truth in art nevertheless impelled him to flout prevailing academic convention by clothing the figures in historical paintings, such as *The Death of Wolfe*, 1770 (National Gallery of Canada, Ottawa), in contemporary rather than classical garb.

Although openly espousing the Revolutionary cause, West enjoyed the continuing friendship and patronage of King George III, and in 1792 he succeeded Sir Joshua Reynolds as second president of the Royal Academy. Founded in 1768, the Academy taught only drawing, and for several decades West's studio served as the principal training ground for young American artists in England (see Matthew Pratt's *The American School*, page 25). Although, in reacting to the purely rational in art, West gradually abandoned his Neoclassical style to depict such proto-Romantic themes as *Death on the Pale Horse*, 1802 (Philadelphia Museum of Art), he continued to be most admired for his treatment of contemporary subjects.

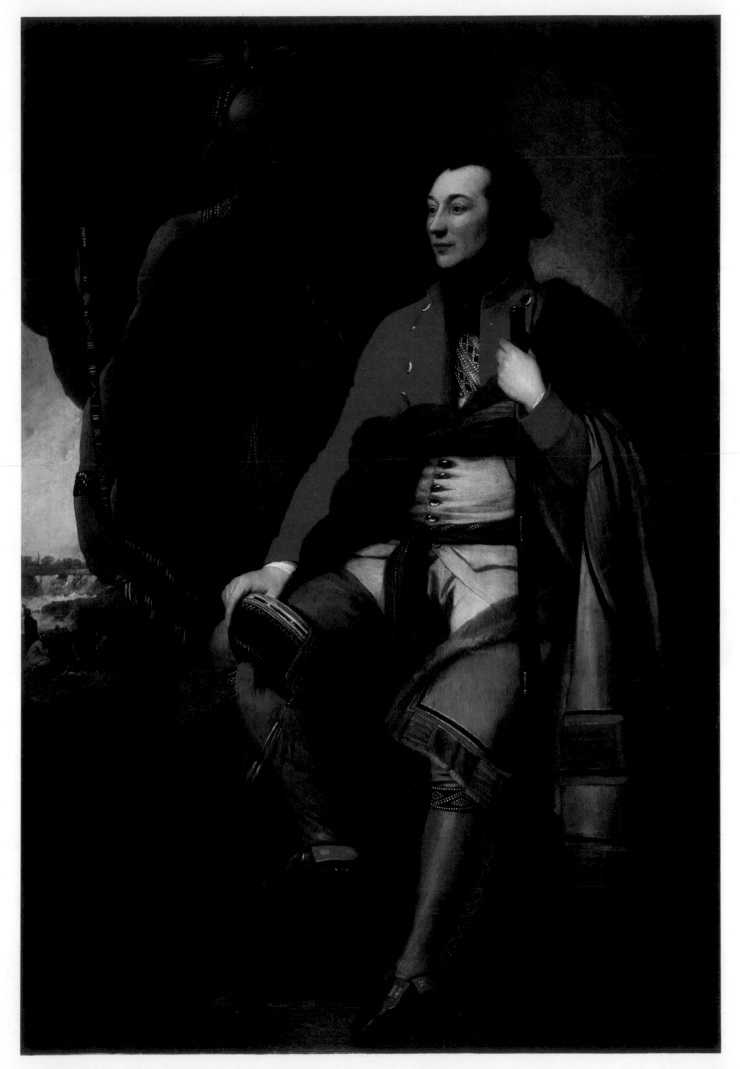

JOHN SINGLETON COPLEY. Born Boston 1738; died London 1815. *Watson and the Shark*. 1778. Oil on canvas, 5′ 11¾″ × 7′ 6½″. National Gallery of Art, Washington, D.C. (Ferdinand Lammot Belin Fund).

Although born in the same year as Benjamin West, John Singleton Copley did not come to England till he was in his mid-thirties and was already established as the leading portraitist in America (page 26). His reputation had long preceded him across the Atlantic, for in 1766 he sent the portrait of his half-brother Henry Pelham (*The Boy with the Squirrel,* page 26) to London for exhibition. As far as is known, it was the first picture painted in America to be shown overseas. West and Sir Joshua Reynolds urged Copley to leave the Colonies to study earlier art and widen his scope, but it was not until 1774, on the eve of the Revolution, that he went to London. He fully intended to return to America but, in fact, was never to do so.

Copley traveled for fourteen months in France and Italy, looking closely at antique art and paintings by old masters and recording his observations. On returning to London he was disappointed to find that, just as in America, he was in demand only for portraits. His first opportunity to undertake a different kind of subject came when he received the commission to paint *Watson and the Shark.*

Brook Watson (1735–1807) was a prominent London merchant who had spent years as a commissary officer in North America. Orphaned in childhood, he had gone to sea; at the age of fourteen, while swimming in Havana Harbor, he had part of his leg bitten off by·a shark before being rescued by his fellow seamen.

To represent this episode, Copley combined realistic detail with a strong compositional structure. Each face is individually characterized. Between the horizontals formed by the panorama of the harbor in the background (based on engravings) and the outstretched body of the naked youth in the foreground, the figures in the boat are grouped in a zigzag formation. One triangle has its apex in the hands stretched downward to the hapless youth; another rises along the diagonal formed by their arms, the balding man supporting them, and the standing black, and culminates· in the end of the boathook at the top of the painting. The violent action in the center is framed by the boy's outflung arm and the parallel gesture of the black man, and is further stabilized by the oar that extends to the left edge of the picture at right angles to the thrust of the boathook.

The painting caused a minor sensation when exhibited at the Royal Academy in 1778. Elected to the top rank of Academicians, Copley thereafter never ceased in ambitious attempts to outrival West. Just as West anticipated by over a decade David's Neoclassicism, so Copley in his *Watson and the Shark* anticipated by more than forty years the Romanticism of Théodore Géricault's *Raft of the Medusa,* 1819 (The Louvre, Paris). The painting is unique in Copley's work, and indeed in the art of its time.

Critics have often expressed surprise that Copley should have rendered an episode in the life of an ordinary citizen in such heroic terms. This, however, is to overlook the significance that the event had for Brook Watson, who commissioned the picture and bequeathed it to Christ's Hospital in Horsham, Surrey—a charitable foundation devoted to orphans such as he had been. The inscription attached to the painting recounts his distinguished military service, his political offices ranging from alderman and member of Parliament to Lord Mayor, his baronetcy, and Deputy Governorship of the Bank of England, and concludes by saying that his career shows that "a high sense of Integrity and Rectitude with a firm reliance on an overruling Providence united to. activity and exertion are the source of public and private virtue and the road to Honours and respect." Obviously a pious man, Watson must have regarded his escape from the shark as due to the miraculous intervention of Providence. The painting is therefore a kind of *ex voto*. The gesture of the man fending off the monster is like that of Saint Michael overcoming the devil, or Saint George raising his lance against the dragon. One can believe that Copley had such a representation in mind and consciously transformed Watson's adventure into an allegory of the triumph of good over evil.

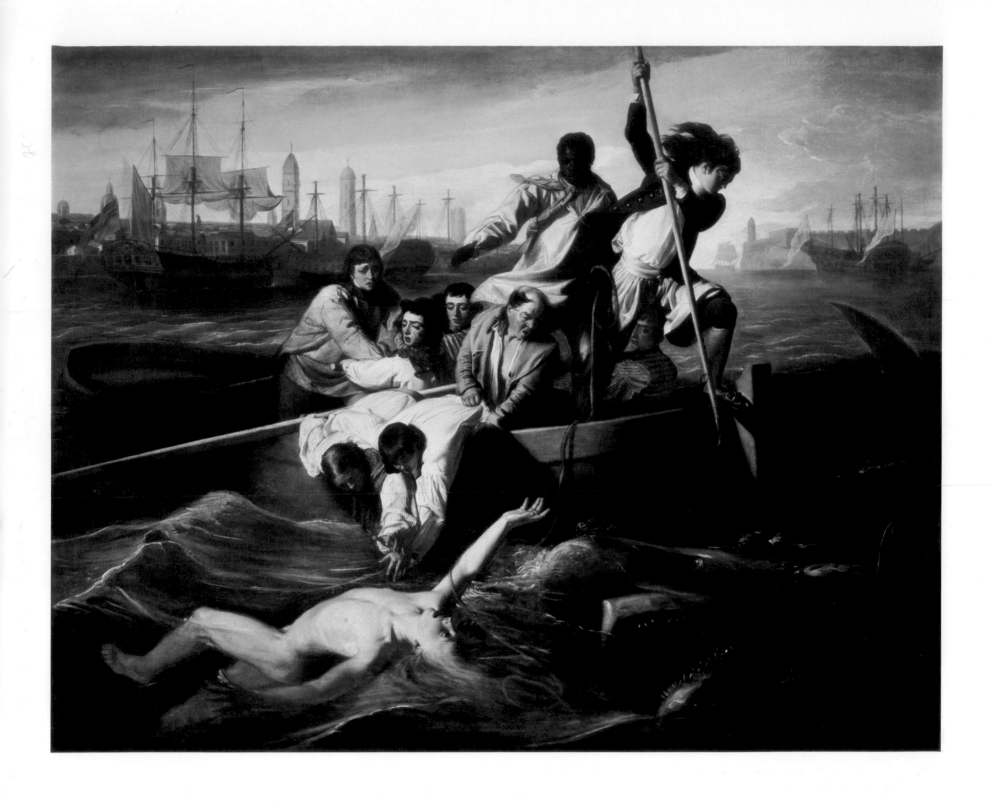

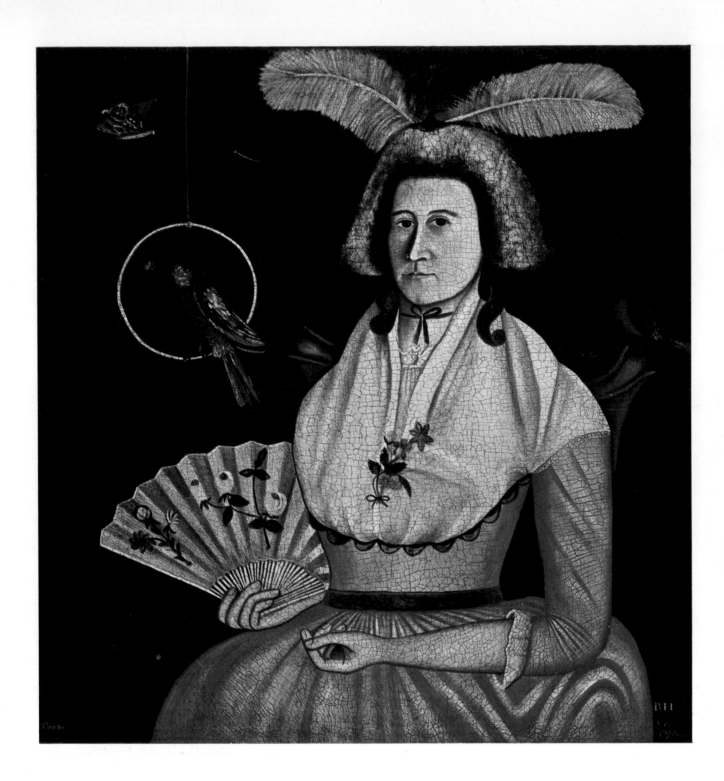

RUFUS HATHAWAY. Probably born Freetown, Massachusetts, 1770; died Duxbury, Massachusetts, 1822. *Lady with Her Pets.* 1790. Oil on canvas, 34¼″ × 32″. The Metropolitan Museum of Art, New York (Gift of Edgar William and Bernice Chrysler Garbisch).

Dated in the lower right corner "Oct^r 1790," this is the earliest known work of Rufus Hathaway, who in that year began his activity as an itinerant limner in Taunton, Massachusetts. In 1795 he married the daughter of a prominent merchant of Duxbury, Massachusetts, and at her persuasion abandoned painting as a profession, studied medicine, and settled in Duxbury as the town doctor. He still continued to paint portraits of his friends or relatives, however, and also did miniatures, ornamental panels, and possibly some woodcarving in addition to the frames he provided for his own paintings.

The sitter represented in the *Lady with Her Pets* has been tentatively identified as Molly Whales Leonard; we may be better informed of the name of the cat, if the inscription "Canter" in the lower left corner applies to him! As in Hathaway's other portraits of women, this lady wears a simple costume; no face or bowknots adorn the severe fichu, and she displays no jewelry. She is nevertheless decked out for the occasion with a sprig of flowers at her bosom, a carefully displayed painted fan, and huge feathers atop her headdress. Her homely strength and individuality have been characterized by the painter in a likeness as compelling as that achieved by Gilbert Stuart with more sophisticated means in his *Mrs. Richard Yates* (opposite).

The organization of the picture is as hieratic as a tombstone carving, with every element presented as in a still life. Against the dark background the figure, cat, birds, butterflies, and fan occupy the same shallow plane, flattened into a bold design full of ingeniously arranged detail. The outspread feathers arrest the design at the top margin of the canvas, and the arm bent at a right angle fulfills the same function at the bottom. The upward curve of the chair back and countercurves of wig and feathers focus on the lady's face; her left arm directs our glance to the cat, while the other hand and fan lead up to the parrot in the ring, then on to the butterflies, across the feathers to the right side of the picture, then down to the other bird, and, in the lower corner, the signature. Despite the rigid pose and limited color scheme, there is a dynamic flow of design, as rhythmical, strong, and even as the scalloped border of the fichu and fluted edge of the fan.

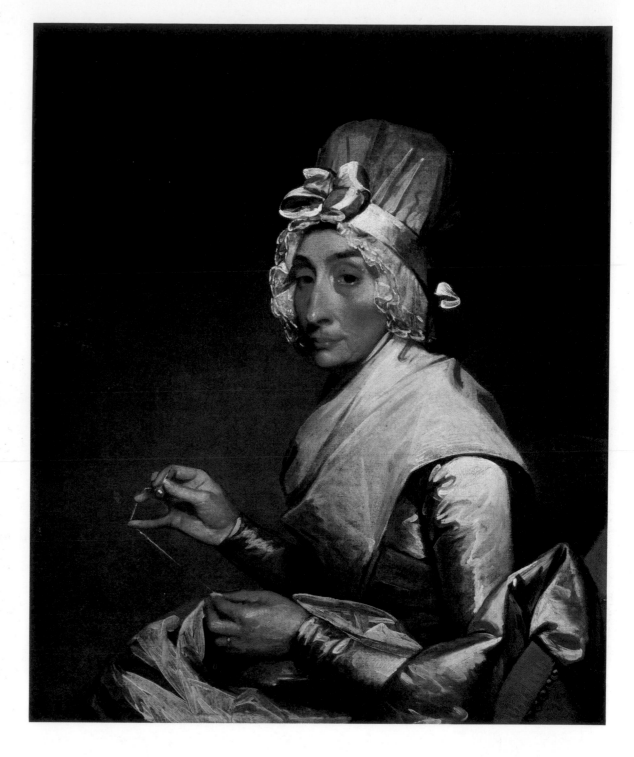

GILBERT STUART. Born Kingston, Rhode Island, 1755; died Boston 1828. *Mrs. Richard Yates.* 1793–1794. Oil on canvas, 30¼″ × 25″. National Gallery of Art, Washington, D.C. (Andrew Mellon Collection).

Unlike West and Copley, Gilbert Stuart never chafed under the restrictions of portraiture; and unlike Earl, his interest was focused on his subjects' faces almost to the exclusion of any accessories. Apprenticed by his father to an itinerant Scottish portrait painter, Cosmo Alexander, who had come to America after studying in Italy, Stuart accompanied him to Edinburgh at the age of seventeen. Following his master's sudden death in 1772, Stuart returned to America and was active for a few years in Newport and Boston before leaving for England in 1775. He soon entered West's studio as a copyist and pupil, which gave him the opportunity to meet many other British and American artists, to study drawing at the Royal Academy, and to have access to the royal art collections.

When Stuart began his independent career, his wit and attractive personality enabled him to put his sitters at ease by engaging them in lively conversation while he captured their expressions and gestures. The effects of spontaneity he achieved were enhanced by his painting technique; instead of following the prevailing practice of filling in drawn outlines, he worked directly in color. Because of the resulting freshness and play of light in his canvases, he soon supplanted the aging Sir Joshua Reynolds as the portraitist most in demand among the wealthy and famous. But Stuart's extravagance increased even more rapidly than his rising fortune. In 1787 he escaped his debtors by fleeing to Ireland. He repeated in Dublin the success he had had in London—and also the habit of piling up debts, which he could never fully meet even by turning out increasingly slapdash work.

In 1793 Stuart decided to return to America. He settled first in New York, where his contacts were with well-to-do merchants. This middle-class clientele and the general lack of pretentiousness in the new republic had the salutary effect of leading him to abandon superficiality and to return to straightforward realism.

One of his first patrons was Richard Yates, who commissioned portraits of himself and his wife, the former Catherine Brass. Mrs. Yates was approaching sixty when she sat for this portrait; it is character, not beauty, that illumines her face. Her glance is penetrating, her expression quizzical. In his *Mrs. Fort*, 1778 (Wadsworth Atheneum, Hartford, Connecticut), Copley had painted a matron similarly engaged in needlework, but the effect is that of a conscious pose rather than of spontaneously suspended action. By contrast, Stuart gives us the illusion that some remark has just arrested Mrs. Yates's attention, making her pause momentarily in mid-stitch.

The background is devoid of any detail that might distract our concentration on the figure. The dress and fichu are also unornamented, but their cool silvery-gray and the cap with its white highlights admirably set off the warm tones of the face and hands. Flesh, Stuart once declared, "is like no other substance under heaven. It has all the gaiety of a silk-mercer's shop without its gaudiness and gloss, and all the soberness of old mahogany without its sadness."

In 1795 Stuart went to Philadelphia while Congress was in session and attained his ambition of painting the portrait of George Washington. The president sat to him several times during the next two years, and Stuart completed three versions from life: two busts, taken respectively from the right and left sides, and one full-length standing figure. Copies of the bust portraits were in such demand that Stuart turned out countless replicas—sources of ready cash that he called "my $100 bills." How amused he would have been to know that an engraving after one of these likenesses now adorns America's dollar bills and so has become actual currency for his countrymen!

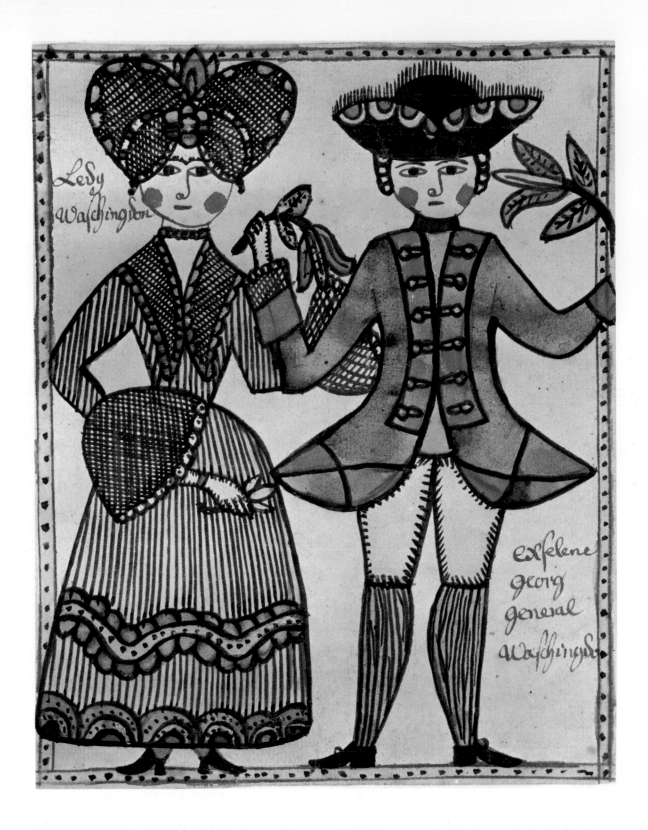

UNIDENTIFIED ARTIST. *Excelenc Georg Waschingdon and Ledy Waschingdon.* c. 1775–1800. Watercolor on paper, 8″ × 6¼″. Abby Aldrich Rockefeller Folk Art Collection, Williamsburg, Virginia.

"Every American considers it his sacred duty to have a likeness of Washington in his home, just as we have images of God's saints," wrote the Russian diplomat Paul Svinin in 1829 in an article on the liberal arts in America that he published as a postlude to his memoirs of travels in the United States from 1811 to 1823. "He would fain keep before his eyes the simulacrum of the man to whom he owes his independence, happiness and wealth! Washington's portrait is the finest and sometimes the sole decoration of American homes. Citizens of the first

two classes go out of their way to have these portraits painted by Stuart, and pay a hundred dollars for it." Those less affluent had to content themselves with prints or, as in this case, turn to humbler artists in their own communities.

The general with his "ledy" is the most delightful of a small group of watercolors attributed to an unknown Pennsylvania *fraktur* maker. This word, like its English cognate, means "broken"; it was first applied to the angular script, resembling early black-letter typefaces, that German immigrants (the so-called Pennsylvania Dutch) used for their documents, which they often decorated with paintings like the illuminations in medieval manuscripts.

In this tiny picture (which can look monumental when reproduced in large scale) the figures not only dominate their space but break over the painted

border. They remain paper thin, however; notice how the artist has avoided foreshortening the feet. The garments, similar to those in the portraits of *Captain Samuel Chandler* and *Mrs. Samuel Chandler* (page 33), are stylized with draftsman's conventions—crosshatching for the delicate fabric of Martha Washington's cap, fichu, and bell-shaped cuffs and the ruffles at George Washington's wrists, stripes for the heavier material of his hose and her dress. The scallops of her skirt are repeated in inverted form on his tricorne hat. With their bright patterned costumes, identical faces, and puppetlike poses, America's most famous personages look rather like the anonymous figures on early European playing cards.

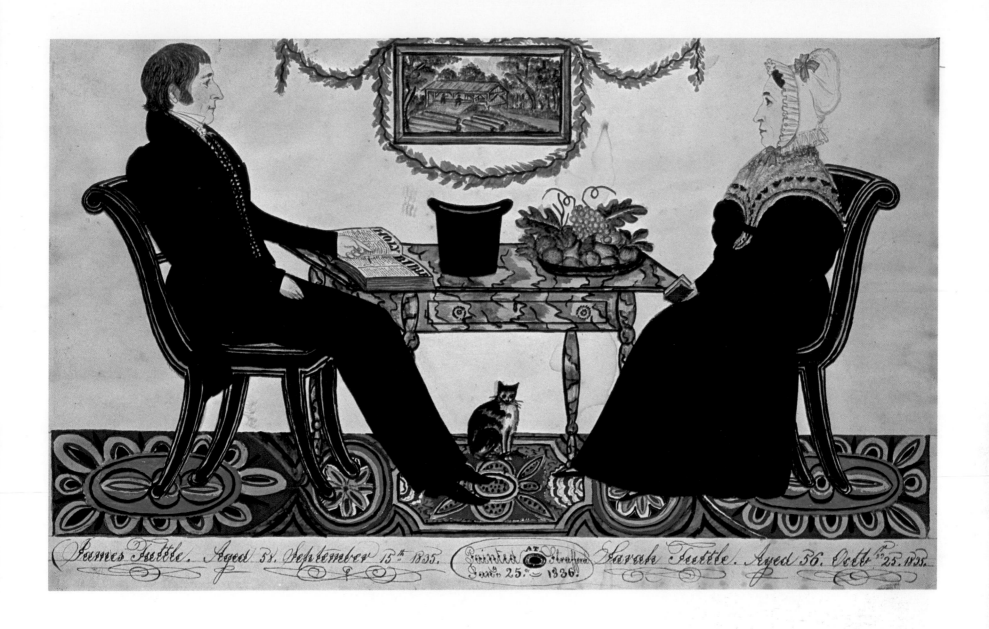

James Tuttle. Aged 58. September 15th 1835. Painted AT Strafford Jan'y 25th 1836. Sarah Tuttle. Aged 56. Oct'r 25. 1835.

JOSEPH H. DAVIS. Active Maine and New Hampshire 1832–1837. *James and Sarah Tuttle.* 1836. Watercolor and ink on paper, 9½″ × 14½″. The New-York Historical Society, New York.

More than a hundred portraits, all dated within a span of six years, have been attributed to the prolific itinerant who signed one of his works "Joseph H. Davis Left Hand Painter." He traveled through a band of small farm villages ranging inland from Portsmouth, New Hampshire, to North Berwick, Maine, painting portraits that were a happy compromise between the cheap but detail-lacking silhouettes and the more costly oils. His figures were painted in watercolor, full length and in profile, in settings complete with furniture, wall decorations, floor coverings, and household pets. Davis's formula for these family portraits (for which, according to local tradition, he charged

$1.50) scarcely varied except for the accessories that identified his subjects' interests or activities.

James Tuttle of Strafford, New Hampshire, shown with his Bible and tall hat, was a surveyor of lumber who, a few years before Davis portrayed him, had purchased a local sawmill and lived on its land. Davis invented a painting of this sawmill, centering it on the wall and further emphasizing it by a garland of greenery. Besides this portrait of Mr. and Mrs. Tuttle, dated January 25, 1836, Davis also painted at least two of their children, Betsy and Esther. The latter's portrait is dated January 18, which shows that the painter was busy in the Tuttle household at least a week. (Itinerants' bed-and-board was as important for their livelihood as the cash payments they received for their work.)

Davis's group portraits, of which *James and Sarah Tuttle* is a prime example, are brilliant arrangements of pattern and color. Here the marble-

ized table, painted chairs, bowl of fruit like a still life, and calligraphic inscription below add up to dazzle the eye with a staccato beat. As is the case in every folk-art masterpiece, the naïve artist's sense of design is remarkable. Notice how the centered rectangular element in the fancifully patterned rug relates to the rectangular painting at top center, with the cat and hat as vertical links between them; the end ovals of the pattern act as bases for the chair legs and are echoed in the central oval of the inscription and the garland around the picture on the wall directly above it. Everything is symmetrically balanced, but the elements are sufficiently varied in placement and shape to avoid rigidity: the cat is exactly centered, but not the hat; the feet of Mr. and Mrs. Tuttle are placed slightly differently on the rug; his hand pointing to the Bible and hers holding a small book are at different levels.

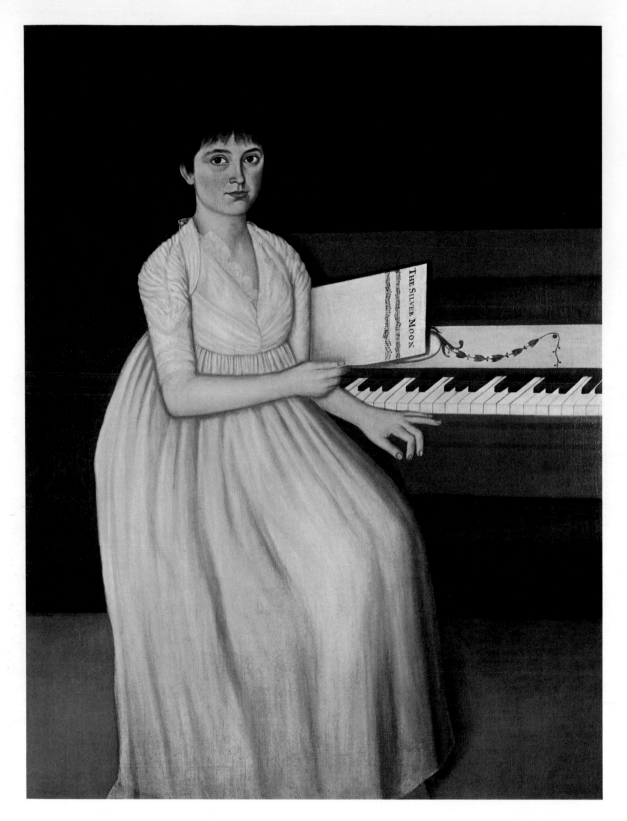

JOHN BREWSTER, JR. Born Hampton, Connecticut, 1766; died Buxton, Maine, 1854. *Sarah Prince.* c. 1801. Oil on canvas, 50½″ × 40″. Collection of Mrs. Jacob M. Kaplan.

John Brewster was a remarkable painter and a man of great courage. A deaf-mute, he continued to support himself as a portrait painter after enrolling at the age of fifty-one in the Asylum for Deaf and Dumb Persons in Hartford, the first school for the deaf in America. He probably knew the work of Winthrop Chandler (see pages 24 and 33), who had painted subjects in Windham County, the boyhood home of Brewster's father; the scale, content, and style of Brewster's portraits are more closely related to Chandler's work than to that of any other Connecticut limner.

The calm, almost monochromatic portrayal of Brewster's niece, young Sarah Prince of Newburyport, Massachusetts, is one of our most beautiful and moving folk paintings. We sense the artist's personal serenity, and it is touching to find the painter to whom the world was silent placing the girl, holding a popular song of the period, "The Silver Moon," before a pianoforte. The black-and-white keyboard and delicate decoration in orange and green on the panel above it are the only sprightly accents in the quiet scene.

The owner of the painting, Mrs. Jacob Kaplan, says: "What impresses is the sensitive juxtaposition of reality and abstraction. Against horizontal bands of flat color, the sharply drawn black-and-white keys alone define the piano; just two lines of notes on an otherwise blank sheet evoke a musical mood. Only a masterful artistic vision could have exercised such remarkable restraint."

Analyzing the manner in which the artist designed this painting, Tom Armstrong, Director of the Whitney Museum of American Art, points out that "Brewster developed his composition in a particularly fascinating way. For example, look at the subject's left hand resting on the piano. The line delineating the arm, wrist, and hand continues and becomes the same line representing the edge of the piano. In working out his composition, Brewster has rhythmically connected one object to another so that the identity of the particular elements is subjugated to the development of an overall pattern. It is the intuitive employment of compositional devices such as this that designate a portrait like *Sarah Prince* as one of the masterpieces of American painting."

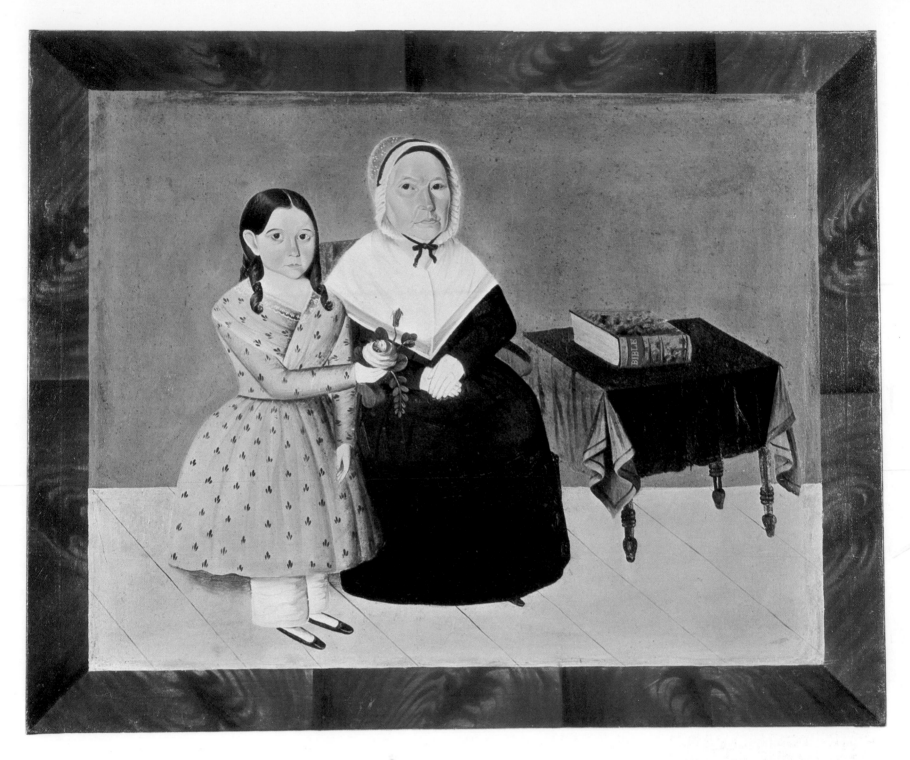

SHELDON PECK. Born Cornwall, Vermont, 1797; died Lombard, Illinois, 1868. *Anna Gould Crane and Granddaughter Jennette*. 1837. Oil on canvas, 35½" × 45½". Collection of Mr. and Mrs. Peter H. Tillou.

Sheldon Peck specialized in painting family group portraits in Vermont and western New York, and after settling in Lombard, Illinois (near Chicago), in 1838 he continued to work as an itinerant from his home there. Many of his portraits still have their original frames, which feature painted graining; in some, such as this one, the frame with its simulated graining is actually a part of the canvas.

This picture, made in Eola, Illinois, is recorded in the family Bible as having been "painted in trade for one cow." Its mood is diametrically opposed to the serenity of Brewster's *Sarah Prince*. A number of critics singled it out from the more than 150 paintings shown in 1974 at the Whitney

Museum of American Art's exhibition "The Flowering of American Folk Art," remarking on its strange magnetism. Douglas Davis, stating categorically that Peck's paintings were "the most important work" on view, commented on the "mordant skill" of the artist in focusing attention on the faces, especially the bold black eyes that dominate the entire composition. "The effect," he concluded, "is unforgettably dramatic—with a hint of tragedy."

There are provocative polarities in this portrait: between the facial expressions that suggest some poignant emotion and the static poses; between the homely table with its heavy Bible and the pretty pattern on Jennette's dress; between the exact verticals of the stolid figures and the sharp diagonals of the floorboards and placement of the table. All these together create psychological and compositional tensions. If we were to look for the most striking antithesis to a suave, academic nineteenth-century portrait, Sheldon Peck's crude, powerful painting would be a prime choice.

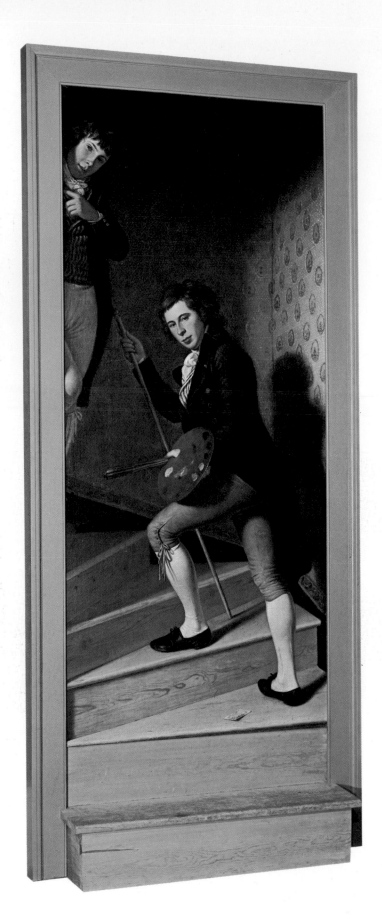

CHARLES WILLSON PEALE. Born Queen Annes County, Maryland, 1741; died Philadelphia 1827. *The Staircase Group.* 1795. Oil on canvas, 7′ 5″ × 3′ 3″. The Philadelphia Museum of Art.

On May 22, 1795, curious Philadelphians crowded into the recently completed Philosophical Hall to view a spectacle quite new in America—what was intended to be the first annual exhibition of "The Columbianum, or American Academy of Fine Arts." Paintings and drawings by some thirty pro-

fessional and amateur artists were on display, and welcoming the visitors was the man responsible for launching the organization, Charles Willson Peale. At the end of the hall appeared two of his sons, to whom he had given names consecrating them likewise to the study of art. The eldest, Raphaelle, maulstick in one hand and palette in the other, turned as he ascended the stairs, while his younger brother Titian peeped shyly from above. But those who approached to salute the lads discovered that only the doorframe and lowest step were three-

dimensional; they had been tricked by the eye-fooling illusionism of a life-size double portrait.

Peale, who had begun as a saddlemaker before adding sign painting and portraiture to his other trades, had little professional instruction until benefactors sent him to London in 1767. There he became one of the first Americans to study in Benjamin West's studio. Three years after his return to America in 1769, Peale painted the first of a number of portraits he was ultimately to execute of George Washington, then a colonel. After serving with Washington in Revolutionary campaigns, Peale settled in Philadelphia to resume his activity as a portraitist. He specialized in likenesses of illustrious personages, especially America's national heroes. These he exhibited in his studio, a museum that also included birds, beasts, and fishes, which Peale dissected, classified according to the Linnaean system, and displayed in habitat settings. An added attraction were transparencies—illuminated projections of street scenes, landscapes, and battles with appropriate light and sound effects. Peale first advertised them as "Perspective Views with Changeable Effects; or, Nature Delineated and in Motion," but later called them "Moving Pictures." The gallery was air-conditioned by twelve ceiling fans operated by machinery.

Because of the popularity of the museum and the growth of his collections, Peale obtained permission to transfer them to the headquarters of the American Philosophical Society, of which he had been a member since 1786. Another removal took place in 1802, this time to the State House in Independence Square (vacant since Lancaster had become the state capital). Above the cases containing ornithological specimens in the Long Room on the second floor hung the portraits of the illustrious; *The Staircase Group* was installed in a niche in one end wall. The museum was open weekdays from sunrise to sunset, and sometimes also at night with illumination from the first gaslight in America. A view of the Long Room appears in the background of the full-length self-portrait of Peale, commissioned by the museum's trustees in 1822. It is now in the Pennsylvania Academy of the Fine Arts, which Peale had been instrumental in founding in 1808. In 1823, at the age of eighty-two, he painted another self-portrait for the museum his son Rembrandt had opened in Baltimore (see page 42); now lost, it is known only from descriptions. Reverting to the theme of *The Staircase Group,* Peale showed himself descending the stairs, holding palette and maulstick. At his feet, in reference to his first métier, lay a saddler's hammer; his painting room was shown behind him, and beyond, on a higher level, a view of the museum.

The Staircase Group remained on view in its niche at the State House until the dispersal of Peale's collections in 1854, when it was sold at auction for $175.

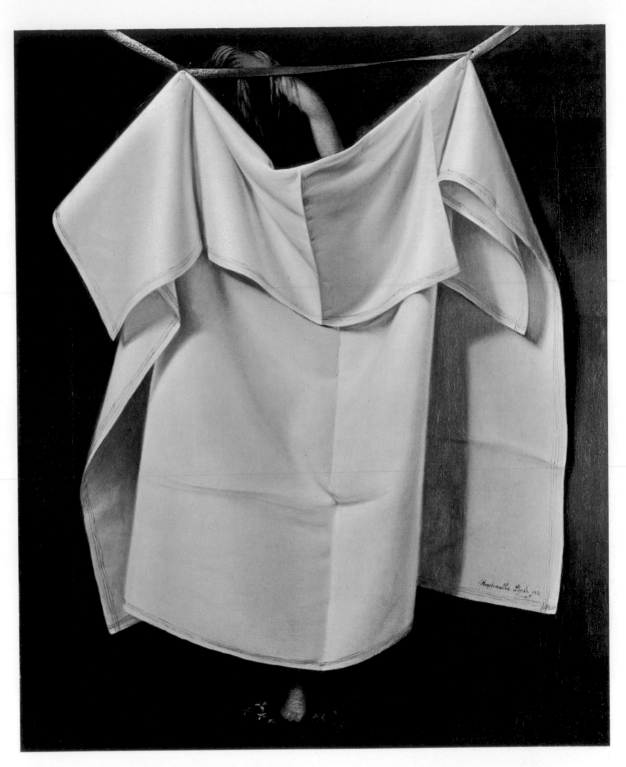

RAPHAELLE PEALE. Born Annapolis, Maryland, 1774; died Philadelphia 1825. *After the Bath*. 1823. Oil on canvas, 29″ × 24″. William Rockhill Nelson Gallery of Art—Atkins Museum of Fine Arts, Kansas City, Missouri (Nelson Fund).

The Columbianum exhibition of 1795 in which Charles Willson Peale first displayed his *Staircase Group* included a dozen works by Raphaelle, the elder of the sons portrayed. Two belonged to the same eye-fooling category of pictures that we to-day call trompe l'oeil, but were then known as "deceptions." It was Raphaelle's skill in this genre that brought him renown, although he also painted portraits, miniatures, and still lifes. Among his deceptions was a *Catalogue for the Use of the Room*, done in 1812—a mock guide to his father's museum.

Raphaelle, perhaps the most talented of Peale's numerous children, was also the one who caused him most concern. Rembrandt and Rubens painted

diligently, assisted their father in managing the Peale museum in Philadelphia, and founded similar establishments in Baltimore and New York. Raphaelle, however, became a wastrel and an alcoholic, whose dissolute ways resulted in crippling gout. His father was obliged to contribute to the support of his family, which included six children, and his wife Patty was reduced to taking in boarders. She has gone down in history as a nagging shrew, but the circumstances of her married life would seem to have given ample cause for her chronic ill temper.

After the Bath, Raphaelle Peale's best-known work, was, in fact, painted as a joke to fool his wife. Tradition has it that, entering his painting room one day, she was enraged to see what appeared to be a piece of her best table linen hung up to screen a nude model, with hands stretched up to arrange her hair and bare feet peeping out below. But when Mrs. Peale rushed forward to snatch

away the cloth, her nails encountered only a painted canvas, while her humiliation was aggravated by the mocking laughter of her husband, children, and boarders.

However trivial and malicious the motive that inspired it, the picture fully exemplifies the artist's talents. The handling of light on the textured folds of linen is masterly, as is the contrast between the expanse of white cloth and the warm reddish-brown of the background. The same elimination of non-essential details, the same luminosity, and the same delicate rendering of textures characterize Raphaelle Peale's still lifes (page 12). He died only two years after completing *After the Bath*. It may be symptomatic of his self-destructive personality that, as X rays have revealed, he painted the picture over the replica of a portrait his father had made of him in 1817.

41

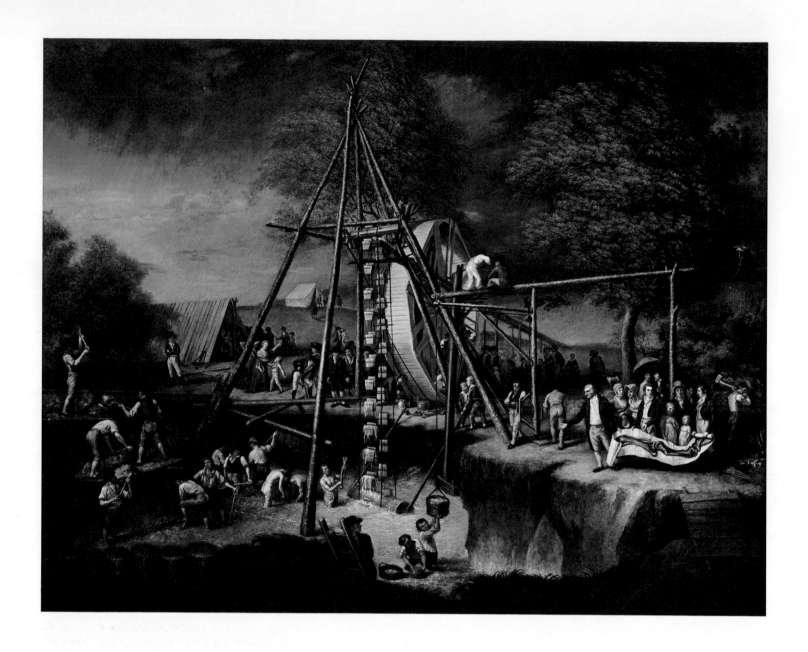

CHARLES WILLSON PEALE. Born Queen Annes County, Maryland, 1741; died Philadelphia 1827. *Exhuming the First American Mastodon.* 1806–1808. Oil on canvas, 50″ × 62½″. The Peale Museum, Baltimore (Gift of Mrs. Harry White).

When some bones of a prehistoric monster unearthed in Ohio were brought to Peale's studio in 1784 so that he might make drawings of them, a friend of his declared: "I would have gone 20 miles to behold such a collection. Doubtless there are many men like myself who would prefer seeing such articles of curiosity than any paintings whatever." It was then that Peale first began to acquire birds and beasts of all sorts and exhibit them together with his paintings, in order, as he said, "to bring into one view a world in miniature." This aim was consistent with his deist philosophy, which saw the ordered processes of nature as manifestations of a Supreme Being's universal laws.

In 1801, when Peale read in a newspaper that the skeleton of a prehistoric creature had been discovered on a farm in Orange County, New York, he set off at once for the site. With his own money and funds advanced by the Philosophical Society, he acquired the bones that had already been exhumed and the right to dig for more. In the course of his five-month expedition another skeleton was discovered nearby. These were the first almost complete remains ever found of the mastodon, a species of prehistoric elephant. Mistaking them for a related species unearthed in Siberia, Peale called them by the Russian name, *mammoth*—a word immediately taken up by the American public to describe anything immense.

Peale wrote to Benjamin West in 1807: "The desire to represent the Scene of getting up the Bones of the Mammoth, it being a very interesting article of the Museum, last summer I undertook a picture. . . . [It] contains a great number of figures, for while I was engaged in that labour, my exertions excited the admiration of all the people for a considerable distance around. . . . 18 of my figures are portraits, having taken the advantage of taking most of this number of my own family."

This artistic license went so far that Peale included, in his otherwise quite realistic representation of the scene, not only his third but also his second (deceased) wife! He showed himself standing at center right, holding one end of a long scroll on which are drawn several of the large bones. The other end of the scroll is held by his son Raphaelle, with two other sons, Rembrandt and Rubens, in the center. On the ladder in the foreground is the owner of the farm; the spectator standing with folded arms in front of the shed at the left is Peale's friend, the poet and naturalist Alexander Wilson. The composition and its landscape setting are dominated by the huge wheel, powered by men walking inside it as in a treadmill, and the attached mechanism to pull up buckets of water from the swampy pit. Keeping the excavations free of washouts was a constant problem; the lightning bolt at the right, signaling an impending thunderstorm, lends a note of dramatic urgency to the picture.

Peale installed one skeleton (now in Darmstadt) in his museum in Philadelphia, where it created a sensation. He gave the other to Rembrandt, who made it a feature of the somewhat similar museum that he founded in Baltimore in 1814. Although it now belongs to the American Museum of Natural History, New York, several of its bones have been lent back for display in the reconstituted Peale Museum in which this picture, *Exhuming the First American Mastodon*, now hangs. This is very likely the first painting ever made of a scientific expedition, and the building that houses it—restored after many vicissitudes—is the first in the United States erected specifically to serve as a museum. It is, in fact, among the oldest such structures in the world, antedated only by the Ashmolean Museum in Oxford (1682) and the Prado in Madrid (begun in 1785 as a natural history museum and enlarged as a painting gallery from 1814 to 1819).

JOHN JAMES AUDUBON. Born Les Cayes, Saint-Domingue (now Haiti), 1785; died near New York City 1851. *Trumpeter Swan.* 1836–1837. Watercolor on paper, 23″ × 37¾″. The New-York Historical Society, New York.

As expeditions such as those of Meriwether Lewis and William Clark (1803–1806) opened up the West, Americans became increasingly conscious of the vastness of their continent and curious about its natural wonders. Romanticism about the untamed wilderness went hand in hand with scientific interest in its flora and fauna. Both attitudes, together with great artistry, were combined in the work of John James Audubon.

Audubon was eighteen when he came to the United States from France, where his education had included brief training in the studio of Jacques-Louis David. He first became interested in drawing and collecting ornithological specimens while managing the Pennsylvania estate of which his father was the absentee owner. The decisive turning point in his career came in 1820, when he helped arrange exhibits and painted landscape settings for the natural history section of the newly founded Western Museum in Cincinnati. Audubon conceived an "ardent Wish to Compleat a collection of drawings of the *Birds* of our Country, from *Nature* . . . and to Acquire either by *occular* or reliable observations of others the Knowledge of their Habits & residence . . ."

Setting off down the Mississippi, Audubon kept a journal of what he saw in his four-month-long progress to New Orleans. For six years he made that city the base for his expeditions, meanwhile earning his living by painting portraits, shop signs, and murals for steamboats, and also teaching drawing, French, dancing, music, and fencing. In 1824 he shipped a large collection of his drawings to Philadelphia but found no one there willing to undertake a publication rivaling the recent nine-volume compendium on the birds of America by Alexander Wilson, the naturalist friend of Peale's whose likeness is among those included in the *Exhuming the First American Mastodon* (opposite).

Audubon met with better luck two years later when he took some 240 of his drawings abroad. Oil copies of his drawings and watercolors created a sensation in London and Paris, and he made enough from sales to begin underwriting the making of engravings. Between 1829 and 1837 the London firm of Havell and Son issued *The Birds of America* in a series of large portfolios with hand-colored aquatints, which reproduced Audubon's first drawings and others that he completed on three trips to America, during which he journeyed from the Florida Keys to Labrador. He also collaborated with a young Scottish scientist, William Macgillivray, on a five-volume *Ornithological Biography* (Edinburgh, 1839).

The majestic fowl represented in the *Trumpeter Swan* was a species Audubon greatly admired. "To

form a perfect conception of the beauty and elegance of these Swans," he wrote, "you must observe them when they are not aware of your presence, and as they glide . . . over and beneath the surface of the liquid element with surprising agility and grace. Imagine, Reader, that a flock of fifty Swans are thus sporting before you, as they have more than once been in my sight, and you will feel, as I have felt, more happy and void of care than I can describe."

Audubon included two plates of the trumpeter swan in *The Birds of America*—one drawn in 1822, showing a young bird in winter, and an adult male, reproduced from this drawing. In order to fit the imposing image of one of the largest of America's wild fowl within the format of his paper, Audubon represented it with its head arched backward. In the engraving, this action is motivated by introducing an insect for which the great beak is reaching; waves and clouds are added for pictorial effect. In the watercolor, however, the light blue sky is cloudless, and so that the claws and scaly texture of the webbing and legs can be shown in precise detail, the swan's foot is not submerged in the waves but is deployed against the white wake made as it glides through the deep blue water.

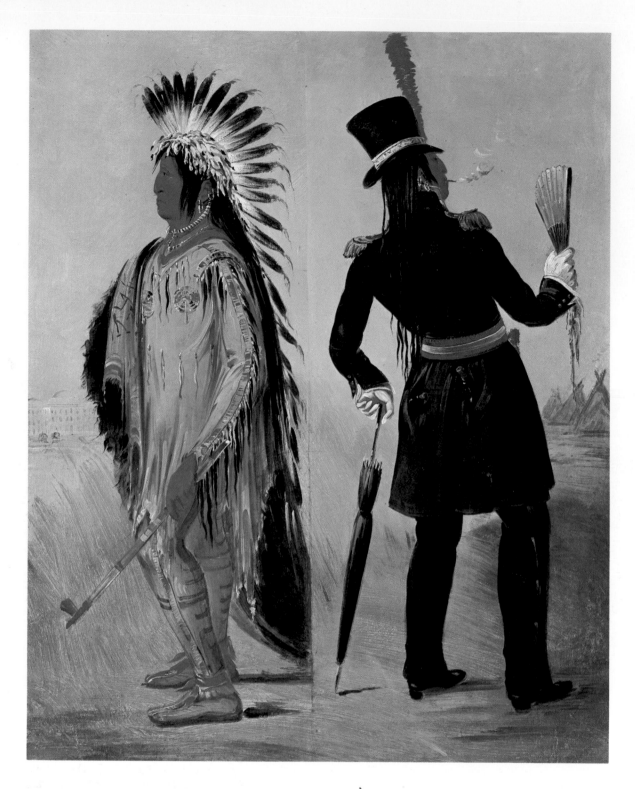

GEORGE CATLIN. Born Wilkes-Barre, Pennsylvania, 1796; died Jersey City, New Jersey, 1872. *Pigeon's Egg Head Going to and Returning from Washington.* 1832. Oil on canvas, 27¾″ × 23″. Smithsonian Institution, National Collection of Fine Arts, Washington, D.C. (Gift of Mrs. Sarah Harrison).

A singleness of purpose like that of Audubon inspired George Catlin to a comparable undertaking, the seeking out and recording of "the noble races of red men . . . spread over these trackless forests and boundless prairies." For a brief time Catlin had dutifully followed his father's wishes and begun the practice of law, but he soon decided to become an artist. He had been interested in Indians since childhood; and when he saw a group of them from the Far West passing through Philadelphia on

their way to visit the president, he conceived the idea of compiling a gallery of Indian portraits along the lines of the gallery of illustrious personages in Peale's museum (see page 40). "I . . . resolved," he wrote, "to use my art and so much of the labors of my future life as might be required in rescuing from oblivion the looks and customs of the vanishing race of native men in America." Although powerless to save them from their doom, he could at least "rescue their looks and their modes" so that "phoenixlike, they may rise from the 'stain on a painter's palette,' and live again upon canvas." He brought an eloquent pen as well as painter's tools to the fulfillment of his mission.

Catlin had made the first of his expeditions among the Indians in the Northwest Territory when, in the fall of 1831, he met in Saint Louis members of a delegation from the Upper Missouri tribes, en

route to Washington. Among them was Wi-jun-jon or Pigeon's Egg Head (also known as "The Light"), son of an Assiniboin chief. Persuaded to sit for his portrait, the young brave reluctantly appeared in Catlin's painting room "as sullen as death . . . though his pride had plumed and tinted him in all the freshness and brilliancy of an Indian's toilet. . . . His leggings and shirt were of the mountain-goat skin, richly garnished with quills of the porcupine. . . . Over these floated his long hair in plaits that fell nearly to the ground; his head was decked with the war-eagles' plumes, his robe was of the skin of the young buffalo bull, richly garnished and emblazoned with the battles of his life."

The dual portrait *Pigeon's Egg Head Going to and Returning from Washington* documents a sad instance of cultural shock. By chance, Catlin was a fellow passenger aboard the steamer *Yellowstone* the following year, when Wi-jun-jon made the return journey to his tribe thousands of miles up the Missouri River. In Washington, he had "exchanged his beautifully garnished and classic costume for a full dress *en militaire*. . . . It was broadcloth of the finest blue, trimmed with lace of gold. On his shoulders were mounted two immense epaulettes . . . his feet were pinioned in a pair of waterproof boots with high heels. . . . On his head was a high-crowned beaver hat, with a broad silver lace band, surmounted by a huge red feather, some two feet high. . . . On his hands he had drawn a pair of white kid gloves, and in them held, a blue umbrella in one, and a large fan in the other."

Arriving home in this outfit, Wi-jun-jon was at first hardly recognized by his tribe; and when he recounted all that he had seen on his travels, he was set down as a liar and impostor. Although he acquired considerable repute as a medicine man, admiration for his extraordinary skill was eventually succeeded by dread and terror. Three years or so after his return, Catlin relates, his fellows conspired "to rid the world of a monster whose more than human talents must be cut down to less than human measurement." Convinced that his medicine was so great that no ordinary rifle bullet could kill him, they fashioned an iron one for this purpose from the handle of a pot.

GEORGE CATLIN. 1796–1872. *Shooting Flamingoes*. 1857. Oil on canvas, 18½″ × 26″. Memorial Art Gallery, Rochester, New York (The R. T. Miller Fund).

Besides portraits of Indians, Catlin painted their ceremonies, buffalo hunts, and the landscapes in which they lived. After exhibiting his "Indian Gallery" in the United States, he took it abroad in 1839. Both the subject matter and the style of these pictures created a sensation in England, France, and Holland; and when interest in them flagged, Catlin stimulated it further by staging Wild West shows.

He remained abroad until 1852. Then, learning of some lost gold mines in the Crystal Mountains of South America, he set out to find them. During the next three years he painted the Indians of South America, and also those of the North American coast west of the Rocky Mountains, an area he had not previously visited.

Catlin had sketched his pictures of the 1830s rapidly, using thin pigments that would dry quickly to allow the canvases to be rolled up as he moved from place to place. In the jungles of South America he painted on bristol board; the copies in oil on canvas he subsequently made for a number of patrons still convey a sense of immediacy and technical speed.

Shooting Flamingoes is one of six scenes of hunting in North and South America, commissioned by the Colt Firearms Company of Hartford, Connecticut, to be reproduced by lithography and distributed for advertising. Catlin describes the episode in *Last Rambles Amongst the Indians of the Rocky Mountains and the Andes*. Together with a young half-Negro, half-Indian guide, his horse Yudolph, and his Colt gun (which was of a type with revolving barrel not yet known in that region, and which he called "Sam" after its inventor, Samuel Colt), Catlin traveled to the great salt marshes near Buenos Aires. In the summer the sun evaporates the water and leaves a slimy mud "so nauseous that no animal whatever will venture into it, and none of the feathered tribes except the . . . flamingoes." To hatch their young, they build on the ground nests of grass and weeds, "generally about one foot high, open cones, and from ten to three feet apart . . . looking from a distant elevation like a mass of honey-comb."

On reaching the site, Catlin and his guide made a screen of alder and willow bushes to shield them from view as they advanced upon the birds. When he fired, "Those that were near were wheeling about in the air, like a cloud above us, . . . those rising more slowly in the extreme distance looked like a white fog streaming up from the ground . . . and the whirling multitudes in the air formed into lines like infantry, and each, with its leader, was moving around and over our heads. . . . Seven or eight were lying dead, and others were hobbling off with broken wings." After having picked up and reassured his little guide, who had inadvertently been knocked over by the butt of the gun and believed that he, too, had been shot, Catlin surveyed the scene before him. It "was strange in the extreme, a landscape, a perspective of nests, with the heads of young birds standing out, as far as the eye could discern, and nothing else."

Catlin's always strong sense of color and pattern is particularly apparent in this painting. Against the greenish-blue sky, the pink and white birds with touches of black describe brilliant straight lines and arabesques, diminishing in scale; those in the foreground are contrasted against the green ground. In the center and right of the picture are row upon row of conical brown nests, from which peep the tiny heads of the fledglings; in the distance at the left rise the snow-clad peaks of the Andes.

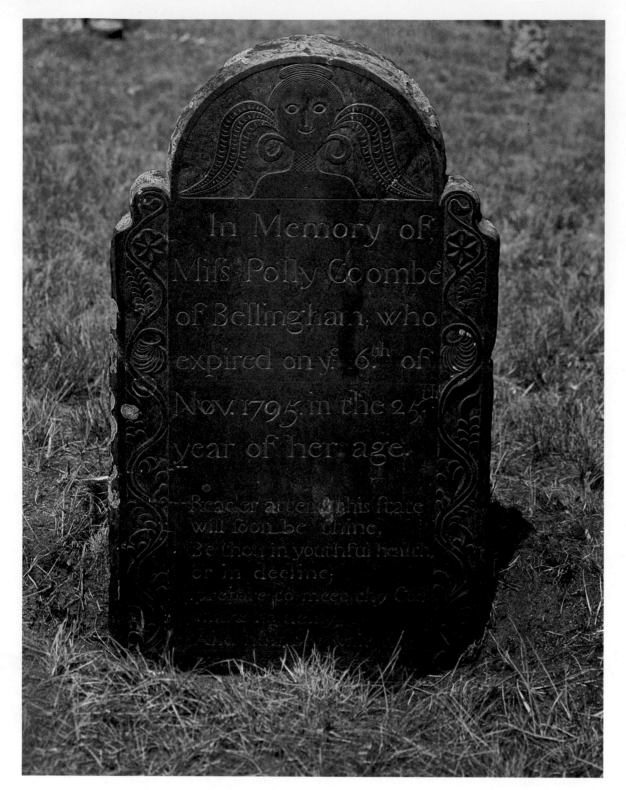

UNIDENTIFIED ARTIST. *Gravestone of Polly Coombes.* c. 1795. Slate, 26″ × 17″. Bellingham, Massachusetts, graveyard.

America's first native sculptors were the stonecutters who made gravestones for village burial grounds. These anonymous artisans, especially those in rural New England communities, created some of the most remarkable examples of early American portrait sculpture (compare page 22).

A representative example is the stone for Polly Coombes, who died in Bellingham, Massachusetts, in 1795. In representations of this type, which have been called "soul effigies," conventional cherubim derived from European prototypes merge with glorified images of the departed. Here, Polly's sprightly face is flanked by a pair of wings—graphic assurance to her family of her happy state of angelic immortality. The attitude underlying such representations is clearly indicated in the inscription on an almost exactly contemporaneous gravestone, that of Abigail Barber (1797) of Hebron, Connecticut:

> In faith she died in dust she lies,
> But hope pursues her to the skies,
> And sees her Angel spirit blest
> In mansions of eternal rest.

Polly's smiling face and the lively carving are in perfect accord, resulting in a cheerful portrait reduced to a few well-coordinated elements of design. The focal point of her countenance—the perky smile—is emphasized by all the other reverse curves: the lines of hair, wings, and sloping shoulders. The material of this stone, which is slate, invited sharply incised contours and shallow, two-dimensional relief; the carving on the gravestone is almost a drawing. This image is both the portrait of a real girl and—what gives it more significance as we view it today—a splendidly conventionalized design and a timeless symbol of immortality.

WILLIAM RUSH. Born Philadelphia, 1756; died there 1833. *The Schuylkill Freed.* c. 1828. Pine, 3′ 6″ × 7′. Philadelphia Museum of Art (on loan from the Commissioners of Fairmount Park).

The son of a Philadelphia ship carpenter, William Rush received his first training as an apprentice to a shipcarver from London. He soon had his own shop and won renown for his figureheads, which excited admiration not only in ports along the Eastern seaboard but as far away as London and Calcutta. Rush imparted such motion to these figures that it was said, "They seem rather to draw the ship after them than to be impelled by the vessel."

In 1794 Rush joined with Charles Willson Peale and Giuseppe Cerracchi, an Italian sculptor active in America, in founding the Columbianum as "an association of the Artists in America for the protection and encouragement of the Fine Arts" (see page 40). He subsequently served with Peale on the first board of directors of the Pennsylvania Academy of the Fine Arts, carved bones to replace those missing from the mastodon skeleton in Peale's museum (see page 42), and made sectional models that were used for teaching anatomy at the University of Pennsylvania Medical School.

Rush was a member of the commission that planned Philadelphia's new waterworks and selected its site on the east bank of the Schuylkill River (then outside the city limits). The ensemble, completed in 1828, included two templelike pavilions on the terrace overlooking the river. To top their pediments, Rush carved two reclining figures, *The Schuylkill River Chained* (based on the Hellenistic statue *Father Nile* in the Vatican Museum, Rome), and a female counterpart, *The Schuylkill Freed.* Praising the latter as "unequalled in kind throughout the world," a contemporary account described it:

"On the left side is represented a water-wheel; her left arm gently waved above it is indicative of the water-power; her right arm or elbow, rests on the edge of a large vase, representing the reservoir at Fairmount. On the side of the vase a pipe represents the ascending main. Water gushes out of the top, falling into the vase, and, to make it more picturesque, but not appropriate, overflowing the vase and falling down its sides."

The figures remained in their original positions until removed in 1937 to the Philadelphia Museum of Art to ensure their preservation. Originally they were painted white to simulate marble, but the absence of this coating allows us to see more clearly the crispness of Rush's carving and the flowing lines of drapery.

Although the pose of many of Rush's figures was suggested by casts of antique sculpture or illustrations in such books as Charles Taylor's *The Artists Repository or Encyclopedia of the Fine Arts* (London, 1808), he was firmly convinced of the value of drawing from the live model and tried to introduce this practice into the instruction at the Columbianum. The figure in clinging Grecian robe, *Water Nymph and Bittern,* which he carved in 1809 for a fountain in Centre Square, was influenced by a cast of the Venus de' Medici; but he greatly shocked the prudish Philadelphians by using as model the daughter of a local merchant. Years later this episode was to assume for another Philadelphia artist the quality of a personal allegory, symbolizing artistic freedom and truth to nature. Between 1877 and 1908, Thomas Eakins, whose insistence on teaching both men and women students from completely nude models forced him to relinquish directorship of the Pennsylvania Academy of the Fine Arts (see page 94), painted no fewer than four versions of *William Rush Carving His Allegorical Figure of the Schuylkill River.*

ISAAC FOWLE. Active Boston from 1807; died there 1832. *Lady with a Scarf*. c. 1820. Painted wood, 6′ 2″ high. The Bostonian Society, Old State House, Boston.

As gravestones were the first American sculptures in stone, so the trade of shipcarving provided the first opportunity for representations in wood. With the rapid rise of shipbuilding in the early nineteenth century, this robust Yankee craft reached its height in figureheads and sternboards. Isaac Fowle was active as a shipcarver in Boston from 1807, when he started a prosperous business that continued after his death as a company bearing his name. Besides a number of figureheads, a carved sign for a hardware shop is attributed to him.

The *Lady with a Scarf* was used as a shop sign by the carver and so has only one unweathered coat of white paint. It exemplifies the art of the American figurehead carvers at its greatest, with the sense of forward motion that William Rush had introduced into such figures (see page 47), combining functional sturdiness with a poetic sense of the thrust and speed of the graceful sailing ships.

The lady represents, most likely, a sea captain's wife. She stands firmly on the carved prow as she gazes out to sea. A strong wind blows back her skirt in handsome swirls and reveals the tip of her edged petticoat, a small staccato accent that contrasts with the ample rhythms of the edge of her dress. Everything is boldly and beautifully carved— the swelling bosom under its tight bodice, broad folds of dress, and wavy hair. One's lasting impression is of a lovely New England housewife striding into a strong sea wind, held back only by her winding scarf that, like the stylized acanthus leaves carved on the prow, the hem of the dress, and even the lady's hair, suggest the ocean waves that swirled beneath a ship's figurehead.

UNIDENTIFIED ARTIST. *Sternboard of the Eunice H. Adams.* 1845. Polychromed wood, 7′ wide. Whaling Museum, New Bedford, Massachusetts.

The *Eunice H. Adams,* a whaling brig, was probably named for the shipowner's wife, although it could have been named for, and the sternboard carved to portray, the captain's wife or daughter. The ship, built at Bristol, Rhode Island, was used in the Massachusetts whaling trade out of Nantucket, and then New Bedford.

Each kind of ship required a different sort of carved decoration, which was designed to suit the individual ideas of its builder and owner and was adapted to its basic structure and function. For whalers, relatively small and strictly utilitarian, carved decoration was kept to a minimum. As much to the point in accounting for the simplicity of the carving is the fact that New Bedford and Nantucket, the chief whaling ports, were dominated by the Quakers with their dislike of luxury and show. Whereas warships like the *Constitution* (see page 50) were most typically decorated with figures of naval heroes and statesmen, clippers with beautiful maidens or Indian princesses, and steamboats with important personages or American emblems, the frugal owner of a whaleship would most likely order a plain likeness of his or the captain's wife or daughter in her Sunday best.

Such is Eunice Adams, a forthright, serene portrait of a woman of the old New England whaling families. One can imagine that she is about to put down her book, look to her chowder in the summer kitchen, and then climb to the "widow's walk" to watch for the distant sails that would announce the return of a long-absent ship.

The carver has cleverly managed to suggest the whole seated figure just by slanting the line of the lady's body enough to show a triangle of skirt below her left arm, and he has given her three-dimensional reality by having the head protrude above the background. The pose is flexible and alive, but it is interesting to see how the carver emphasized the figure as an integral part of the sternboard lunette by stopping the right arm and torso on, not behind, the framework of the board that also serves as a ledge on which Eunice's book rests. Notice too how the front ends of the acanthus leaves are carved as if they continued through the bottom framing ledge.

The whole piece is beautifully composed. Eunice Adams's head—the only part of the sculpture that breaks through the contour of the curved board—is the focus, well off center but balanced by the arm resting on the book, which slants just a bit to the right, stabilizing the slant of the head to the left. Color is balanced too: the delicate blue of the dress accented by the red of the belt and book, the flower in Eunice's black hair, and her rosy lips. This is a superb ship carving and one of the most attractive of all our nineteenth-century portraits—painted *or* carved.

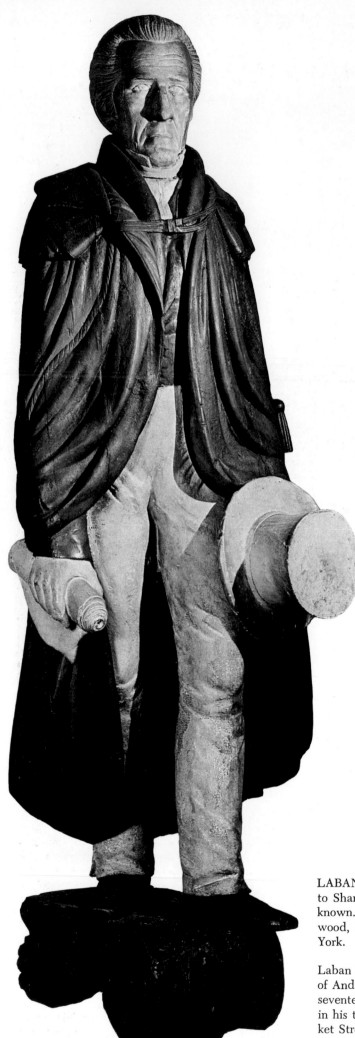

The huge portrait of President Jackson for the U.S.S. *Constitution* was a prestigious commission. Launched in 1787 as one of six frigates built by authorization of Congress to fight Barbary pirates, the ship had copper fittings by Paul Revere and a figurehead representing Hercules and the Hydra, designed by William Rush (see page 47). When this figurehead was damaged in a collision, a new one was made, which in turn was damaged during the War of 1812. The seeming invulnerability of the *Constitution* to heavy fire in its battle with the British ship *Guerrière* won it the affectionate nickname "Old Ironsides." When in 1830 the secretary of the navy ordered the valiant vessel scrapped, its demolition was prevented by a nationwide protest stirred by Oliver Wendell Holmes's poem, beginning:

> Ay, tear her tattered ensign down!
> Long has it waved on high . . .

The ship had therefore become a cherished symbol of American naval power by the time Beecher was charged with carving her third figurehead. The basic design, for which Beecher was paid $250, was drawn from a popular lithograph of Andrew Jackson after a painting done in 1826 by R. E. W. Earle. The president is shown in what is said to have been his riding habit, holding his hat in one hand and in the other a scroll, which Beecher substituted for the cane in his model.

Jackson was then in the midst of the controversy over the Bank of the United States, and partisan feelings ran high in Massachusetts. Shortly after Beecher's figurehead had been set in place on the frigate, a young officer of the merchant marine rowed out by night and sawed off its head just below the nose. This politically motivated act of vandalism was treated in the press as a national incident. The ship was taken to New York, where a new head was carved by the firm of Jeremiah Dodge and his son Charles.

The mutilated head was ultimately recovered and is now in a private collection. The figure was removed in 1846 and replaced by another image of Jackson (now in the U.S. Naval Academy Museum at Annapolis), carved by J. D. and W. H. Fowle. The Beecher-Dodge Andrew Jackson was sold and for a while was set up in an amusement park near Lowell, Massachusetts; it later passed to the Seawanhaka Corinthian Yacht Club on Long Island, and since 1952 has been safely housed in the Museum of the City of New York. As for the *Constitution*, after seeing long service as a training ship it fell into disrepair, but in 1925 was restored with the aid of funds contributed from all over the country. It is now back once more in Boston Harbor, as a floating U.S. naval museum.

Both its appearance and its history make this figurehead an embodiment of the tough endurance and simple dignity of our young nation as personified by "Old Hickory." It also exemplifies the American ability to develop visual symbols that express ideal aspirations in terms of forthright realism.

LABAN S. BEECHER. Born Connecticut c. 1805; to Sharon, Wisconsin, in 1830s; date of death unknown. *Andrew Jackson.* 1834. Polychromed wood, 11′ 10″ high. Museum of the City of New York.

Laban Beecher, the carver of this heroic figurehead of Andrew Jackson, left his home in Connecticut at seventeen to learn his craft in Boston. While still in his twenties, he had his own shop, first on Market Street and then on Commercial Street, making carvings for merchant vessels and warships.

HIRAM POWERS. Born Woodstock, Vermont, 1805; died Vallombrosa, Italy, 1873. *Andrew Jackson.* 1837 (from clay model of 1835). Marble, 34½" high. The Metropolitan Museum of Art, New York (Gift of Mrs. Frances V. Nash).

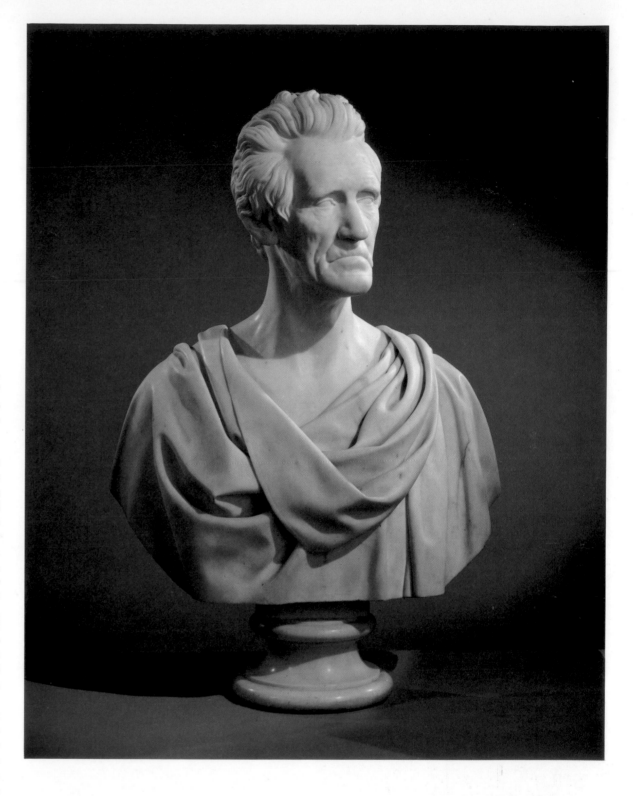

The year after the effigy of Andrew Jackson was carved as a figurehead for the frigate *Constitution* (opposite), Hiram Powers modeled the president's head from life. The only instruction Powers had received was from a German sculptor working in Cincinnati, who taught him how to model directly rather than by taking plaster casts of his subjects. After he began to obtain portrait commissions, Powers's patron, Nicholas Longworth, offered to send him to Italy—the goal of all aspiring sculptors because of the prototypes offered by the antique, the availability of marble, and the abundance of skilled artisans to translate the artist's clay into stone. Deciding that it would add to his prestige abroad if he were first to execute portraits of American statesmen, Powers came to Washington in 1835.

President Jackson gave him three sittings. Just before the bust was completed, one of his aides told Powers "that perhaps I had copied the peculiarities of the mouth too faithfully; alleging that the General had lost his teeth . . . and that his mouth had fallen in, which left him, in that respect, unlike his former self. But I liked the expression of his mouth even as it was. . . . The same firmness and inflexibility of character his mouth expressed in the prime of life, is to be found there still. . . . The face is the true index of the soul, *where everything is written had we the wisdom to read it.*" Powers decided nevertheless to refer the matter to the president himself: " 'Make me as I am, Mr. Powers,' he replied, 'and be true to nature always, and in everything. . . . I have no desire to *look* young as long as I *feel* old: and then it seems to me . . . that the only object in making a bust is . . . that it shall be as nearly as possible a perfect likeness.' "

The conflict between realism and idealism is also revealed in Powers's conversation with the minister from Russia, a reputed connoisseur, who declared: " 'You have got the General completely: his head, his face, his courage, his firmness, his identical self;

and yet it will not do! You have also got all his wrinkles, all his age and decay. You forget that he is President of the United States, and the idol of the People. You should have given him a dignity and elegance he does not possess. You should have employed your *art*, sir, and not merely your nature.' . . . I did not dare . . . to tell the Baron . . . that my 'art' consisted in concealing art, and that my 'nature' was the highest art I knew or could conceive of."

The striking realism of this portrait, despite the toga dictated by convention for such representations, is even more apparent in the original clay, recently rediscovered with other contents of Powers's studio and now owned by the National Collection of Fine Arts, Washington, D.C. The *Andrew Jackson*, however, is probably one of four busts that he carved himself shortly after his arrival in

Italy, before he began to employ studio workmen. In Florence, where he remained the rest of his life, Powers soon turned from realistic portraiture to "ideal" subjects. His *Greek Slave* of 1843 won him both fame and fortune, although its nudity was hotly debated. (In some cities during its American tour, men and women were admitted separately to view it.) A staunch defender of the female nude, Powers declared: "Beauty and innocence can bear to be seen from head to foot as God made it . . . his most perfect and wonderful work."

Nathaniel Hawthorne, whose romantic notions about sculpture are incorporated in *The Marble Faun*, found that Powers "sees too clearly what is within his range to be aware of any region of mystery beyond"—a criticism strikingly like that which Henry James was later to make of Winslow Homer (see page 90).

SAMUEL FINLEY BREESE MORSE. Born Charlestown, Massachusetts, 1791; died New York City 1872. *Marquis de Lafayette*. 1825. Oil on canvas, 8′ × 5′ 4″. Art Commission of the City of New York, City Hall.

The father of Samuel F. B. Morse was a Congregational minister and the author of the first American geography and geographical index; his mother was the granddaughter of a former president of Princeton College. After his graduation from Yale, his parents reluctantly consented to his pursuing the career of artist and in 1811 allowed him to go abroad with his master, the foremost American Romantic painter, Washington Allston. Like many American artists of the preceding generation, in London Morse entered the studio of Benjamin West, then president of the Royal Academy. Impressed by the high esteem in which artists and their works were held in England, in contrast to the situation in America, Morse wrote his parents in 1814 that he was loath to come home and "settle down into a mere portrait painter . . . for I cannot be happy unless I am pursuing the intellectual branch of the art. Portraits have none of it; landscape has some of it, but history has it wholly."

On returning to the United States the following year, Morse found that, as he had feared, it was only as a portraitist that he could earn his living. He was fortunate, however, in obtaining a number of important commissions. In a competition with other leading artists he was selected by the City of New York in 1825 to paint a full-length portrait of the Marquis de Lafayette when he visited the United States as "the Nation's Guest." On the eve of the first sitting, Morse wrote from Washington that he had already seen the sixty-eight-year-old Lafayette: "He has a noble face . . . there never was a more perfect example of accordance between the face and the character." Completion of the work was interrupted by the many demands on Lafayette's time and the tragic death in childbirth of Morse's young wife. Years later, Morse wrote that although he himself was not wholly satisfied with the portrait, Lafayette had declared that he was well pleased with his likeness. Describing his conception, Morse said that he had placed his subject "against a glowing sunset sky, indicative of the glory of his own evening of life. Upon his right . . . are three pedestals, one of which is vacant as if waiting for his bust, while the two others are surmounted by the busts of Washington and Franklin. . . . In a vase on the other side is a flower—the helianthus [sunflower]—with its face toward the sun, in allusion to

the characteristic stern, uncompromising consistency of Lafayette . . . the great prominent trait of that distinguished man." The heroic size and stance of the figure, and the fidelity with which Morse unflinchingly rendered Lafayette's "stern, uncompromising" mien, make this one of the most impressive official portraits ever painted.

Morse took an active part in founding the National Academy of Design in New York and served as its first president from 1826 to 1845, and again from 1861 to 1862. At New York University he held the first chair in painting and sculpture in any American college and gave public lectures on art, hoping to "enlighten the public mind so as to make it easier for those who come after me." Despite these activities, from the 1830s on Morse devoted himself increasingly to photography and science rather than art, especially to the invention and perfection of the telegraph. Unlike Peale, who had been quite content with his role as a portraitist while finding his scientific interests equally rewarding, Morse never ceased to regret that he had not fulfilled his own aspirations as an artist. In 1849 he wrote bitterly: "Painting has been a smiling mistress to many, but she has been a cruel jilt to me. I did not abandon her; she abandoned me. . . . My ideal for the profession was perhaps too exalted."

53

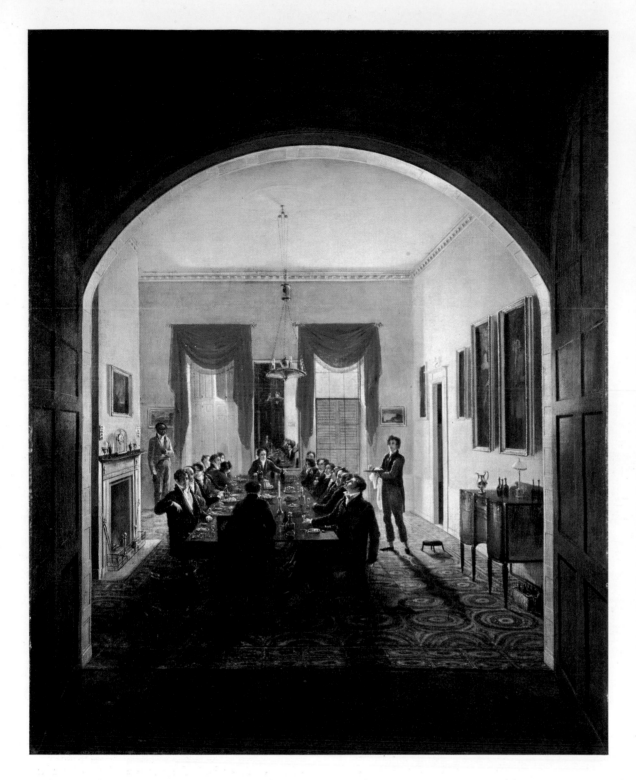

HENRY SARGENT. Born Gloucester, Massachusetts, 1770; died Boston 1845. *The Dinner Party*. 1821. Oil on canvas, 59½″ × 48″. Museum of Fine Arts, Boston (Gift of Mrs. Horatio A. Lamb, in memory of Mr. and Mrs. Winthrop Sargent).

In September 1821 Henry Sargent wrote from Boston to the veteran painter John Trumbull to introduce a Mr. D. L. Brown, who "takes with him a picture called the Dinner Party which he has purchased of me; and intends exhibiting in New York and Philadelphia—Should you be able to render him any advice or assistance, it will be conferring a favor on me; as I feel a very great solicitude on the occasion, this being my first attempt of a work of this kind."

The anxiety Sargent felt was understandable. In his youth, having been encouraged by Trumbull to become a painter, he had spent six years in London studying with Benjamin West. But on his return home in 1799 he feared that he might not find sufficient patronage and took a commission in the army. He had a distinguished military career, rising to the rank of colonel, and also served as a state senator until 1817. When growing deafness forced his retirement from public life, he once more resumed activity as a painter. *The Dinner Party*, however, was not only a departure from his usual portraits and religious subjects but, as a genre picture showing ordinary people engaged in everyday affairs, was also exceptional in American art at that time.

The painting had a surprising prototype. John Neal, one of the earliest commentators on American artists, wrote in his novel *Randolph* (1823) that Sargent "has just painted a piece called the DINNER PARTY, after the manner of the 'Capuchin Chapel.'" This was a work by a pupil of David's, François Marius Granet, who had abandoned his master's heroic Neoclassical style for a picturesque mode and specialized in interior views shown in deep perspective with striking chiaroscuro effects. His representation of a ceremony in the Capuchin Church in Rome was so popular that he made more than a dozen versions of it: one (perhaps the original) is now in The Metropolitan Museum of Art in New York, and another large one, shown in Paris at the Salon of 1819, is in the Hermitage at Leningrad.

Emulating the general proportions, deep perspective, and contrasting light-and-shade effects of Granet's picture, Sargent applied them to a secular subject in a domestic setting. This has been said to represent a gathering of the Wednesday Evening Club in Sargent's own house at No. 10 Franklin Place in the Tontine Crescent, a development built by Charles Bullfinch, from 1793 to 1794, along the lines of similar urban complexes in Bath, England. Founded in Boston in 1777, the club met once a week for social conversation. Its original membership of three representatives apiece from the clerical, legal, and medical professions was subsequently enlarged to admit merchants, including "manufacturers and gentlemen of letters and leisure." Although Sargent's name does not appear among those in that category in its roster of known members, the list does include that of John Welles, brother of his father-in-law, Samuel Welles. It is the house of the latter that is depicted here, according to Mr. Daniel Sargent, a direct descendant of one of the artist's brothers. The wealthy merchants Samuel and John Welles had built two houses in the Neoclassical style side by side at 57 and 58 Summer Street, close by the Tontine Crescent in the then highly fashionable South End of Boston; the area had already become largely commercial before most of its remaining fine residences were destroyed in the great fire of 1872.

The large paneled doorway in the picture's frontal plane provides a kind of proscenium arch through which the action in the room beyond appears like a scene in a play. Daylight comes through the windows at the rear, and the clock on the mantle marks 5:05, for dinner in those days began at about 3:00 P.M. This meal has progressed beyond the first two courses, and the linen cloth has been removed for the serving of fruits, nuts, and wine on the polished tabletop. (The wine cooler in the foreground at the left is now also on view at the Museum of Fine Arts, Boston.) Although Sargent has somewhat differentiated the appearance of the figures, he has expended more care on reproducing the furniture and other objects, displaying a special fondness for the highlights on glass and metal.

Despite its wealth of realistic detail, today we would not regard this as a "deception" like that of Raphaelle Peale (page 41); but Neal, in the passage noted above, says that *The Dinner Party* "is so admirable as to deceive dogs," and cites an anecdote in which one animal, misled by the illusion of the laid table, rose up on its hind legs to beg.

Sargent's misgivings about the picture were unwarranted, for it proved so popular that he soon afterward painted a companion piece, *The Tea Party* (also in the Museum of Fine Arts).

JOHN QUIDOR. Born Tappan, New York, 1801; died Jersey City Heights, New Jersey, 1881. *The Money Diggers*. 1832. Oil on canvas, 16¾″ × 21½″. The Brooklyn Museum, Brooklyn, New York (Gift of Mr. and Mrs. A. Bradley Martin).

By the second quarter of the nineteenth century, New York had supplanted Boston and Philadelphia as the chief cultural center of the United States. Besides a growing number of art associations, there were clubs and societies in which writers and artists met together with men from other professions and with prosperous merchants interested in intellectual discussions and eager to become patrons of the arts. At the same time that some painters in this milieu continued to find their subjects in the Bible, classical antiquity, or European history and literature, others took their cue from the American tales of Washington Irving and James Fenimore Cooper.

Early in his career, John Quidor abandoned the realistic portraiture he had learned as an apprentice to John Wesley Jarvis in order to paint themes more congenial to his romantic temperament. Although ultimately derived from illustrations and caricatures by such English artists as William Hogarth and Thomas Rowlandson, his style was highly personal and original.

The Money Diggers is based on an episode in one of Irving's *Tales of a Traveller*, published in 1824.

For years Wolfert Webber, a New York farmer of Dutch descent, had dreamed of mending his declining fortunes by discovering buried treasure. When he learned that an old fisherman, Black Sam, had once in his youth come upon a group of buccaneers burying a chest in a wild spot along the shores of upper Manhattan Island, Webber determined to find the golden hoard. Taking Black Sam as his guide, he enlisted the aid of a German quack and necromancer, Dr. Knipperhausen. On the night of their expedition the site of the treasure was located by the doctor with his divining rod. After making a smoking fire on which he threw herbs and drugs, he began to recite magic incantations, while Sam dug a hole with his pickax and Webber held a lantern.

"At length the spade of the old fisherman struck upon something that sounded below. . . . ' 'Tis a chest,' said Sam. 'Full of gold, I'll warrant it,' cried Wolfert, clasping his hands with rapture.

"Scarcely had he uttered the words when a sound from above caught his ear. He cast up his eyes, and lo! by the expiring light of the fire, he beheld, just over the disk of the rock, what appeared to be the grim visage of the drowned buccaneer, grinning hideously down upon him.

"Wolfert gave a loud cry, and let fall the lantern. . . . The negro leaped out of the hole; the doctor dropped his book and basket, and began to pray in German. All was horror and confusion."

Quidor has closely followed Irving's descriptions of the locale, of Dr. Knipperhausen with "a pair of green spectacles set in black horn upon his clubbed nose, . . . in his camblet robe by way of surcoat, his black velvet cap under his cocked hat," and of Wolfert, wearing Dame Webber's long red cloak flung over his shoulders and clasped under his chin, and "a large flapped hat tied under the chin with a handkerchief of his daughter's to secure him from the night damp." He has intensified the effect, however, by an expressionistic use of unnaturalistic hues, especially in the faces lit by the lurid fire. The gestures of the frightened men, grotesquely distorted to induce the viewer's laughter rather than his fear, are complemented by the angular, twisted branches of the trees and bushes.

Too eccentric in his personality and too individualistic in his art to attain recognition in his lifetime, Quidor seems never to have sold any of his visionary easel pictures and made his living by painting signs, banners, and fire-engine panels. He had no followers and was virtually ignored by criticism for over half a century after his death; an exhibition organized by John I. H. Baur at The Brooklyn Museum in 1942 was largely responsible for reviving interest in his work.

FRANCIS GUY. Born in the Lake District, England (Burton-in-Kendall, Westmorelandshire, or Lorton, Cumberlandshire), 1760; died Brooklyn, New York, 1820. *Winter Scene in Brooklyn.* 1817–1820. Oil on canvas, 4′ 10¾″ × 6′ 3″. The Brooklyn Museum, Brooklyn, New York (Gift of the Brooklyn Institute).

Just as portraiture—the faithful recording of a sitter's likeness, and often of his possessions—was predominant in early American painting, so also portraits of places—topographical views of towns or privately owned estates—constituted the earliest type of landscape in this country. Francis Guy was one of several immigrant artists from England who specialized in paintings of this sort. Originally a tailor, he had invented machinery for glazing cloth and boasted of having enjoyed royal patronage as "Dyer, Callenderer, and Orris Cleaner to the Queen and Princesses of England."

After arriving in America in 1795, Guy lived briefly in Brooklyn and then Philadelphia before settling in Baltimore, where he remained for almost twenty years. When his dyeing establishment burned down, he decided to change his trade from tailor to artist. He taught himself to paint by an ingenious method described by Rembrandt Peale in a reminiscence written in 1856. "He constructed a tent, which he could erect at pleasure, whenever a scene of interest offered itself to his fancy. A

window was contrived, the size of his intended picture—this was fitted up with a frame, having stretched on it a piece of black gauze. Regulating his eyesight by a fixed notch, a little distance from the gauze, he drew with chalk all the objects as seen through the medium, with perfect perspective accuracy. This drawing being conveyed to his canvas, by simple pressure from the back of his hand, he painted the scene from Nature . . ." Peale judged the paintings Guy produced in this way better than those he attempted freehand. Unfortunately, most of his prolific output is lost, including an 1812 view of Baltimore's Roman Catholic Cathedral, then under construction by Benjamin Henry Latrobe, who provided Guy with a detailed architectural sketch of the building and advised him how to paint its setting.

Winter Scene in Brooklyn engaged Guy's attention from the time of his return to Brooklyn in 1817 until his death three years later. A combination of landscape and genre, it presents a view from the artist's window showing the buildings at the intersection of Front and James streets, enlivened with numerous figures going about their daily occupations. Thomas Birdsall, owner of the large white building at the right (which a sign identifies as post office and hardware store), recalled that as Guy painted, he "would sometimes call out of the window, to his subjects as he caught sight of them on their customary ground, to stand still, while he

put in the characteristic strokes." Given Guy's habit of working from direct observation in this way, the resemblance that this snow-clad scene peopled with amusing anecdotal groups bears to paintings by Brueghel is probably fortuitous.

A leaflet issued by a New York art gallery after Guy's death describes the "Brooklyn Snow Piece" in detail, identifies the buildings and personages portrayed, and praises the painting as "one of the most natural, lively, and fascinating Pictures ever produced." "Although the painter has a view upon three different streets, not two buildings are to be seen alike. . . . As to the likenesses introduced, most of them are very striking, and the accuracy with which their faces are painted (the small size of the figures considered) is wonderful."

Approximately a fifth of the painting was destroyed by fire in 1890, but the whole composition is known not only from this description but also from another version in the Museum of the City of New York and an 1865 lithograph. Among those Guy showed standing near his dwelling in the lost section at the left was Augustus Graham, who at his death in 1852 left a bequest to the Brooklyn Institute for an art school and gallery. Acquired for this collection, the *Winter Scene* now hangs in The Brooklyn Museum, which is a department of the organization that succeeded the original Brooklyn Institute.

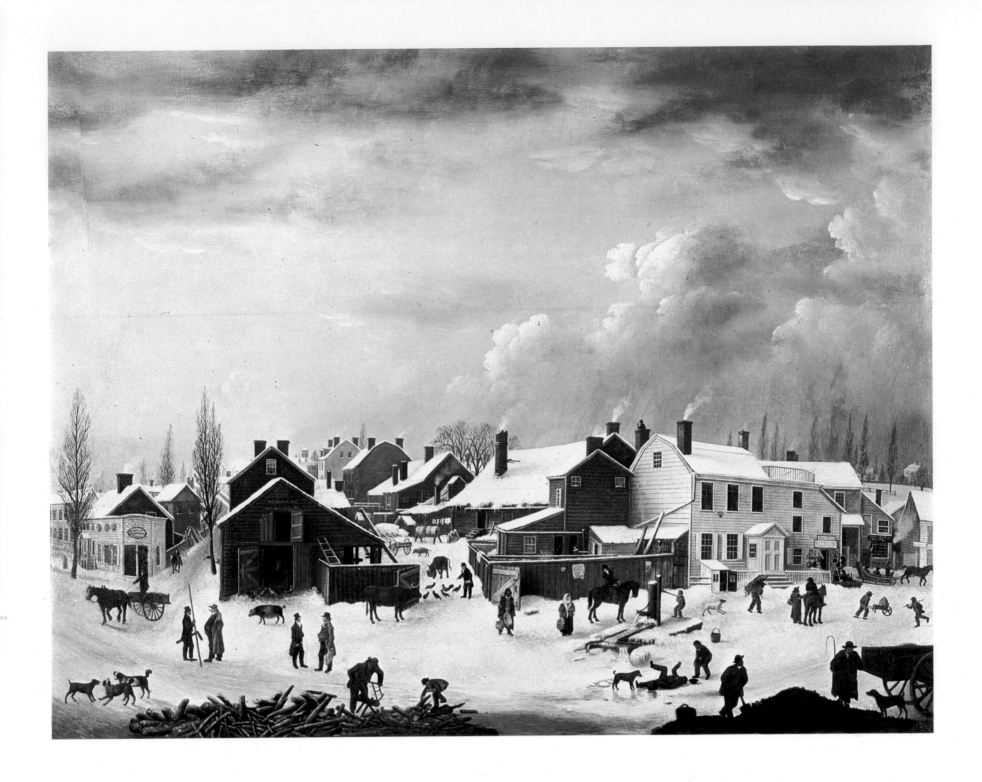

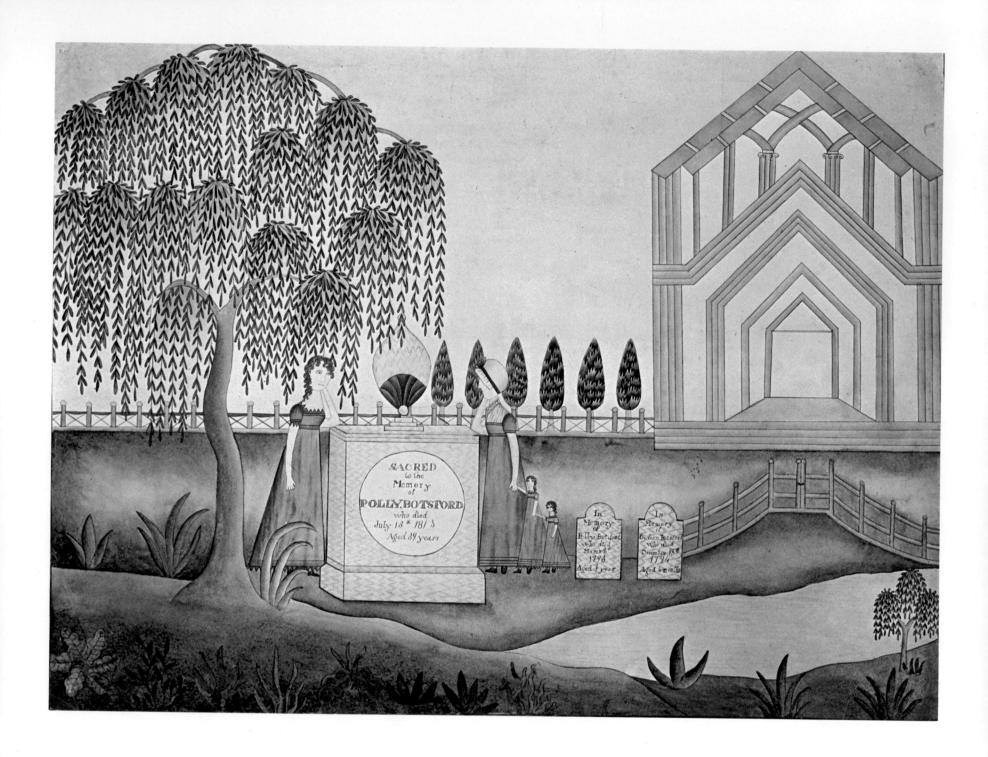

UNIDENTIFIED ARTIST. *Mourning Picture for Polly Botsford and Her Children.* c. 1813. Watercolor and ink, 18″ × 23½″. Abby Aldrich Rockefeller Folk Art Collection, Williamsburg, Virginia.

Homage to the dead was paid not only on gravestones but also in mourning pictures that similarly documented their name, the date of their death, and the age at which they died. These were usually the work of young women seminarians and had their prototypes in needlework; many of the stitchery conventions were preserved in the stylized brushstrokes of the watercolor memorials.

Starting with the conventional props—willows, cypresses, church, mourners, tomb—the anonymous artist of this memorial picture (found in Connecticut) created an impressive example far removed

from the common genre. The stylized scene with the church reduced to a skeleton framework relates to various aspects of contemporary abstract painting. The paper itself, as in Paul Seifert's farm scene (page 61), is an important abstract element of the design; it is left uncolored for the interior of the church and the tomb inscription. The linear precision foreshadows a similar quality in the work of some twentieth-century artists (see page 15). Effective use of arbitrary scale is another element of the unselfconscious abstraction, as are the formal design repeats—triangles of church arches, triangular figures, showers of triangular willow leaves, and conical cypresses.

The poet Stanley Kunitz has written some moving verses for Polly Botsford and her mourners, a literary memorial dedicated to a painted one:

Mourn for Polly Botsford, aged thirty-nine,
and for her blossom Polly, one year old,
and for Gideon, her infant son, nipped in the bud.
And mourn for the mourners under the graveside
 willow,
trailing its branches of inverted V's,
those women propped like bookends on either side
 of the tomb,
and that brace of innocents in matching calico
linked to their mother's grief with a zigzag clasp
 of hands,
as proper in their place as stepping-stones.
Mourn, too, for the nameless painter of the scene
who, like them all, was born to walk a while
beside the brook whose source is common tears,
till suddenly it's time to unlatch the narrow gate
and pass through the church that is not made
 with walls
and seek another home, a different sky.

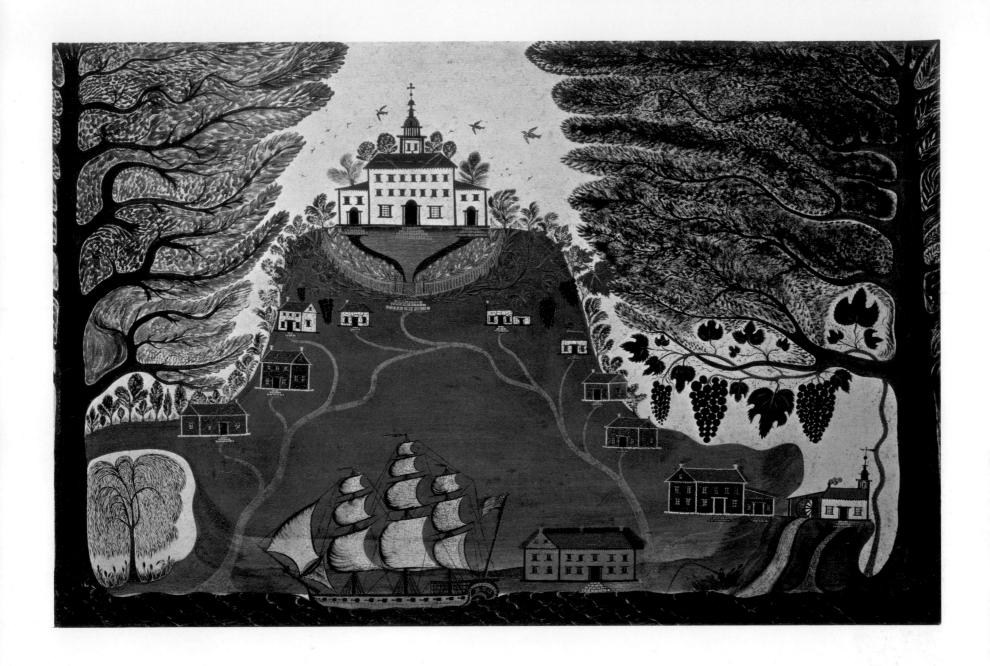

UNIDENTIFIED ARTIST. *The Plantation.* c. 1825. Oil on wood, 19⅛″ × 29½″. The Metropolitan Museum of Art, New York (Gift of Edgar William and Bernice Chrysler Garbisch).

Portraits of places continued to be a staple of American folk art throughout the nineteenth century, and even into the twentieth (see page 81). However, the elaborateness of the complex shown in this picture, which was found in Virginia, has led authorities to believe that it is an imaginary or composite view. Like the *Mourning Picture for Polly Botsford and Her Children* (opposite), the painting technique is reminiscent of conventions used in needlework.

Design is what this scene is all about, and everything is subservient to its interests. The giant grapevine, to be clearly visible in its entirety, needed pockets of sky in the dense foliage of the tree at the right, and its wavy stem rises free of the tree trunk on which it should actually have grown. At the left another pocket, a pond, isolates the tiny willow as if it were painted on a free-form plate. The entire composition builds up to the Palladian house, crowned by a cupola, which with its swags of flowering gardens tops the brown, tree-trimmed hill. The serpentine path—outbuildings set like fruits at the ends of its branches—ends at the stone entrance steps to the main house. All the limbs of the trees point to the house, and at the top birds (some twice the size of the windows) fly near it. The main subject of the composition—hill and house, neatly edged with a fringe of trees—is framed on three sides by the vertical tree trunks and connecting horizontal strip of the river. The *missing* horizontal at the top maintains the focus on the plantation house.

The artist's instinctive sense of design is flawless. The house on its hilltop and the large sailing vessel below are left of center, but our eyes are drawn to the right by the huge grapevine and the mill on a dramatically curved cliff. Notice the two large birds on the right of the house, and one to the left. This is among the most "primitive" of our folk paintings, and is also one of the most marvelously composed.

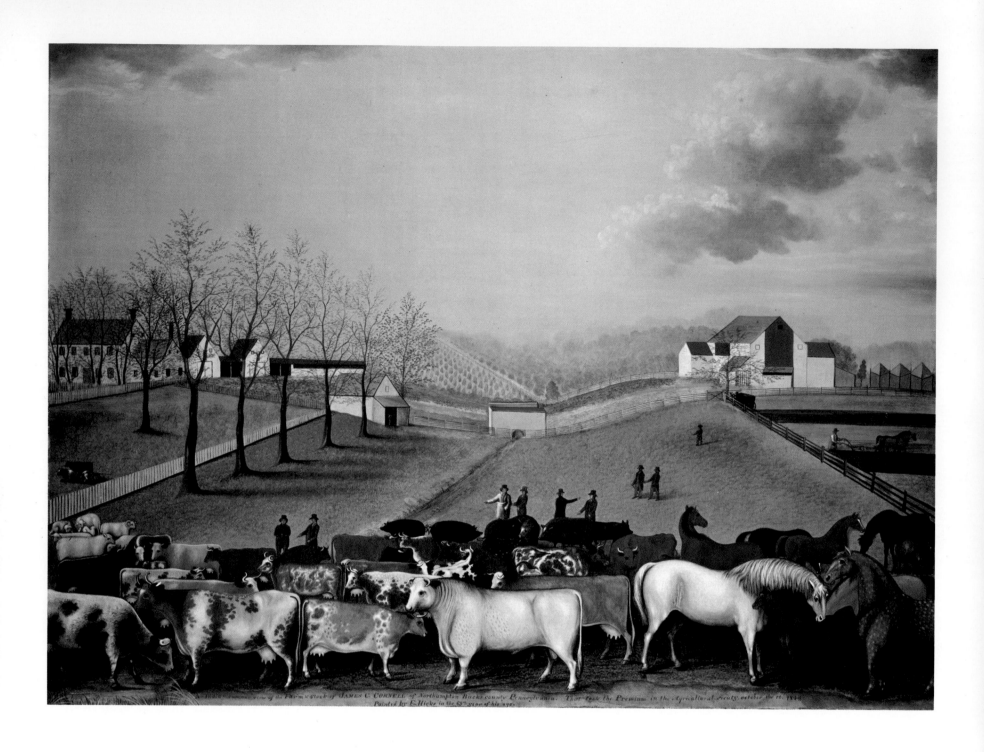

EDWARD HICKS. Born Langhorne, Bucks County, Pennsylvania, 1780; died Newtown, Pennsylvania, 1849. *Cornell Farm*. 1848. Oil on canvas, 36¾″ × 49″. National Gallery of Art, Washington, D.C. (Gift of Edgar William and Bernice Chrysler Garbisch).

Edward Hicks is the best known of American folk painters. He lived most of his life in or near Newtown, Pennsylvania, beginning his career as a coachmaker and sign painter. Besides his many versions of The Peaceable Kingdom (see page 62), for which he is most revered, he painted a number of landscape, historical, and farm scenes as gifts for his family and friends.

This farmscape is inscribed at the bottom of the canvas where the ground is ingeniously sliced away to make room for the lettering: "An Indian summer view of the Farm & Stock of James C. Cornell of Northampton Bucks County Pennsylvania. That took the Premium in the Agricultural Society, october the 12, 1848"; it is signed "Painted by E. Hicks in the 69.th year of his age." This was a year before his death.

The man in the gray belted coat has been identified as James Cornell, whose prize-winning animals are profiled in a splendid frieze in the foreground. The animated little gentlemen seem to be pointing out interesting features of the farm. The background recedes to show the Cornell house at the left; only the homestead is lightly obscured by thinly leafed trees, while the farm buildings, fields, and fences are more prominent in placement and color. The hazy autumn sky blends softly toward

the horizon with distant orchards and hayfields; all of the central farm scene is neatly ordered and sharply delineated. The place of honor accorded the magnificent white bull in the center of the foreground is emphasized by the perspective recession of the fences at right and left.

The vitality and power of Hicks's painting is apparent in every detail, and the scope of his style is impressive. It ranges from the strong line of a horse's arching neck to the delicate, painterly rendition of clouds. Boldly designed and executed with exquisite care, this is a Hicks masterpiece—and an American masterpiece.

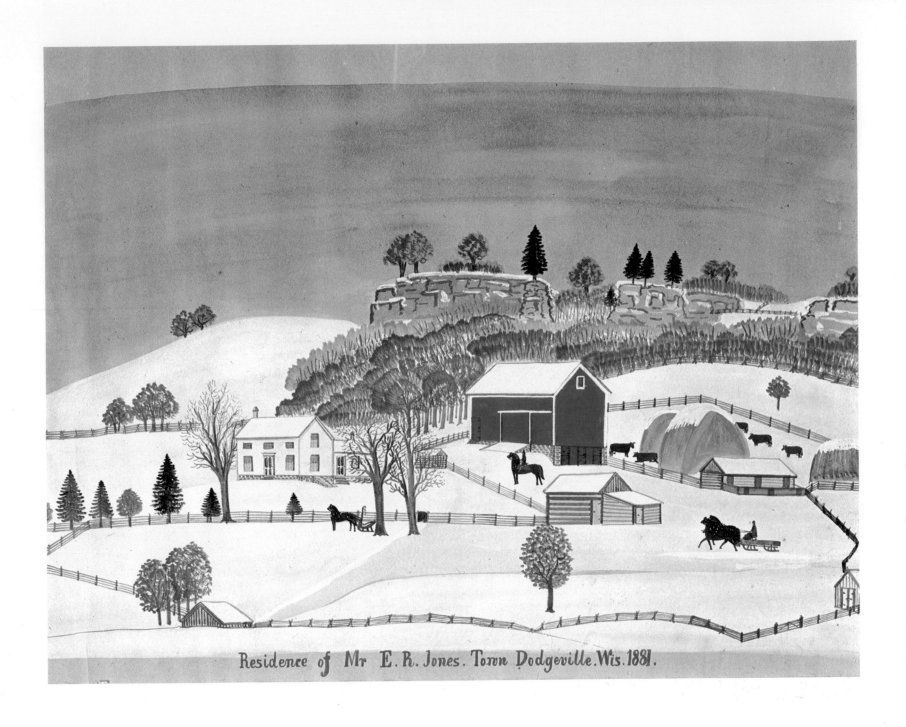

Residence of Mr E. R. Jones. Town Dodgeville. Wis. 1881.

PAUL A. SEIFERT. Born Dresden, Germany, 1840; to United States 1867; died Wisconsin 1921. *Residence of Mr. E.R. Jones.* 1881. Watercolor and tempera on paper, 21½″ × 27½″. New York State Historical Association, Cooperstown.

After graduating from college in Leipzig, Paul Seifert immigrated to America in 1867. He soon began to paint "portraits" of the farms near his home in Wisconsin, charging $2.50 for the large framed watercolor scenes. His major occupation was raising flowers, fruits, and vegetables for sale. Besides painting farmscapes as an itinerant, which he continued doing till about 1915, he planted fruit orchards for the farmers. In his old age he gave up walking from farm to farm as a way of life and spent his last years as a taxidermist in a shop he set up near Gotham, Wisconsin. There he also made and sold paintings on glass (a folk-art technique particularly common in Central Europe). Seifert's granddaughter recalls his matter-of-fact explanation of his reason for painting: "People like my work, and I like to paint for them."

Mr. Jones's farm in Dodgeville, Wisconsin, is shown at its most picturesque: after an early snowfall when the foliage of the oaks was still autumn-bright, the last haystack still green. Seifert frequently left areas of his paper unpainted, as did the earlier anonymous artist of the *Mourning Picture for Polly Botsford and Her Children* (page 58); this was not only timesaving but, since he used colored papers—gray, tan, or pale blue—also produced interesting effects. The colored backgrounds give his scenes an unconventional and effective compositional unity. In this picture the sky ends in an arc below the edge of the gray paper, much as small children instinctively draw the sky, and in the foreground the snow ends to leave a strip of unpainted paper for the inscription (compare this unrealistic device with a similar placement of the inscription in Hicks's *Cornell Farm*). The paper is also left unpainted for several buildings that are merely striped to indicate their timbered structure, and the gray tint showing through the thin wash of sky and snow gives a wintry cast to the landscape. In this composition, as in that of Hicks, the big barn rather than the house is the center of interest; the matching red color in the inscription reemphasizes its importance.

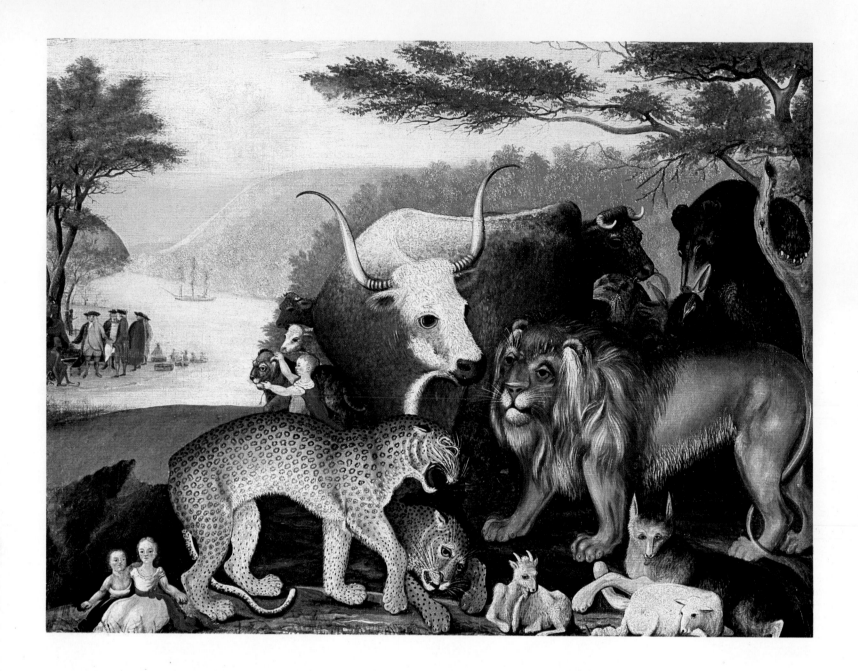

EDWARD HICKS. Born Langhorne, Bucks County, Pennsylvania, 1780; died Newtown, Pennsylvania, 1849. *The Peaceable Kingdom.* 1844. Oil on canvas, 24″ × 31¼″. Abby Aldrich Rockefeller Folk Art Collection, Williamsburg, Virginia.

Edward Hicks was an ardent Quaker and active as a preacher, visiting meetinghouses of the Society of Friends in Pennsylvania, New Jersey, New York, and New England to the end of his life. He considered that Penn's treaty with the Indians was the fulfillment of the prophecy in Isaiah 11:6: "The wolf also shall dwell with the lamb, and the leopard shall lie down with the kid; and the calf and the young lion and the fatling together; and a little child shall lead them." Hicks painted over sixty versions of The Peaceable Kingdom, following this description exactly for the biblical scene and in most cases combining it with a vignette of the historical event as an inspiring parallel. As a basis for his representations of Penn's treaty he used an engraving after Benjamin West's famous painting of the subject (see page 28), depicting Penn and his associates in Quaker dress. Other iconographic details were adapted from a variety of sources, transformed by Hicks's spiritual and creative vision.

This great version of the subject was done to-ward the end of Hicks's life and shows the serenity, order, and depth that mark his later masterpieces. The arched leopard and splendid horns of the bull establish a strong curvilinear interest in the composition. The horizontal branch of the tree at the right, russet colored like the bull, is a sheltering canopy over the pyramidal group of peaceful creatures. A soft light floods the background, but in the middle distance the episode of Penn's treaty is as clear and colorful as the assemblage of animals in the foreground. The combining of two different scenes within one picture area represents a nonrealistic (conceptual and abstract) approach to the subject that is typical of primitive artists throughout the ages. Hicks must have thought of his Peaceable Kingdoms as painted sermons. Today, it is the artist's fresh vision, sound craftsmanship, and sure sense of design that impress us.

In a letter that accompanied this painting, which was made for Dr. Joseph Watson of Newtown, Pennsylvania, Hicks described it as "one of the best paintings I ever done (& it may be the last) The price as agree.ᵈ upon is twenty dollars with the additional sum of one dollar 75 cents which I give Edward Trego for the fraim. . . . With gratitude and thankfulness for thy kind pattrenage of the poor painter. . . ."

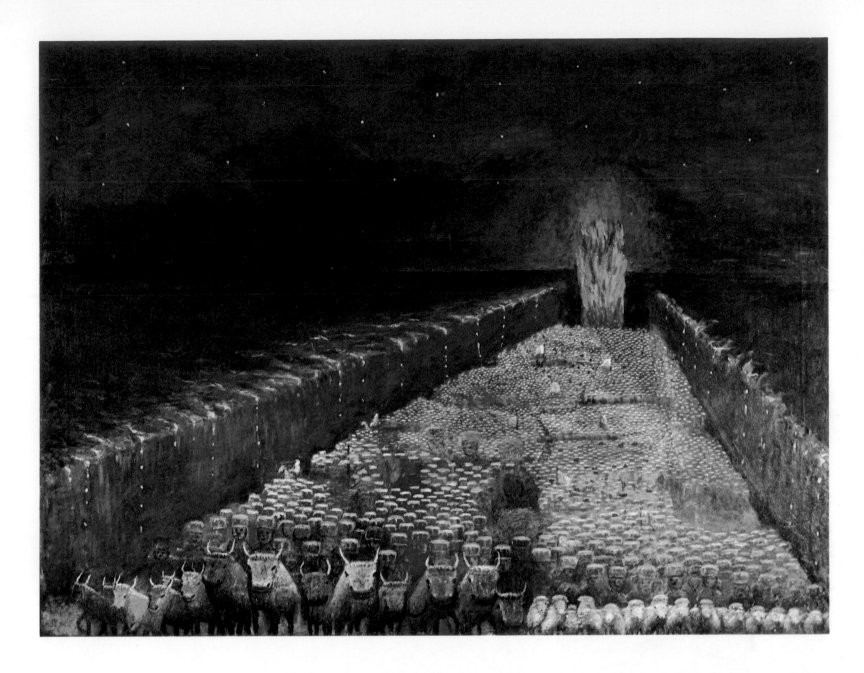

ERASTUS SALISBURY FIELD. Born Leverett, Massachusetts, 1805; died Plumtrees, Massachusetts, 1900. *Israelites Crossing the Red Sea*. 1865–1880. Oil on canvas, 34¾″ × 46″. Collection of Mr. and Mrs. W. B. Carnochan.

Erastus Salisbury Field was a self-taught artist, although he studied briefly in New York with Samuel F. B. Morse when he was working on the portrait of the Marquis de Lafayette (pages 52–53) mentions Field as a pupil in his studio.

As an itinerant portrait painter, chiefly in New England, Field had a successful career, but with the rise in popularity of the daguerreotype demand for his services seems to have declined. He lived in New York from 1841 to 1849, continuing to paint portraits but also learning the new art of photography, in which his former teacher Morse was engrossed. After his return to Massachusetts in 1849, photography formed the basis for his portraits, and gradually he ceased painting them altogether.

Following the death of his wife in 1859, Field turned to religion for consolation and to the Bible for inspiration. The *Israelites Crossing the Red Sea* is one of a cycle of paintings, executed between 1865 and 1880, that deal with the plagues visited upon the Egyptians and the final freeing of the Israelites. Although the series was based on prints of paintings by the English artists John Martin and Richard Westall, Field totally transformed his sources. In this picture, a stunning compositional tour de force, the waters, following the description in the Bible, are literally "a wall unto them on their right hand, and on their left" (Exodus 14:22). In the first ranks, moving in mass toward the spectator, are the "mixed multitude" of sheep and cattle. Behind are the 600,000 children of Israel, represented full face in the first rows and then by colorful dots—a pointillist blend of "Egyptian" colors. (Several spectral figures of immense size among the first group must be part of the underpainting and indicate how the artist changed the scale of his figures.) The perspective focuses on the pillar of cloud that "came between the Egyptians and the camp of Israel; and it was a cloud and darkness to them, but it gave light by night [to the Israelites]; so that the one came not near the other all the night" (Exodus 14:19–20). The great fire and evenly scattered stars provide the only illumination of the night scene. Anything but somber, however, it almost anticipates twentieth-century technicolor film spectaculars.

Field reverted to secular subjects to celebrate America's Centennial in 1876 and created a huge canvas, thirteen feet long by nine feet high, as visionary as any of his biblical themes and without parallel in the country's art. This *Historical Monument of the American Republic* (Springfield Museum of Art, Springfield, Massachusetts) has been described by Oliver W. Larkin: "From a strange architectural base rose stranger towers in diminishing stages, their round or polygonal sides incrusted with reliefs and statues of unbelievable complexity in which every major historic episode and every national hero was represented. Seven of these Babel towers were joined near their tops by steel bridges with steam trains puffing along them, and the eighth and central turret was given to Abraham Lincoln and the Constitution. Troops paraded the avenue below and citizens in their Sunday best entered the portals of a structure whose extravagance exceeded the 'waking vision' in Whitman's 'Song of the Exposition':

> Mightier than Egypt's tombs,
> Fairer than Grecia's, Roma's temples,
> Prouder than Milan's statued, spired
> cathedral. . . ."

OLOF KRANS. Born Selja, Sweden, 1838; to United States 1850; died Galva, Illinois, 1916. *Women Planting Corn.* c. 1896–1900. Oil on canvas, 25″ × 40⅛″. Bishop Hill Memorial, Bishop Hill, Illinois.

The tradition of seeking religious freedom in America that began in the seventeenth century joined in the nineteenth with two other newer tendencies: the founding of utopian communities such as Robert Owen's New Harmony, Indiana, and pioneering in the midwestern prairies. In 1846 a small band of pietist Swedes, dissenting from the orthodox Lutheran sect, arrived in western Illinois with their leader, Erik Jansson, from whom they took the name "Janssonists," and they called the religious community that they founded "Bishop Hill" after his birthplace, Biskopskulla. Soon it numbered 1,200 immigrants—the first Swedish settlement in the Middle West. Communal principles governed the buildings they erected, the farming in the surrounding countryside, and their entire way of life.

At the age of twelve, Olof Krans was brought from Sweden to Bishop Hill, where he worked as

an ox boy and later in the paint shop and blacksmith shop. While serving in the Illinois Voluntary Infantry, he was injured, and shortly after being mustered out he settled in nearby Galva, where he became a house painter and decorator. It was not until he was almost sixty and recuperating from a leg injury that he began to paint pictures. He recorded from memory his recollections of the manner in which labor had been shared by men and women at Bishop Hill in his boyhood; for unfortunately by 1860 the community, like many other utopias, had begun to fall into a decline owing to dissent and mounting debt. Krans also painted portraits of citizens of the village from photographs he had taken earlier. In 1912 he presented ninety-six of his paintings to the Old Colony Church, where they are carefully preserved; for thanks to the concern of some of its native sons, Bishop Hill is now an Illinois State Memorial, listed in the National Register of Historic Places, and many of its buildings have been restored.

Esther Sparks, formerly a member of the Illinois Arts Council, has described *Women Planting Corn,* explaining Krans's recollection of the activity it records: "It shows a Janssonist principle: Men

and women must share equally in labor. It also records Janssonist ingenuity. Twenty-four women, dressed in the Colony uniform, advance over the field in a row. They follow a rope tied with twenty-four knots of colored thread to mark each planter's position. Each woman holds a long stick with two points; one to make a hole for a few kernels of corn from her apron pocket, another to measure the distance to the next row. After the hole is filled, the men move the rope forward and the women plant the next row. The horizon seems limitless, just as the young Olof would have remembered it. Some furrows did stretch unbroken for miles across the fertile prairie.

"*Women Planting Corn* shows the stringent organization that marked all aspects of life at Bishop Hill. All dressed alike. All worked in teams for eighteen hours a day—whether in the fields, the shops or the kitchens."

The organization of Olof Krans's painting is as stringent as the daily life he portrayed. His subject is magnificently interpreted in a stylized composition that by its boldness and simplicity communicates to us today a moving purity and unity of intention and expression.

ERICK ALBERTSON. Active Mendocino, California, 1865–1870. *Father Time*. 1866–1870. Painted wood, life size. Masonic Temple, Mendocino, California.

The Masons have been an important force in American life, numbering among their order some of our most illustrious citizens and contributing many ideas to our national life. On the Great Seal of the United States and engraved on our dollar bills is a Masonic emblem—the eye surrounded by sunlike beams, which forms the apex of a broken pyramid.

The sculptural group topping the cupola of the Masonic Temple in the small coastal town of Mendocino, California, was carved from a single huge redwood log by the local blacksmith, Erick Albertson. Mendocino, 128 miles north of San Francisco, was founded in 1852 and was a shipping

point for lumber and farm produce. Albertson, who also worked in the lumber mill, served as the first Master of the Lodge after it received its charter in 1866. He built the new Masonic hall at a cost of $1,000, carved and installed this remarkable life-size group, and also did the ornamental carving in the small upstairs Lodge Room. Local tradition has it that a sculpture similar to the *Father Time* exists somewhere in New England, and the young girl does have the look of a nineteenth-century figurehead. Albertson, who is said to have been of Swedish origin, as his name suggests, might have spent some time in the East before coming to the California coast, but to date nothing more has been found about him or his work. Certainly he was one of our most talented folk carvers.

A history of Mendocino County published in 1880 describes the work: "On the pinnacle of the dome there is a beautiful piece of sculpture carved

from a block of the indigenous redwood. It represents the beautiful Masonic emblem, the broken pillar—the maiden beside it, with the sprig in her hand, and old father Time toying with her tresses. The execution of the design is very perfect, and speaks volumes for the skill and ability of the workman who produced it. There it ever stands, visible to all who enter the town or pass through the streets, proclaiming in silent majesty that grandest of all lessons which the teachings of this worthy fraternity seek to inculcate."

Seen in full face or profile against the clear blue California sky, the carving is enormously impressive, and as an architectural decoration the continuity between the broken columns in the sculpture and the Ionic columns of the cupola suggest that the entire temple is a base for the monumental symbolic carving—both designed by Albertson.

JOB. Active Freehold, New Jersey, c. 1825. *Cigar-store Indian.* c. 1825. Polychromed wood, 71″ high. New York State Historical Association, Coopers-town.

A slave named Job is said to have made this figure as a shop sign for a tobacconist in Freehold, New Jersey. The carver's African heritage is apparent, especially in the masklike face. This carving transcends its simple trade-sign function and its superficial relationship with other cigar-store Indians to become a great American sculpture. The hieratic pose, simple dress, and bold reduction of form and color (just brown, green, and ocher) somehow add up to an impression of dignity and pride that were, perhaps, the personal attributes the slave Job valued most highly.

Stanley Kunitz (whose verses for Polly Botsford are quoted on page 58) also dedicated a poem to Job:

> Dreaming of Africa
> and the kings of the dark land,
> bearer of a suffering name,
> you carved this Indian
> out of a man-sized log
> to be your surrogate
> and avatar.
> Outside the smoke-shop
> he stands aloof and bold,
> with his raised foot poised
> for the oppressor's neck.
> The cigars he offers
> are not for sale.
> They fit his hand
> as though they were a gun.

UNIDENTIFIED ARTIST. *Man with Grapes.* c. 1875. Polychromed wood and wire, ivory eyes, 15″ high. Private collection.

Although cigar-store Indians were the most numerous kind of figures made to advertise shops, many other businesses, too, set up carved figures to promote their wares. Today their former shop-sign function is less important than their direct sculptural appeal.

This perky little figure, probably intended to advertise or decorate a bar, was found in Maine by the sculptor Robert Laurent. He was one of a number of American artists who began to collect folk art in the 1920s; in fact, artists were the first to "discover" American folk art, just as European artists were the first to esteem African primitive sculpture for its expressive power rather than for its ethnographic value, and also the first to appreciate the traditional folk art of their own

countries. In their break with academic, realist traditions modern artists felt a kinship with the inventiveness and straightforwardness of folk art; some, like Elie Nadelman, not only collected it but were influenced by it in their own work (see page 127), as was Laurent.

Laurent himself pointed out that one of his carvings of about 1930, *Man with Cane,* shows provocative stylistic relationships with the *Man with Grapes.* But the interesting fact is that he found the bar figure shortly *after* he had carved his *Man with Cane!* He was struck by their similarities and even suggested that the nattily dressed gentleman who holds the oversized grapes aloft in his left hand probably once held a cane in the other, although he might instead have held a bar glass.

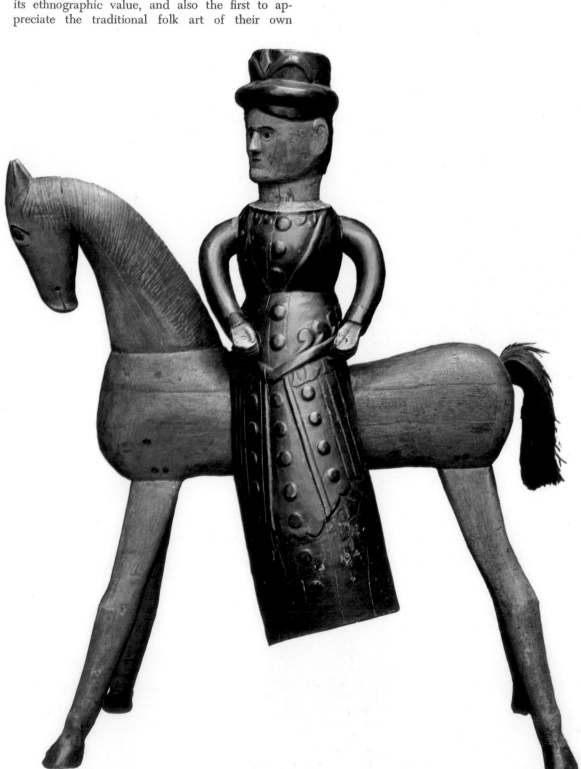

UNIDENTIFIED ARTIST. *Bootmaker's Sign.* c. 1850. Polychromed wood, horsehair tail, 40″ high. Everhart Museum of Natural History, Science and Art, Scranton, Pennsylvania.

This trade sign, which was found in Pennsylvania, was used to advertise ladies' riding boots and probably graced a rural shopwindow. The lady's seemingly precarious sidesaddle seat on her horse (we are tempted to say hobbyhorse) was originally made firmer by the reins—leather thongs, no doubt—that she once held in both hands and that ran through the hole at the top of her steed's mouth. It has been suggested that the missing footwear might have been a pair of real leather boots, extending to the bottom of her skirt and replaced as styles changed or when those on display were sold.

The lady and horse are both carved in the round, but the meek horse's plain contours and lack of detail concentrate attention on the robustly sculptured lady, whose face and costume are represented in high relief and painted. Simplified though the carving is, she looks quite like an imposing Pennsylvania Frau; her mount, austerely constructed of pegged strips of shaped wood, could stand in for one of those popular modern Swedish or Danish toys.

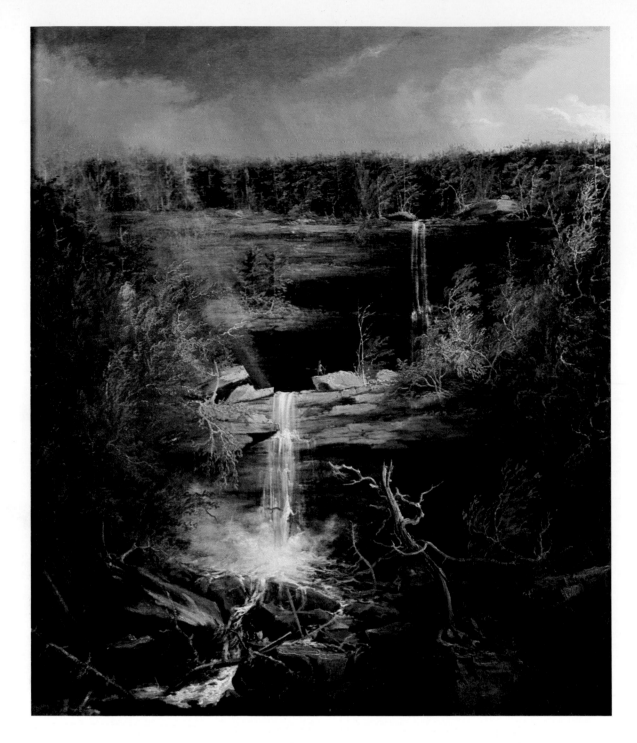

It was believed by these men that the contemplation of nature, besides stimulating an aesthetic appreciation of beauty, also had great moral value by turning men's minds to a contemplation of the sublime and the infinite. In the preface to his projected anthology of engraved views, *The American Landscape*, Bryant wrote in 1830: "Foreigners who have visited our country . . . have spoken of a far-spread wildness, a look as if the new world was fresher from the hand of him who made it . . . of something which, more than any scenery to which they had been accustomed, suggested the idea of unity and immensity, and abstracting the mind from the associations of human agency, carried it up to the idea of a mightier power, and to the great mystery of the origin of things."

An old label on the back of Cole's *Kaaterskill Falls* bears Bryant's name, suggesting that it may once have belonged to him. One of the earliest of Cole's paintings of the Hudson River region, it is based on two drawings made during his first trip to the Catskills in the summer of 1825. As in many of his early landscapes, there is a synthesis between sketches made on the spot and pictorial formulas, like the gnarled tree trunks, derived from such masters as the seventeenth-century Italian Salvator Rosa. Every detail is treated with equal emphasis, but the tiny figure of the Red Indian, placed in almost the exact center of the picture, provides both a compositional and a symbolic focus for the scene.

Of this particularly spectacular site, later to be depicted by many other artists, Cole wrote: "the waterfall . . . at once presents to the mind the beautiful, but apparently incongruous idea, of fixedness and motion—a single existence in which we perceive unceasing change and everlasting duration. The waterfall may be called the voice of the landscape, for, unlike the rocks and woods which utter sounds as the passive instruments played upon by the elements, the waterfall strikes its own chords, and rocks and mountains re-echo in rich unison. . . . In the Kaaterskill we have a stream, diminutive indeed, but throwing itself headlong over a fearful precipice into a deep gorge of the densely wooded mountainside . . ."

THOMAS COLE. Born Bolton-le-Moor, Lancashire, England, 1801; to United States 1819; died Catskill, New York, 1848. *Kaaterskill Falls.* 1826. Oil on canvas, 43″ × 36″. Gulf States Paper Corporation Art Collection, Tuscaloosa, Alabama.

With Thomas Cole and his followers landscape painting in America came into its own. Like Francis Guy (see pages 56–57), Cole was born in England, and as a youth he often found escape from the industrial towns of Lancashire by taking long walks in the countryside and reading his favorite poets, Byron and Wordsworth. His romantic imagination was stirred by descriptions of America, and in 1819 he persuaded his family to immigrate. In Steubensville, Ohio, he learned the rudiments of painting from an itinerant portrait painter, who also lent him an illustrated book that discussed design, composition, and color. While studying figure drawing at the Pennsylvania Academy of the Fine Arts in Philadelphia, Cole saw some landscapes in its collection and determined to be guided by his deep love of nature and devote himself to that branch of art.

At the time, this was considered to be far inferior to the more elevated mode of history painting, and it was certainly much less likely than portraiture to attract patrons. Cole was lucky, however, for his arrival in New York in 1825 coincided with a growing romantic view of nature, and particularly an appreciation of the American landscape, which had already found expression in literature. He was fortunate also in that some of his pictures excited the admiration of the veteran painter John Trumbull, who introduced Cole to an influential circle that included the engraver-painter Asher B. Durand; William Dunlap, the painter who in 1834 was to publish a two-volume history of art in the United States; the writers Washington Irving and James Fenimore Cooper; and the poet and art patron, William Cullen Bryant.

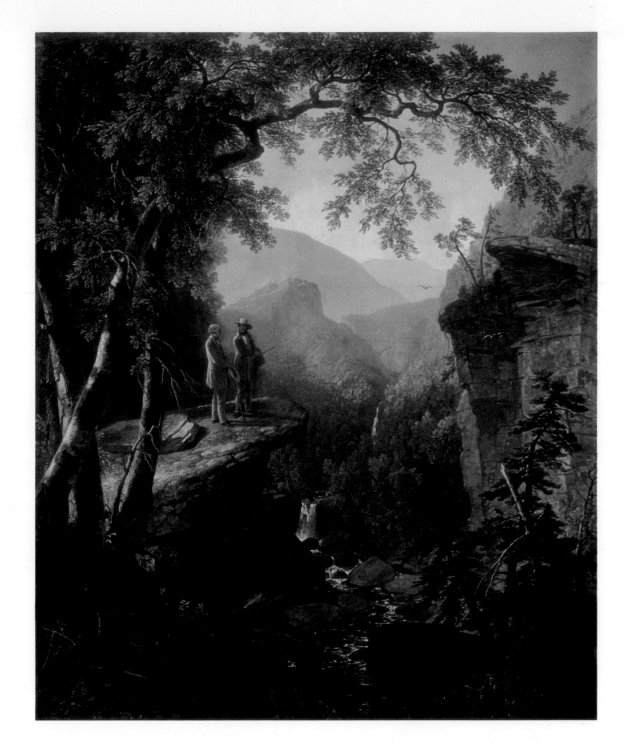

ASHER B. DURAND. Born Jefferson Village (now Maplewood), New Jersey, 1796; died Maplewood, New Jersey, 1886. *Kindred Spirits.* 1849. Oil on canvas, 44″ × 36″. The New York Public Library (Gift of Miss Julia S. Bryant).

Cole's death of pneumonia at the age of forty-seven came as a great shock to his friends and admirers. Bryant, whose veneration for the American landscape had been a major influence on Cole, delivered the funeral oration, in which he extolled the mastery and reverence with which Cole had "copied the forms of nature, and . . . blended with them the profoundest human sympathies, and made them the vehicle, as God has made them, of great truths and great lessons."

In appreciation of this eloquent address the prominent art patron Jonathan Sturges asked Asher B. Durand to paint a picture to be presented to Bryant, in which he and Cole should be associated as "kindred spirits." This phrase, like some of the picture's imagery, was taken from Keats's sonnet "To Solitude":

O Solitude . . . climb with me to the steep,—
Nature's observatory . . . let me thy vigils keep
'Mongst boughs pavillion'd . . .
But though I'll gladly trace these scenes with thee,
Yet the sweet converse of an innocent mind,
Whose words are images of thought refin'd,
Is my soul's pleasure; and it sure must be
Almost the highest bliss of human-kind
When to thy haunts two kindred spirits flee.

As in Cole's *Kaaterskill Falls,* a waterfall occupies the center of Durand's composition. The spot may be the very one that, in a letter of 1840, Cole invited Bryant to visit with him: "There is a valley reputed *'beautiful'* in the mountains a few miles South of the Clove—I have never explored it & am reserving the delicate morsel to be shared with you. . . . If report says true there is a beautiful little Lake with a Cascade tumbling into it—If you can only leave the City for a few days now, come!"

Durand and Cole are regarded as the founders of the Hudson River School. This is the name given to a number of landscape painters active between 1825, when Cole arrived in New York, and about 1875, when Albert Bierstadt and others glorified the more spectacular scenery of the Rocky Mountains and the Andes. Just as the Holy Roman Empire is said to have been neither holy nor Roman nor an empire, so the Hudson River School was neither a school with a unified style, nor did its artists all live in the area or confine their subjects to it. They did, however, share a romantic turn of mind and a conviction that the American landscape was not only more beautiful than that of Europe but, being still largely untouched by the works of man, was also closer to divinity and should therefore be represented as accurately as possible. As Durand wrote, the legitimate purpose of man's imaginative faculties did not lie in "creating an imaginary world . . . but in revealing the deep meaning of the real creation around and within us."

Beyond representing the scene itself, Durand's picture focuses on the two men's joint contemplation and discussion of it. According to their shared philosophy, such contemplation of nature brought man into communion with eternity. Bryant and Cole are made appropriately small in scale, subordinate to the majesty of their surroundings.

Durand had acquired one of Cole's first landscapes of the Catskills in 1825 and subsequently became one of his close friends. Abandoning a successful career as an engraver to devote himself to painting, he soon gave up portraiture for landscape. He concentrated on the scenery of upstate New York and New England and built a studio near the home in Catskill, New York, in which Cole had settled. Durand was probably the first American artist who not only sketched directly from nature but painted carefully finished studies outdoors. Reflecting these on-the-spot observations, his landscapes gradually became more complex and detailed—realistic rather than ideal.

THOMAS COLE. Born Bolton-le-Moor, Lancashire, England, 1801; to United States 1819; died Catskill, New York, 1848. *The Architect's Dream.* 1840. Oil on canvas, 4′ 6″ × 7′. The Toledo Museum of Art, Toledo, Ohio (Gift of Florence Scott Libby).

As Cole matured, he became increasingly preoccupied with the symbolic content of his paintings. To his veneration for nature, as manifested, for example, in *Kaaterskill Falls* (page 68), was added an interest in architecture as the concrete expression of man's aspirations, achievements, and ultimate destiny. From 1829 to 1832 he made a study trip abroad, visiting England, France, and Italy. During his nine months on the Continent, Cole came to regard antiquity as a kind of Golden Age and its ruins as a melancholy reminder of the transience of man's works. This is the theme of *The Course of Empire* (The New-York Historical Society), a moralistic drama in five scenes that Cole painted for the collector Luman Reed. The first three canvases of this epic trace man's progress from savagery to the pastoral state and then to the culmination of his greatness, as manifested in the classical buildings of a mighty capital; whereas in the final two episodes these once-proud buildings, having been sacked and burned, crumble into ruins.

Cole applied himself to the study of architecture with great seriousness. In 1838 he submitted a Greek Revival design to the competition for the Ohio State Capitol; it won third prize, and some of its features were incorporated into the completed building. Two years later he was commissioned to paint a canvas for Ithiel Town, who in partnership with Alexander Jackson Davis operated the leading architectural firm in New York, which pioneered in revival styles. Like Cole, Town had been among the founders of the National Academy of Design in 1826. He was a widely traveled man of impressive learning, who had amassed a library of 11,000 volumes, as well as engravings, medieval manuscripts, and a collection of pictures.

It was natural for Cole to suppose that *The*

Architect's Dream, which flattered Town's erudition and reflected his eclectic taste, would please the man who had commissioned it. In the painting the architect, framed by massive pillars and parted curtains, reclines on a marble pedestal inscribed with his name. He holds a scroll and is surrounded by large leatherbound tomes. Behind him stretches a vast panorama—a body of water flanked by a pyramid, Egyptian, Greek, and Roman temples, and at the left a Gothic church. Boats bring people to swell the throngs on shore and join the procession toward a ceremony being enacted before the nearest temple on the right. This building and the adjacent colonnaded structure, topped by a gilded dome, are cream colored; the other buildings at the right, receding toward the distant pyramid, are suffused with a warm, rosy glow that contrasts with the blue-gray water, the dark steepled church at the left, the tall cypresses in the foreground, and the pillars and theatrical curtains at the sides and top of the painting.

To Cole's chagrin, Town found the picture not at all to his liking. He wrote the artist a letter in which he declared that instead of "an almost exclusively architectural subject of great size," in keeping with Cole's "great and very just fame as a landscape painter . . . I wish the landscape to predominate—the Architecture, history, etc. to be various and subservient or mainly to enrich a very bold and richly various landscape." Much enraged, Cole wrote to his friend Durand: "Do you know I have received a letter from Town, telling me that neither he nor his friends like the picture I have painted for him, and desiring—expecting me to paint another in place of it. . . . After having painted him a picture as near as I could accommodate his pictorial ideas to his prosaic voluminousness,—a picture of immense labour, at a much lower price than I have painted pictures of the same amount of work for several years past—he expects me to again spend weeks and weeks in pursuit of the uncertain shadow of his approbation. I will not do it; and I have written to him saying that I would rather give him his books back, and consider the commission as null."

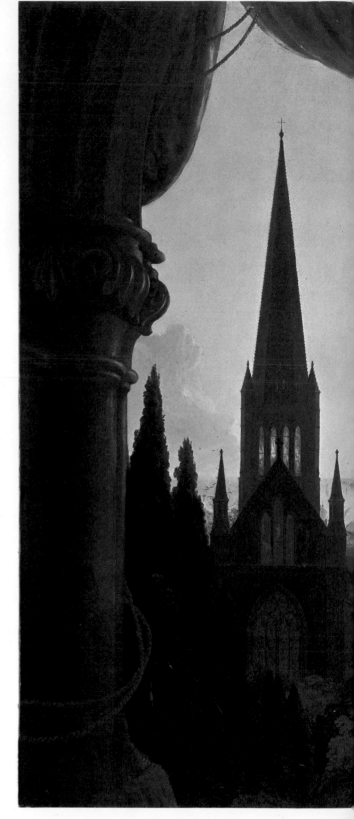

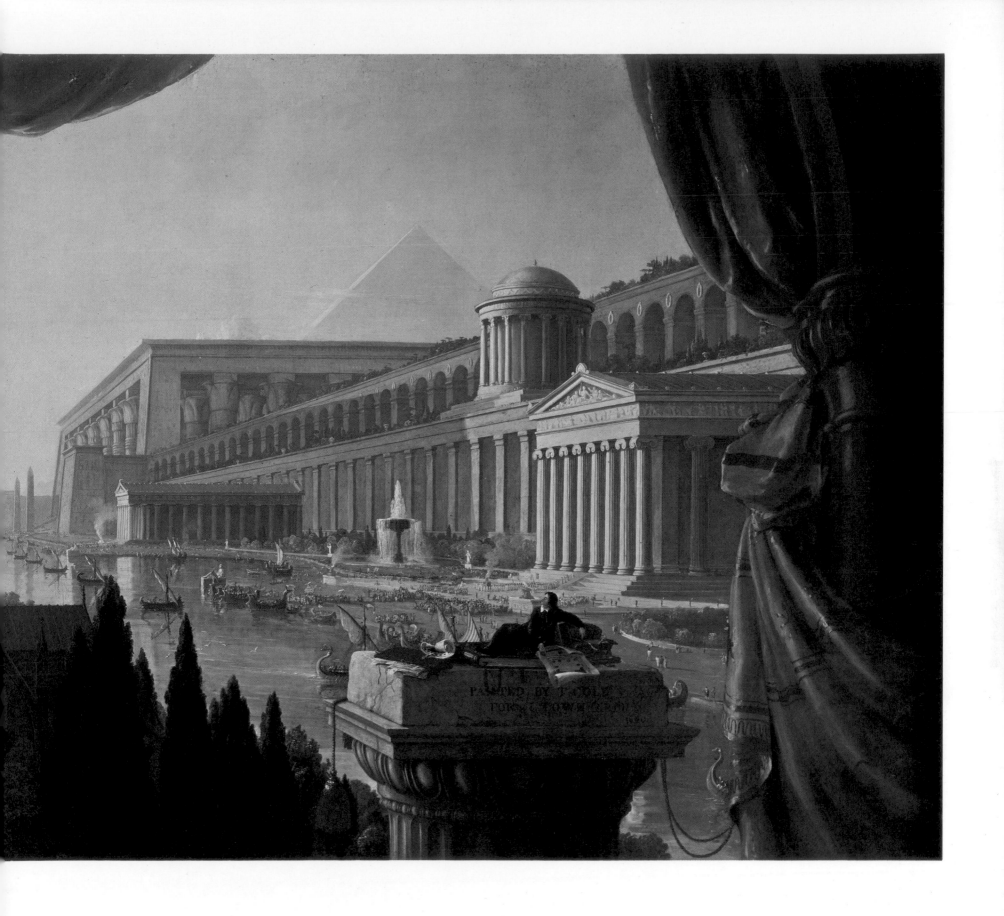

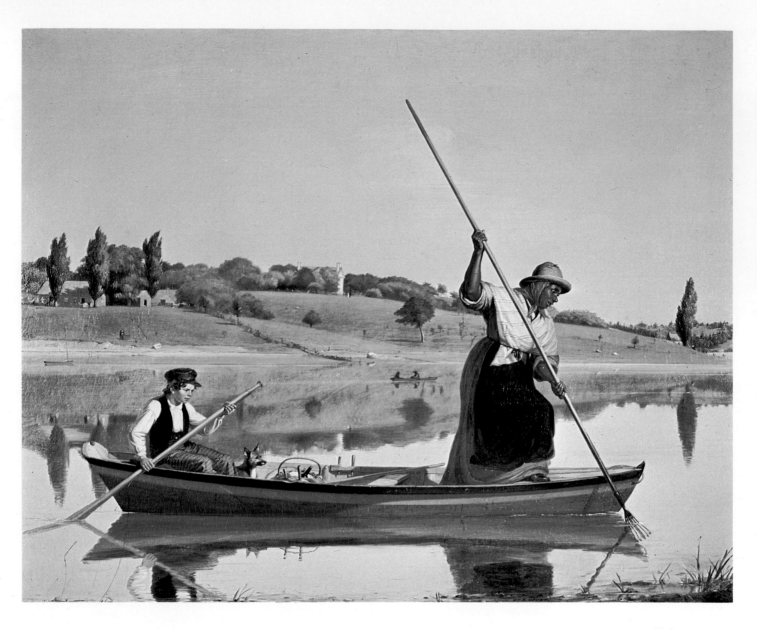

WILLIAM SIDNEY MOUNT. Born Setauket, Long Island, New York, 1807; died there 1868. *Eel Spearing at Setauket.* 1845. Oil on canvas, 29″ × 36″. New York State Historical Association, Cooperstown.

The same upsurge of national pride that led to the rise of landscape painting in America in the second quarter of the nineteenth century also fostered the rapid development of genre. Two artists, William Sidney Mount and George Caleb Bingham, who could hardly have differed more in their lives and temperaments, were chiefly responsible for the enormous growth in popularity of scenes of daily life.

Mount was born and brought up in rural Long Island, where he lived almost all his life. At seventeen he became an apprentice in the sign-painting shop of his older brother Henry in New York and then studied portrait painting with Henry Inman. He soon decided that his natural bent lay in another direction and returned to his home in Stony Brook to paint the familiar scenes he knew and loved so well.

Eel Spearing at Setauket is an idyllic recollection of his boyhood: "An old Negro by the name of Hector gave me the first lesson in spearing flatfish & eels. Early one morning we were along shore according to appointment, it was calm, and the water was as clear as a mirror, every object per-

fectly distinct. . . . 'Steady there at the stern,' said Hector, as he stood on the bow (with his spear held ready) . . . while I would watch his motions, and move the boat according to the direction of his spear. . . ." Except for the replacement of Hector by a woman, this is a very precise description of the painting.

A comparison of the composition with Copley's *Watson and the Shark* (page 31) shows a surprising similarity in the action of the figure standing in the bow in each case, and the relation of the diagonal of the spear to that of the oar in the stern. Yet how different the total effect! In Copley's picture there is tense, dramatic action; in Mount's, the quiet concentration of the figures is matched by the stillness around them. Field and trees, boy, dog, and woman, spear and oar, and boat (almost exactly parallel to the picture's lower edge), together with their reversed images in the unrippled water, are all motionless within a moment of suspended time.

Mount's careful study of perspective is apparent in the structure of this picture. The boy's oar points directly to the house of Judge Selah B. Strong, a member of whose family commissioned the painting. The prominent scene in the foreground tends to make one overlook the fact that sky and landscape occupy almost two-thirds of the canvas. Mount was especially interested in landscape. He

was a friend of Cole's, whom he accompanied on sketching trips, and he built himself a portable studio for painting outdoors. But in spite of his close observation of nature and his interest in color theory, the color in this picture is not naturalistic. Blue, red, green, and yellow are sparingly used, with only a few small bright touches. A unified blondness pervades sky, fields, and water, ranging from cream color through deeper shades of tan. This golden tonality and the smooth evenness with which the paint is applied derive from Mount's study of Dutch art. In a notebook entry of about the same date as this painting, he wrote: "The simplest arrangement and treatment of colours will be found in the style of Cuyp and Both; objects in shadow are relieved against a warm, sunny sky, and do not present much variety of tint. The whole aspect or general tone of the picture is warm." Mount never went abroad but studied and took detailed notations on pictures he saw in New York, and he read extensively on old-master techniques. His contemporaries, however, appreciated his works for their anecdotal rather than their formal qualities; and he himself believed that the subject of a picture should be familiar and immediately apprehended. One should, he said, "never paint for the few, but the many."

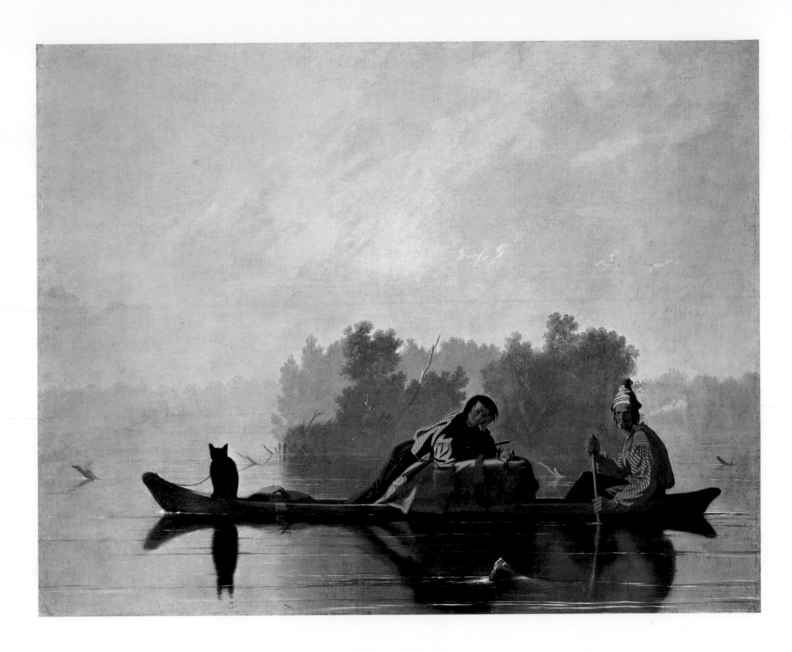

GEORGE CALEB BINGHAM. Born Augusta County, Virginia, 1811; died Kansas City, Missouri, 1879. *Fur Traders Descending the Missouri*. 1845. Oil on canvas, 29″ × 36½″. The Metropolitan Museum of Art, New York (Morris K. Jesup Fund).

In contrast to Mount, whose life was spent in a well-settled rural area close to the growing metropolis of New York, George Caleb Bingham grew up in a region of Missouri that was still frontier. He studied law and theology, was apprenticed to a cabinetmaker, and (like Mount) did sign painting, before becoming a largely self-taught itinerant portraitist. In 1838 he studied briefly at the Pennsylvania Academy of the Fine Arts and visited New York, where his first recorded genre painting was exhibited. He engaged actively in politics and spent four years painting portraits in Washington until the defeat of his party made him return to Missouri.

No longer satisfied with what reputation he could gain in provincial centers, Bingham was determined to win recognition for his art in New York. He was aware of the interest that Catlin's pictures of the Indians (see page 44) had aroused in the East, and also of the growing popularity of genre subjects, such as those by Mount. He decided that he, too, should paint what he knew

best—life along the Missouri and Mississippi rivers.

It was a propitious moment for this theme. There was already a body of literature on the river people who engaged in the flourishing fur trade that had grown up after the Louisiana Purchase, with Saint Louis as its center. Washington Irving's *Astoria* (1836), based largely on documents of the American Fur Company, described the "singular aquatic race . . . the boatmen of the Mississippi," including the "mongrel Frenchmen who had intermarried with Indians."

Under the title "French Trader and Halfbreed Son," this painting was among the first that Bingham sold to the American Art-Union in New York for public exhibition and distribution by lot among the association's members. By 1845, when it was painted, steamboat traffic had made obsolete the type of craft shown here, so that Bingham's *Fur Traders Descending the Missouri*, like Mount's *Eel Spearing at Setauket*, is the nostalgic record of a boyhood memory. This may account for its dreamlike quality, which is enhanced by the contrast between the brightly lit figures in the foreground, seen in sharp focus, and the haze-blurred screen of trees that forms a backdrop behind them. As if in a trance, the man and boy stare out at the spectator, as does the furry little creature in the bow, which seems more mascot than intended victim. In this carefully studied composition the

water—as in Mount's painting—serves as a mirror, and the boat again lies parallel to the picture's lower edge; here, its horizontal lines are repeated by those of the flowing current. The color is higher in key than Mount's, with prominence given to bright reds and blues.

The year after he painted this picture Bingham again became active in public life. He was elected to the Missouri state legislature, and politics provided the subject for many of his subsequent works. From 1849 on he painted principally in Philadelphia and New York, then from 1856 to 1859 studied at the Royal Academy in Düsseldorf. Mount had always refused to go abroad for fear that exposure to European art might make him lose his "nationality"; this fate did indeed befall Bingham, for the classical, monumental style of his later works lacks the vitality and originality of his genre pictures of the decade 1845 to 1855.

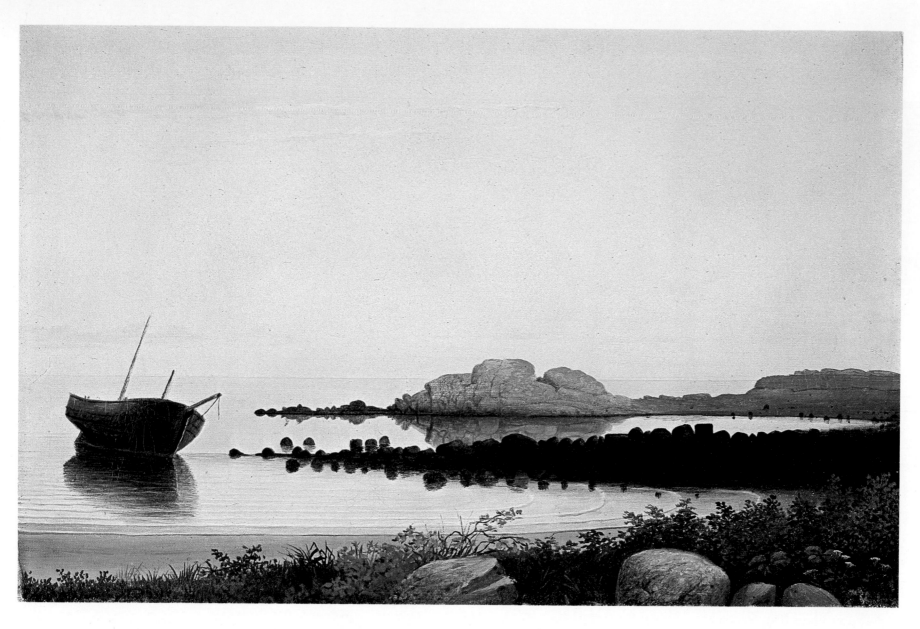

FITZ HUGH LANE. Born Gloucester, Massachusetts, 1804; died there 1865. *Brace's Rock, Eastern Point, Gloucester*. 1863. Oil on canvas, 10″ × 15″. Private collection.

By mid-century, coinciding with a strong sense of national identity and the conviction of America's "manifest destiny," landscapes began to replace portraits as the principal subjects in painting. A number of artists, however, became preoccupied with the quality of light in the American landscape rather than with its picturesque details. In a pioneering article of 1954 John I. H. Baur defined this tendency as "luminism" and said of its artists: "Technically they were extreme realists, relying on infinitely subtle variations of light and tone to capture their magical effects. Spiritually they were the lyrical poets of the American countryside and the most sensitive to its nuances of mood."

A leading practitioner of this mode of painting was Fitz Hugh Lane. Crippled from infancy, he spent almost his entire life in his native Gloucester and nearby Boston, although from 1849 on he made numerous trips during the summer to the Maine coast (see page 11), at that time still a somewhat remote wilderness. He was largely self-taught and (like Asher B. Durand) began as a graphic artist, working for a leading firm of lithographers in Boston before setting up his own shop. Lane

specialized in marine views and panoramas of harbors that were influenced by seventeenth-century Dutch artists and the work of Robert Salmon, an English-born painter of marine subjects who was active in Boston in the 1830s.

About 1848 Lane decided to return to Gloucester, which was then becoming a popular summer resort. As he painted its smoothly curving beaches, bold dark rocks, and offshore islands, he became increasingly interested in the phenomena of light. He recorded familiar scenes as viewed from different vantage points, with their aspect modified by the time of day or change of season. Lane was among the first to adopt newly introduced pigments that gave a high-keyed palette with hot reds, yellows, and oranges.

Unable to paint outdoors because of his lameness, Lane worked from pencil sketches and photographs, which he carefully ruled off into quadrants to ensure the accurate placement of the elements making up his compositions; but in his final paintings, he made delicate adjustments of spacing and eliminated details to achieve order and balance. In John Wilmerding's words, "the outer eye of the camera actually assisted Lane in clarifying what was physically unseen—what is called by some the moral order of nature. For him, as for Emerson, the physical and metaphysical world were inextricably related."

In his mature works Lane departed from topographically accurate description to produce carefully designed compositions that concentrate the effects of space, light, and color. Dating from the last year of his activity, *Brace's Rock* shows a promontory that was a notorious hazard for navigators. The wrecked hull at the left is a reminder of this, but there are neither figures to suggest a specific incident nor any picturesque motifs to frame the canvas at the sides in the conventional manner of Romanticism. From the narrow fringe of beach in the foreground the scene extends backward in a series of repeated horizontals. The water near the shore forms a pattern of concentric ripples; beyond the derelict boat and dark, geometric blocks of the projecting ledge, its flat, glassy surface reflects the pinkish mass of Brace's Rock. Still further in the distance, the pale blue-green sea stretches to the low-lying horizon where the sun's last rays flood sea and sky with all-encompassing light. The small size of the picture seems to strengthen its intensity. As in Bingham's *Fur Traders Descending the Missouri* (page 73), the clearly defined foreground details offset against an evanescent, atmospheric background create a dreamlike scene—at once real and unreal, tangible and impalpable, momentary yet timeless.

UNIDENTIFIED ARTIST. *Meditation by the Sea.* c. 1855. Oil on canvas, 13½″ × 19½″. Museum of Fine Arts, Boston (M. and M. Karolik Collection).

Some of the qualities of the luminist painters Fitz Hugh Lane and Martin Johnson Heade (pages 11, 74, 76, and 77), and of New England coastal scenes by John Frederick Kensett, are combined here with the theme of contemplation of nature expressed in Durand's *Kindred Spirits* (page 69). The anonymous *Meditation by the Sea* is a very small but enormously impressive painting. Its immediate impact and lasting fascination are hard to analyze. The tiny pensive figure, stylized waves, high sand dune bordered with sea grass (perhaps Cape Cod?), bit of dead tree, row of pale rocks in line with the dark horizon—all add up to an odd but somehow enthralling composition.

This allover interest, however, is deceptive, for everything focuses on the solitary figure in the foreground. Waves rush toward him; the large boulder is his solid backdrop; the perspective of sand dune and beach lead from the background to the figure; the scattering of stones in the foreground forms a triangular base where he stands. The calm sky and flat horizon line maintain the aura of stillness that characterizes the pose of the stocky gentleman who, with arms akimbo and feet firmly planted in sand, looks out to sea as if he would never choose to move. Although the space represented in the painting extends in depth as far as the low horizon line, it is stopped by rocks at the left and sailboats at the right, and topped by two parallel lines of low clouds. These limit the distance, maintaining all the landscape as territory for the figure. Unconsciously, the artist captured the dreamlike implications of deep space and of the human enigma later to be exploited by Giorgio de Chirico, the Surrealists and their associates such as Kay Sage (see page 139).

Looking steadily at this small painting, our interest is constantly renewed. It is a work that challenges our accepted values of training versus innate talent, sophisticated versus naïve art.

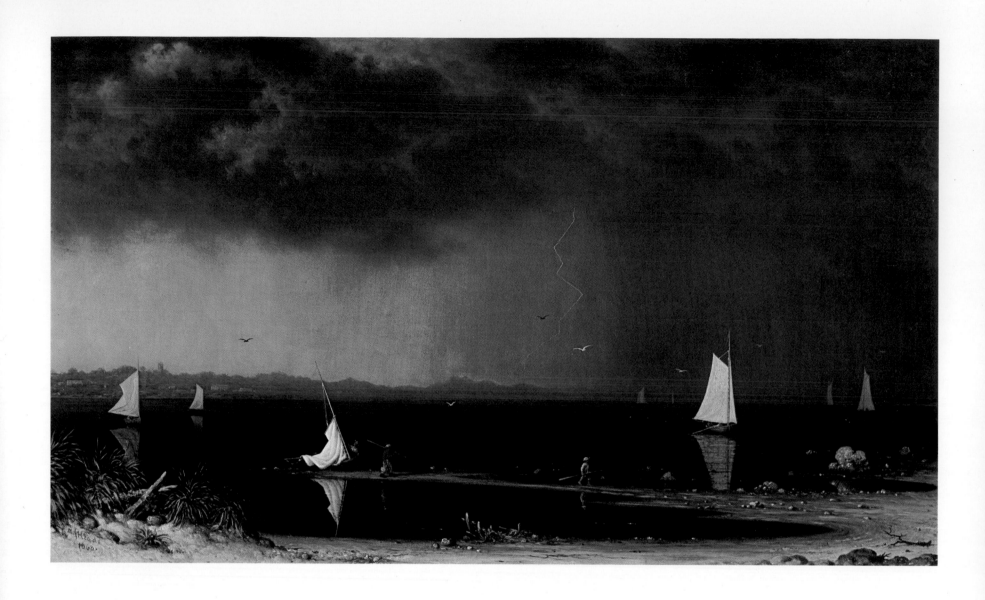

MARTIN JOHNSON HEADE. Born Lumberville, Pennsylvania, 1819; died Saint Augustine, Florida, 1904. *Thunderstorm over Narragansett Bay*. 1868. Oil on canvas, 32⅛″ × 54¾″. Collection of Ernest T. Rosenfeld.

In contrast to the lyrical, transcendent radiance of Lane's *Brace's Rock* (page 74), it is the dramatic possibilities of light that are explored in Martin Johnson Heade's *Thunderstorm over Narragansett Bay*. A heavy curtain of dark cloud, rent by a lightning bolt, obscures all the sky except for a small rectangle of brightness at the left. Although reflecting this ominous blackness, the water is still calm. Its surface mirrors the boats with their sharply silhouetted white sails, and the sandy spit along which two fishermen hasten to shore while their companion lowers the canvas on their craft. As in Lane's picture, a narrow strip of beach runs along the bottom edge of the composition, stretching from edge to edge of the canvas.

Heade may have known the work of Lane, but he developed independently and had a very different career. After learning coach painting from Ed-

ward Hicks (see pages 60 and 62), he spent two years abroad. The few surviving portraits done after his return in 1840 seem little affected by his exposure to the art he saw in Italy, England, and France; and for many years he also remained untouched by the major currents of art in America, although he exhibited regularly in Philadelphia and New York.

A loner with wanderlust, Heade moved his studio repeatedly from city to city. In 1859 he came to New York, where he developed a close and lifelong friendship with Frederic E. Church. Perhaps under his influence, Heade abandoned portraiture and genre for landscape; but the subject he made particularly his own was at an opposite pole from the spectacular panoramas of exotic regions that Church was producing at the time (pages 78–79). Heade chose to paint the flat salt marshes around Newburyport and elsewhere along the coasts of Massachusetts, New Jersey, and Florida. Preoccupied with light, he showed the stacks of salt hay in varying conditions of time and weather. In developing a similar theme some years later, Claude Monet dissolved his haystacks in a

brilliant play of Impressionist color; but Heade retained their solidity as masses that created a play of light and shadow on the uneventful expanses of the marsh, as clouds moved across the sky.

These placid pictures are quite at variance with Heade's eerily dramatic *Thunderstorm over Narragansett Bay* and a related work of the preceding year, *Approaching Storm—Beach near Newburyport* (Museum of Fine Arts, Boston). Few critics of the time responded favorably to such emotion-charged scenes. When *Thunderstorm over Narragansett Bay* was exhibited at the National Academy of Design in 1868, a reviewer rebuked Heade for revealing "a painful amount of labor with a corresponding feeling of hardness in color and execution; it is to be regretted that so hard and chilling a painting as this should have been allowed to leave his studio." Ironically, it was this very picture, rediscovered in 1942 and included the next year in The Museum of Modern Art's exhibition "Romantic Painting in America," that largely served to reawaken interest in Heade. Almost totally forgotten for nearly sixty years, he is now ranked, with Lane, as a foremost luminist painter.

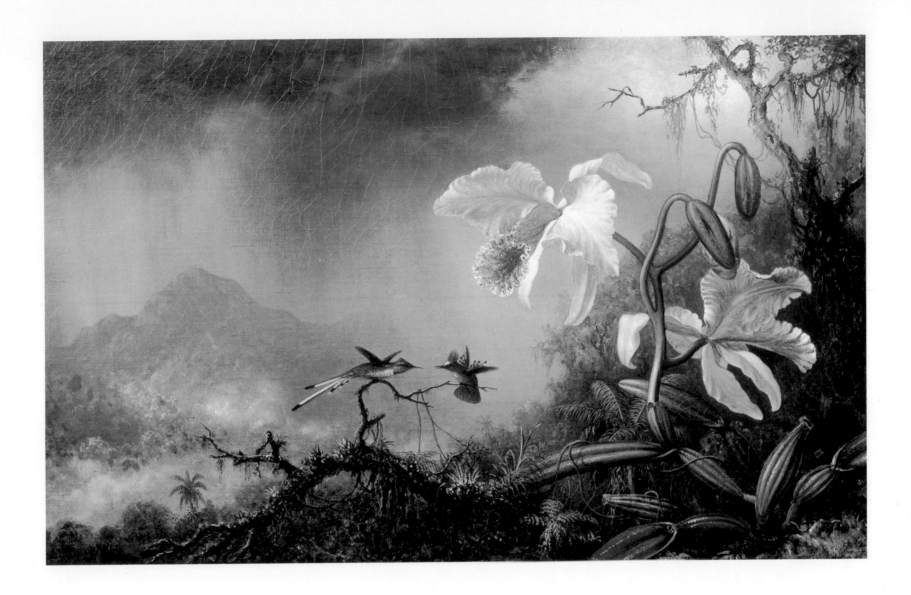

MARTIN JOHNSON HEADE. 1819–1904. *Two Fighting Hummingbirds with Two Orchids*. 1875. Oil on canvas, 17½″ × 27¾″. Whitney Museum of American Art, New York (Gift of Henry Schnakenberg, in memory of Juliana Force).

Late in 1863 the travel-loving Heade interrupted his series of salt-marsh paintings to journey to a far different ambience in Brazil. Instead of seeking the cosmic vistas that inspired his friend Church, Heade went to the tropics in quest of the hummingbird. He had loved these tiny creatures since childhood and throughout his life continued to study them, paint them, and contribute articles about them to scientific journals.

When Heade exhibited twelve small paintings on this theme in Rio de Janeiro in 1864, the Emperor Dom Pedro II honored him by making him a Knight of the Order of the Rose. In the hope of bringing out by subscription an album of 20 colored lithographs, Heade took his paintings to London; but the project never materialized, either because the trial proofs were of mediocre quality or because an exhaustive five-volume monograph

on the hummingbird, with 360 hand-colored illustrations, had been published by the naturalist John Gould only a few years before.

Heade did not abandon the subject, however, and after returning in 1870 from a trip to Colombia, Panama, and Jamaica, he began a new series of hummingbird paintings. *Two Fighting Hummingbirds with Two Orchids* is perhaps the greatest among them. Far larger than the series executed earlier in Brazil, it is both a still life and a landscape. The diminutive combatants in the center, the huge orchids at the right, and the sinuous vine below occupy the front plane of the picture and are painted with bright colors in minutely studied detail. Their enlarged scale and the exactness with which they are represented dwarf the lofty mountain that rises in the distance under a stormy, cloud-filled sky. Here again we see the characteristic luminist contrast between clearly defined objects in the foreground and a vaporous atmosphere that serves as their backdrop.

In his recent monograph on Heade, Theodore E. Stebbins, Jr., comments that "While Frederic Church saw the Western hemisphere as the New

Eden, painting spectacular geography as an icon of the Creation, Heade responded to it in a very private way, portraying the fecund scene as an illustration of a corner of the Garden of Eden." He also points out that the orchid was never mentioned in any of the popular nineteenth-century books on flower symbolism; it "was not considered a proper subject for art, since it carried with it an unmistakably dangerous aura of sexuality . . . [it] was a standard aphrodisiac of antiquity and bears the Greek name 'orchis,' meaning testicle." In this picture the conscious or unconscious sexual reference is reinforced by the fight between the two birds inspired by male jealousy.

The sensuality inherent in this and similar works by Heade is especially apparent in his still lifes, particularly those he did about 1890, some years after he settled in Florida. They represent in enormous scale on the lush surface of velvet such local flowers as magnolias and Cherokee roses. In the 1920s Georgia O'Keeffe (see page 112) took up this motif, showing single flowers as sensuous, inflated images that are permeated with implicit sexual connotations.

FREDERIC E. CHURCH. Born Hartford, Connecticut, 1826; died New York City, 1900. *Rainy Season in the Tropics*. 1866. Oil on canvas, 4′ 8½″ × 7′ ⅛″. The Fine Arts Museums of San Francisco—California Palace of the Legion of Honor (Mildred Anna Williams Fund).

Romantic landscape in America as initiated by the Hudson River School (see page 69) found its culmination in the work of Frederic E. Church, whose paintings were a remarkable synthesis of realism and spiritual intensity.

Born of a wealthy Hartford family, Church was disinclined to attend a university or become a businessman like his father; he decided to be a painter. Accepted as Cole's only pupil, he spent two years with him at Catskill before opening his own studio in New York. He had no wish to go abroad to study the old masters or to be exposed to foreign influences that might dilute the American quality of his art. Instead, he ranged from the torrid zones of Colombia and Ecuador to the icy shores of Newfoundland and Labrador. When he finally crossed the Atlantic in 1867, he spent relatively little time in conventional art centers such as London, Paris, and Rome but pushed on eastward to Beirut, Jerusalem, Petra, Damascus, Baalbek, Constantinople, and Athens.

Church was inspired to visit South America by a recently published book by the great German naturalist Baron Alexander von Humboldt, who declared that in the luxuriant vegetation of the tropics and majesty of the snow-clad Andes "inexhaustible treasure remains still unopened by the landscape painter." During two trips that Church made in 1853 and 1857, he kept journals in which he recorded his observations on the geology, botany, and meteorology of all the regions he visited.

The vast panoramas that he produced after returning to New York created a sensation. Although his forms retained their solidity, Church's subtle effects of light, careful gradations of color, and mastery of aerial perspective were quite new in American painting. The profusion of minute details was painted with such illusionistic realism that viewers inspected the pictures bit by bit through opera glasses, as if they were present at the scene itself. When the *Heart of the Andes* (The Metropolitan Museum of Art, New York), completed in 1859, was sent abroad for exhibition, Church was hailed as the first truly independent artist of the New World. Ruskin marveled at the perfect illusion of a rainbow, the English gave Church their highest accolade by likening him to Turner, and in 1867 the French awarded him a gold medal at the International Exposition in Paris.

To a pious age accustomed to think of nature as God's handiwork, Church's exotic vistas revealed hitherto unsuspected aspects of His creation. Cole had depicted nature as the theatre wherein moral allegories of human destiny were enacted, and Durand had made it the subject for reverent contemplation. Church offered epiphanies. His *Cotopaxi* (Collection of John Astor), painted in 1862, shows the most terror-inspiring volcano of the Western Hemisphere as if in continuous eruption; yet the effulgent sun, rising in glory, symbolizes the ultimate triumph of light in its cosmic struggle with the forces of darkness.

Rainy Season in the Tropics, done four years later, is a vision of the earth's regeneration. As described by a contemporary critic, Henry T. Tuckerman: "Athwart a mountain-bounded valley and gorge, floats one of those frequent showers which so often drench the traveller and freshen vegetation in those regions, while a bit of clear, deep blue sky smiles from the fleecy clouds that overlay the firmament, and the sunshine, beaming across the vapory vale, forms thereon a rainbow, which seems to clasp the whole with a prismatic bridge; . . . water, air, cloud, hill, and vale—all wear the tearful glory of 'The Rainy Season in the Tropics.' "

The tiny figures on the path at the lower right and the village barely discernible in the distance imply that, even in these awesome surroundings, man may dwell with confident serenity; for the rainbow, age-old symbol of hope, is the token of God's covenant.

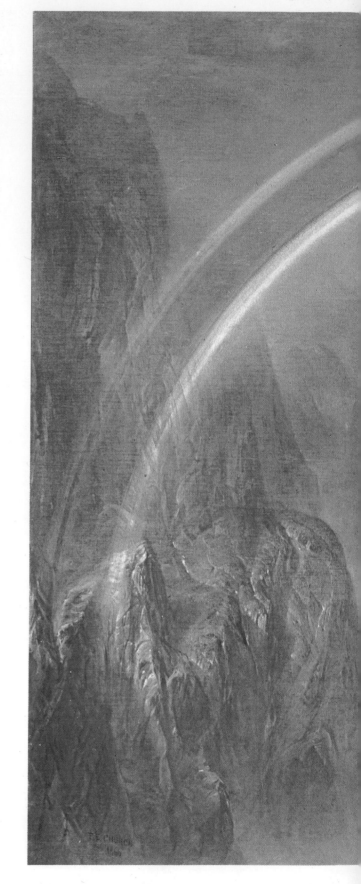

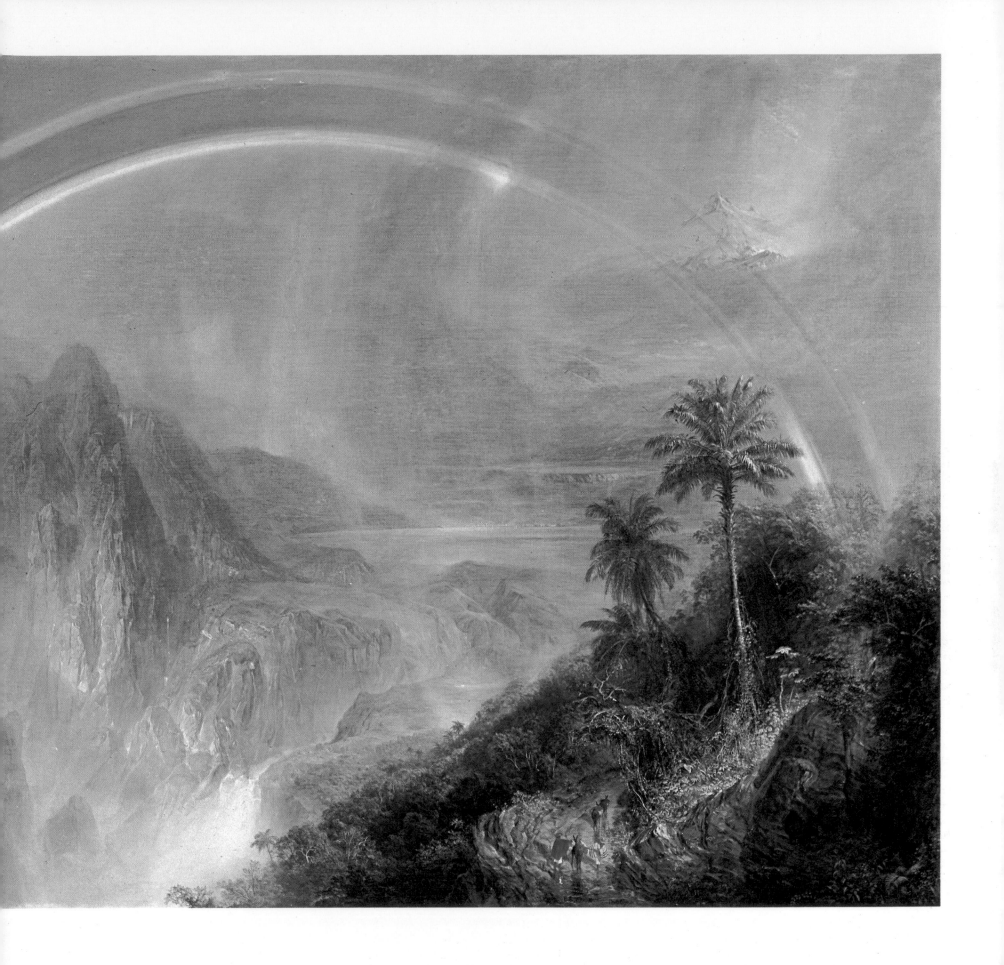

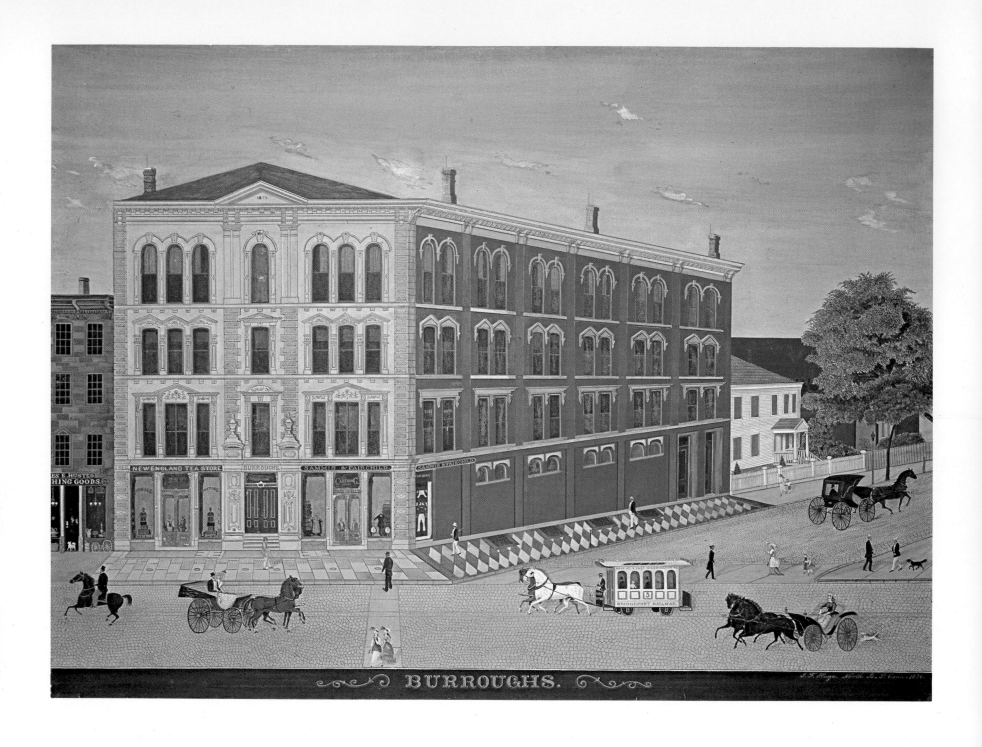

BURROUGHS.

JURGAN FREDERICK HUGE. Born Hamburg, Germany, 1809; to United States c. 1830; died Bridgeport, Connecticut, 1878. *Burroughs.* 1876. Watercolor and ink on paper, 29¼″ × 39½″. Bridgeport Public Library, Bridgeport, Connecticut.

The increasing urbanization and industrialization of America throughout the nineteenth century found reflection in some folk art, as in this painting by J. F. Huge (as he usually signed his paintings). He came from Germany about 1830, settled in Bridgeport, Connecticut, and spent the rest of his life there. He is listed in Bridgeport directories as a grocer and "teacher in drawing and painting, landscape and marine artist." About fifty of his works, mostly large watercolors and a few oils and drawings, have been recorded.

Like Francis Guy, Huge also did paintings of private residences, and his picture of the old Burroughs Building at the corner of John and Main streets in Bridgeport with the lively action going on outside it makes a delightful comparison with Guy's *Winter Scene in Brooklyn* (pages 56–57). Erected in 1872, the building was painted by Huge when it was still quite new. It is interesting to compare its actual heavy architecture, as seen in a photograph taken just a few years later (the building was demolished in 1927), with Huge's delicate, flattened, linear presentation. The interest in detail and design, the precisionist drawing and clear color, the elaborate lettering of the title below, and the painstakingly delineated signs are all consistent with his superreal style.

The town's life and look are fully sampled in Huge's carefully composed street scene, and no detail is lost in his sharp watercolor-and-ink rendering of the elaborate façade and pavements, the shop windows and even the shoppers inside, the horse-drawn streetcar, carriages, horseman, and people of all ages. The pair of ladies in the foreground, handsomely dressed in purple, emerald-green, and white, wearing jewelry represented by tiny blobs of gold paint and holding parasols at identical angles as they step forward in unison, one could imagine as making a splendid painting by themselves.

JOSEPH PICKETT. Born New Hope, Pennsylvania, 1848; died there 1918. *Manchester Valley*. 1914–1918. Oil with sand on canvas, 45½″ × 60⅝″. The Museum of Modern Art, New York (Gift of Abby Aldrich Rockefeller).

It is indicative of the timelessness of American folk art and its persistent emphasis on decorative patterning that *Manchester Valley* was thought to be a work of the first half of the nineteenth century when it was included in 1930 in a group show in New Hope, Pennsylvania. Subsequent research brought to light information about its artist, Joseph Pickett, a native son of that industrial town, who painted this view of it between 1914 and 1918.

Pickett's entire life was spent in New Hope, as a canal-boat builder, carpenter, and later storekeeper. His general store included a shooting gallery that he also took around to fairs. He began painting late in life, and his total known output includes only about half a dozen works. A meticulous craftsman, he made his own brushes, and for *Manchester Valley* invented his own technique, mixing sand with ordinary house paints, building up his forms in low relief, and giving each surface a special texture.

In the foreground of the painting are two flax mills, where millhands from Manchester, England, worked. The canal, running between Lumberville and New Hope, was a very active artery of communication until it was supplanted by the railway. The train in the picture belonged to the Philadelphia and Reading line, which first came through the town about 1890; Pickett gave it the gay colors of a child's toy.

Dominating the composition is the large building on the hill, the schoolhouse, built in 1851. As in *The Plantation* (page 59), there is no attempt at scientific perspective; the elements in the picture are arranged in tiers, one above the other, to give prominence to the central structure. The sides of the buildings are shown as completely as their façades, and—as in Huge's *Burroughs*—each square of masonry is distinct, with the repeated rectangles of the windows (here as bright as if illuminated from within, although this is a daytime view) giving unity to the scene. The flag on top of the schoolhouse is oversize to show off its stars and stripes to best advantage, and the trees in the background are as large as those in the foreground. Like Hicks in his *Cornell Farm* (page 60) and Seifert in the *Residence of Mr. E. R. Jones* (page 61), Pickett has shown the lacy network of branches and made use of the vertical and horizontal repetitions of fence posts and rails (here matched by the lines of railroad tracks and ties). The white flow of the current through the water is echoed in the puff of steam issuing from the engine, the waterfall plunging down in the distance at the left, and the clouds streaming across the sky.

It is said that one of the artists who helped to make New Hope the flourishing art center that it has become encouraged Pickett to send one of his works to the annual exhibition of the Pennsylvania Academy of the Fine Arts in 1918, where it received three votes from the jury—one being Robert Henri's (see page 102). At the auction of Pickett's effects after his death, only $1.00 was bid for his *Manchester Valley*; his widow therefore bought it and presented it to the supervising principal of the school. It hung in the school for many years but in 1931 was sold to help raise funds for a new building.

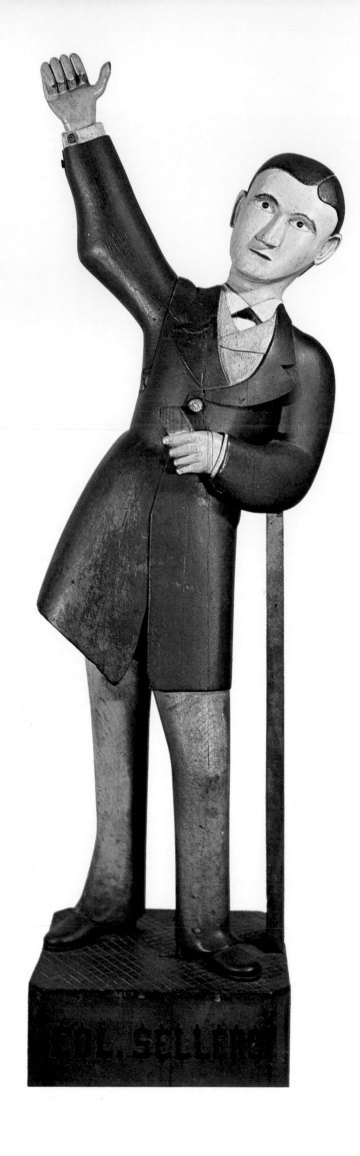

UNIDENTIFIED ARTIST. *Col. Sellers.* c. 1875. Polychromed wood, 59½″ high. New York State Historical Association, Cooperstown.

One of our most unusual folk carvings is this sign for an apothecary shop that portrays Colonel Sellers, the super-promoter featured in Mark Twain's novel *The Gilded Age* (1873), written in collaboration with Charles Dudley Warner. The sign was made for a shop in Sellersville, Pennsylvania, a town that would naturally have taken a special interest in Colonel Sellers.

The pose of the carved figure is based on an engraving featured in the playbill for Twain's popular dramatization of the book, *Colonel Mulberry Sellers,* which he wrote as a starring vehicle for the comic actor John T. Raymond. The colonel is shown at a peak of enthusiasm as he extols some sure-fire product with "oceans of money in it"— probably his "Infallible Imperial Oriental Optic Liniment and Salvation for Sore Eyes—the Medical Wonder of the Age," which he holds in his left hand. The figure's tense angled pose, right fist clenched, feet spread apart to suggest mobility, and head to one side, is close to that of its engraved model, but the drastically simplified carving totally changes the concept. The printed playbill shows a realistically gesturing gentleman whose left elbow rests comfortably on the back of a chair. The crudely carved apothecary sign is both structurally compact and surprisingly dynamic; the elimination of the chair has created a new tension in the pose, which contrasts with the abstractly simplified silhouette and masklike face. The line of the left leg carries up through the right arm, raised above the solid mass of the body like a sturdy exclamation point, but the rest of the figure is static and the face totally expressionless.

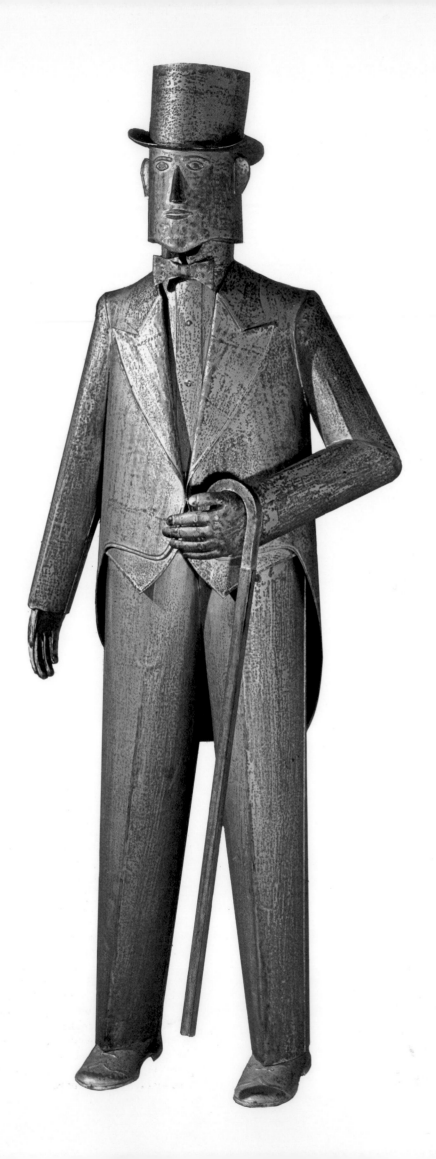

DAVID GOLDSMITH. Born Rymanower, Austria (now Poland), 1901; to United States 1920. *Tin Man.* 1930. Aluminum-painted sheet tin, 6′ high. Collection of Eugene S. Cooper.

The *Tin Man* gives evidence that, well into the twentieth century, the trade sign continued to provide a natural outlet for the creativity of self-taught artists. Since it first came to the attention of the art world in the mid-1960s, this figure has been misattributed and dated between 1894 and 1900. Its true authorship and the story of its making have only very recently come to light.

This striking work is the only sculpture ever made by David Goldsmith, whose surname was taken by his great-grandfather to replace his original name of Lefkowitz when he came from Russia to Galicia and was adopted by a goldsmith. Succeeding generations of the family pursued the same trade; but it had little appeal for young David, who thought it too niggling, although at the age of twelve he evinced a talent for metalwork by designing a tin kerosine lantern. He immigrated to America in 1920 as a self-trained sheet-metal worker and in 1929 founded his own firm, the West End Sheet Metal & Roofing Works, in Long Island City, New York. With the onset of the Depression, however, business was very slow, and in 1930 to pass the time he embarked on the making of the *Tin Man*.

Folk art is notable for its inventive use of materials; this figure departs from the traditional techniques of carving, modeling, and casting just as its bold, precisionist style departs from academic conventions. Goldsmith worked from the bottom up, beginning with the feet, which he weighted with cement so that the man could stand without support. Tracings of his own hands provided templates for those of the *Tin Man,* and his coat jacket was laid out as a pattern from which to cut and bend that of the figure. The only machine tool used was a small crimper, for simulating the garment's stitched edges. The head with its stovepipe hat he thought of as bearing some resemblance to representations of Uncle Sam (without the beard). An old photograph shows the *Tin Man* towering over a heap of metal-roofing supplies in the shop window. After Goldsmith sold his business in 1964, he lost sight of the *Tin Man* for over a decade, until his granddaughter recognized it in a newspaper reproduction.

With his stylized rendering, masklike face, and flawlessly tailored suit, this tall tin gentleman would certainly have been appreciated by Elie Nadelman (pages 126–127), and also by the precisionists Charles Sheeler and Charles Demuth, two among the group of artists who selected the first exhibition of American folk art, held at the Whitney Studio Club in 1924. The detachable tin cane is an amusing detail, but it does not diminish the impressive force of this dashing figure, which ranks with the top examples of folk sculpture of any period.

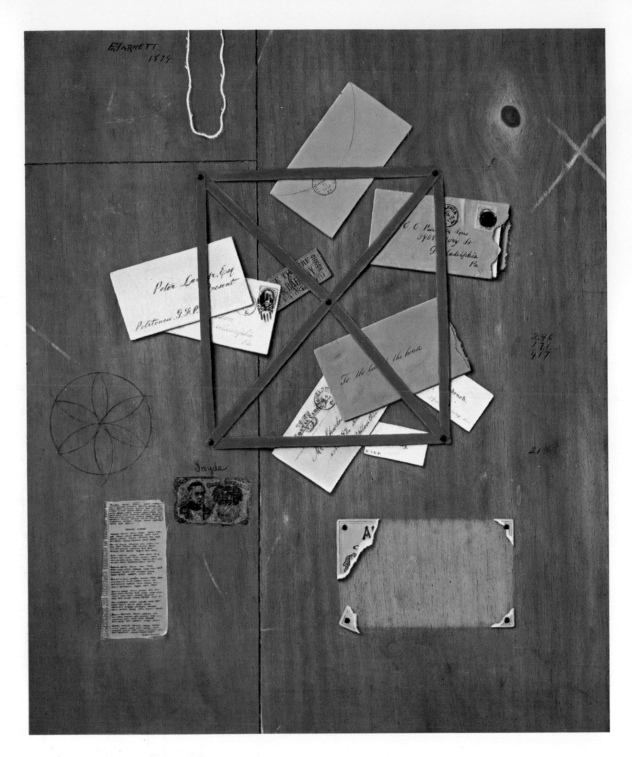

WILLIAM MICHAEL HARNETT. Born Clonakilty, County Cork, Ireland, 1848; to United States 1849; died New York City 1892. *The Artist's Card Rack.* 1879. Oil on canvas, 30″ × 25″. The Metropolitan Museum of Art, New York (Purchase, Morris K. Jesup Fund).

One type of realism much favored in America throughout the second half of the nineteenth century was still-life painting in the trompe-l'oeil tradition. Two of its leading practitioners were William Michael Harnett and John Frederick Peto, who were acquainted and reciprocally influenced each other in style and choice of subject. Both began their careers in Philadelphia, where they were undoubtedly familiar with still lifes by the Peales in this illusionistic manner and their prototypes by seventeenth-century Dutch masters.

Rack pictures such as this one were rare in Harnett's work but were a specialty of Peto's. He made dozens of what he called "office boards," the earliest dating from a few months before Harnett's *Artist's Card Rack.* Alfred Frankenstein has pointed out the optical reasons that make subjects with a flat wall or board as background particularly well suited to the trompe-l'oeil technique: "If depth can be eliminated entirely or reduced to the shallowest possible dimensions, the discrepancy between the muscular experience required for the perception of nature and that which is required for the perception of painting is correspondingly reduced and the pictorial illusion of reality is correspondingly heightened."

The public delighted in Harnett's pictures because they enjoyed being tricked by his sleight of hand. Some critics, however, disparaged this kind of painting as mere imitation, which appealed neither to man's mind nor to his moral faculties, as Art with a capital A ought to do. Both approaches ignored the formal qualities that give such paintings as *The Artist's Card Rack* its special value in modern eyes. The objects in the composition were obviously deliberately selected and arranged to form not only an eye-fooling but an eye-pleasing combination of colors, textures, and shapes. In a newspaper interview about ten years after this picture was made, Harnett explained that he chose the things he represented with regard to their painterly and picturesque qualities; he especially wanted them to have "the rich effect that age and usage gives . . . a soft tint that harmonizes well with the tone of the painting."

In this carefully calculated composition one long vertical and one short horizontal line divide the simulated grained-wood background into three rectangles of different proportions; geometry also asserts itself in the inscribed compass rose. Against this background are set other rectangles, varied in color and size and mostly askew, like the rose-colored tapes whose crossed bands repeat the chalked X at the upper right.

Every trompe l'oeil is a deception, a joke played on the viewer, as notably in Raphaelle Peale's *After the Bath* (page 41). In *The Artist's Card Rack* Harnett has slyly interpolated another kind of trick. Although the handwritten or printed inscriptions on the theatre ticket, envelopes, and cards are perfectly legible, each is incomplete, so that names and addresses remain unintelligible. The newspaper clipping at the lower left, on the other hand, clearly bears an introductory paragraph and a poem of nine four-line verses, with title above and author's name below—but not one single word of print can be read! Illusionism here has paradoxically been transformed into elusiveness.

JOHN FREDERICK PETO. Born Philadelphia 1854; died Island Heights, New Jersey, 1907. *The Poor Man's Store.* 1885. Oil on canvas and wood, 36″ × 25½″. Museum of Fine Arts, Boston (M. and M. Karolik Collection).

The career of John Frederick Peto is in sharp contrast to that of Harnett. The latter studied in Philadelphia at the Pennsylvania Academy of the Fine Arts and in New York at the National Academy of Design and Cooper Union; he spent six years in Europe, from 1880 to 1886—four of them in Munich; and he eventually settled in New York. Peto, on the other hand, was almost entirely self-taught. Whereas Harnett's work was widely exhibited and reproduced in the United States and abroad, Peto's was seldom shown and rarely noticed in the press.

Unable to make a living by painting, Peto left Philadelphia in 1889 for the small seaside community of Island Heights, New Jersey, where he spent the rest of his life. He divided his time between photography, playing the cornet, and painting pictures that he sold locally for a pittance. He was soon completely forgotten by the art world, and many of his paintings entered the market under the more illustrious name of Harnett, whose fraudulent signature was frequently painted over Peto's. It was not until 1949 that brilliant art-historical detection by Alfred Frankenstein brought these forgeries to light and led to a revaluation of Peto's achievement.

As in most trompe-l'oeil paintings, the space represented in *The Poor Man's Store* is shallow; our eyes cannot penetrate the blackness of the room beyond the open window. The objects portrayed, however, unlike those in Harnett's *Artist's Card Rack*, are all three-dimensional. In some passages the technique, far freer than that in Harnett's picture, is almost impressionistic. The illusionistic effect attained through purely pictorial means is enhanced by a device similar to that in Charles Willson Peale's setting for *The Staircase Group* (page 40): the canvas on which are painted the window and shelves that hold the stock is recessed slightly behind the surrounding wood on which are depicted the wall, signs, open shutter, and window ledge.

The poverty implied in the picture's title is indicated by the crudely lettered signs, some hanging awry like the broken metal support for the missing shutter at the left, and by the peeling away of paint from the remaining shutter and dark green outer wall to expose the surface of the wood beneath. In contrast to these tokens of neg-

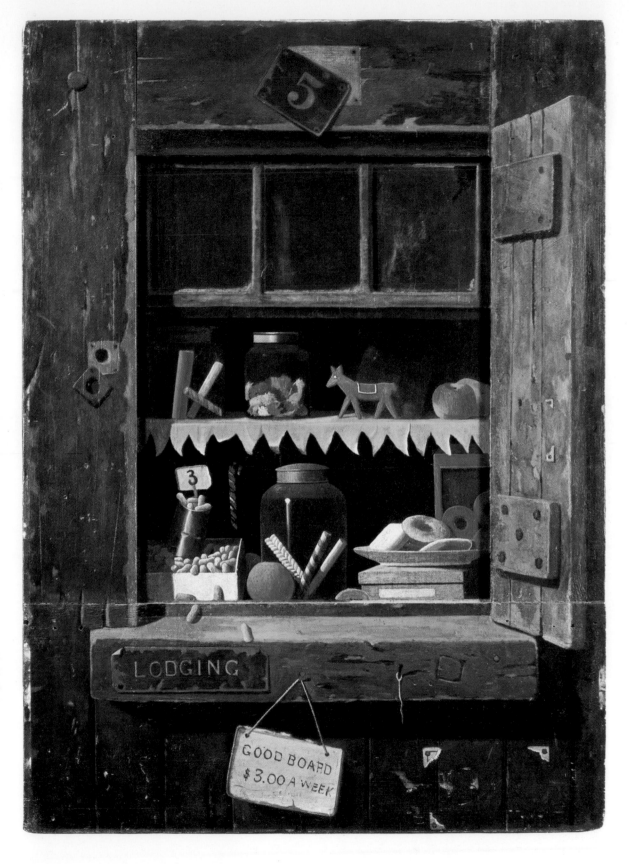

lect and dilapidation are the brightly colored wares in the window. No jewels could be more enticingly displayed; each object appeals to our eyes and touch as it would to a child gazing in longingly from the street. The gingerbread horse stands out bravely on the upper shelf, which has been ornamented with paper irregularly cut into a sawtooth pattern. Rival temptations are the cookies on the plate below, set atop a blue box in front of a red-framed slate. Light models the roundness of the orange and apples and shines on the glass jars holding confections, and on the

burnished measuring cup in the box, out of which peanuts spill onto the outer ledge.

From these commonplace objects, rendered with loving precision, Peto has created a poignant visual poem. Reality is invested with a magic akin to that in the still lifes with interiors that Giorgio de Chirico painted in Ferrara some thirty years later, struck, as he said, by "the appearance of . . . certain window displays, certain shops . . . as for instance the old ghetto where one could find candies and cookies in exceedingly strange and metaphysical shapes."

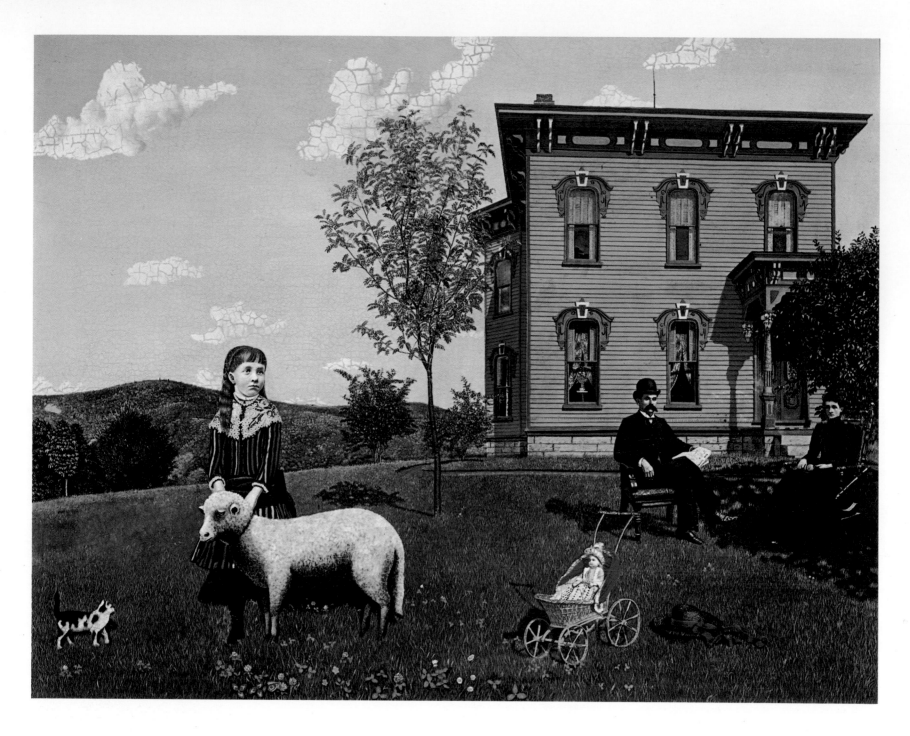

EDWIN ROMANZO ELMER. Born Marshall County, Illinois, 1850; died Ashfield, Massachusetts, 1923. *Mourning Picture.* c. 1889. Oil on canvas, 28″ × 36″. Smith College Museum of Art, Northampton, Massachusetts.

This *Mourning Picture* belongs to a tradition well established in American folk art, particularly in New England. It nevertheless lacks all the conventional emblems—inscribed tombstones, urn, weeping willows. cypresses—found in such a work as the *Mourning Picture for Polly Botsford and Her Children* (page 58). The anonymous artist of that earlier memorial had been concerned with combining these iconographic elements into a decorative design; Edwin Romanzo Elmer's aim, by contrast, was to portray as realistically as possible specific persons, together with their house, animals, and accessories, and details of the surrounding landscape.

The little girl standing in the foreground was Elmer's daughter Effie, who died in 1889 at the age of eight. The lamb, a frequent symbol on chil-

dren's gravestones, was in this case a pet of Effie's, as was the kitten; together with her hat, doll, and doll carriage, they were included as poignant reminders of the living child. The moustached man in a derby hat is Elmer himself; the woman seated beside him, his wife; and the Victorian house behind them had been built in Shelburne Falls, Massachusetts, by Elmer and his brother. Grief-stricken by the loss of their only child, the Elmers moved away from this home shortly after the tragic event.

The term *magic realism* is sometimes applied to meticulously detailed paintings of this sort, which produce a hallucinatory effect by keeping all objects, near and far, in equally sharp focus, with no atmospheric blurring. Here, the fixed stares of the figures and their isolation from one another add to the trancelike impression made by the *Mourning Picture.*

Although Elmer was born in Illinois while his family was temporarily homesteading there, both his parents came from northwestern Massachusetts, and he spent most of his life in that area.

His father was a farmer; his mother had attended a school taught by Mary Lyon, the founder of Mount Holyoke, and for a time assisted in teaching grade-school children. When he was sixteen, Elmer went to Ohio to join his older brother, who worked in the Belding Brothers spool-silk business. His encounter with artists in Ashtabula and Cleveland led him to his first ventures in sketching and painting.

Returning to Massachusetts around 1875, Elmer farmed and invented a number of practical devices—machines for weaving whip-snaps, for shingling houses, and for churning butter—while devoting as much time as he could spare to drawing and painting. *Mourning Picture,* one of his first completed works, suggested to him the making of enlarged crayon portraits as memorials of the dead. They were done on commission for very small sums and were much in demand. In the meanwhile, Elmer also painted other pictures that gave greater outlet to his creative imagination.

EDWIN ROMANZO ELMER. 1850–1923. *Magic Glasses*. c. 1890. Oil on canvas, 14″ × 10¼″. Shelburne Museum, Inc., Shelburne, Vermont.

This highly original little still life presents another aspect of Elmer's magic realism. According to his niece, Maud Valona Elmer, to whom we owe most of our information about his career, although he had little formal schooling, he was greatly interested in mathematics, had a scientific turn of mind, and filled his notebooks with pencil drawings, "especially, studies in perspective, accurately figured out by the length of the shadows cast from a half-opened door." Only a few elements compose his *Magic Glasses*. Against the plain background of a wall, a glass spoon holder etched with a fern pattern stands on a marble tabletop, casting a shadow on one side and a pale reflection on the polished surface before it. (A spoon holder identical with the one represented in the picture is exhibited together with it at the Shelburne Museum.) A magnifying glass set within the vessel reflects two images of a window, beyond which are seen a pile of cordwood and a stand of trees against a cloud-filled sky. The convex surface of the magnifying glass bends and distorts these reflections, inverting one as would a camera lens.

Mirror images on shining glass or metal surfaces, distorted by refraction, are a frequent motif in old-master paintings, beginning with Jan van Eyck's famous *Arnolfini Portrait* of 1434 (National Gallery, London). They were introduced into Italy by Giovanni Bellini, a notable example being the Mannerist *Self-Portrait with Convex Mirror* by Parmigianino, 1524 (Kunsthistorisches Museum, Vienna), and were common in seventeenth-century Dutch genre and still-life pictures. The development of such representations is connected with the rise of realism in painting, and particularly with the scientific study of optics and perspective; however, mirror reflections often have a symbolic meaning also, signifying vanity and the transience of human life.

Elmer probably undertook his painting as a "puzzle picture" in which he set himself an intricate problem in perspective. As Alfred Frankenstein has noted, *Magic Glasses* appears to be a unique example in American still life of the dis-

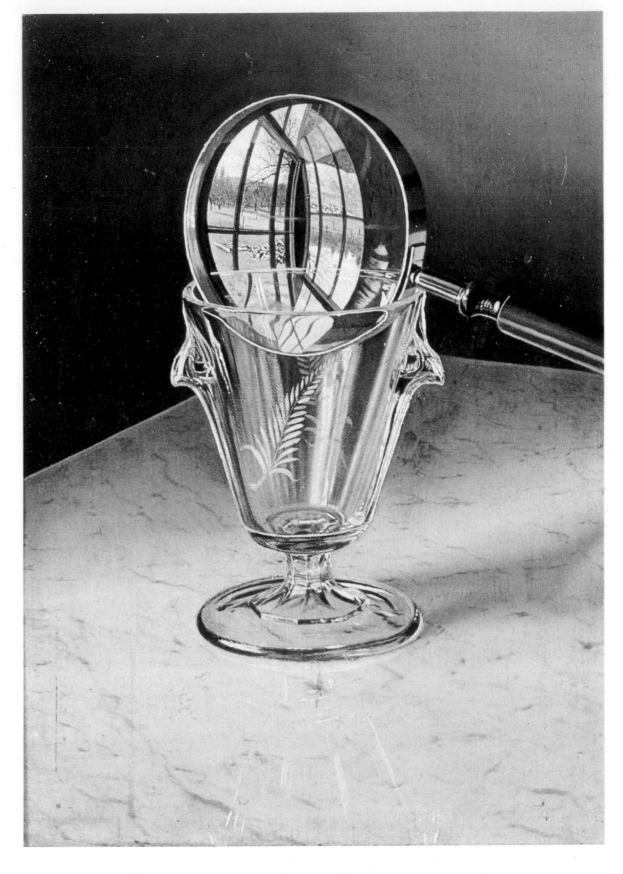

torted reflection of a scene: "Even among the Dutch the reflected image is usually verified, not to say identified, by its repetition in large elsewhere in the canvas. To present the reflected image of a scene entirely outside the spectator's line of vision is unusual. To present two such images is even more unusual; to turn one of them upside down is probably altogether unique."

In his forties Elmer at last fulfilled his long-felt desire to study at the National Academy of Design in New York. The Impressionist mode then dominated academic instruction, and although the New England scenes that Elmer painted in that style after his return to Massachusetts were favorably received when he exhibited them locally in a one-man show in 1902, they lack the strength and originality of his earlier "primitive" pictures. These, like Peto's works (see page 85), remained unknown to the art world for many years after the artist's death. Interestingly enough, they were rediscovered on the occasion of a Peto exhibition at the Smith College Museum of Art in 1950, when Elmer's niece, who had come to see it, showed the director photographs of her uncle's paintings.

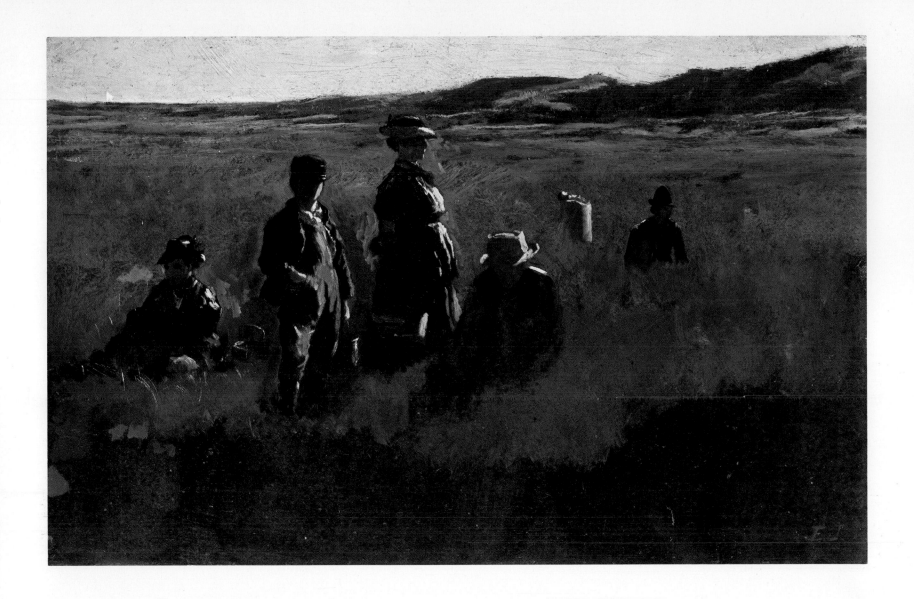

EASTMAN JOHNSON. Born Lovell, Maine, 1824; died New York City 1906. *In the Fields*. 1875–1880. Oil on academy board, 17¾" × 27½". The Detroit Institute of Arts (Dexter M. Ferry, Jr., Fund).

As a growing number of American artists acquired the habit of painting outdoors, they became increasingly interested in the way in which light modifies perception of mass and color. Some of them arrived at solutions not unlike those of the French Impressionists—whose art, however, was unknown to them.

The brilliant sunlight in Eastman Johnson's *In the Fields* falls from the right on a group of men and women in a landscape, creating strong contrasts of light and dark. Modeled without details or clearly drawn outlines, the figures stand out solidly against the blurred ground. The color gamut is restricted, ranging from a darker brown in the foreground through a warmer, rusty tone for most of the fields; a bit of pale green lies below the brown and tan slopes of the dunes in the background. A horizontal band of pale gray-blue at the top denotes either sky or, more probably,

sea, for the setting is the island of Nantucket. A few touches of bright color relieve the darkness of the group of figures, but their faces are not illuminated by the sunlight. Only the boy—most of whose face, too, is in shadow—looks out at the spectator; each person seems isolated from the others, preoccupied or sunk in reverie.

This is one of several studies for a large painting, *The Cranberry Harvest*, of 1880. In the 1870s Johnson had begun to spend his summers on Nantucket, which became the locale for many of his portraits and genre pictures. Cranberry picking was a typically "American" subject, like the making of maple syrup—the theme of an earlier series of scenes that Johnson had painted during several visits to camps around his boyhood home in Fryeburg, Maine, intending to combine them into a single large composition. Unlike most genre paintings of the time (including many of Johnson's own), these studies are neither sentimental nor anecdotal but are straightforward representations of contemporary rural activities.

Johnson never exhibited such paintings as *In the Fields*, regarding them as no more than "finished studies." In this respect, he differed from

the Impressionists, who considered their first, direct transcriptions from nature to be truer and more "real" than works done in the studio. The looseness of handling that modern eyes find especially attractive in Johnson's studies is lacking in his completed pictures, which vacillate among several styles. Some show the tight, precise draftsmanship he learned during two years in Düsseldorf, where he studied at the Royal Academy before moving into the studio of Emmanuel Leutze (then engaged on his monumental *Washington Crossing the Delaware*). Others reveal a richly modulated color and freer use of the brush, evidence of Johnson's admiration for paintings by Rembrandt and Van Dyck that he saw during his three years' residence in The Hague, and of several months spent in Thomas Couture's atelier in Paris.

Although Johnson's reputation was first established by a genre picture, *My Old Kentucky Home* (originally called *Negro Life in the South*), which was shown at the National Academy of Design in 1859, he abandoned genre altogether after 1887. His career ended as it had begun, with portraiture, which assured him well-paying commissions from prominent clients.

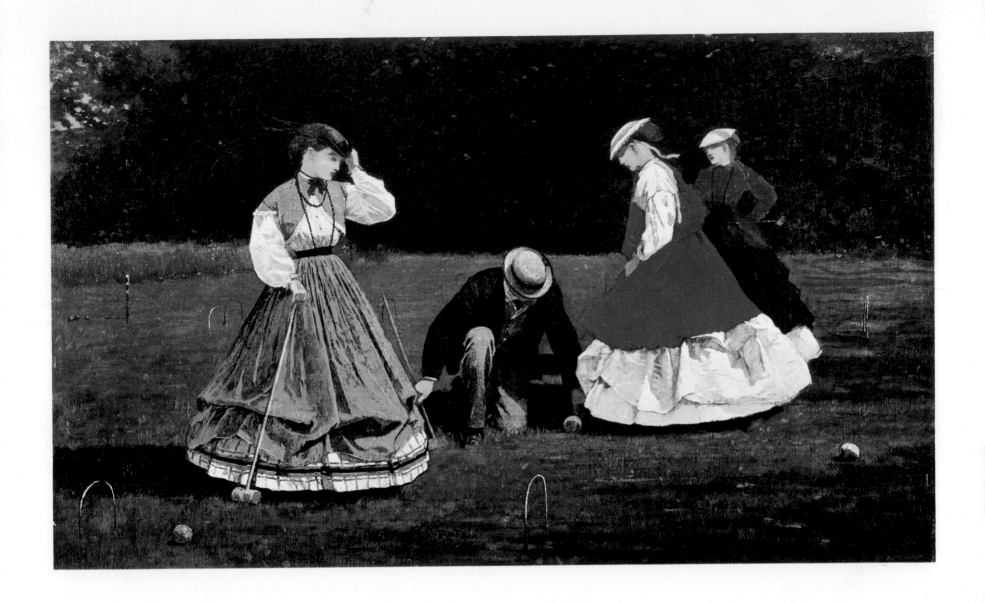

WINSLOW HOMER. Born Boston 1836; died Prout's Neck, Maine, 1910. *Croquet Scene.* 1866. Oil on canvas, 15⅞″ × 26⅛″. The Art Institute of Chicago (Friends of American Art Collection).

Like Eastman Johnson's studies, Winslow Homer's early paintings have been compared to French Impressionist works. *Croquet Scene,* for example, with its group of people diverting themselves in a sunny landscape, has resemblances to Claude Monet's *Women in the Garden* (The Louvre, Paris), painted in the same year. But despite some flattening of the form of the woman at the far right by the brilliant sunlight, Homer's figures retain their weight and mass, as do Johnson's; and like Heade's haystacks in contrast to those of Monet (see page 76), they remain solid units, set firmly on the ground and casting shadows that define their positions in space.

In the *Croquet Scene* the carpet of lawn and dark screen of trees form a background for the women's colorful garments with their harmony of blues, reds, and browns contrasted with white. The light straw hat mitigates the sobriety of the man's clothing. The persons shown are linked both

spatially and psychologically, with the kneeling man as center of the composition and focus of attention. The rounded crown of his hat repeats the shape of the balls; the curve made by his shoulders and arms echoes the arches of the wickets.

After an apprenticeship with a firm of lithographers in Boston, Homer determined to become a free-lance artist, and with this in mind he mastered the technique of the woodcut, only recently introduced into America. Unlike engraving and lithography, the wood block is incapable of reproducing subtle gradations of tone. It depends for its effect on simplified outlines, bold contrasts of dark and light, and a sensitive balance between objects and intervening spaces. Homer discovered the properties of the medium by trial and error, but his style (like that of the French Impressionists) may also have been influenced by Japanese woodcuts, already known to artists in Boston and New York.

In 1859 Homer moved to New York and began submitting illustrations to *Harper's Weekly.* During the Civil War he portrayed for that magazine scenes of daily life in the camps, shown without sentimentality or heroics. When he began working in oils, he carried over into painting the decorative

principles he had employed in woodcuts and also gradually developed a fine color sense.

After the war, impelled by his love for the outdoors, Homer painted pictures of vacationers at mountain and seaside resorts, such as *Croquet Scene,* and subjects drawn from rural life. They manifest the naturalist tendency that shortly after mid-century superseded Romanticism on both sides of the Atlantic. *Naturalist* was a term coined in 1863 by the French critic Jules Antoine Castagnary, who wrote: "The naturalist school declares that art is the expression of life under all phases and on all levels, and that its sole aim is to reproduce nature by carrying it to its maximum power and intensity: it is truth balanced with science.— The naturalist school re-establishes the broken relationship between man and nature. . . . It is the outcome of the very depths of modern rationalism. . . . Naturalism, which accepts all the realities of the visual world . . . does not bind the painter's personality, but gives it wings. It says to the artist: 'Be free!'"

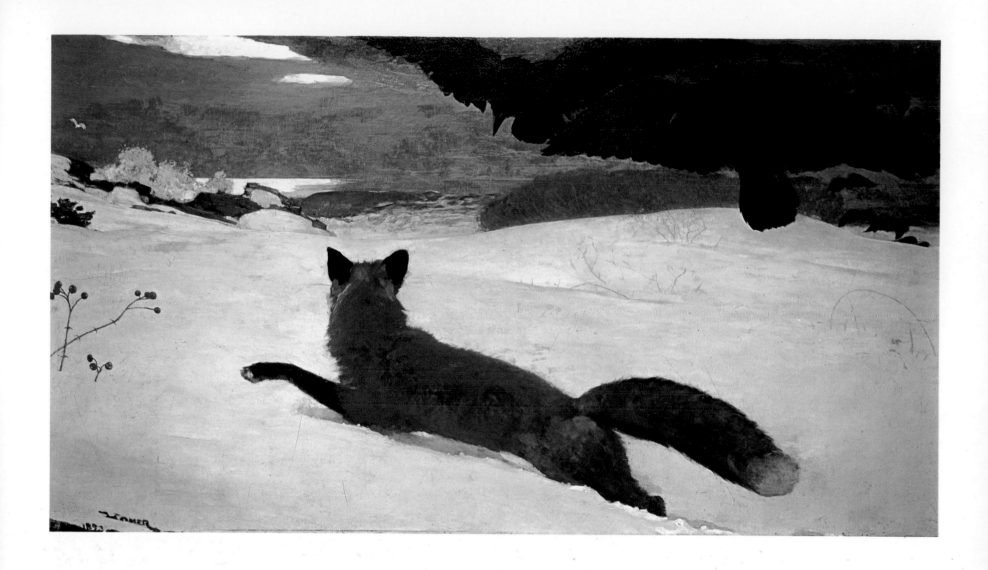

WINSLOW HOMER. Born Boston 1836; died Prout's Neck, Maine, 1910. *The Fox Hunt*. 1893. Oil on canvas, 38″ × 68″. Pennsylvania Academy of the Fine Arts, Philadelphia.

Homer spent ten months in France during 1866–1867, painting in the countryside for most of the time. Although his palette became somewhat lighter and his handling of pigment looser than in such works as the *Croquet Scene* (page 89), his themes and his approach to them remained essentially the same as before. Writing in 1875, Henry James, that master of nuance and indirection, deplored Homer's prosaic subjects and matter-of-fact way of portraying them, which he found lacking in "secrets and mysteries and coquetries." He conceded nevertheless: "He is a genuine painter; that is, to see, and to reproduce what he sees, is his only care. . . . He has chosen the least pictorial features of the least pictorial range of scenery and civilization; he has resolutely treated them as if they *were* pictorial . . . and, to reward his au-

dacity, he has incontestably succeeded. . . . Mr. Homer has the great merit, moreover, that he naturally sees everything at one with its envelope of light and air."

A few years after James wrote this criticism Homer's subjects and style underwent a radical change. A visit to Tynemouth on the North Sea powerfully affected his imagination, and after his return, in 1882 he moved to Prout's Neck, a rocky peninsula in Maine with rugged cliffs jutting out into the Atlantic (see page 13). In this remote, sparsely inhabited community he lived alone for the rest of his life, except for summer trips. He painted with intensified naturalism the sea, woods, and mountains, and the drama of sailors, fishermen, and huntsmen pitted against the harsh forces of nature.

The Fox Hunt depicts a more primordial struggle for survival. The snow that blankets the earth during the long, severe Maine winter impedes the desperate flight of a lone fox striving to elude a flock of starving crows that have gathered to attack him.

As in the best of Japanese prints, there are only a few compositional elements, carefully placed in relation to one another. The diagonal thrust of the fox with his tail streaming out behind intersects the horizontal expanse of snow; the outspread wings of the two nearest crows overshadow him with a parallel diagonal. These large diagonals are repeated in miniature in Homer's signature, slashed into the snow near the lower left corner, a subtle dark accent within the reduced range of colors in the picture. The whiteness of the snow recurs in the clouds, breaking waves, and a solitary gull, contrasting with blue-gray sky and darker blue sea below. Against the snow, a few berries clinging to the bare twigs at the left are a brighter red than the fox's russet coat; the black of his ears and forepaw is repeated in the feathers of the ominous birds gathering for the kill, and in the rocks at the left.

The Fox Hunt is one of Homer's largest and finest paintings, in which his powerful naturalism is in equal balance with his strong sense of decorative effect.

ALEXANDER POPE. Born Dorchester, Massachusetts, 1849; died Hingham, Massachusetts, 1924. *The Trumpeter Swan.* 1900. Oil on canvas, 57" × 44½". The Fine Arts Museums of San Francisco—M. H. de Young Memorial Museum.

Alexander Pope was in the main self-taught as a painter, although for a brief time he studied anatomy under William Rimmer (see page 99). A sportsman and lover of animals, he specialized in portraits of dogs and birds, done on commission from their owners. Whenever possible he placed his models in appropriate landscape settings to make the pictures more lifelike and lend the requisite touch of the picturesque and ideal. Aspiring, like many an American artist before him, to themes more elevated than portraiture, he painted several compositions in which animals were shown in a narrative context: *The Martyrdom of St. Euphemia*, with the saint lying in the arena surrounded by lions; and his own favorite among his works, *Glaucus and the Lion*, illustrating an episode from Bulwer-Lytton's *Last Days of Pompeii*.

His careful study of animal anatomy and facility in depicting texture through the skillful manipulation of light and shade led Pope to produce still lifes of firearms, rabbits, or game birds hanging on doors in the trompe-l'oeil mode popularized by Harnett. *The Trumpeter Swan* is a masterly example. The magnificent bird with snowy plumage, which Audubon had portrayed alive in its habitat (page 43), here hangs dead, pinioned against a dark green door. By 1900 this species had become almost extinct; and Pope, who took great interest in wildlife conservation, perhaps intentionally gave his image its pathetic evocation of a crucifixion. For a number of years the painting hung in the Boston headquarters of the Massachusetts Society for the Prevention of Cruelty to Animals.

Pope's trompe-l'oeil paintings were immensely popular with the public. Captivated by its deceptive illusionism, a writer in the *Boston Sunday Post* declared that *The Trumpeter Swan* (then called simply "A Wild Swan") could make one "almost believe the days of sorcery have returned." On the other hand, some critics raised the same kind of objection as had been made earlier to Harnett's pictures (see page 84). In an article of 1901 in the magazine *Brush and Pencil* the writer praised *The Martyrdom of St. Euphemia* and *Glaucus and the Lion* as "dramatic incidents forcefully depicted, which appeal to the spectator not less from the masterful execution than from the worth of the conception embodied"; he said that Pope's still-life illusions, however, "were a witness rather of his cleverness with the brush than of his ability as an artist in the best sense." In the recently painted "white swan hanging to a door" the author found "nothing to lend attractiveness to the picture *save the beauty of outline and the delicacy of the white plumage*" (italics ours).

91

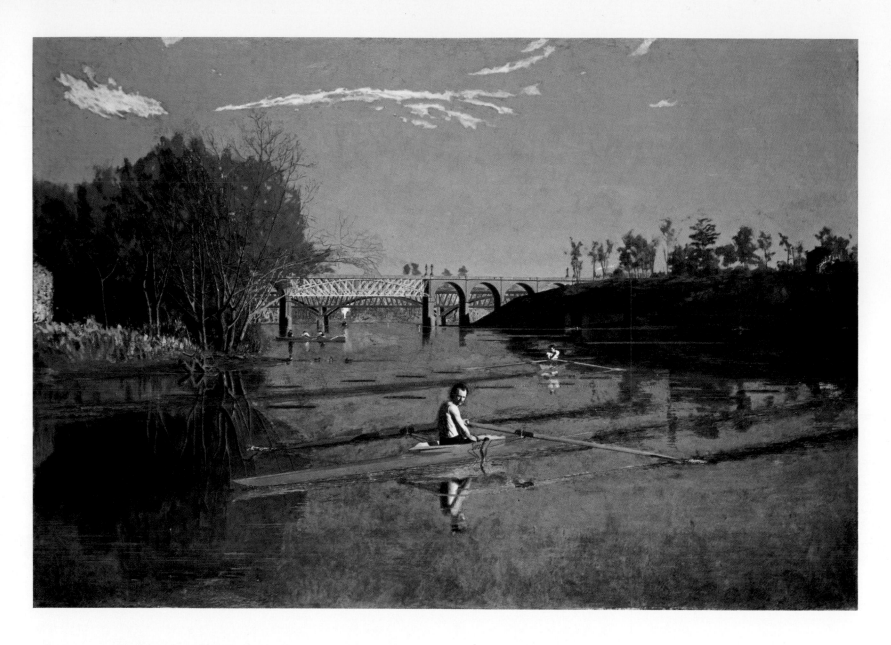

THOMAS EAKINS. Born Philadelphia 1844; died there 1916. *Max Schmitt in a Single Scull.* 1871. Oil on canvas 32¼″ × 46¼″. The Metropolitan Museum of Art, New York (Alfred N. Punnet Fund and Gift of George D. Pratt).

Thomas Eakins shares with Winslow Homer the topmost rank among America's naturalist artists. Unlike Homer, who found his subjects in the country and concentrated increasingly on nature, Eakins was a city dweller, whose art, as Lloyd Goodrich has said, "was always centered on humanity, and for him nature was an environment for man and his work and recreations . . . not the principal actor in his pictures." Castagnary's definition of naturalism as "truth balanced with science" (see page 89) applies with special aptness to Eakins's art. Morse had turned from painting to science when frustrated in his artistic ambitions (see page 52); for Eakins, there was no dichotomy between the two disciplines. He took courses in anatomy at the Jefferson Medical College in Philadelphia simultaneously with studying at the Pennsylvania Academy of the Fine Arts; mathematics, perspective, and the study of motion with the aid of photography were likewise central to his art.

During the three years he spent in Paris from 1866 to 1869 studying at the Ecole des Beaux-Arts with the leading academic painter Jean Léon Gérôme, Eakins seems to have been oblivious of the work of Gustave Courbet, arch-protagonist of French naturalism, and his fellow revolutionary Edouard Manet. On a visit to Spain, however, Eakins was deeply impressed by the paintings of Diego Velázquez and Jusepe de Ribera; he recognized that their realism had been attained through a mastery of light and color and a use of oil glazes far richer and more complex than the conventional methods he had been taught.

Max Schmitt in a Single Scull is among the earliest scenes of contemporary outdoor life that Eakins painted on his return to Philadelphia. It is one of several works in which he showed amateur or professional oarsmen engaged in the popular sport of rowing. The essential difference between these and Homer's pictures of outdoor recreation (page 89) is that Eakins was not painting genre, but portraits; the people and the locales he represented are specific rather than generalized. Max Schmitt, who appears in his shell *Josie* in the exact center of the foreground, was a boyhood friend; and Eakins also included a portrait of himself, seated in the middle distance in the shell that bears on its stern his name and the date 1871. The site is a point on the Schuylkill River above the Girard Street Bridge. The arches, girders, and braces of this industrial structure, which—like the puffing steam-boat and the approaching train—would have been considered ugly at the time, are shown in careful detail. Equally painstaking is the rendering of perspective and of the reflections on the water. (Eakins was later to write papers on the mathematical problems presented by these phenomena.) The sharpness of focus resembles that of the luminists.

Eakins never painted outdoors but relied on small sketches, color notes, and an almost photographic recollection of his observations. As a further aid in painting his boating pictures he made a miniature boat out of a cigar box, with rag figures dressed in appropriate colors, and set it out on the roof in sunlight to help him get the true tones.

However it was achieved, *Max Schmitt in a Single Scull* is no mere pedestrian transcription of reality but the lyrical evocation of a moment happily experienced and faithfully recalled. For all his scientific detachment, Eakins—who in his teaching and writings never commented on aesthetics—well understood that some element in the artistic process will forever elude explanation. In making a picture, he said, one "combines and combines, never creates—but at the very first combination no man, and least of all himself, could ever disentangle the feelings that animated him just then, and refer each one to its right place."

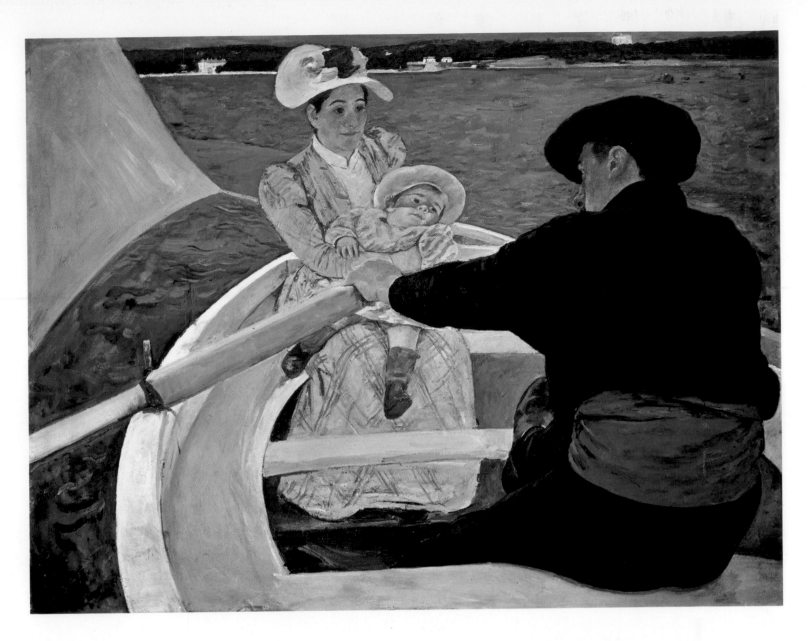

MARY CASSATT. Born Allegheny City, Pennsylvania, 1844; died Château de Beaufresne, Mesnil-Theribus, France, 1926. *The Boating Party*. 1893–1894. Oil on canvas, 35½″ × 46½″. National Gallery of Art, Washington, D.C. (Chester Dale Collection).

Although some of Winslow Homer's early paintings and Eastman Johnson's outdoor studies have a style resembling that of the French Impressionists, neither artist knew the innovative work of his contemporaries abroad. Mary Cassatt, on the other hand, was closely associated with the Impressionists and participated in four of their exhibitions. She was endowed with a vigorous, independent personality, and being the daughter of a prominent industrialist she had sufficient means to allow her to study and travel as she pleased. Dissatisfied with the pedestrian program at the Pennsylvania Academy of the Fine Arts, which she attended from 1864 to 1865, she went abroad and visited France, Italy, Spain, Belgium, and Holland before settling in Paris. No formal instruction was as important for her development as the painters whose work she admired—Correggio, Velázquez, and Rubens among the old masters, Manet, Courbet, and especially Degas among the moderns.

Degas, ordinarily highly critical of his fellow artists, was impressed by Cassatt's paintings at the Salon of 1874; three years later, he invited her to join the Impressionists' circle and exhibit with them. "I accepted with delight," she later declared. "At last I could work in complete independence, without bothering about the eventual judgment of a jury." Although this association was important for Cassatt, leading to a brighter palette and a freer handling of the brush, her paintings were differentiated in several respects from those of the other Impressionists. Her forms remained solid, not dissolved by color and light, and a certain adherence to naturalism gave her art a distinctively American flavor. "She remains exclusively of *her* people," the French critic André Mellerio remarked. "Hers is a direct and significant expression of the American character."

After seeing a large number of Japanese woodcuts in an exhibition in 1890, Cassatt began working on a series of color prints inspired by their compositional design and sense of pattern. *The Boating Party* with its unconventional perspective and high vantage point also shows a debt to this source, as well as to Manet, especially his *Boating at Argenteuil* (New York, The Metropolitan Museum of Art). Manet's picture, painted in 1864, was later acquired by Cassatt's friends the H. O. Havemeyers, who, among many other American art patrons, were to become interested in the Impressionists through her guidance.

The Boating Party is painted with broader brushstrokes and firmer outlines than Manet's *Boating at Argenteuil,* and the decorative organization of its bold composition more clearly reflects Japanese influence. The man seated with his back to the viewer is brought forward to the front plane of the picture; the angle made by his outthrust arm and the oar points in the direction taken by the sharply uptilted boat. The silhouette of his black-clad figure contrasts strongly with the colors of the water, the boat, and the garments of the woman and child who face him from the bow. At the left, the curve of the gunwale parallels that of the sail's lower edge, as the horizontal thwart at the bottom of the picture parallels the line of shore, trees, and sky at the top. No hint of conventional sentimentality sweetens the relationship between woman and child; both fix their attention on the oarsman. The sprawling posture of the child, also, is realistic rather than graceful.

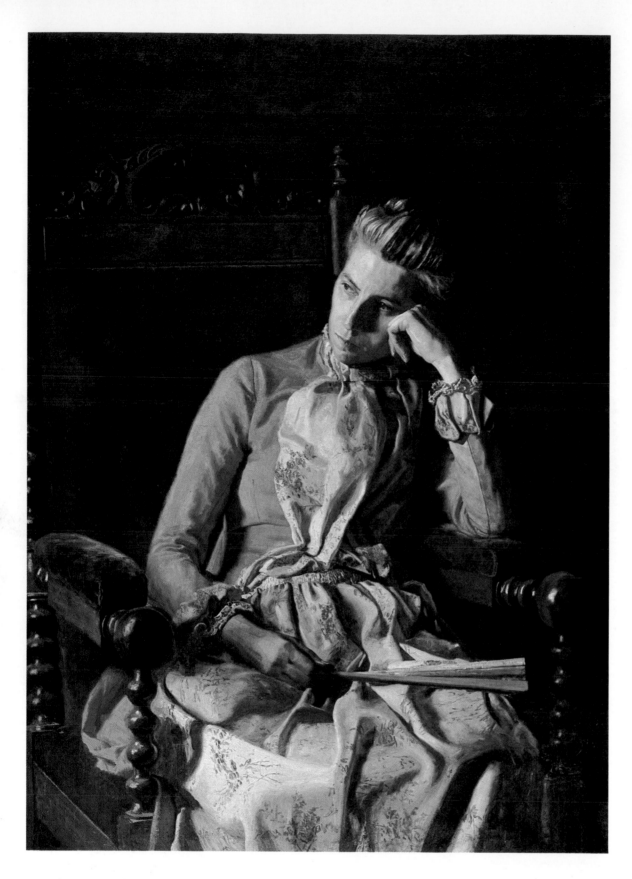

THOMAS EAKINS. Born Philadelphia 1844; died there 1916. *Miss Van Buren*. 1889–1891. Oil on canvas, 45″ × 32″. The Phillips Collection, Washington, D.C.

After he was forty, Eakins devoted himself almost entirely to portraiture. He received few commissions, however, and most of his sitters were his students or friends whom he asked to pose for him. Amelia C. Van Buren had been one of his pupils at the Pennsylvania Academy of the Fine Arts, where Eakins had taught since 1876 and of which he became director in 1882. Four years later, he

was forced to resign amid a storm of protest when his insistence on teaching from the completely nude model affronted a number of women in his life class. A majority of his students sided with Eakins and also resigned to found the cooperative Art Students League of Philadelphia, which they invited him to head. Eakins maintained close relations with those who had been loyal to him, Miss Van Buren among them. She is the subject of three of his photographs, related to this painting only in their sensitive characterization and controlled use of light.

Both in this country and abroad, the second half

of the nineteenth century saw a growing interest in the psychology rather than just the physical appearance of persons portrayed. Gesture and attitude, not accessories, define the individual. Figures seldom look straight out of the canvas but appear to be musing or preoccupied; nor does the artist invariably assume the same frontal position as the viewer.

In his *Mrs. Richard Yates* (page 35), Gilbert Stuart evoked a "speaking likeness" by engaging the woman's attention so that she seems to pause momentarily in her sewing. Miss Van Buren, gazing off to one side, may be either aware of the artist or lost in meditation; her attitude does not suggest arrested action but repose. Whereas Mrs. Yates is brought forward to the picture plane and set within a shallow space before a flat background, Miss Van Buren, seated in a chair that is positioned obliquely, occupies considerable depth within a receding space. Mrs. Yates's dress and cap are brushed in with bravura highlights that suggest the stuff of which they are made but serve principally to set off the flesh tones of her face and hands. In Eakins's portrait the pattern, texture, folds, and color of the dress, like the carved wood and velvet upholstery of the chair, receive full attention; they are unified with the figure through their light-and-shade modeling. We are made conscious of the body's weight and the underlying bony structure of head and hands. Finally, whereas Stuart lays on his pigment in broad brushstrokes to create a shimmering surface, Eakins uses successive layers of paint to build up solid forms in depth.

Despite the contrast in their approach and method, owing as much to differences in temperament as to disparity in date, it is clear that the paramount interest of both artists lay in their sitter's personality. By seeking this out and conveying it in a memorable image, each succeeded brilliantly.

AUGUSTUS SAINT-GAUDENS. Born Dublin, Ireland, 1848; to United States 1848; died Cornish, New Hampshire, 1907. *Adams Memorial.* 1886–1891. Bronze, 70″ high. Rock Creek Cemetery, Washington, D.C.

Augustus Saint-Gaudens began his career working as a cameo cutter in New York while attending night classes at Cooper Union and the National Academy of Design. When he was nineteen, his father, a French shoemaker who had come to the United States from Ireland, sent him abroad to study. During the next several years, Saint-Gaudens divided his time among Paris, Rome, and New York before establishing his studio in the latter city. His first important commission for the *Farragut Memorial* in New York's Madison Square (1876–1881) was soon followed by others: the *Shaw Memorial* (Boston, 1884–1897), the statue of Lincoln (Chicago, 1887), and the equestrian *Sherman Memorial* (New York, 1892–1903). In these works Saint-Gaudens departed from both Neoclassicism and the prevailing mode of realistic sculpture to achieve an idealized realism devoid of prosaic literalness.

Probably the most difficult commission he ever undertook was that for the *Adams Memorial*—a private rather than a public monument, which it was stipulated should be without either religious symbolism or a representation of the dead woman. Suffering from melancholia, Marian Hooper Adams, wife of the historian Henry Adams, had committed suicide in 1885. The grief-stricken widower gave the sculptor little direction beyond showing him photographs of statues of Buddha and telling him to look at reproductions of Michelangelo's frescoes for the Sistine ceiling. He then went off to the South Pacific for several years and saw the work only after it had been set in place in Rock Creek Cemetery, backed by a stele designed by the architect Stanford White.

Adams seems to have been satisfied that Saint-Gaudens had fulfilled his intentions, for in a letter of 1896 he wrote: "The whole meaning and feeling of the figure is in its universality and anonymity. My own name for it is 'The Peace of God.' . . . A real artist would be very careful to give it no name that the public could turn into a limitation of its nature." In 1905, in his autobiographical *Education of Henry Adams,* he said that any Asiatic would instinctively have understood its meaning, but the American public either took it for a portrait or were baffled by it—except for the clergy, who "broke out passionately against the expression they felt in the figure of despair, or atheism, of denial. . . . The American layman had lost sight of ideals; the American priest had lost sight of faith." As for Saint-Gaudens, he said in 1904 that he called the figure "the Mystery of the Hereafter," and in 1906: "Perhaps 'The Peace that Passeth Understanding' is as near as I can get to it in words. I feel as if it could only be expressed by music."

The art historian George Hamilton has drawn a perceptive comparison between Saint-Gaudens and Thomas Eakins, both of whom faced the problems of "reconciling a realist technique which they accepted as the inevitable mode of expression at the time, with the requirements of a style both traditional, in that they had no desire to renounce the European past, and symbolic, in that they were trying to create symbols valid for contemporary American life." Eakins, however, painted what was directly before his eyes; but in the *Adams Memorial,* Saint-Gaudens portrayed a figure so generalized that, in his son's words, it was "both sexless and passionless . . . for which there posed sometimes a man, sometimes a woman"; yet he invested it (as he had said of his *Shaw Memorial*) with "the feeling of death, mystery and love." Mr. Hamilton concludes that this work is "the single most successful resolution of realism and idealism for a paramount expressive and symbolic purpose in American sculpture of that day. The robe and rock *are* real, in an artistic sense; one sees and feels their weight and density. But the figure as a whole is something else again."

Gardens on the opposite bank, and he painted this popular pleasure resort a number of times. Despite its title, there is little actual black in the *Nocturne in Black and Gold,* except in the mass of trees at the left. Elsewhere, it is mixed with a dark, dull blue or toned to a gunmetal gray. The "gold" that illuminates the water basin and falls in a shower of sparks from the rocket is principally made up of rosy pink and pale blue-green. Much of the painting is as diaphanous as a watercolor; no shapes are clearly outlined, and the vertical streaking of the brush imposes its own rhythm on the surface.

Never has so small a picture created so great a turmoil! The venerable arbiter of English taste, John Ruskin, wrote in his magazine *Fors Clavigera* that "the ill-educated conceit of the artist . . . approached the aspect of wilful imposture. I have seen, and heard, much of Cockney impudence before now; but never expected to hear a coxcomb ask two hundred guineas for flinging a pot of paint in the public's face." When Whistler brought suit for damages, it was not so much this *Nocturne* but the entire aesthetic it represented that went on trial. Leading academicians testified that the painting showed "no finish" and was "not serious work—not true representation"; its musical title in itself was an affront or, as Whistler later wrote, a "red rag"; almost worst of all, when asked how long it had taken him to "knock off that nocturne," Whistler replied about a day, perhaps two. "The labour of two days, then, is that for which you ask 200 guineas?," demanded the attorney-general. "No," answered Whistler, "I ask it for the knowledge of a lifetime."

Although costs of the trial drove Whistler to bankruptcy, he considered his token award of one farthing in damages a great moral victory and continued to propound his beliefs in lectures and writings. "To say to the painter, that Nature is to be taken as she is, is to say to the player, that he may sit on the piano." "As music is the poetry of sound, so is painting the poetry of sight, and the subject-matter has nothing to do with harmony of sound or of colour." "Art . . . should stand alone, and appeal to the artistic sense of eye or ear, without confounding this with emotions entirely foreign to it, as devotion, pity, love, patriotism or the like." "The work of the master . . . suggests no effort—and is finished from its beginning."

Concepts such as these, which were to become the truisms of modern art, were revolutionary for England in the 1870s and 1880s. But well before Whistler's death in 1903, the doctrine of "art for art's sake" and the Aesthetic Movement of which he had been a forerunner had become dominant in that country, with advocates in America as well.

JAMES ABBOTT McNEILL WHISTLER. Born Lowell, Massachusetts, 1834; died London, England, 1903. *Nocturne in Black and Gold: The Falling Rocket.* c. 1875. Oil on canvas, 24¾″ × 18½″. The Detroit Institute of Arts (The Dexter M. Ferry, Jr., Fund).

Although James A. McNeill Whistler never returned to the United States after leaving it in 1856 to study art in Paris, he was proud of his three years as a cadet at West Point, and it was as a draftsman for the U.S. Coast and Geodetic Survey that he learned the techniques of printmaking. Of all the expatriate American artists, he was the most involved in successive avant-garde tendencies of his day. First influenced by Courbet and the Pre-Raphaelites, he soon revolted violently against what he called "damned Realism," "beautiful Nature and the whole mess," and also the Impressionists' emphasis on color, although he continued to admire Degas and Velázquez. Whistler was among the first to receive inspiration from Oriental art, especially the Japanese woodcut. Writers rather than artists influenced the formulation of his aesthetic ideas—Baudelaire, Rimbaud, and especially the Symbolist poet Mallarmé and his dictum "Do not paint the object but the effect which it produces."

When he moved to London in 1863, Whistler took a house in Chelsea overlooking the Thames. At night, from its windows or a rowboat, he loved to watch the fireworks shot off from Cremorne

JOHN SINGER SARGENT. Born Florence, Italy, 1856; died London, England, 1925. *Robert Louis Stevenson*. 1885. Oil on canvas, 20″ × 24″. Collection of Mr. and Mrs. John Hay Whitney.

Sometimes mistakenly described as an Impressionist, John Singer Sargent was never an adherent of that group, although he knew many of its members and enjoyed a close friendship with Claude Monet. The son of expatriate parents, he was born in Florence; he did not visit the United States until he was twenty but returned to it frequently on visits and always retained his American citizenship. After attending art schools in a number of cities, he entered the atelier of the leading portrait painter of Paris, Carolus Duran, in 1874. Like Mary Cassatt, Sargent was influenced by his admiration for certain artists whose works he saw on his travels, notably Velázquez in Spain and Frans Hals in Holland. Under this stimulus, he adopted the technique of direct painting with bravura strokes of the brush, instead of going through the stages of drawing, underpainting, and successive overpaintings.

Sargent's virtuosity soon won him commissions from French and American patrons; but the daring décolletage shown in his portrait of a famous beauty (*Madame X*, The Metropolitan Museum of Art, New York) created such a scandal at the Salon of 1884 that he withdrew it from exhibition, fearing that its impropriety might lose him his clientele. Later that year he moved to London and shortly thereafter made the acquaintance of Robert Louis Stevenson, who found him "a person with a kind of exhibition manner . . . who proves, on examination, simple, bashful, enthusiastic, and rude."

In a letter of October 22, 1885, Stevenson wrote to a friend from his home in Bournemouth: "Sargent was down again and painted a portrait of me walking about in my own dining room, in my own velveteen jacket and twisting as I go my own moustache; at one corner a glimpse of my wife, in an Indian dress, and seated in a chair that was my grandfather's, . . . adds a touch of poesy and comicality. It is, I think, excellent, but too eccentric to be exhibited. I am at one extreme corner; my wife, in this wild dress, looking like a ghost, is at the extreme other end; between us an open door exhibits my palatial entrance hall and part of my respected staircase. All this is touched in lovely, with that witty touch of Sargent's."

By accepted standards of the day, the portrait was indeed eccentric, for its seeming lack of finish and informality of pose as well as for its composition. The center of the picture is occupied by an open door and the view beyond, whereas the main subject—as Stevenson noted—is boldly displaced to one side, and the sketchy figure of Mrs. Stevenson at the extreme right is cut off by the framing edge in the manner that Degas had adopted from Japanese prints.

"Is Mr. Sargent in very fact an American painter?," another noted expatriate, Henry James, asked in 1889 in an article for *Harper's Monthly Magazine;* he went on to say: "We shall be well advised to claim him . . . the burden of proof would rest with those who should undertake to show that he is a European." James expressed great admiration for the accomplishments of the young artist, then only thirty-three; but he astutely foresaw that Sargent's extraordinary precocity might "breed an irresponsibility of cleverness. . . . The question with regard to his future . . . becomes more purely a question of responsibility, and we hold him altogether to a higher account." James concluded: "The gift that he possesses he possesses completely—the immediate perception of the end and of the means." In this uncommissioned portrait, done out of friendship and without any pressure to meet fashionable requirements, that innate gift of Sargent's is strikingly evident.

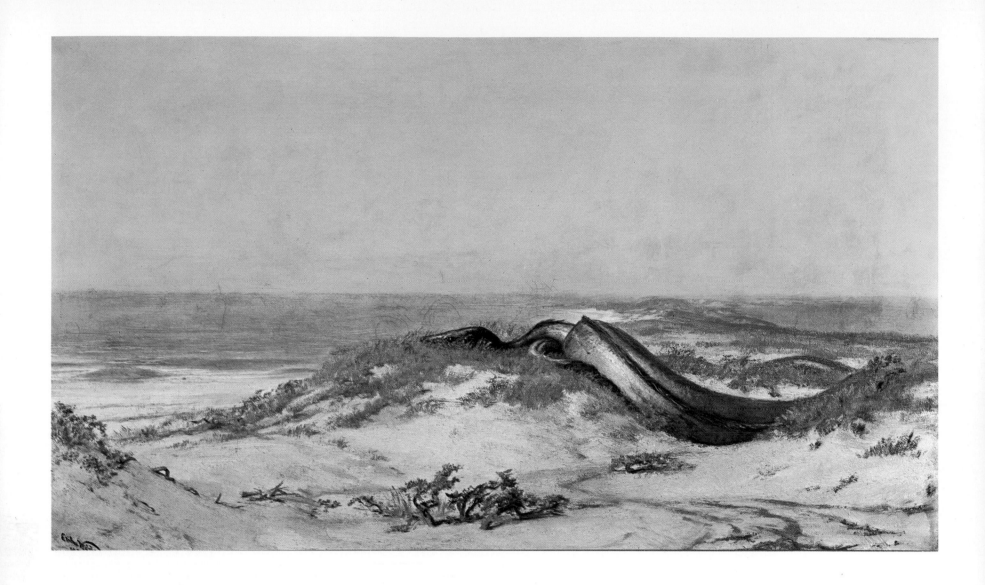

ELIHU VEDDER. Born New York City 1836;
died Rome, Italy, 1923. *Lair of the Sea Serpent.*
1864. Oil on canvas, 21″ × 36″. Museum of Fine
Arts, Boston (Bequest of Thomas G. Appleton)

Not all American artists adhered to the prevailing
tradition of realism. Three who painted their pri-
vate visions were Elihu Vedder, William Rimmer,
and Albert Pinkham Ryder. The first two mani-
fested their eccentricity principally by their choice
of subject, but Ryder evolved a highly indi-
vidual style and an unconventional painting tech-
nique for the expression of his concepts.

Vedder, best remembered today for the illustra-
tions of *The Rubáiyát of Omar Khayyám* he did
from 1884 to 1889, began his training in art at
twelve. He went to Paris when he was twenty and
enrolled at the Ecole des Beaux-Arts under the
academic artist François Picot, then studied in
Rome and Düsseldorf. The *Lair of the Sea Serpent*
is an early work, painted during Vedder's four-year
sojourn in New York from 1861 to 1864. The next
year he returned to Europe and settled permanently
in Rome, making occasional trips back to the United
States, where he executed some important mural
commissions.

In this picture, as in many by twentieth-century

Surrealists, fantasy is cloaked in a completely real-
istic guise that gives it the compelling believability
of a nightmare. The sandy dunes overlooking the
ocean are so true to nature that two of Vedder's
friends, as he relates in his autobiography, took
him to Manchester-by-the-Sea north of Boston to
point out the exact spot where they were sure he
must have painted it; but "as a matter of fact, I did
not paint it there, but, like the talented boy, 'drew
it all out of my own head with a common lead pen-
cil.'" The serene locale and sunlit, blond tonality
somehow make the apparition more alarming than
would a darker, more agitated setting. The mon-
ster, probably modeled on an ordinary eel, may
derive its menacing quality from a childhood ex-
perience of Vedder's. He recalls that while on a
visit to New Jersey as a small boy, "fishing in a
ditch I caught a great eel. I was frightened when
I got the great brute out on the grass, for he
seemed to my childish eyes a veritable python . . ."

Vedder's talent was quickly recognized, and he
was elected to the National Academy of Design
when only twenty-seven—among the youngest art-
ists to be so honored. Not all critics admired his
art, however, for truth to nature and nobility of
sentiment were the accepted standards for judging
paintings. A reviewer of the National Academy's

1864 exhibition wrote of the *Lair of the Sea Ser-
pent* that the picture "shows a tendency toward
melo-dramatic and sensational subjects which we
cannot too earnestly deprecate. . . . We believe
that no rightly constituted mind can look at such a
picture . . . without actual disgust—disgust propor-
tioned to the intensity and truth of the conception.
. . . We cannot see what good or high purpose is
served by painting this loathly beast. . . . Yet Mr.
Vedder's conception of his subject shows remarkable
power. . . . The color that he loves is not natural,
except in certain subjects, certain scenes; the sub-
jects that he delights in are exceptional, and if too
much dwelt among will narrow and not enlarge the
mind. . . . Why will he not take a theme from
Dante? . . . We heartily wish Mr. Vedder would
try his hand at some such noble, worthy work, and
leave Sea Serpents and Roc's Eggs for people who
cannot do better. He can."

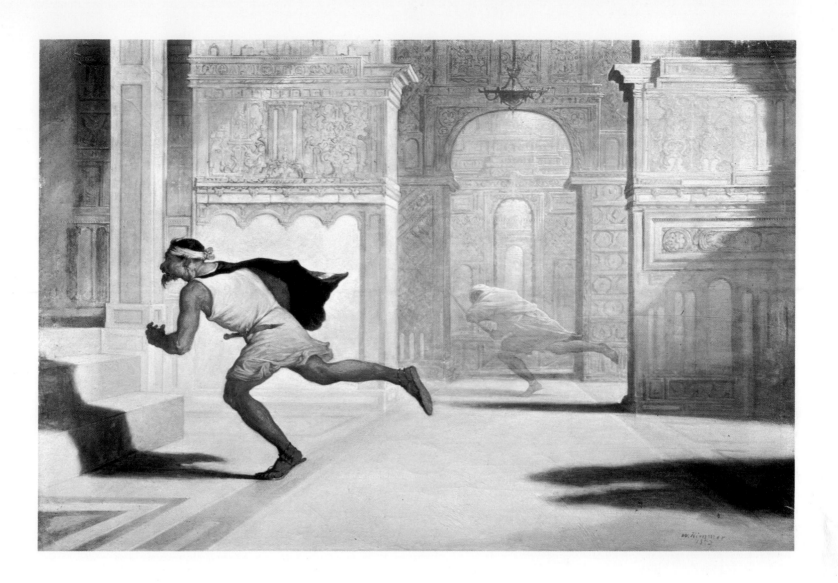

WILLIAM RIMMER. Born Liverpool, England, 1816; to United States 1826; died South Milford, Massachusetts, 1879. *Flight and Pursuit.* 1872. Oil on canvas, 18″ × 26¼″. Museum of Fine Arts, Boston (Bequest of Miss Edith Nichols).

William Rimmer was not only a self-taught artist but was also largely self-taught in the practice of medicine, by which he earned his living even before being licensed in 1855. His interest in anatomy was still more profound than that of Eakins (see page 92) and was the connecting link between his activities as doctor, artist, and teacher. By studying from books and attending the dissecting rooms at medical college, Rimmer made himself such an authority on the subject that he became a lecturer in Boston, Worcester, Lowell, and New York, where from 1866 to 1870 he also directed Cooper Union's School of Design for Women. The titles of his books, *Elements of Design* (1864) and *Art Anatomy* (1877), are indicative of his twin interests.

Rimmer completed only about twenty paintings and fewer than a dozen works in sculpture. The powerful modeling and expressiveness of his *Falling Gladiator* and *Dying Centaur* set them completely apart from the glacial classicism of the American sculptors in marble working in Italy, or the sentimental realism of Civil War monuments and ubiquitous small Rogers groups. In some respects they anticipate Rodin; in fact, when the plaster for *Falling Gladiator,* for which Rimmer used his own body as model, was exhibited at the Paris Salon of 1862, he was accused of having taken casts from life—the same charge that was to be brought against Rodin's *Age of Bronze* five years later.

The style of Rimmer's *Flight and Pursuit* shows how much he had assimilated from reproductions and paintings by earlier and contemporary artists that he saw exhibited at the Boston Athenaeum or in New York. But although its subject reflects the vogue for Oriental exoticism that had spread from France and England to America by mid-century, it has no antecedents in academic painting. Who is the man racing so desperately through these Moorish halls, pursued by his own black shadow and closely followed by the menacing shadows of unseen pursuers? What is the significance of the shrouded wraith with drawn sword, whose attitude exactly mirrors that of the fleeing man?

An allegory of man and his conscience, the picture probably takes its theme from a poem by Ralph Waldo Emerson. Rimmer was a Transcen-dentalist and had established a friendship with the Concord circle of Emerson and Bronson Alcott. The first and third stanzas of Emerson's *Brahma* (1857) read:

> If the red slayer thinks he slays,
> Or if the slain thinks he is slain,
> They know not well the subtle ways
> I keep, and pass, and turn again. . . .
>
> They reckon ill who leave me out;
> When me they fly, I am the wings;
> I am the doubter and the doubt,
> And I the hymn the Brahmin sings.

This becomes somewhat less obscure if we refer to an extract from the Hindu scripture Vishnu Parana that Emerson copied into one of his notebooks in 1845: "What living creature slays or is slain? What living creature preserves or is preserved? Each is his own destroyer or preserver, as he follows evil or good."

Emerson's concept may have served as Rimmer's point of departure, but no knowledge of its source is needed to experience the haunting quality of this fantastic painting. Even more nightmarish than Vedder's *Lair of the Sea Serpent,* it invites each viewer to imagine its meaning.

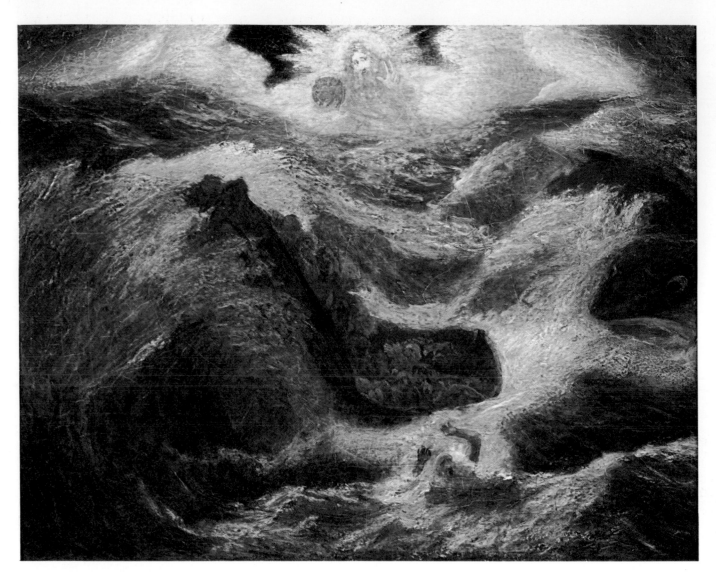

ALBERT PINKHAM RYDER. Born New Bedford, Massachusetts, 1847; died Elmhurst, Long Island, New York, 1917. *Jonah*. c. 1890. Oil on canvas, 26½" × 23½". National Collection of Fine Arts, Smithsonian Institution, Washington, D.C. (Gift of John Gellatly).

"I am in ecstasies over my Jonah," wrote Albert Pinkham Ryder to the collector Thomas B. Clarke; "such a lovely turmoil of boiling water and everything. If I get the scheme of colour that haunts me I think you will be delighted with it." This small painting is filled with a chaotic violence, an interplay of swirling dark shapes and luminous areas of high-keyed color. Mercilessly tumbled by mountainous waves, the boat holding its terrified occupants is bent into a curve that counterpoints the shape of the approaching whale. In the seething water Jonah flings up his arms in despair; he does not perceive behind him amid the bright clouds on the horizon the apparition of the Almighty, with hand raised to quell the tumult.

In Copley's *Watson and the Shark* (pages 30–31), a comparable image of providential salvation from a sea monster, the narrative unfolds through an accumulation of realistic details. As John Dos Passos has remarked, it "could stand as an illustration for a horror story by Poe. . . . [It] tells its story much as a writer would tell it." Ryder eliminates detail; instead he conveys terror expressionistically, through rhythmic forms and patterns of light and color in an agitated state of flux. In Copley's pic-

ture we read fright in the faces and gestures of the actors; looking at Ryder's, we immediately experience this emotion, even before our eyes separate out the animate and inanimate components of the drama.

Although Ryder moved with his family to New York as a youth, he had been born in New Bedford and always retained his love of the sea, which he made the subject of many of his pictures. His recollection of his native town, then the greatest whaling port in the world, is of special interest for the *Jonah*.

Ryder had some brief formal instruction in art, but it had as little effect on his intensely personal style as the paintings he saw later during several trips abroad. While most of his contemporaries were striving for naturalism, and· even fellow romantics like Vedder and Rimmer gave their visions the illusion of reality, Ryder declared: "The artist should fear to become the slave of detail. He should strive to express his thought and not the surface of it. What avails a storm-cloud accurate in form and detail if the storm is not therein?" Whether he took his subjects from nature, literature—the Bible, classical mythology, Shakespeare—or Wagnerian operas, everything was transformed by Ryder's personal vision. He always retained a passionate love of color and a sensuous delight in the material itself, building up his pictures with heavy layers of pigment and glazes. Although warned that this would lead to serious cracklings and discolorations (as indeed it did), he serenely

replied, "When a thing has the elements of beauty from the beginning it cannot be destroyed." He worked very slowly; once an idea came to him, it went through a long period of gestation, as he painted and repainted, changed the shape and position of elements within a picture, and kept it in his studio "ripening," as he said, "under the sunlight of the years that come and go."

Some critics disparaged Ryder's "bad drawing," and one commented that his *Jonah* "was chiefly remarkable for the bad taste in the attempt to represent the Almighty"; but demand for his works was sufficient to evoke a number of forgeries, even in his lifetime.

Although Ryder was the last of the high romantics in American art, certain aspects of his painting foreshadowed modern developments: his abandonment of objective "truth to nature" in favor of subjective emotion and expressionism; his concern for precise adjustments of the forms and colors within a picture to produce semiabstract designs; his involvement with the physical properties of paint and the process of painting itself. Thus, it is not surprising that he was admired by Marsden Hartley (see page 114), an early adherent of modernism who was thirty years his junior, and two generations later by the pioneer Abstract Expressionist, Jackson Pollock (see page 142).

LOUIS EILSHEMIUS. Born Laurel Hill Manor (near Newark), New Jersey, 1864; died New York City 1941. *Jealousy.* 1915. Oil on academy board, 19½″ × 25″. Philadelphia Museum of Art (Gift of Mr. and Mrs. Henry Clifford).

Tracing a current of erotic sensibility that ran through French, English, and Italian literature and art in the nineteenth century, Mario Praz showed in *The Romantic Agony* that the ideal of woman as a pure and noble creature—a source of inspiration to be set on a pedestal and worshiped from afar—had its dark counterpart: the cruel and lustful *femme fatale* who enticed men by her beauty only to destroy them. There is a similar duality of attitude in the paintings of Louis Eilshemius. Many of them celebrate nymphs innocently dancing in idyllic landscapes or bathing in tropical streams. His *Jealousy,* on the other hand, is one of several works in which he portrayed women as sensual and demonic.

Within the painted interior frame (a device Eilshemius often adopted to distance his subjects from reality), the violent action seems like the climactic scene in a melodrama whose plot we do not know. This effect is aggravated by the strong lighting of the women's bodies within the dark room. Drawn with no attempt at anatomical accuracy, the figures become almost abstract elements in a composition loosely painted with strokes as fluent as in a watercolor. Actually, Eilshemius had a sound academic training in this country and

abroad and was a skillful draftsman. His apparent ineptitude was due in part to his rapid execution but even more, as one critic remarked, to the fact that his paintings "are direct projections of the mental image on the canvas with the least possible interference of outside considerations. Here we find no desire for conformity to worldly standards of painting, . . . no desire to exploit technique. The dreamer is concerned with his dream."

This was written in the 1930s, when after decades of neglect and ridicule Eilshemius's work was enjoying great popularity. As a young man, he had seemed well launched on a successful career when some of his paintings were accepted by the National Academy of Design for its 1887 and 1888 exhibitions. He was never again to receive such official recognition. After extensive travels in Europe, North Africa, and Samoa, Eilshemius settled in New York, where he painted city scenes and theatre interiors not unlike those being produced at the time by John Sloan (page 14), Everett Shinn, and others of The Eight. Those extroverted artists, however, delighted in depicting the lively human comedy of the metropolis, whereas Eilshemius, withdrawn and alienated, painted the city by moonlight, its streets empty of inhabitants. Contact with Ryder in 1908 intensified Eilshemius's own inclination to romanticism. Both his style and his subject matter grew increasingly idiosyncratic; and as his themes became more fantastic, his forms became more simplified.

Chagrin at the constant rejection of his work

turned Eilshemius into an eccentric who persistently bombarded the press with self-advertising correspondence. This brought him notoriety but not acceptance. But in 1917 one of his paintings at the Society of Independent Artists' annual exhibition attracted the attention of Marcel Duchamp, who three years later, with Katherine Dreier, gave Eilshemius his first one-man show at the Société Anonyme (see page 106). Several avant-garde artists praised his paintings, and even some formerly hostile critics were won over.

This success came to Eilshemius too late. He ceased painting in 1921, was paralyzed following an accident in 1932, and nine years later died while a mental patient in Bellevue Hospital. Two years after his death, Duchamp wrote of him: "He was a poet and painted like one, but his lyricism was not related to his time and expressed no definite period. He painted like a 'Primitive'—but was not a primitive—and this is the origin of his tragedy. His landscapes were not landscapes of a definite country; his nudes were floating figures with no definite anatomy. His allegories were not based on accepted legends."

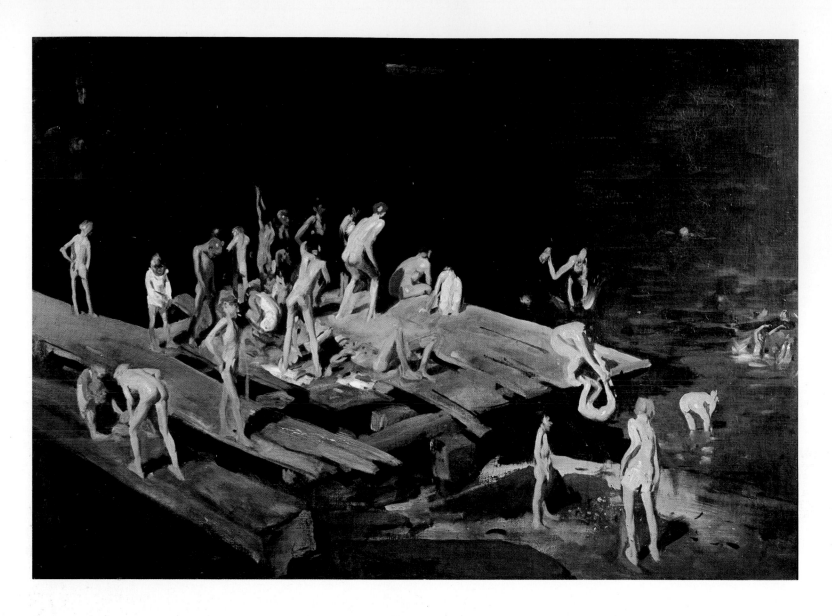

GEORGE BELLOWS. Born Columbus, Ohio, 1882; died New York City 1925. *Forty-Two Kids.* 1907. Oil on canvas, 42⅜″ × 60¼″. The Corcoran Gallery of Art, Washington, D.C. (William A. Clark Fund).

Although not one of The Eight—the group whose 1908 exhibition of paintings representing some of New York's seedier aspects won them the epithet "the Ashcan School"—George Bellows was allied to them by friendship and community of ideas. After leaving Ohio State University, where he had been an outstanding athlete, he enrolled at the New York School of Art. His teachers were William Merritt Chase, whose Impressionist brushwork applied to conventional, "genteel" subjects was already degenerating into a formula, and—far more important for Bellows—Robert Henri. Henri was a dynamic person, who urged each of his students to study the techniques of earlier masters but to develop his own individuality, and above all to find his subjects in contemporary life around him: "Let your history be of your own time, of what you can get to know personally—of manners and customs within your own experience."

Following this precept, Bellows roamed New York's waterfronts and poorer quarters. His *Forty-Two Kids,* a scene along Manhattan's East River, is a variant of *River Rats* (Collection of Everett D. Reese) of the preceding year. A quarter century before, Thomas Eakins had painted a similar theme in *The Swimming Hole,* 1883 (Fort Worth Art Center, Fort Worth, Texas). His landscape, however, was rural and based on photographs he had taken of the site, and the nude bodies and contrasting postures of the bathers reveal Eakins's usual concern for anatomical accuracy.

Although Bellows, like Henri, greatly admired Eakins, his aims were entirely different. In this night scene the landscape is sketchily brushed in, serving only to provide a dark contrast to the worn planks of the old bridge in the foreground and the bright cluster of animated boys. Bellows's interest is not in any individual figure but in the cumulative effect of lively action produced by the spontaneous attitudes of the spindly bodies. A comparable interest in crowds is apparent in his rendering of the excited spectators in the first of his prizefight pictures, *Club Night* (Collection of Mr. and Mrs. John Hay Whitney), which was painted in the same year.

A contemporary critic called *Forty-Two Kids* a "tour-de-force in absurdity" and declared that the boys were "more like maggots than humans." Two years later, however, it was the first of Bellows's pictures to be acquired by a private collector, and he was also elected an associate member of the National Academy at twenty-seven—one of the youngest artists in its history to receive such recognition. His sudden death at the age of forty-two cut short a career crowned with many other honors. His street scenes, landscapes, and prizefight pictures all found favor with the public, as did his portraits. The latter were usually affectionate but unsentimental characterizations of members of his family, painted with a strong sense for decoration and, as his art matured, with brighter and purer colors than those in his earlier works. A consummate draftsman, Bellows took up lithography in 1916 and brought about the revaluation of what was then generally regarded as only a commercial medium.

Bellows was a liberal whose ideas were more radical than his art. He participated in the Armory Show in 1913 (see page 105), more because he recognized the importance of the modern revolt than out of liking for the kind of art it produced. He was an ardent Socialist and pacifist, contributing illustrations to the *New Masses,* of which John Sloan was art editor, and he engaged in several spirited controversies with leading critics over artists' rights. A true disciple of Henri's, in 1917 Bellows formulated his own credo: "It seems to me that an artist must be a spectator of life: a reverential, enthusiastic, emotional spectator, and then the drama of human nature will surge through his mind. . . . There are only three things demanded of a painter: to see things, to feel them, and to dope them out for the public."

GEORGE LUKS. Born Williamsport, Pennsylvania, 1867; died New York City 1933. *Mrs. Gamley*. 1930. Oil on canvas, 66″ × 48″. Whitney Museum of American Art, New York.

Like Everett Shinn, William Glackens, and John Sloan, his friends among The Eight, George Luks began his career as a newspaper artist in Philadelphia. After attending the Pennsylvania Academy of the Fine Arts, he had gone abroad to enter the Düsseldorf Art Academy and spent nine years traveling in Europe before returning to Philadelphia in 1894. His fellow artists on the *Press* initiated him into the circle around Robert Henri. Following a brief assignment in Cuba as artist-reporter covering the Spanish-American War for the *Philadelphia Evening Bulletin,* Luks came to New York in 1896 to do illustrations, caricatures, and comic strips for the *New York World.* It was not until 1898 that, with Henri's encouragement, he took up painting in oils, working in the style of dark Impressionism favored by the Munich School, Chase, and Henri himself.

Although like the others of his group Luks was attracted to the colorful life of the city streets, he differed from them in concentrating on the study of individual character. Without satire or ridicule, and with a warmth of human feeling, he painted ragamuffins, derelicts, beggars, and old crones.

Mrs. Gamley, one of his late works, gives evidence that Luks's approach to his subjects always remained the same, although his style became more solid and colorful. The dignified old woman stands in her old-fashioned kitchen, her hair as white as the feathers of the rooster she so pridefully holds. Age has marked her face, hands, and body but has not robbed her of the enjoyment of life, for her expresssion is full of good humor. Against the dark browns of the rear wall, door, and floor, her printed blouse with its blue border, the red and yellow highlights of her skirt, and the cock's scarlet comb provide accents of bright color.

Given to tall stories and braggadocio, Luks boasted that "there are only two great artists in the world—Frans Hals and little old George Luks." He was a swashbuckling character who deliberately affected the role of bohemian and incorrigible *enfant terrible*. The manner of his death had the kind of fitting logic encountered more often in romantic fiction than in real life: as lusty, cantankerous, and given to drink as Falstaff or W. C. Fields, Luks died in a barroom brawl at the age of sixty-six.

Guy Pène du Bois, another of Henri's former students, characterized Luks as artist and man in an article published in 1923: "The tonic thing that Luks says is only newly said in this country. . . . The best word to describe it, I should think, is flamboyance, which has a root in flame and suggests the gesture of fire. Luks' art makes that gesture along with the man. . . .

"Art is too generally confused with artisanship by the conception that it is made in three parts at

least of good taste. . . . The fact is . . . that there is an enormous amount of willfulness, of intellectual direction, in the consistent good taste of most American canvases. This is true to a nearly intolerable extent in the prize-winning examples. . . . Good taste or the thought of it, as we know it in this country, is very largely a middle-class concern which begins at the manner of holding a fork, as an example, and ends at the pronunciation of a word or the decoration of a drawing room. . . .

"George Luks, the flamboyant, has nothing to do with good taste of one kind or another. [His flamboyance] is essentially his own, a natural gift

of vitality just as in the instances of Rabelais and of Rubens. . . . George Luks begins by having the bad taste of the braggart and goes on with a mad extravagance in untempered garruluousness and the impertinence . . . to exhibit canvases fat in form and luscious in color to a people accustomed to the cramped works of painters with whom good taste is a dominating idol. . . . Luks will go to those whose strength almost carries an odor with it. . . . He wants to make a record of the fullness of life, to render its rich warmth and flavor. This he does with a quality akin to mellowness and a sensuousness that is its counterpart."

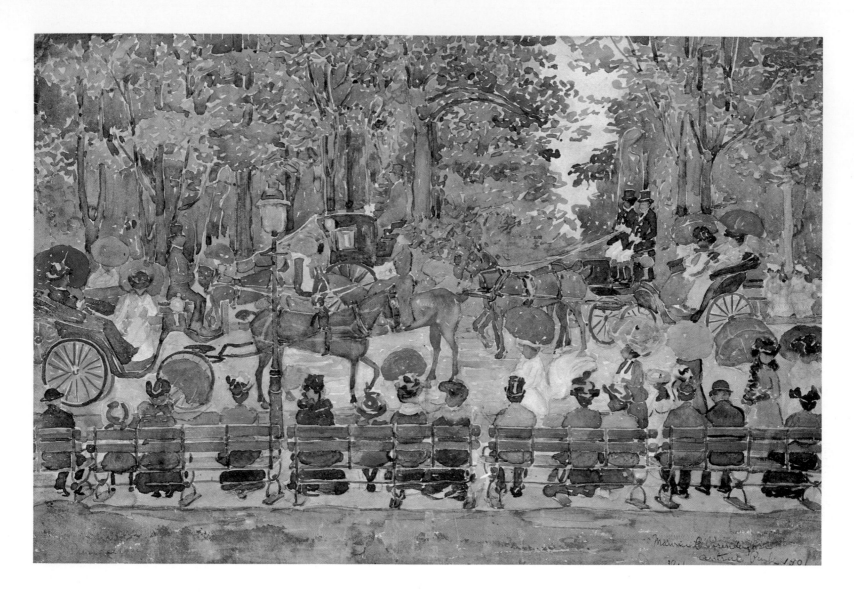

MAURICE B. PRENDERGAST. Born St. John's, Newfoundland, 1859; to United States 1861; died New York City 1924. *Central Park*. 1901. Watercolor, 14½″ × 21¾″. Whitney Museum of American Art, New York.

It was rebellion against the rigid standards of the National Academy of Design rather than any similarity in style that united the members of The Eight. Most of the group adhered to the tradition of dark Impressionism, but Prendergast, the oldest among them, reflected the most advanced tendencies that had been current in Paris in the last decade of the nineteenth century.

Prendergast first earned his living in Boston by doing lettering for show cards. He painted only in his spare time and received no formal training in art until he was over thirty, when he went abroad to study. During his three years in Paris, he was exposed to a number of influences: Japanese prints, the art of Whistler, and the ideas of a group of young artists known as the *nabis* (from the Hebrew word for "prophets"), which included Maurice Denis, Félix Vallotton, and Pierre Bonnard. Taking their cue from Gauguin, in their paintings and prints they emphasized color, symbolism, and decorative, flowing curves. Prendergast was also among the first American artists to know and appreciate the art of Cézanne.

On returning to Boston in 1894, he joined his brother Charles in his picture-framing business and worked as an illustrator, while devoting what-

ever time he could spare to painting in and around Boston and along its north shore. Another trip to Europe took him to Italy. He spent most of his time in Venice, delighting in the colorful spectacle of that city's daily life and festivals as he observed it at firsthand or encountered it in paintings by such old masters as Vittore Carpaccio and Francesco Guardi.

Back in America, Prendergast began making visits to New York to paint. His vision of the city was quite different from that of Bellows, Luks, or the other realists. This little picture of Central Park—one of a number he did on this subject between 1901 and 1903—might be a scene in Paris during the *belle époque*, and its friezelike composition is especially close to one of Bonnard's color lithographs, *Boulevard*, in the album *Quelques aspects de la vie de Paris*, published by Vollard in 1895. Prendergast's *Central Park* reflects the same love of crowds and processions as his earlier paintings of Venice or of seaside resorts, but underlying its decorative patterning there is now a far firmer compositional structure. In the foreground the long row of rectangular bench slats contrasts with the vertical lamppost and the curving forms, colorful garments, and parasols of the seated and strolling figures. Carriages and a horsewoman pass along the bridle path in the middle distance; wheels and parasols repeat the rounded shapes that Prendergast liked so well. Beyond, the screen of foliage is painted with the broken strokes of Impressionism; the vertical tree trunks provide a counterrhythm to

the horizontal bench slats in the foreground. An oil variant, *Central Park in 1903*, which Prendergast began in that year but worked on as late as 1915, is in The Metropolitan Museum of Art, New York; like others of his mature works, it shows his conversion of the Neo-Impressionist dots used by Georges Seurat and Paul Signac into schematized, rectangular brushstrokes that create a mosaiclike effect.

While in New York, Prendergast came to know the other artists of The Eight with whom he participated in the 1908 exhibition; one critic of the show condemned his "spotty canvases" as "artistic tommy rot." Five years later, seven of his watercolors were among the most advanced works by any American artist included in the Armory Show (see page 105). It is Prendergast's emphasis on the formal organization of composition and color, rather than on representation, that sets him apart from his realist associates, who detested modernist innovations, especially abstraction, as heartily as did the academicians and conservative critics. Perry T. Rathbone, former Director of the Boston Museum of Fine Arts, observed: "Prendergast's world was largely a peaceful world of holiday; a parade of picnics and beach parties, of summer outings, excursion crowds, of Sunday afternoons in the park. It is paradoxical that this beguiling spectacle with its sunlit charm, its lighthearted gaiety . . . should have been the spearhead in America of a radical artistic development."

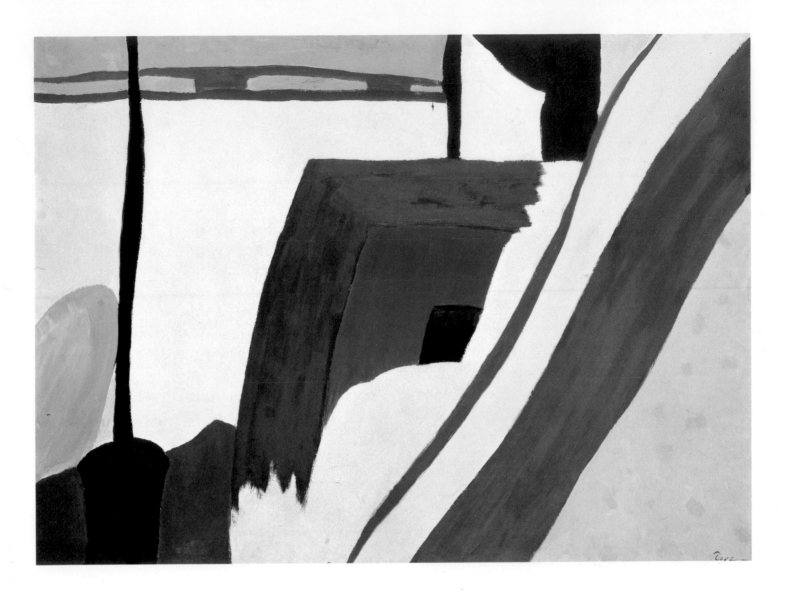

ARTHUR G. DOVE. Born Canandaigua, New York, 1880; died Centerport, Long Island, New York, 1946. *Sand Barge*. 1930. Oil on wood, 30″ × 40″. The Phillips Collection, Washington, D.C.

Although Prendergast assimilated the styles that had been in the vanguard during the years when he studied in Paris, and was among the first to absorb some of Cézanne's principles, he remained immune to the more recent tendencies that developed in Europe after the turn of the century. It was the large "International Exhibition of Modern Art," organized in 1913 by an ad hoc group calling itself the Association of American Painters and Sculptors, that first introduced to a wide public in America the innovations of modern art from Post-Impressionism to Cubism. Presented at the Sixty-ninth Regiment Armory in New York and then in Chicago, the show with its attendant publicity drew enormous crowds. Besides sounding the death knell both for the Academy and for the realism of The Eight, it opened the way for dealers who specialized in modernist art and patrons eager to buy it.

Even before the Armory Show, however, a number of American artists studying abroad shortly before and after 1910 had absorbed some of the new influences. Many of them were first exhibited in this country at the Photo-Secession Gallery, founded by the photographer Alfred Stieglitz at 291 Fifth Avenue in New York, where works by such Europeans as Toulouse-Lautrec, Rodin, Rous-

seau, Cézanne, Picasso, and Matisse were shown. Arthur G. Dove—like John Marin, Marsden Hartley, Charles Demuth, and Georgia O'Keeffe—was among the American pioneers of modernism first presented in Stieglitz's exhibitions at "291."

After graduating from Cornell University in 1903, Dove had become a successful magazine illustrator. He went abroad in 1907 and spent the next two years in Paris, where he met a group of other young American artists who introduced him to the art of Cézanne and the *fauves* ("wild beasts") headed by Henri Matisse. Shortly after returning to the United States, Dove met Stieglitz, who gave him his first one-man show in 1912 and continued to exhibit his work regularly thereafter.

At about the same time that Wassily Kandinsky and František Kupka were painting the first abstractions in Europe, Dove was independently creating the first American abstract pictures. From 1910 to 1920, while he lived in Westport, Connecticut, and supplemented his earnings as an illustrator by farming and fishing, he produced a series of works, often in pastel, that were brilliant in color and filled with bold, curvilinear rhythms.

Sand Barge was painted later, while Dove was living along the Long Island shore. A passage in the foreword he wrote for an exhibition catalogue of his works in 1927 might serve as its rubric: "I should like to take wind and water and sand as a motif and work with them, but it has to be simplified . . . to color and force lines and substances, just as music has done with sound." Selecting a

few elements from his environment, Dove reduced them to flat, abstract patterns that subtly balance and offset one another: the horizontals of the bridge and water beneath it, the verticals of chimney and smokestack, the diagonals of sand and water at the right, and the concentric inverted Ls of the cabin in the center. Within the low-keyed color range, even the orange is of muted intensity.

In 1930, the year in which *Sand Barge* was painted, the steady patronage of the critic and collector Duncan Phillips enabled Dove to give up illustration and devote himself entirely to painting. Living first on a farm in upstate New York near the area in which he had been born, and in Centerport, Long Island, from 1938 until his death, he reverted to the lyricism of his earlier abstractions but with stronger, more simplified forms. Nature always remained his point of departure, and at a time when the general trend of abstraction was toward geometrical analysis, Dove's style was highly personal; his shapes were never bounded by straight lines or precise arcs but were always responsive to organic rhythms of their own.

MAN RAY. Born Philadelphia 1890; lives in Paris. *The Rope Dancer Accompanies Herself with Her Shadows.* 1916. Oil on canvas, 4′ 4″ × 6′ 1⅜″. The Museum of Modern Art, New York (Gift of G. David Thompson).

Besides the activity of Stieglitz and the impetus of the Armory Show, a further stimulus to modernism —particularly abstraction—soon came from the presence of European artists in the United States during the war years. Most important among them were Marcel Duchamp, whose *Nude Descending a Staircase,* 1912 (Philadelphia Museum of Art), had been by far the most notorious item in the Armory Show, and Francis Picabia, who in close association with Duchamp evolved a type of abstraction largely devoted to exploring the erotic implications of machines. The work that they produced during their residence in New York closely approximated what was being evolved simultaneously by the Dadaists in Zurich and Berlin, who had a more programmatic intention of overthrowing accepted canons of art.

Man Ray, who had studied at the National Academy of Art and the Art Students League and had been a pupil of Henri's, was deeply impressed by the Armory Show. He determined to change his style completely, reducing human figures to flat-patterned, disarticulated forms; as he later wrote: "All idea of composition as I had been concerned with it previously . . . was abandoned, and replaced with an idea of cohesion, unity and a dynamic quality as in a growing plant." He formed a close friendship with Duchamp when the latter arrived in New York in 1915. In that year Man Ray "started a large canvas. . . . The subject was a rope dancer I had seen in a vaudeville show. I began by making sketches of various positions of the acrobatic forms, each on a different sheet of spectrum-colored paper, with the idea of suggesting movement not only in the drawing but by a transition from one color to another. I cut these out and arranged the forms into sequences before I began the final painting. After several changes in my composition I was less and less satisfied. It looked too decorative and might have served as a curtain for the theater. Then my eyes turned to the

pieces of colored paper that had fallen to the floor. They made an abstract pattern that might have been the shadows of the dancer or an architectural subject, according to the trend of one's imagination if he were looking for a representative motive. . . . Scrapping the original forms of the dancer, I set to work on the canvas, laying in large areas of pure color in the form of the spaces that had been left outside the original drawings of the dancer. No attempt was made to establish a color harmony; it was red against blue, purple against yellow, green versus orange, with an effect of maximum contrast. The color was laid on with precision, yet lavishly. . . . When finished, I wrote the legend along the bottom of the canvas: The Rope Dancer Accompanies Herself with Her Shadows. The satisfaction and confidence this work gave me was greater than anything I had experienced heretofore, although it was incomprehensible to any of our visitors who saw it. . . . What to others was mystification, to me was simply mystery."

In 1916 Man Ray joined with Duchamp and the collector Walter Arensberg in founding the Society of Independent Artists, and three years later together with Duchamp, Katherine C. Dreier, and others founded the Société Anonyme: Museum of Modern Art (despite its name, a peripatetic organization), which became a major force in exhibiting and acquiring works of modern art. On his arrival in Paris in 1921 Man Ray was welcomed as the first American member of the Dada group, and André Breton wrote an ode hailing him as "The catcher of the seen and the celebrant of shadows." Man Ray also played a leading role in launching the Surrealist movement, which had its first exhibition in Paris in 1925. He remained in Paris until World War II, then came to California, but returned to Paris in 1951.

A prolific worker in many mediums, Man Ray has been active as photographer, filmmaker, and maker of objects. His art exerted an important influence on Pop and neo-Dada artists in the 1960s; and, as the critic Jules Langsner has pointed out: "The *Rope Dancer* (along with certain other works between 1916 and 1920) parallels current efforts to interlock flat color forms on the surface plane."

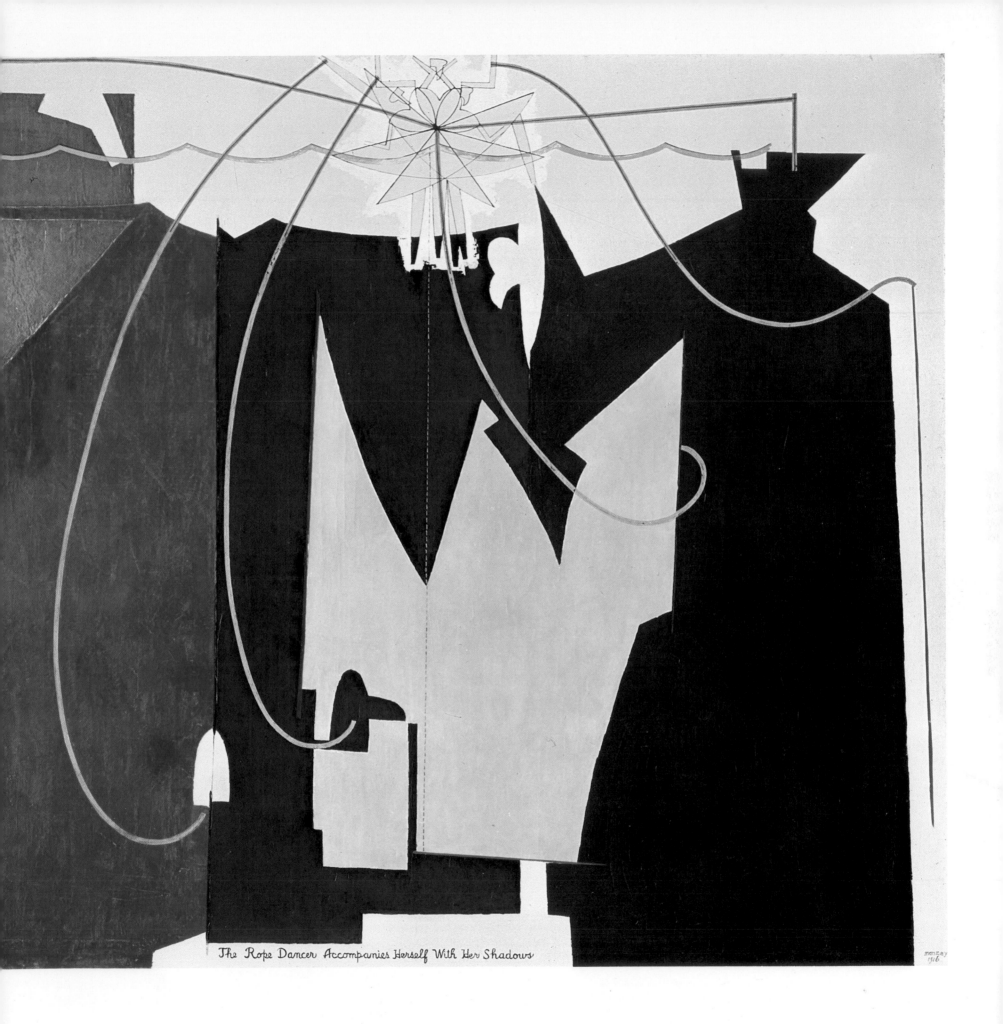

The Rope Dancer Accompanies Herself With Her Shadows

JOHN COVERT. Born Pittsburgh, Pennsylvania, 1882; date and place of death (sometime after 1960) unknown. *Brass Band*. 1919. Oil and string on board, 26″ × 24″. Yale University Art Gallery, New Haven, Connecticut (Société Anonyme Collection).

John Covert was among those whose art underwent a radical change through contact in New York with Picabia, Duchamp, Stieglitz, and others who frequented the salon of the collectors Walter and Louise Arensberg (see page 106). He had studied for six years at the School of Design in Pittsburgh and four more years in Munich before moving to Paris in 1912. Until his return to the United States in 1915, he painted in an academic style, seemingly quite oblivious of—or at least impervious to—any of the current modern movements.

The oil-and-string technique and rounded forms in Covert's *Brass Band* derive from Duchamp's *Chocolate Grinder, No. 2*, made in 1914 as one of the preparatory studies for the so-called "Large Glass" (*The Bride Stripped Bare by Her Bachelors, Even*), which was owned by the Arensbergs as early as 1918 (both now in the Louise and Walter Arensberg Collection, Philadelphia Museum of

Art). The two works are nevertheless entirely different in intention and effect. Duchamp's was an accurate, although geometrically schematized, representation of an actual chocolate-grinding machine. Even though its design was to be completely flattened when transferred from canvas to a central position on the "Large Glass," in his study Duchamp showed the object in carefully calculated perspective, in accordance with his desire to liberate himself entirely from the influence of Cubism, with its emphasis on shallow space.

Covert's work, on the other hand, is totally abstract, devoid of any representation beyond the suggestion of drums implied in the title. It is a study of directional movement and intersecting planes, which operate not only across the surface but also advance and recede in depth. To enhance the illusion of three dimensions, the prevailing ivory-colored paint (probably white originally) is shaded with tones of tan and gray, deepening to charcoal in the areas of greatest recession. The precision with which the strings are placed to create the effect of perspective is countered by the many casual drippings of oil paint on the rough surface.

Covert produced only a few abstract works, all

as individual in style as *Brass Band*. After participating as a founder and director of the Society of Independent Artists and exhibiting in its first show in 1917, he decided he could not make a living as an artist. In 1923 he returned to Pittsburgh and worked in the steel industry until his retirement. He then came back to New York, where he lived in total seclusion; although he reportedly resumed painting, absolutely nothing is known of his last years.

Before leaving New York in 1923 Covert gave to the Société Anonyme six of his paintings, which became the nucleus of its collection (since 1941, in the Yale University Art Gallery at New Haven) In the Société Anonyme catalogue Marcel Duchamp wrote: "Among the young American painters who, in 1915, joined forces with the pioneers of the new art movement, John Covert was an outstanding figure from the beginning. Instead of following and adopting one of the new expressions, he found his personal form in a combination of painting and sculpture, reliefs made of superimposed planes." Duchamp observed that the "unrolling of interwoven surfaces" in Covert's works anticipated a like effect in some of Antoine Pevsner's Constructivist sculpture.

PATRICK HENRY BRUCE. Born Long Island, Campbell County, Virginia, 1881; died New York City 1936. *Vertical Beams.* c. 1932. Oil on canvas, 31⅞″ × 51¼″. Hirshhorn Museum and Sculpture Garden, Smithsonian Institution, Washington, D.C.

Among the American artists most firmly committed to total abstraction in the first third of the twentieth century was Patrick Bruce. After a year or so of study with William Merritt Chase and Robert Henri, he went to Paris in 1904, where he remained until shortly before his death. He first became interested in modern movements through Gertrude and Leo Stein, whom he met in 1907. The following year he joined their sister-in-law Sarah Stein in organizing the classes taught by Henri Matisse. One of Matisse's precepts was to "construct by relations of color, close and distant," and this, as well as Cézanne's system of laying on color in parallel brushstrokes, greatly influenced the development of Bruce's style.

From 1912 to 1913 he was associated with the circle around Robert Delaunay, whose rhythmic abstractions in pure color the poet-critic Guillaume Apollinaire called "Orphic" because of their analogies to music. Like the artists of this group Bruce made an intensive study of the optics of color, especially the theories first postulated by Michel-Eugène Chevreul in 1839 and elaborated some forty years later by the American physicist O. N. Rood. Their most important principle—also used by Seurat and his followers—was the "law of simultaneous contrasts," which asserted that juxtaposed colors change one another's aspect when observed at the same time.

Vertical Beams belongs to a series of abstract geometrical compositions called Forms, which Bruce began in 1918 and continued to develop until 1932. Although the interaction of colors remained a central concern, he progressively simplified these compositions with respect to the number of elements used in each, attaining an ultimate reduction and condensation of forms in this, his last completed painting. In Bruce's late works, William C. Agee has said: "Each and every surface, angle, and connecting joint was painstakingly related to the crystalline fusion of surface and depth. Like the still-lifes of Cézanne . . . they pose the problem of reconciling the illusion of three dimensions on a two-dimensional canvas, of creating movement and depth while maintaining surface flatness . . . functioning with the logic and sureness of a machine, yet avoiding a mechanistic dryness by their reliance on the contrasts of color and value and the infinite number of formal alternates, contradictions, and intricacies they presented. . . . As Bruce mastered his problem he relied on fewer and fewer spatial demarcations . . . he used a minimum of hues . . . to bind and interlock the color planes. . . . Thus the interacting colors were fundamental to the planar construction of his painting, constructed without recourse to connecting lines." Bruce declared that "line is only the border of surface. Line exists only as a draughtsman's tool. If line is apparent, it is a drawing."

Whereas some of the paintings within the series are highly abstracted still lifes on tilted tabletops, reminiscent of Cézanne's compositions, *Vertical Beams,* as its descriptive title implies, is architec-

tonic in its conception. A dynamic tension is set up between the three-dimensionality of the gabled structure in the lower left, and especially that of the large horizontal element that thrusts its way diagonally across the canvas from the upper left corner, and the flatness of the other units within the picture. The prominent areas of white and silvery gray are offset against a bright blue background that suggests the sky; the few other colors—rose, yellow, mauve, a pale bluish green, and a pale grayish blue—are of low intensity.

Earlier in his career Bruce had exhibited frequently, and five of his paintings done between 1914 and 1918 were acquired by the Société Anonyme. But the lack of understanding accorded his later work discouraged and depressed him. In 1932 he gave up painting altogether and destroyed all but about a dozen of his remaining canvases. Four years later he returned to New York and shortly thereafter committed suicide.

During the first sixteen years of his European sojourn Bruce maintained close contacts with Americans in addition to the Steins, already mentioned. He joined with a group of other painters to form the New Society of American Artists in Paris in 1908, participated in the Armory Show in 1913, and was represented in exhibitions in New York in 1917 and 1918. As Mr. Agee has pointed out, his efforts to adapt nineteenth-century color theories to twentieth-century concepts of abstraction place Bruce squarely within the tradition of American artists who have sought an alliance between science and art.

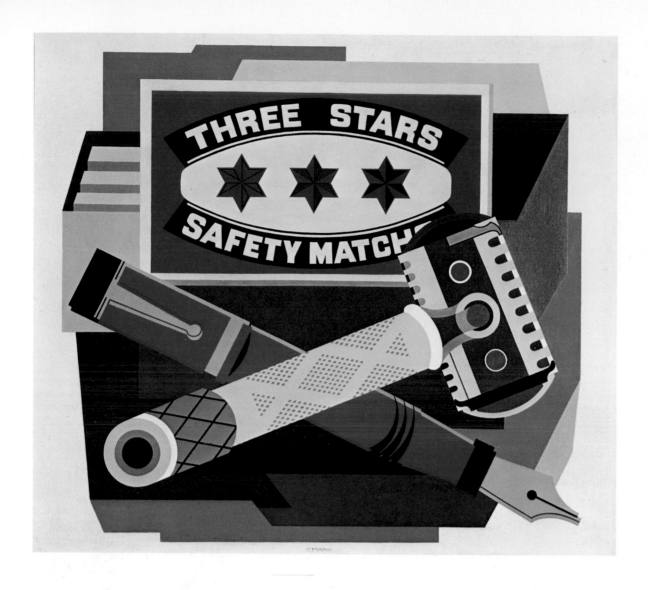

GERALD MURPHY. Born Boston 1888; died East Hampton, Long Island, New York, 1964. *Razor*. 1924. Oil on canvas, 32⅝" × 36½". Dallas Museum of Fine Arts, Foundation for the Arts Collection, Dallas, Texas (Gift of the artist).

Malcolm Cowley wrote of the "lost generation" of American writers and artists who lived and worked in France in the 1920s that they had left the United States in rebellion: "First . . . against the conventionality of their elders and the gentility of American letters; then . . . against the high phrases that justified the slaughter of millions in the First World War; then . . . against the philistinism and the scramble for money of the Harding years." They were drawn to Paris because it seemed to them the center of all that was interesting in the arts and letters; yet "the voyage had an unexpected effect on most of them: it taught them to admire their own country, if only for its picturesque qualities. But they still preferred to admire it from a distance."

Gerald Murphy was thirty-three when he came to Europe in 1921, planning to live on funds from his father, head of the successful New York firm of Mark Cross and Co., and the comfortable income inherited by his wife, Sara. Except for a course in mechanical drawing taken at Harvard, he had had no art instruction or any intention of becoming an artist; but when he saw paintings by Picasso, Matisse, Braque, and Gris in a Paris gallery, he

exclaimed, "If that's painting, that's what I want to do." He studied for a while with the Russian emigrée Natalia Goncharova, whose teaching was entirely concerned with abstraction, and then worked alone with total dedication, first in his Paris studio and then in his villa at Antibes.

As methodical in his habits as he was precise in his painting technique, Murphy jotted down his ideas for pictures in a notebook. One of these entries reads: "Picture: razor, fountain pen; etc.; in large scale nature morte big match box." The Gillette razor blade and the red-rubber Parker fountain pen were regarded as specifically American objects, like the brand of safety matches in their strikingly designed box with its bold lettering.

"*Razor* is an essentially Cubist picture," William Rubin has written in his monograph on Murphy. "The centralized, almost iconic still-life objects are seen against a structure of abstract forms which establish a shallow 'relief' space. . . . What appears to be an effect of foreshortening in the razor is actually a result of the Cubist device of representing elements of the same object from different angles. . . . Murphy summarized this presentation as treating the razor 'mechanically, in profile and section, from three different points of view at once.' . . . The fountain pen . . . gets its relief from its brilliant red and yellow coloring. (Its somewhat orangeish red is purposely and grindingly at odds with a more bluish red and the red-brown of the matchbox front, asserting a kind of 'bad taste'

and giving an individual note to what threatened in Murphy's art . . . to descend to 'good taste.'" Murphy's painting impressed Picasso as simple, direct, and distinctively American; his work was also admired by Léger, who when he came to the United States during World War II declared that "bad taste is one of the valuable raw materials" of this country.

Mr. Rubin also points out that "While frontality, simple geometricity, and precise impersonal execution" are characteristic of many Cubist still lifes of the 1920s, "these same stylistic properties are also to be found in American naïf art, which was one of Murphy's great passions. . . . The naïveté of American primitivism and the sophistication of French Cubism . . . surprisingly shared more common ground than one might think." The accurate depiction of banal objects in large scale and the deliberate embracing of "bad taste" in *Razor* also foreshadow Pop art to a surprising degree.

A series of family misfortunes and obligations compelled Murphy to give up painting after he had completed only about a dozen works between 1922 and 1929. He returned to the United States and assumed control of Mark Cross; but, like Samuel F. B. Morse (see page 52), he felt bitter sorrow at having to abandon art and said, "I was never happy until I started painting, and I have never been thoroughly so since I was obliged to give it up."

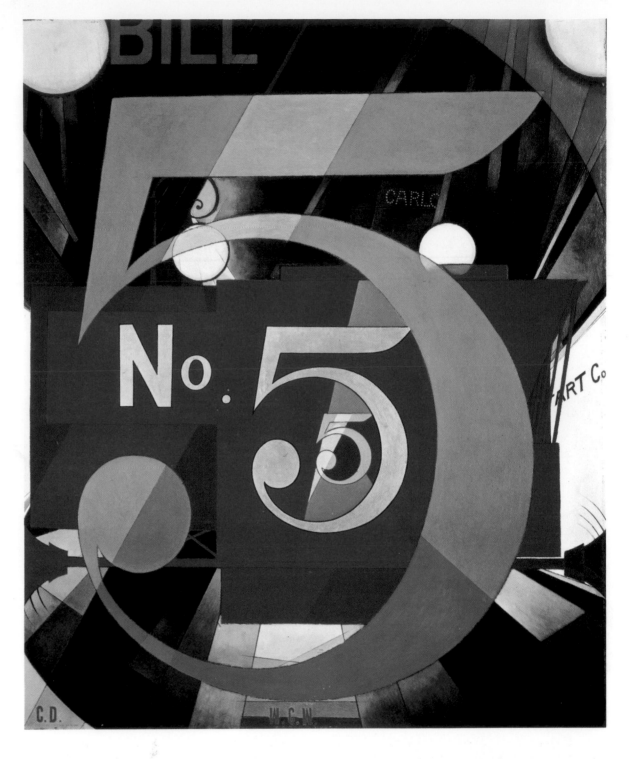

CHARLES DEMUTH. Born Lancaster, Pennsylvania, 1883; died there 1935. *I Saw the Figure 5 in Gold*. 1925. Oil on composition board, 36″ × 29¾″. The Metropolitan Museum of Art, New York (Alfred Stieglitz Collection).

Charles Demuth met Marcel Duchamp and many of the Cubists while studying in Paris between 1912 and 1914, and on his return to the United States he was quickly drawn into the circle of modernists who frequented the Arensbergs' salon in New York (see page 108). From 1925 on, Demuth was also closely associated with Alfred Stieglitz and his circle (see page 105). He alternated his life in New York with retreats to his home in Lancaster, Pennsylvania, making the Colonial architecture and industrial buildings of that town the subject of many of his paintings.

The series of abstract "poster portraits" that Demuth created of many of his close friends—including Arthur Dove, Marsden Hartley, John Marin, and Georgia O'Keeffe—differed from Hartley's "military portraits" (see page 15) because of their allusions to specific subjects. Finest among them is *I Saw the Figure 5 in Gold*, dedicated to the poet William Carlos Williams, with whom Demuth enjoyed a lifelong friendship dating back to their student days in Philadelphia in 1905. The title of the painting and much of its imagery derive from one of Williams's poems:

> THE GREAT FIGURE
> Among the rain
> and lights
> I saw the figure 5
> in gold
> on a red
> firetruck
> moving
> tense
> unheeded
> to gong clangs
> siren howls
> and wheels rumbling
> through the dark city.

Henry Geldzahler, Curator of Contemporary Arts at The Metropolitan Museum of Art, has written a definitive analysis of this work: "The painting has futurist and cubist features: the prismatic breakdown of space and light, which in part refers to the rain and light in the poem, the use of

words and numbers to help establish the two-dimensionality of the picture plane, as in the largest 5, the word BILL, and, at the bottom of the painting, the initials C.D. and W.C.W., referring to the artist and the poet. However, the letters and numbers are used not only to establish the surface plane but also to suggest the opposite: deep space. We see this in the diminishing and therefore receding 5's and in the word CARLOS, the latter cut off by an element that lies behind the planes of the 5's. The painting is pulled back from complete abstraction only by the use of words and letters and by the street lamp and distorted buildings. The angularity of the prismatic background is played off against the recurring circles: those of the four lights in the top half, the curve of the street-lamp standard, the bulbs at the lower tips of the 5's, and the quite arbitrary curve at the lower left and upper right of the painting. We feel the tremendous activity within the painting and also its final

calm and control. Despite the directional lines borrowed from the futurists and the intellectually organized space that comes from cubism, the cumulative effect of directness, sense of scale, and clarity is American. Of his relationship to the art of Europe Demuth once observed, 'John Marin and I drew our inspiration from the same source, French modernism. He brought his up in buckets and spilt much along the way. I dipped mine out with a teaspoon but I never spilled a drop.'"

The references to the American environment, the translation of elements from the "real" world into formal geometrical patterns, and the incorporation of letters, words, and numerals into this and other works of Demuth were all motifs taken up later by Pop artists. Two of them, Jasper Johns and Robert Indiana, have paid specific tribute to *I Saw the Figure 5 in Gold* in paintings of their own in which the number 5 forms the central feature of the composition.

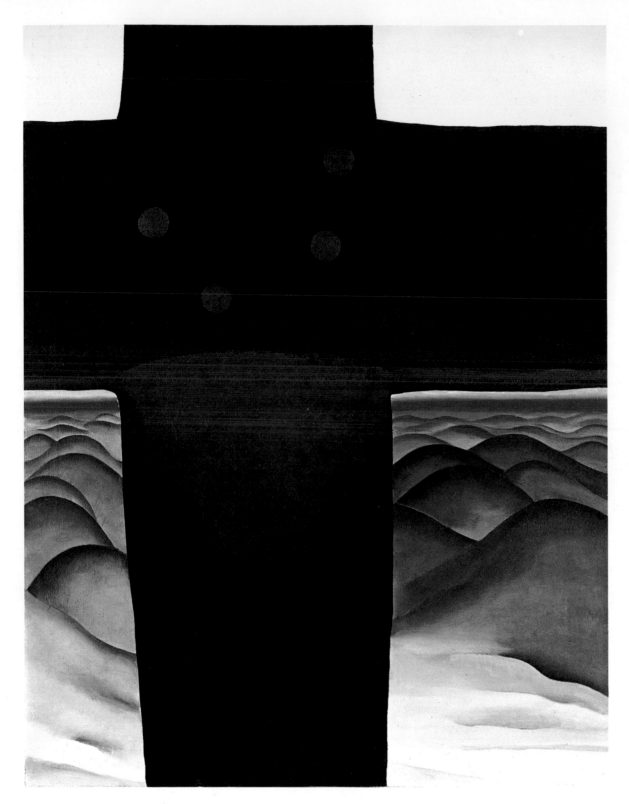

GEORGIA O'KEEFFE. Born near Sun Prairie, Wisconsin, 1887. *Black Cross, New Mexico.* 1929. Oil on canvas, 39″ × 30″. The Art Institute of Chicago.

Georgia O'Keeffe first met Alfred Stieglitz in 1916, when she came to "291" to protest his unauthorized hanging of some charcoal drawings that a friend had shown him without her knowledge. (His initial reaction to them, "At last, a woman on paper!," was much like that of Degas half a century before when he first encountered the paintings of Mary Cassatt.) The following year Stieglitz gave O'Keeffe the first of the many one-man shows he was to organize for her, and in 1924 they were married.

O'Keeffe's style underwent many influences and ranged from precise realism to pure abstraction before she fully developed her personal means of expression. She had studied at Teachers College, New York, with Arthur Dow, the most unorthodox among American art teachers; basing his instruction on the principles of design he discerned in Oriental art, he rejected realism and emphasized simplification, flat patterns, and harmonious composition. Some of O'Keeffe's early paintings—abstractions characterized by bright color and rhythmic curves—resemble those that Arthur Dove was doing at about the same time (see page 105). In the 1920s she worked in a more geometrical, hard-edge style, close to Charles Demuth's precisionism; the sharp focus and closeup views in many of these paintings have sometimes been thought to reflect Stieglitz's photographic vision.

Whether she painted at Lake George, on the Gaspé peninsula, in Bermuda, or in the Southwest, the sources of O'Keeffe's imagery have always been in nature. Born on a 600-acre farm in Wisconsin, she declared herself at home amid the vast plains, wide skies, and "terrible loneliness" of the windswept Texas Panhandle, where she had her first teaching job after leaving art school. She visited Taos, New Mexico, in 1929 and from then on spent most of her summers in New Mexico or Arizona. In 1945 she bought a house in Abiquiu and after Stieglitz's death settled there permanently in a one-story adobe that she rebuilt. One of the few non-Spanish Americans in that small and remote community, she has continued to find her subjects in the surrounding desert, with its animal skulls and bones bleached by the action of sand, sun, and wind, and in the nearby mountains, mesas, and cliffs.

O'Keeffe's love of that landscape with its brilliantly colored land and sky, and her sense of the spiritual life of its inhabitants, are epitomized in *Black Cross.* "In New Mexico the crosses interest me because they represent what the Spanish felt about Catholicism—dark, somber—and I painted them that way," she said. The huge outstretched arms of the cross, brought up to the very front plane of the canvas, loom impressively against the background of pale bluish gray sky, lit by a single star in the upper right, and deepening through yellow to red at the horizon. Beyond the white, gray, and yellow sand just behind the cross, the rounded contours of successive mountain ranges run a gamut of hues, through reds and blues to lavender in the distance.

This picture was painted in the year that O'Keeffe spent her first summer in New Mexico. Ten years later, she wrote of the similar topography of Arizona: "Badlands roll away outside my door—hill after hill—red hills of apparently the same sort of earth that you mix with oil to make paint. All the earth colors of the painter's palette are out there in the many miles of badlands. The light Naples yellow through the ochres—orange and red and purple earth—even the soft greens. . . . Our waste land—I think our most beautiful country."

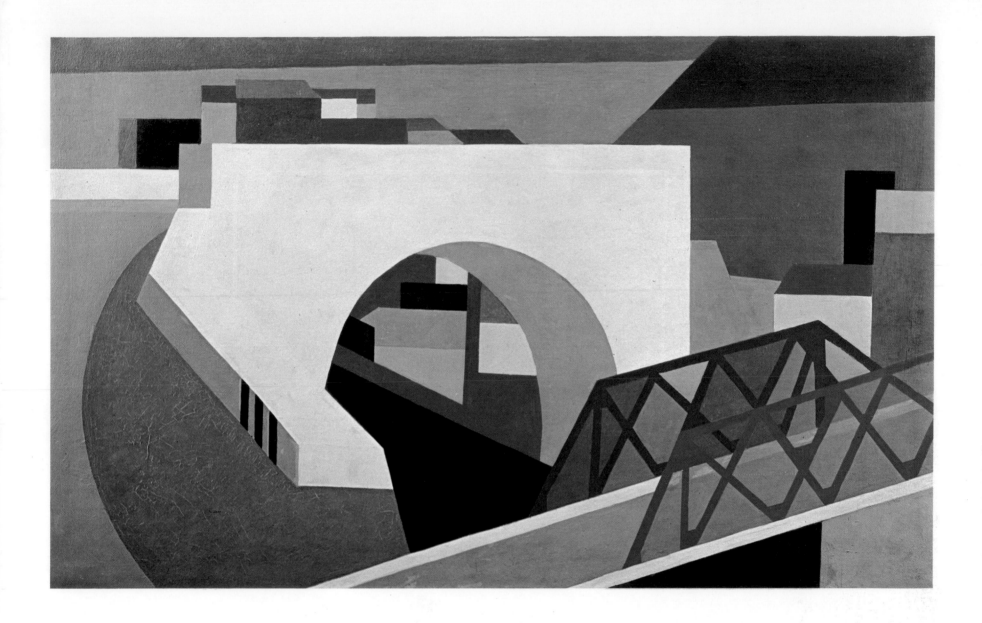

NILES SPENCER. Born Pawtucket, Rhode Island, 1893; died Dingman's Ferry, Pennsylvania, 1952. *Two Bridges*. 1947. Oil on canvas, 28½″ × 45½″. Neuberger Museum, State University of New York College at Purchase, New York.

Niles Spencer—like Charles Demuth, Charles Sheeler, and for a time Georgia O'Keeffe—was among those artists who adapted Cubist principles to create a precise, hard-edge style with which to depict America's urban and industrial scene. He studied first at the Rhode Island School of Design in Providence and then with George Bellows and Robert Henri in New York, but he differed from them in seeing the city unpeopled and in terms of abstract patterns. After traveling in France and Italy, Spencer divided his time between New York and seacoast towns, successively Ogunquit, Maine, Provincetown, Massachusetts, and Sag Harbor, Long Island, where he converted an old saltbox into a studio and summer residence.

The surfaces of Spencer's paintings are matte and slightly rough, unlike those of the other precisionists, and his colors are darker and richer than theirs. From Cubism he assimilated spatial ambiguities and shifting planes, but he used these devices in a personal way that imparted an aura of mystery to his pictures.

In *Two Bridges,* one of Spencer's late works, all the elements from the locale that served as his motif have been subjected to strict geometrical control. The diagonal of the bridge with its crisscrossed red struts shoots off to the right at an acute angle from the bottom of the canvas, passing over the black roadway below. The strongly defined arch of the bridge and sweeping green curve at the left contrast with the predominantly rectilinear forms that make up the design. The support of the archway angles off in another direction at the left, then back and upward to the top of the structure, which is exactly parallel to the picture's upper edge and the dark gray band below it. The buildings seen through and beyond the arch are flattened shapes, but two rectangular openings at the upper left—one black, the other white—are shown in three dimensions. There is a sense of constant movement back and forth in space as well as across the surface of the picture.

During the 1930s and 1940s the issue of realism versus abstraction was hotly debated among artists. Proponents of Social Realism and "the American scene" accused those who applied to their paintings abstract principles derived from Cubism of being overly subordinate to foreign influences. The fact is, of course, that a preference for clean, hard-edged contours has existed as a strong tendency in

American painting ever since the days of the early limners and has sometimes even been considered *the* distinctive characteristic of our art. As for the supposed dichotomy between realism and abstraction, Spencer made his views clear in a statement made for a group show in 1941: "The term Realist, as it is applied to contemporary painting, has acquired a number of contradictory associations. . . . There is realism in the work of abstract artists. Picasso, for example, is always concerned with some basic reality. . . . The deeper meanings of nature can only be captured in painting through disciplined form and design. The visual recognizability is actually irrelevant. It may be there or not. 'Realism' is a pretty much battered around word, but its true meaning has always been a part of the modern artist's concern, and if he is to realize his purpose, it always will be."

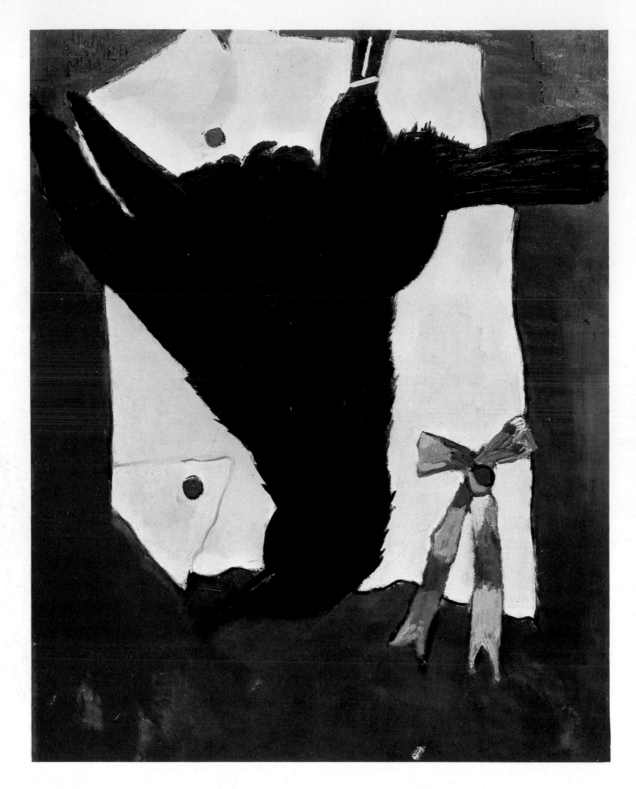

MARSDEN HARTLEY. Born Lewiston, Maine, 1877; died Ellsworth, Maine, 1943. *Crow with Ribbons*. 1941–1942. Oil on masonite, 28″ × 22″. Hirshhorn Museum and Sculpture Garden, Smithsonian Institution, Washington, D.C.

Marsden Hartley is another of the artists who was deeply influenced by his first encounter with modern art, especially with that of Cézanne, at Stieglitz's "291" gallery. Stieglitz gave Hartley his first one-man show in 1909 and three years later helped to finance his first trip abroad. Unlike most of the American artists who went to Europe at that time, Hartley was not attracted by the intellectual Cubism then dominant in Paris but by the emotionally charged art of the German Expressionists. He participated with them in exhibitions in Munich and Berlin, and after a brief return to the

United States—during which he was represented in the Armory Show and had another exhibition at "291"—he went back to Berlin, where he remained throughout the first two years of World War I.

The so-called "military portraits" that Hartley exhibited after his return to America in 1915 are in fact abstract compositions, painted in heavy impasto with strong reds, yellows, greens, blues, and black and made up of such emblems as flags, letters and numerals, epaulettes, and the Maltese iron cross (page 15). He denied that they were intended to be symbolic: "The forms," he declared, "are only those which I have observed casually from day to day. . . . Things under observation, just pictures of any day, any hour. I have expressed only what I have seen . . . my notion of the purely pictorial."

Soon afterward, Hartley abandoned abstraction

for more natural representation. A loner and a wanderer, he visited the American Southwest, Mexico, Bermuda, and many parts of Europe; he lived abroad from 1921 to 1929, spending many months in Aix-en-Provence with the avowed intention of taking up where Cézanne had left off. During the 1920s and 1930s his style underwent many changes, but especially decisive for his final development was his experience in Nova Scotia. He lived with a fisherman's family and produced a number of pictures imbued with a strong sense of religiosity and painted in a boldly simplified, consciously primitive style, with bright colors, heavy outlines, and strongly marked rhythmic patterns.

Even more important was Hartley's return to Maine in the late 1930s. There at last he found his spiritual home; he celebrated the occasion with a poem, "The Return of the Native," called one of his exhibitions "On the Subject of Nativeness—A Tribute to Maine," and styled himself a "Maine-iac" and "the painter from Maine"—pointing out that he had a special claim to the title, since unlike Winslow Homer and John Marin he had been born in that state. His art became increasingly romantic, carrying on the tradition of Albert Ryder, whom Hartley had known and admired profoundly because he possessed "the eye of the imagination, that mystical third somewhere in the mind which transposes all that is legitimate in expression."

The fate of wildlife in the rigorous winter climate of Maine deeply moved Hartley, as it had Homer in *The Fox Hunt* (page 90). He painted a number of pictures of dead birds—a subject that Ryder had also portrayed. It is not with Homer or Ryder, however, that Hartley's *Crow with Ribbons* invites comparison, but rather with Alexander Pope's *Trumpeter Swan* (page 91). In both paintings, the dead bird is hung up like a trophy, its form suggesting a crucifixion. In contrast to Pope's illusionistic rendering, which emphasizes the texture of the soft white plumage, Hartley's crow with its jagged outline is painted with a drier brush in broad, flat strokes of almost unrelieved matte black. The limp body, its legs bound by a dull yellow cord, stands out starkly against the white cloth affixed to a russet background; but there are touches of bright color in the stud heads and the ribbon, with one streamer in shades of red, the other in shades of blue.

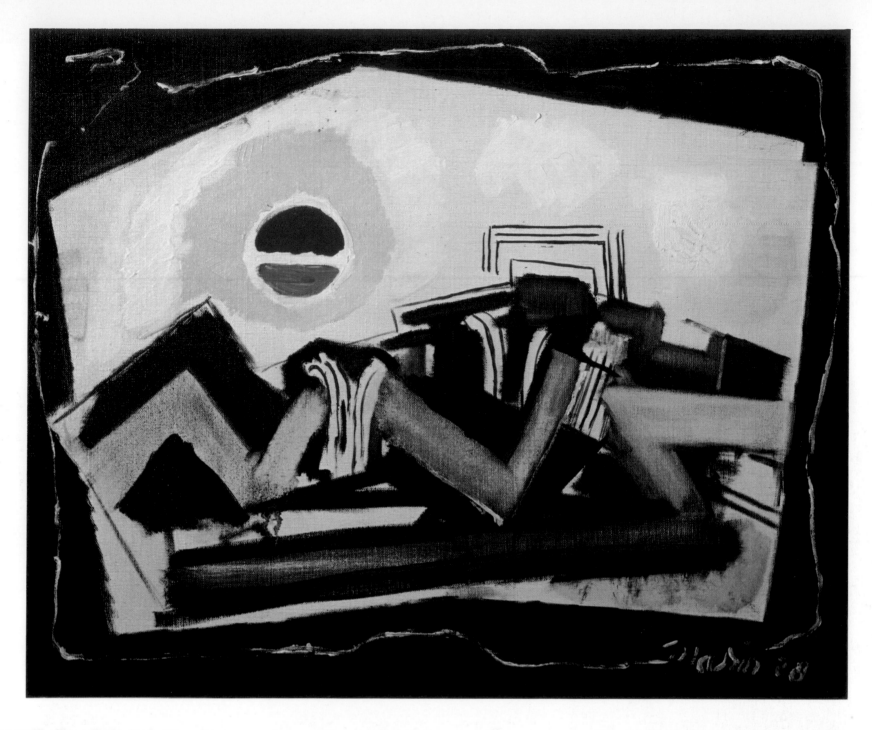

JOHN MARIN. Born Rutherford, New Jersey, 1870; died Cape Split, Maine, 1953. *Movement in Brown with Sun*. 1928. Oil on canvas, 22″ × 27″. Collection of Andrew J. Crispo.

Although John Marin was senior to Dove by ten years and to Hartley by seven, and although he lived and exhibited abroad from 1905 to 1911, his style did not begin to develop its individuality until he established contact with Stieglitz in 1909, when he was almost forty. Previously his work had been delicate, with mingled influences from Impressionism, Whistler, and Oriental art. Marin's return to New York and his contact with Cubism and Futurism released in him a burst of explosive energy. Like Dove, he always took motifs from the real world as his point of departure, but in contrast to Dove's lyricism, Marin's art was excited and dramatic. In the catalogue of his one-man show at "291" in 1913, in which he exhibited watercolors of New York, he said he wanted to express in them "great forces at work; great movements . . . the warring of the great and the small; influences

of one mass on another greater or smaller mass . . . these powers are at work pushing, pulling, sideways, downwards, upwards." This formulation anticipates by several decades a similar concept of Hans Hofmann, who called the dynamic interaction between flatness and depth "push and pull," and whose teachings strongly influenced the development of Abstract Expressionism in the 1940s (see pages 17 and 141).

Beginning in 1914 Marin spent most of his summers in Maine. He brought to his paintings of its rugged coast and surrounding waters the same expressionistic violence that had characterized his pictures of New York. Although he is best known for his watercolors, from the late 1920s on he also worked extensively in oils, the medium in which the *Movement in Brown with Sun* is painted.

Marin here utilized one of his favorite devices, which he had adapted from Cubism and used in a highly personal way: an irregular frame-within-a-frame surrounds the central subject in order to reconcile illusionistic depth with the desired sense of the canvas's flatness. The white line that

meanders over the surface of this frame seems like a graphic extension of the signature and date in the lower right corner.

The key to the composition is provided in the title, the word *movement* denoting a system of thrusts and counterthrusts. Elements taken from nature are freely transformed both in color and in shape. The dark tonality with brown predominating is surprising and somewhat exceptional in Marin's work. The jagged zigzags of pier and breakwater are repeated in the triangular peaks of the islands at the left; the sky with its white clouds is a strange, dull yellow; the sun's disk is split into two segments, dark red and orange, and surrounded by concentric rings of white, yellow, and white again. Much of the tension within the painting is provided by the contrast between the darkness of the foreground and the radiance of the background, and between the heavy massiveness of some of the forms and the openness of the system of parallel lines that Marin used like a kind of visual shorthand to define the breakers and the skeletonized bridge.

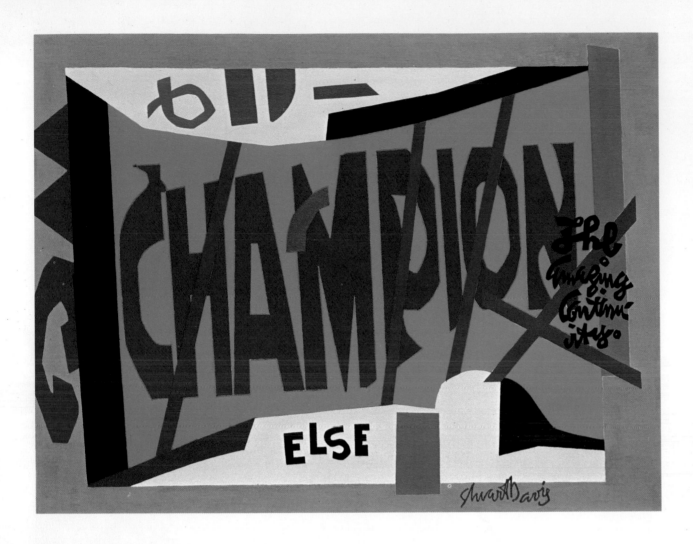

STUART DAVIS. Born Philadelphia 1894; died New York City 1964. *Visa.* 1951. Oil on canvas, 40″ × 52″. The Museum of Modern Art, New York (Gift of Mrs. Gertrud A. Mellon).

If one were to be inveigled into the inane exercise of nominating the "ten most American painters of the twentieth century," Stuart Davis would surely place near the top of the list. Yet his style received its major impetus from Cubism, and he vehemently opposed every kind of artistic chauvinism, insisting that any attempt to isolate American artists from their European roots and contacts would be to deprive them of their cultural heritage. At the same time he acknowledged that his pictures always received their impulse from the American environment, listing among the things that stimulated him: "American wood and iron work of the past; Civil War and skyscraper architecture; the brilliant colors on gasoline stations; chain-store fronts, and taxicabs; . . . electric signs; the landscape and boats of Gloucester, Mass.; 5 & 10 cent store kitchen utensils; movies and radio; Earl Hines hot piano and Negro jazz music in general." Davis also believed, like Niles Spencer (see page 113), that the distinction between "abstraction" and "realism" was completely artificial; what he called "genuine" painting was "the language of color-space, or form and color. . . . The form is always . . . of a certain kind of space, and of objects that have reference to objective reality . . . interpreted by those who understand in terms of their own optical and motor experience." He thought modern idioms were a necessary mode of expression be-

cause of the "revolutionary lights, speeds, and spaces of today, which science and art have made possible. An artist who has traveled on a steam train, driven an automobile, or flown in an airplane doesn't feel the same way about form and space as one who has not. An artist who has used telegraph, telephone, and radio doesn't feel the same way about time and space as one who has not."

Davis's father was art editor of the *Philadelphia Press* at the time when it employed several of the artists in Robert Henri's circle who were later to organize The Eight. Davis himself left high school in 1910 to come to New York and study for three years with Henri. This, he later said, was one of the two dominant forces in his early art education—the second being his exposure to the work of European modernists in the Armory Show. He had already rebelled against Henri's overemphasis on subject matter and now set out to reeducate himself as a modern artist. Departing from naturalistic representation, he concentrated on such formal elements of composition as space, color, and planes. In some of his pictures from 1924 and 1925, he reduced commonplace objects such as a bottle of mouthwash to simplified, geometric forms arranged on the flat surface of the canvas in a manner not unlike that of Gerald Murphy's *Razor* (page 110) and similarly anticipating Pop art.

The bold, bright colors of *Visa* in combination with black and white are applied without textural effects. These areas, although flat, nevertheless establish spatial relationships by implying advancing and receding planes. As to the subject, Davis said that he used words because they were part of

the urban scene: "We see words everywhere in modern life, we're bombarded by them. But physically words are also shapes." He chose them partly for their shapes, partly for their associations—in his own mind, rather than in the observer's, because he did not wish to set up a chain of ideas that might divert attention from the picture. In the case of *Visa*, Davis explained: "The big word in there, the word 'champion,' . . . was derived quite casually and spontaneously from a book of paper matches which has this word printed on it. . . . Needless to say, the letters themselves in 'champion' and the color and their arrangement have no identity with the source. . . . The word 'else' . . . was in harmony with my thought at the time that all subject matter is equal. . . . The word 'amazing' was in my mind at that period as being appropriate to the kind of painting I wanted to look at. The word 'continuity' was also in my thoughts for many years as a definition of the experience of seeing the same thing in many paintings of completely different subject matter and style. . . . The phrase 'the amazing continuity' . . . defines that kind of percept which occurs when you see any painting which we call art as distinct from other types. Therefore, the content of this phrase is real, as real as any shape of a face or a tree." Written in the same distinctive script as the phrase, Davis's signature too constitutes an integral part of his design.

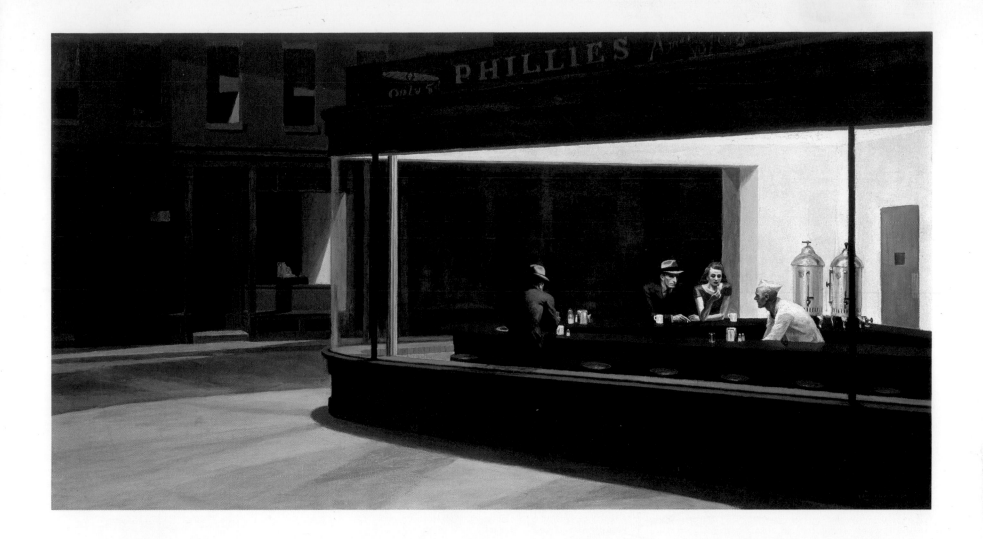

EDWARD HOPPER. Born Nyack, New York, 1882; died New York City 1967. *Nighthawks*. 1942. Oil on canvas, 30″ × 60″. The Art Institute of Chicago (Friends of American Art Collection).

Edward Hopper, like Stuart Davis, was one of Robert Henri's pupils who, although indebted to his master's teaching, believed that he placed too much emphasis on subject matter at the expense of form and design. Hopper made three trips to Europe between 1906 and 1910, spending most of his time in Paris without being attracted to any of the innovative styles there. He admired Courbet, the Impressionists, and Cézanne, and among American artists Thomas Eakins preeminently—to whose realist tradition he himself belongs. Hopper was slow in winning recognition; a painting he sent to the Armory Show in 1913 was his only sale for ten years, and the juries of the National Academy of Design exhibitions consistently rejected his submissions. (Accordingly, when he was belatedly elected an associate member in 1932, he firmly declined the honor.)

When Hopper returned to the United States from his first trip to Paris, he found it "a chaos of ugliness"; nevertheless, it was the contemporary American city that he was to make his particular theme. He did not perceive New York astir with human activity, like Henri and The Eight, admire the dynamism of its traffic and skyscrapers, like Marin, or distill its structures into abstract patterns, like Spencer (page 113). Instead, it was the forms and materials of the city's streets and buildings—stone, concrete, brick, asphalt, steel, and glass—

and the effect of light falling on them that interested Hopper. Light is the principal actor in his paintings, both in his city scenes and in his paintings of Gloucester and South Truro, Cape Cod, where he spent his summers from 1930 on. The people who appear in his pictures are not individually characterized, but all seem lonely, isolated, tired, or bored.

Nighthawks is a supreme example of Hopper's characteristic subject matter and manner of handling it. He named it one of his favorites among his own works, and said that it was "suggested by a restaurant on Greenwich Avenue where two streets meet. *Nighthawks* seems to be the way I think of a night street. . . . I simplified the scene a great deal and made the restaurant bigger. Unconsciously, probably, I was painting the loneliness of a large city."

The painting has been well analyzed by Hopper's friend and biographer, Lloyd Goodrich: "The lunch counter is an oasis of light in the midnight city; strong light falls on the interior and its four occupants, separating them from the outside world; out there, the subdued light of an unseen street lamp shows dark, empty stores. In the play of these two lights against surrounding darkness lies much of the painting's impact. . . . The interplay of light from various sources and in varied colors . . . creates pictorial drama. . . . The strong wedge of the restaurant, thrusting from right to left like the bow of a ship, is countered by the solid row of buildings at right angles to it. Here the moving wedge is met by a static mass. No main planes are parallel to the surface of the painting

. . . and hence no main lines are parallel to the rectangular frame, and none are purely horizontal."

The color accentuates the separation of exterior and interior. Within, the light yellows of ceiling and wall and the green of the tile and fluted pillar contrast with the girl's strawberry-blond hair and red dress, the counterman's white cap and uniform, and the silvery glint on the coffee urns. The restaurant's exterior is an almost undifferentiated dark blue, with tan lettering on the dark brown signboard above. The buildings at the left are a dull, dark rust, with green blinds and door- and window-frames; the green of the pavement is modulated by the play of shadows and reflected lights.

Hopper stood apart from both the abstract and the Social Realist tendencies of his time. He painted the American environment without commenting on it; referring to the Regionalists (see page 118), he said: "I never tried to do the American scene as . . . the midwestern painters did. I think the American scene painters caricatured America. I always wanted to do myself. . . . The American quality is *in* a painter—he doesn't have to strive for it." Elsewhere, he defined what "doing himself" meant: "My aim in painting has always been the most exact transcription possible of my most intimate impressions of nature." The operative words here are "my most intimate impressions"; to quote Mr. Goodrich once more: "In exactly conveying the mood of . . . particular places and hours, Hopper's art transcended realism and became highly personalized poetry."

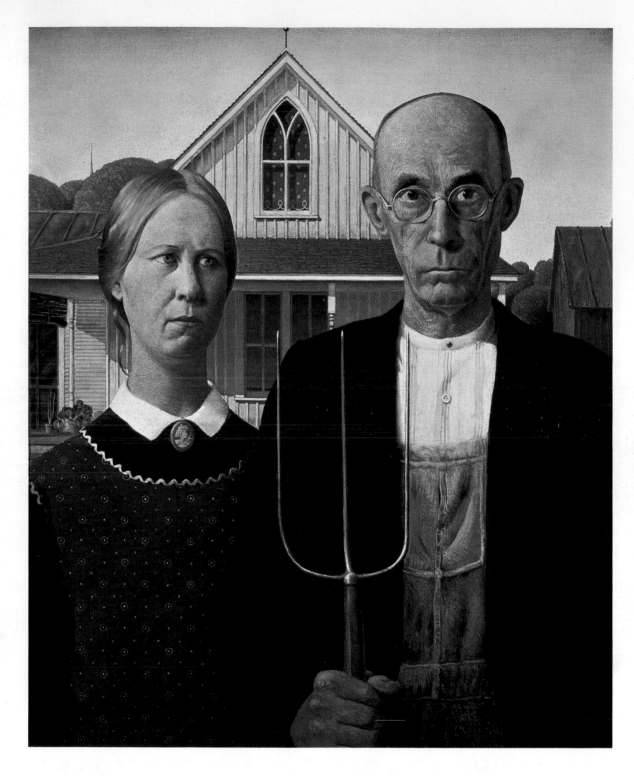

GRANT WOOD. Born near Anamosa, Iowa, 1891; died Iowa City 1942. *American Gothic.* 1930. Oil on beaverboard, 29⅞″ × 25″. The Art Institute of Chicago (Friends of American Art Collection).

Grant Wood, together with Thomas Hart Benton and John Steuart Curry, was one of the leading Regionalists of the 1930s who rejected modernism and sought their subjects in the rural life of America, which they painted in a style easily comprehensible to the average person. Thus, they might be considered as taking up the aims of William Sidney Mount and George Caleb Bingham a century before (see pages 72 and 73). These later painters of the American scene were never as vituperative in rejecting modern movements and their European sources as their polemicist Thomas Craven, who in his book *Modern Art* (1934) not only repudiated all twentieth-century innovations

in art and all links to Europe but also sounded a theme that has recurred frequently in political rhetoric: an elite Establishment, entrenched in the cities of the East and subservient to foreign influences, was betraying the ideals of the "true" America that existed in the heartland of the Middle West. In point of fact, Benton, Curry, and Wood had all supplemented their training in art institutions in the United States with study in Paris.

For Wood, however, it was a later trip to Europe in 1928, during which he visited Germany, that was decisive for his art. Born on an Iowa farm, he had become an illustrator, worked as a decorator and craftsman, and taught art in a Des Moines high school, while finding little patronage for his paintings except for that of a local funeral parlor director (who ultimately bought more than forty of them). In the Munich museums Wood became interested in the technique of oil glazes used by

fifteenth- and sixteenth-century Flemish and German masters, and in the clearly defined contours that characterized their style. This sharp-edged clarity, of course, was also the hallmark of the eighteenth-century American limners, the nineteenth-century luminists, and the contemporary precisionists. It had analogies too with the New Objectivity of Otto Dix and other German painters, which was one manifestation of a tendency—existing on both sides of the Atlantic after World War I —to turn from abstraction to representation and to seek national identity in more traditional forms of art.

On returning to America, Wood searched for the kind of subject he had in mind. One day on a trip to Eldon, Iowa, he saw a small frame house with a porch running across its width below a Gothic-style window. He made a color sketch and photograph of it and at once began to elaborate his ideas for a composition in which the austere, vertical lines of the building would be repeated in the faces of two figures standing in front of it, and in the tines of a pitchfork grasped firmly in the man's hand. After persuading his sister and a dentist who was a family friend to pose for him, Wood supervised every detail of their appearance in conformity with his mental image. His sister's normally wavy hair was parted in the middle and severely slicked back; a search was made for just the right calico and rickrack trim for her apron; and at her throat was pinned a cameo that had belonged to their mother. Similar thought was given to selecting the man's striped shirt, denim overalls, and dark coat of the kind he might wear as his Sunday best.

Wood devoted over three months to painting *American Gothic,* laying on successive coats of thin pigment to produce a smooth surface and delineating the plants on the porch as sharply as the details in the foreground. When he sent the picture to the annual exhibition of the Art Institute of Chicago, it won a prize, was bought for its collection—and stirred up a storm! Newspapers had referred to the picture as an "Iowa Farmer and His Wife," and many rural Iowans, feeling they had been satirized, took umbrage and denounced this representation as "not typical" of them. They were mollified by Wood's somewhat disingenuous explanation that he had *not* represented farmers but small-town dwellers, that the woman was supposed to be the man's daughter, not his wife, and that furthermore his own sister had been the model. Two years later, his *Daughters of Revolution* (Cincinnati Art Museum), showing three tight-lipped ladies drinking tea in front of a reproduction of Leutze's *Washington Crossing the Delaware,* aroused the ire of the D.A.R. Disdainful of "people who are trying to set up an aristocracy of birth in a Republic," Wood privately called them "Those Tory Girls." So much for Craven's one-hundred-percent Americanism!

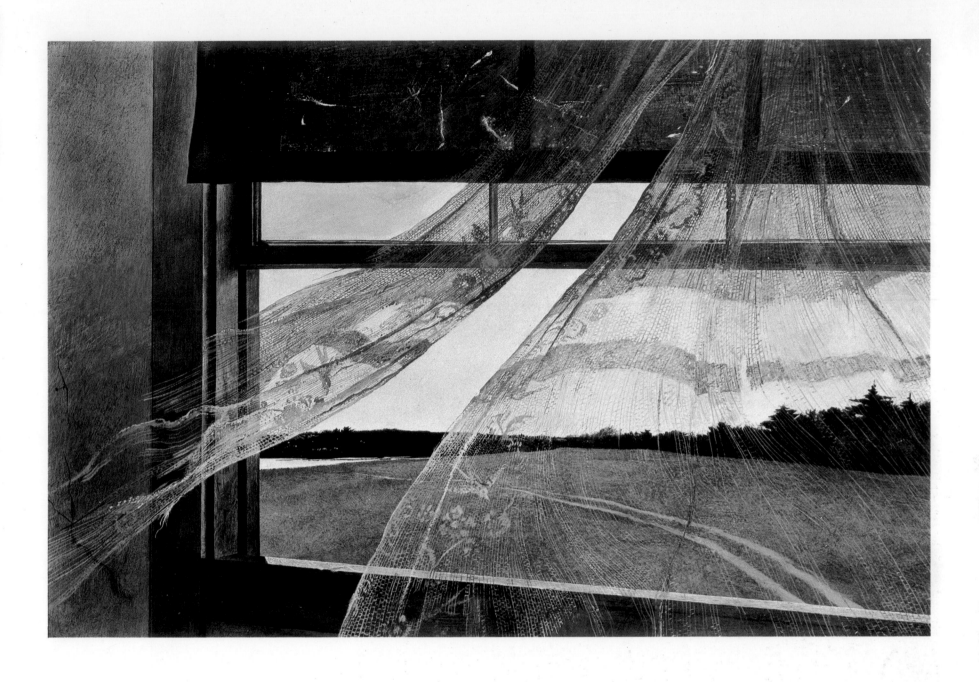

ANDREW WYETH. Born Chadds Ford, Pennsylvania, 1917. *Wind from the Sea.* 1947. Tempera on panel, 19″ × 27⅞″. Private collection.

Andrew Wyeth is the most celebrated living American realist. His work, like Hopper's, is not only beloved by the public but is also widely esteemed by artists of entirely opposite tendencies. The son and pupil of a noted illustrator, N. C. Wyeth, he divides his time between his birthplace, Chadds Ford, Pennsylvania, and Cushing, Maine, and most of his pictures are of those localities.

Like many of Wyeth's paintings *Wind from the Sea* crystallizes a pictorial revelation seen in what the photographer Henri Cartier-Bresson has called "the decisive moment"; and like a photographer, too, Wyeth here uses the framing edge of the picture as a photographer would use cropping, to isolate and lend impact to his image. Yet his technique is the opposite of the camera's instantaneity or that of the Impressionists when they tried to capture a momentary glimpse of reality. Wyeth's method is, in fact, particularly slow and painstaking; his medium is tempera, applied with a dry brush to build up precisely rendered forms through an accumulation of small, delicate strokes.

This picture shows a view of an upstairs bedroom in the house that appears crowning the hilltop in what is probably Wyeth's most famous painting, *Christina's World,* 1948 (The Museum of Modern Art, New York). Built by the seafaring grandfather of Wyeth's friends and neighbors, Alvaro and Christina Olson, it had once served as a boardinghouse. One day Wyeth went upstairs to open a window in a room that had been closed up for a long time—and this is what he saw. But after beginning the picture, he had to wait two months for another wind from the west that would allow him to study the curtains billowing in just that way. "You can't make these things up," Wyeth declared. "You must see how it was. Everything was dry and hot—the shade curtains, the lace, the window pane. I tried to get that quality, and the air blowing."

As in all Wyeth's best pictures the commonplace subject, rendered with utmost precision of detail, has evocative overtones that place the work within the category of sharp-focus painting sometimes called magic realism (see page 86). Obviously, the eye could not really perceive simultaneously, with equal distinctness, the cracks in the wall and window shade, the network pattern of the curtains, and the details of the landscape seen through the window. All this nevertheless becomes believable, abetted by the understated color that avoids any sharp contrasts or bright hues. The tonality ranges from the black of the window frame and the dark gray of the adjacent wall to the ecru of the curtains, the parched brown of the grass, the dark silhouettes of the trees, the silvery glimpse of water at the left, and the pale sky overhead.

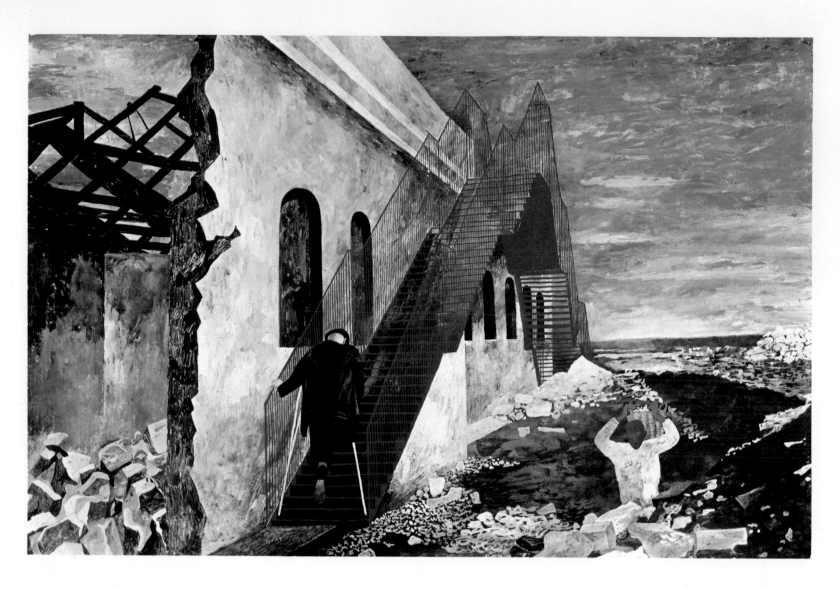

BEN SHAHN. Born Kovno (now Kaunas), Russian Lithuania, 1898; to United States 1906; died New York City 1969. *The Red Stairway*. 1944. Tempera on masonite, 16″ × 23½″. The St. Louis Art Museum.

Such comment on American society as was made in Grant Wood's *American Gothic* (page 118) or *Daughters of Revolution* was only mildly satirical—humorous rather than bitter, generalized rather than specific. Ben Shahn, on the other hand, often used his paintings to protest against injustice, like editorials cast in visual form. He worked on and off as a lithographer from the time he was in high school until 1930. After studying at the National Academy of Design, he went abroad in 1925 and again from 1927 to 1929, traveling in France, Italy, Spain, and North Africa.

Shahn first came to public attention through two series of gouaches done in 1931 and 1932. The subject of the earlier was the trial and execution in 1927 of two Italian-American anarchists, Nicola Sacco and Bartolomeo Vanzetti, whose conviction for murder stirred worldwide indignation (page 16); the other dealt with the labor leader Tom Mooney, accused of having been implicated in a bombing and condemned to life imprisonment. In both cases the convictions were widely believed to have been politically motivated, based on the hysteria generated by the "Red scare" of the 1920s rather than on solid evidence. However righteous the cause Shahn's pictures pleaded, they would not have risen above the level of illustration had

they not been drawn with a skillfully incisive line and a bold sense of design that set artfully characterized figures against appropriately suggestive backgrounds. Often categorized as Social Realism, the paintings actually depart considerably from naturalistic representation; the figures are flattened and drawn with expressionistic distortions, the backgrounds simplified in accordance with abstract principles.

In 1933 Shahn worked as an assistant to the Mexican muralist Diego Rivera on a fresco (destroyed because of its political content) for the lobby of the RCA Building in Rockefeller Center, New York. Experience with this medium heightened his interest in light, color, and atmosphere and led him to recall mural cycles by such Italian masters as Paolo Uccello and Piero della Francesca. The easel paintings of wartime subjects that he did in 1943 and 1944 also reflected Early Renaissance practice; over the opaque tempera he laid translucent tones that gave his color a new richness and variety.

One of the greatest of these paintings is *The Red Stairway*. Working in the Office of War Information, Shahn saw an endless stream of photographs documenting, as he said: "bombed-out places, so many of which I knew well and cherished. There were the churches destroyed, the villages, the monasteries. . . . I painted Italy as I lamented it, or feared that it might become." He had previously painted "the incidental, the individual, and the topical. . . . But then I came to feel that . . . I wanted to reach farther to tap some

sort of universal experience, to create symbols that would have some such universal quality." The new pictures "did not perhaps depart sharply in style or appearance from my earlier work, but they had become more private and inward-looking. A symbolism which I might once have considered cryptic now became the only means by which I could formulate the sense of emptiness and waste that the war gave me, and the sense of the littleness of people trying to live on through the enormity of war."

The Red Stairway is constructed like a diptych, its two sections divided by the diagonal wall with dark, arched openings flanked by the brilliant red horizontals and verticals of the stairway's slender treads and railings. To the left, behind the façade of the ruined building, are fallen blocks of masonry and broken girders that no longer support anything. With the aid of a cane, the bowed figure of a crippled man slowly makes his way up the stairs on his one leg; his painful ascent seems pointless, for the stairs lead nowhere. The desolation and despair on the left side of the picture are mitigated by the hopefulness implicit on the right. Some of the rubble has been cleared, and vegetation has begun to grow. The strong arms of a laborer—who faces forward, in contrast to the amputee seen from the back—support a basket loaded with stones with which to begin rebuilding. The sky in the background, although flecked with clouds, is a promising bright blue.

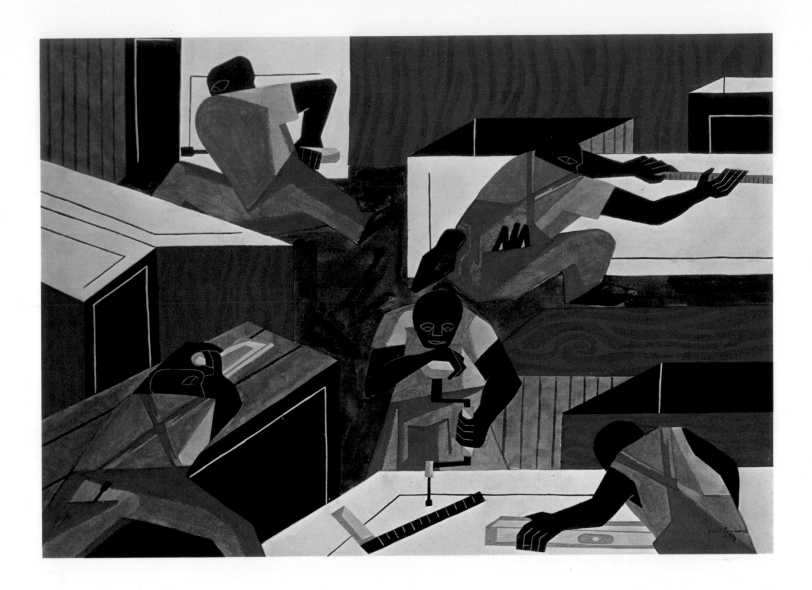

JACOB LAWRENCE. Born Atlantic City, New Jersey, 1917. *Cabinet Makers.* 1946. Gouache on paper, 23″ × 30″. Hirshhorn Museum and Sculpture Garden, Smithsonian Institution, Washington, D.C.

A generation younger than Ben Shahn, Jacob Lawrence also first won public recognition with several narrative series of paintings marked by strong social content. Growing up in Harlem during the Depression, he was naturally aware both of the cultural heritage of the black people and of their particular hardships in a period of economic decline. He began painting in a day-care center as a child and continued to attend art classes while in high school and working at odd jobs. Lawrence's first series dealt with historical figures who had played heroic roles in the liberation from slavery: the Haitian Toussaint L'Ouverture and the Southerners Frederick Douglass and Harriet Tubman. In the sixty paintings of *The Migration of the Negro,* 1940–1941 (now divided between the Phillips Collection, Washington, and The Museum of Modern Art), he treated a contemporary theme closer to his own experience, for as he pointed out, "My parents were a part of this migration—on their way North when I was born in Atlantic City in 1917." The succeeding Harlem series, begun in 1942, was based not so much on conscientious research as on direct observation; as Milton Brown notes, it is "more immediate, full of observed incidents, rich in genre detail, pulsating with life and movement. There is

also a new note of personal involvement. . . . In moving from history painting into the mainstream of social realism, Lawrence had recaptured the native flavor of the Ashcan tradition, though in a new ethnic guise."

As in the case of Shahn's pictures, however, Social Realism is somewhat of a misnomer, for these paintings are in fact highly stylized. Their tempera medium is a natural outgrowth of the poster paints Lawrence had used as a child, and the limited range of pure colors, spiced with black and applied in flat areas to form simplified compositions, also suggests posters. He has said: "My work is abstract in the sense of having been designed and composed, but it is not abstract in the sense of having no human content. In your work, the human subject is the most important thing. An abstract style is simply your way of speaking. As far as you yourself are concerned, you want to communicate. I want the idea to strike right away."

During World War II Lawrence served in the Coast Guard, but thanks to understanding commanding officers was able to continue painting. After his discharge from service in 1945 and before beginning a new series based on his war experiences, he painted a number of pictures that showed people engaged in various occupations—with perhaps a symbolic reference to rebuilding, as in Shahn's *Red Stairway.* "The painting *Cabinet Makers,*" Lawrence said in 1972, "is one of a theme that I have been developing over a period of years. The general theme is *The Builders.* [This is the

title he gave to several of his works dating from 1969 to 1973.] The tools that MAN has developed over the centuries are, to me, most beautiful and exciting in their forms and shapes. In developing their forms in a painting, I try to arrange them in a *dynamic and plastic composition.*" The emphasis on "man" is significant, for although the figures in this painting are black, and Lawrence has always been closely identified with the experience of his race, he considers his people's struggle to be part of the entire "struggle of man always to better his conditions and to move . . . forward in a social sense."

The composition of the *Cabinet Makers* is built on an X-shaped arrangement of black workers, clad in blue, counterpointed by geometrical blocks of worktables and benches. Spatial recession is emphasized by their placement, the vertical floorboards in the center right foreground, and the exaggerated uptilting of the floor to meet the back wall. Hands and features are outlined, light against dark, in a consciously primitive style, the frontal eyes within profiled faces recalling the conventions of Egyptian reliefs. The energetic gestures denote delight in the handling of tools and pride in skilled workmanship. With its artful balance of color patterns and stylized forms, this painting attains a high degree of decorativeness without diminution of forceful expression.

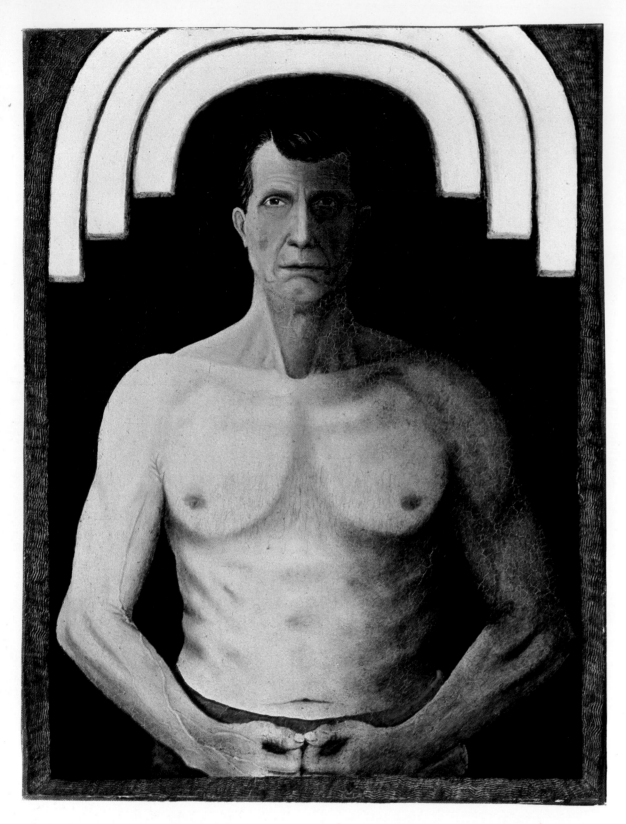

JOHN KANE. Born near Edinburgh, Scotland, 1860; to United States 1880; died Pittsburgh 1934. *Self-Portrait.* 1929. Oil on canvas over composition board, 36⅛″ × 27⅛″. The Museum of Modern Art, New York (Abby Aldrich Rockefeller Fund).

John Kane was among the hundreds of thousands of immigrants whose strength and skills have contributed to building America's industrial might. Coming to this country from Scotland at the age of twenty, he worked as a miner, carpenter, steelworker, house painter, and construction foreman—doing, in fact, as he said in his autobiography, "almost every kind of work a laboring man can do. . . . The amount of work, the hardness of it, the

hours and all like that, didn't worry me a bit. . . . I liked to work and I did not care how hard it was. I think I rather enjoyed using my hard muscles." Among other uses to which he put them was fist fighting, for which he gained considerable renown.

After losing a leg in a railroad accident, Kane worked as a railroad watchman and then got a job painting freight cars. He "learned the use of lead paint, the mixing of colors, the necessity of keeping colors clean. . . . I had always loved to draw. I now became in love with paint." This training he considered better than any he might have received in an art school: "The best thing in the world for a young artist would be to hire himself out to a good

painting contractor who knows his job," he declared. Carpentry also helped him to formulate standards for his art: "I think a painting has a right to be as exact as a joist or a mold or any other part of building construction."

Kane's favorite subjects were recollections of his native Scotland and scenes of Pittsburgh, where he settled after many years as an itinerant laborer. He loved both the surrounding countryside and the city's industrial landscape, rejoicing in his own part in its growth. Although he began painting in 1904, recognition came only after 1927 when one of his pictures was accepted by the Carnegie Institute in Pittsburgh for its International Exhibition; he was the first primitive artist to be so honored.

This *Self-Portrait*, done when Kane was sixty-nine, is an unflinching revelation of a dignified, self-reliant man, proud of his strength, despite his age, and prouder still of his dignity and probity. Against the dark background, he stands staring out with iconlike frontality, hands clenched before him to accentuate the bony framework of his gaunt torso and the sinews, veins, and muscles of his arms. The figure is surmounted by a massive triple arch that strongly accentuates the painting and is surrounded by a painted frame that simulates wood-graining (compare Sheldon Peck's *Anna Gould Crane and Granddaughter Jennette*, page 39, done a century before). This is not only Kane's masterpiece but is also one of the most powerful and moving portraits ever painted by an American artist.

122

MORRIS HIRSHFIELD. Born Russian Poland, 1872; to United States 1890; died Brooklyn, New York, 1946. *Nude at the Window*. 1941. Oil on canvas, 53¼″ × 30″. Collection of Sidney Janis.

Barbara Novak in *American Painting of the Nineteenth Century* has observed that it is amazing that "the primitive can work . . . aiming hard for realism . . . and yet end up with something that is much truer to his mind's eye than to anything his physical eye has perceived. It is almost as though that outer eye were turned off, rendered oblivious to light and air. And the two-dimensionality of that inner image prevails. This is, of course, frequently explained by a reference to technical inabilities. . . . But . . . the problem is more complex, having to do with the nature of artistic vision and with points along a possible spectrum in the conditioned development of perception."

Like most primitive artists, Morris Hirshfield aspired to be a realist, but he said that when he first began to paint, "My mind knew well what I wanted to portray but my hands were unable to produce what my mind demanded." He had come to America from Russian Poland at the age of eighteen. After working for several years in a women's coat factory, he entered into partnership with his brother in the manufacture of boudoir slippers. He took up painting as a pastime at the age of sixty-five after a severe illness had forced his retirement from business. In 1939 Sidney Janis, who had not yet become a dealer but was organizing an exhibition of American primitive artists, came upon two of his pictures in an art gallery and borrowed them for the show. He met Hirshfield at the opening, they became friends, and in 1942 Mr. Janis devoted a chapter of his book *They Taught Themselves* to Hirshfield's life and work.

Nude at the Window, subtitled by the artist *Hot Night in July*, was the second nude Hirshfield had painted; he was inspired to attempt this genre by seeing Henri Rousseau's *The Dream* (The Museum of Modern Art) in the apartment of Mr. Janis, to whom it then belonged. His first nude, *Girl in the Mirror*, 1940 (The Museum of Modern Art) showed a girl seen from the back, which, he explained, he considered to be even more beautiful than a frontal view. This picture, done immediately after, however, shows the woman in full frontality. We quote Mr. Janis's discerning analysis:

"Like a dazzling apparition, this ivory pink creature with yellow blonde hair emerges from the mysterious black depths which we know are no more than the interior of a darkened room. The brilliant red drapes striped with black and yellow are gently held aside by one hand, and the other drape responds before it is touched as if she controlled it magically.

"Around her, the darkened room which is her background takes on the contour of a huge black vase, and at the top of the vase a valance with two pendants appears. The figure within levitates above exquisitely designed slippers which are themselves suspended. The whole is like a reincarnation in a funerary urn. . . .

"The outline contours of the nude are conceived as a set of two continuous curving lines. . . . One begins under the arm, follows down around the torso and legs, taking in the sweep of the abdomen in an oyster-shaped arc on the way, and ends under the other arm. . . .

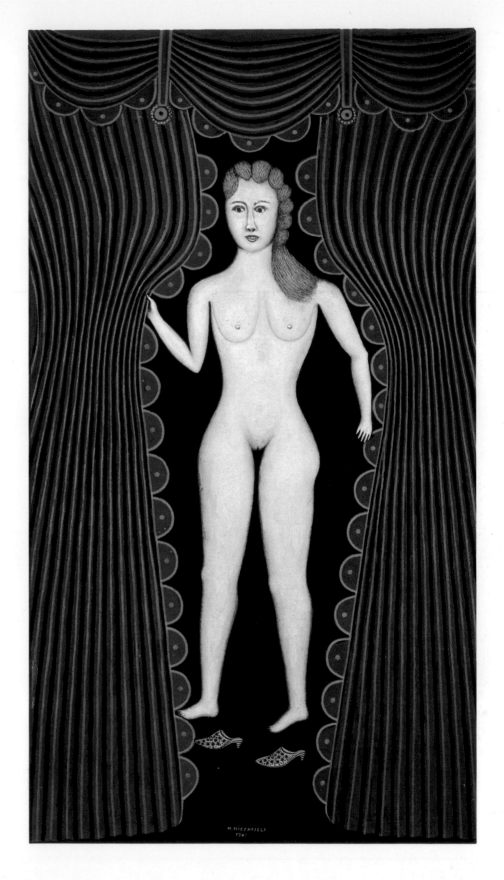

"The other continuous line, starting and ending at the chest, encompasses the breasts, arms and head. Divided into two sections, then, the nude consists of two forms delineated by flowing lines and set upon each other; and the forms are tacked in place at the breasts. Scallops bordering the drapes compulsively repeat this latter motif. . . . The repeating lines of the drapes which surround the nude complement its curvilinear rhythms and are like magnetic currents emanating from the figure."

The slippers, aligned at the bottom, recur in other pictures by Hirshfield, reminding us of his former activity as a slipper manufacturer. He frequently varied the surface of his paintings by building up the texture of hair or fur with individual brushstrokes of thick pigment; here, the girl's coiffure is given a slight impasto, and her nose and nipples are built up in relief.

When Mr. Janis directed a one-man show of Hirshfield's work at The Museum of Modern Art in 1943, critical opinion was largely unfavorable. Piet Mondrian, however, expressed his admiration, and André Breton, dean of the Surrealists, declared that Hirshfield was "the first great mediumistic painter."

GASTON LACHAISE. Born Paris 1882; to United States 1906; died New York City 1935. *Standing Woman.* 1932 (from a plaster of 1928). Bronze, 7′ 4½″ high. The Brooklyn Museum, Brooklyn, New York (Frank Sherman Benson, Alfred T. White, and A. Augustus Healy Funds). (Other casts: The Museum of Modern Art, New York; University of California at Los Angeles.)

At the beginning of this century Auguste Rodin was still the colossus who dominated sculpture both in Europe and in America, where his work was collected with particular enthusiasm. A number of artists, however, reacted strongly against his influence, rejecting especially the emotionalism of his figures and the impressionistic handling of light on their surfaces. One reaction took the form of a return to idealism and an emphasis on smoothly flowing curves, contrary to Rodin's definition of sculpture as "the art of the hole and the lump."

Gaston Lachaise, after studying at the Ecole des Beaux-Arts in Paris, worked for René Lalique as a designer of glass and jewelry before coming to the United States in 1906. He entered the studio of the academic sculptor Henry Hudson Kitson in Boston and moved with him to New York in 1912. The following year Lachaise became chief assistant to Paul Manship, whose sculpture of mannered elegance was an adaptation of Neoclassical forms simplified into fluent curves.

Lachaise's ideal of the human body was far more vital and robust. He based his concept of the female nude less on Greek and Roman sculpture than on the sensuous carvings on Indian temples, prehistoric fertility goddesses such as the Venus of Willendorf with their exaggerated roundness of breasts, bellies, and buttocks, and especially on the mature figure of his wife Isabel, who was ten

years his senior. She was the model for Lachaise's many variations on the theme of a standing woman, of which this sculpture—also known as *Heroic Woman*—is the culminating example.

Standing Woman took Lachaise ten years to complete; the plaster for it was first exhibited in 1928, but it was not cast in bronze until 1932, and was so shown when, in 1935, The Museum of Modern Art gave Lachaise its first retrospective of a living American sculptor. In contrast to the *Standing Woman—Elevation* (Whitney Museum of American Art, New York), which he worked on simultaneously, and which expresses buoyancy by its tiptoe stance and arms bent upward at the elbows, every gesture and curve of this figure emphasizes weight, massiveness, and power. Serenely arrogant, glorying in her vitality and voluptuousness, she is, as Gerald Nordland has said, "the triumph and fulfillment of all Lachaise's small studies, statuettes, and fragments. . . . The figure takes a firm stance, holds her head high and places her hands determinedly on one hip and another thigh. It is a regal pose, one of composure and force. The sculpture is the embodiment of Lachaise's lifelong effort to express the imperious goddess quality in the heroic scale."

The disproportionately small head is set on a thick column of neck, which is given added width by coils of hair on either side. The slenderness of the waist is accentuated by the outward thrust of the huge breasts above and the twin ovoids of the rounded belly below, and by the irregularly diamond-shaped open areas between the waist and the arms set akimbo to frame it. The delicate V of the pubic area is similarly contrasted with the heaviness of the flanking thighs.

In the catalogue of the 1935 exhibition referred to above, Lincoln Kirstein wrote that Lachaise's sub-

ject matter "is not ultimately men and women, nor even Man and Woman. His subject matter is the glorification, revivification and amplification of the human body, its articulate structure clothed in flesh. He is an idol maker. . . . Just as his figures frequently transcend the factually physical, so does their physicality transcend the immediately sexual." The insistent emphasis on maturity that Lachaise gave to his forms, however, violated prevailing standards of good taste, which were more attuned to Paul Manship's svelte, archaistic figures. In an unpublished autobiographical sketch (written c. 1931) Lachaise himself quoted what Henry Adams had written in 1905 regarding his countrymen's reluctance to recognize Woman as a dynamic force: "For evidently America was ashamed of her, and she was ashamed of herself, otherwise they would not have strewn fig-leaves so profusely all over her. When she was a true force, she was ignorant of fig-leaves, but the monthly-magazine-made American female had not a feature that would have been recognized by Adam."

Lachaise nevertheless staunchly asserted that "The New World is the most favorable place to develop a creative artist." In an article of 1928 entitled "A Comment on My Sculpture," he deplored the difficulties artists encountered here, either because of total neglect or because of the low prices paid for their work: "Yet it cannot be overlooked that at present . . . the American artist 'living and true,'—creative and bearer of fruits, has begun to grow roots and function in the rocky soil of America. . . . The American soil is fresh. It is fertile. . . . new species and new beauties will come forth from it to lighten the world. . . . The most favorable ground for the continuity of art is here."

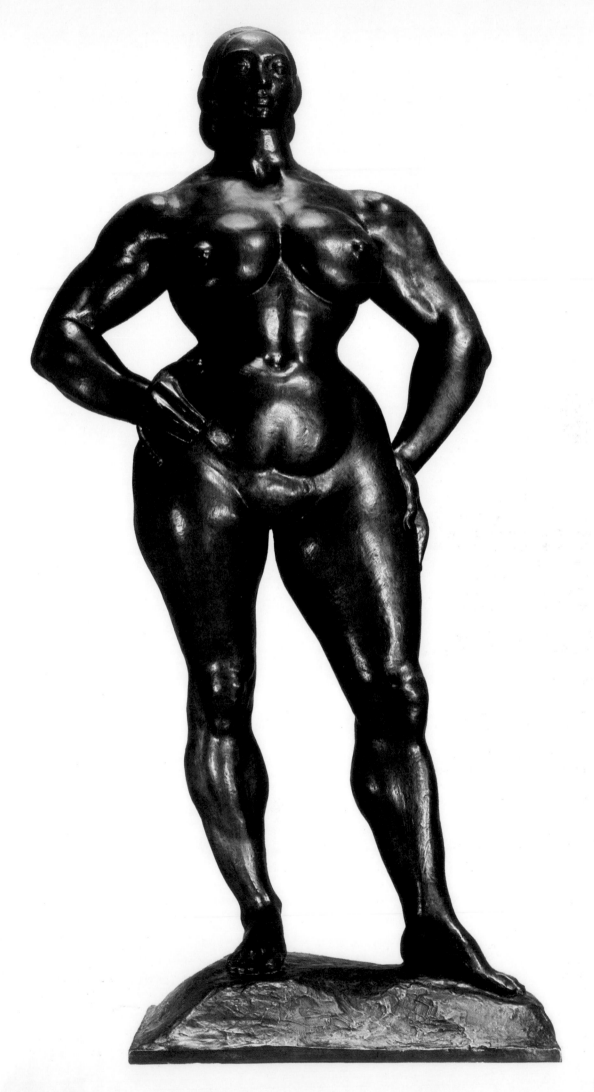

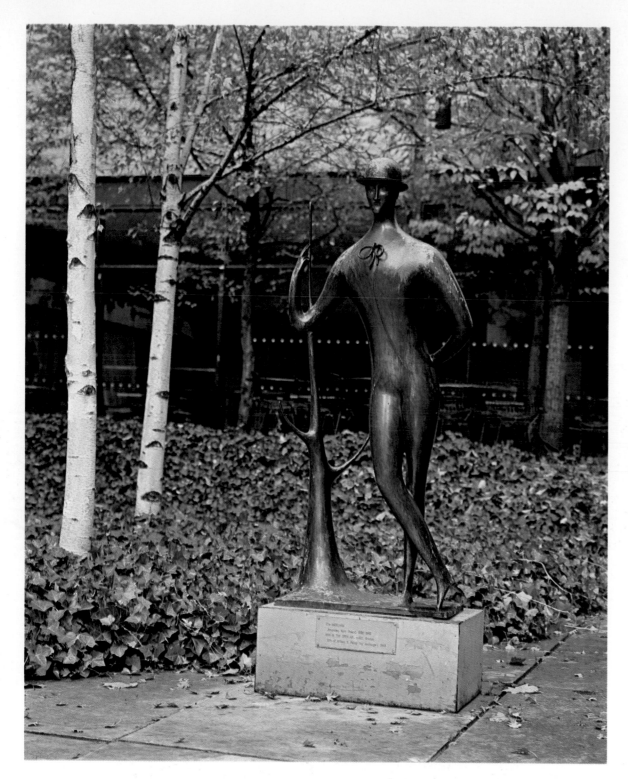

ELIE NADELMAN. Born Warsaw 1882; to United States 1914; died New York City 1946. *Man in the Open Air.* c. 1914. Bronze, 54½" high, including base. The Museum of Modern Art, New York (Gift of William S. Paley). (Other casts: Sheldon Memorial Art Gallery, University of Nebraska, Lincoln; National Museum of Israel, Jerusalem, Gift of Billy Rose.)

In contrast to Gaston Lachaise, whose revitalization of sculptural expression was largely intuitive and subjective, Elie Nadelman took an intellectual and theoretical approach. After studying at the Academy of Fine Arts in Warsaw, he came to Paris in 1904 by way of Munich, where he was greatly impressed by the Greek marbles in its classical museum, the Glyptothek, and by the aesthetic theories of Adolf von Hildebrandt, which emphasized the primacy of formal over imitative qualities in art. In Paris Nadelman haunted the Louvre and made analytical drawings that dissected sculptures of the nude into their essential elements of réciprocal curves and convex and concave planes. He was also influenced by Georges Seurat's paintings, in which figures were reduced to archetypal forms set in a contemporary social context, as in the *Sunday Afternoon at the Island of La Grande-Jatte* (The Art Institute of Chicago). Nadelman became a member of the influential circle around Gertrude Stein and her family, and when he immigrated to the United States in 1914 he was welcomed as a representative of the European avant-garde. His work was already known in America through twelve analytical drawings and a male head in plaster, in the Armory Show, and through a 1910 article in Stieglitz's magazine *Camera Work,* in which Nadelman wrote: "I employ no other line than the curve, which possesses freedom and force. I compose these curves so as to bring them in accord or opposition to one another. . . . The subject of any work of art is for me nothing but a pretext for creating significant form, relations of forms which create a new life that has nothing to do with life in nature, a life from which art is born, and from which spring style and unity."

Man in the Open Air, first shown in plaster at "291" in 1915, is an amalgam of several influences: Seurat's contemporaneity, the formal simplifications and stylizations of prehistoric cave paintings and Cycladic sculpture of the eastern Mediterranean, and classical Greek sculpture of the Golden Age. Nadelman's only full-length male bronze, it has been described by his biographer Lincoln Kirstein: "The sole interruption of the figure's attenuation is the bowstring tie which casts a thin linear shadow on the broad chest. Precise, yet abstracted, this was the culmination of a new development, a turn towards the essence of contemporaneity, personal, strong, light-fingered. . . . This manikin offers himself in the metaphorical nakedness of an acrobat's tights or a dancer's leotard. Bowtie and bowler are the lone badges of modernity. . . . Head, hair, and hat are one form; the brim characterizing a British bowler is but a lid haloing an egg. Anatomy is without muscular articulation; all volumes coalesce to fill a gloved skin.

"The presence of a generalized tree trunk is an important feature . . . definitely an allusion to the Praxitelean 'Apollo Sauroktonos' (ca. 350 B.C.), a youth in momentary frozen dalliance about to toss a pebble at a lizard crawling up a tree. Nadelman's recension sports an entirely superfluous armature of a branch which outrageously pierces rather than sustains the right arm. . . . The nonchalance of the crossed serpentine legs was a further parody of the self-contained elegance with which eighteenth-century English painters endowed baronial youths. . . . In plaster at Stieglitz's it was not well received; it vaunted caprice; it was taken as a tactless joke, and found no purchaser in Nadelman's lifetime."

ELIE NADELMAN. 1882–1946. *Tango*. c. 1918. Cherrywood and gesso, painted, 35½″ high. Whitney Museum of American Art, New York (Promised gift of an anonymous donor in memory of Gertrude Vanderbilt Whitney and Juliana Force).

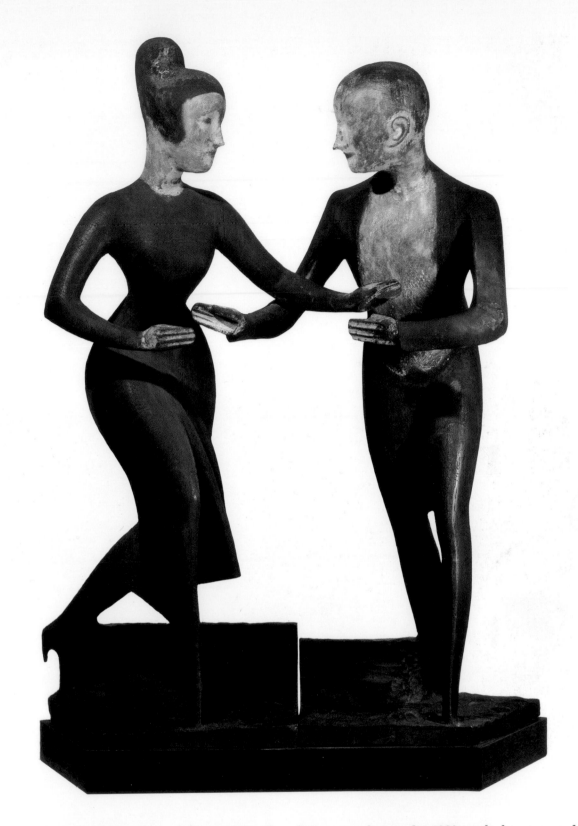

For a war-charity benefit show of sculpture in 1917 Nadelman did four painted plaster figures that met with even less favor than his *Man in the Open Air* two years before. Especially offensive to viewers was his portrayal of a hostess, seated in a wrought-iron chair, which not only mocked a certain type of society woman but violated convention by its contemporary costume. As a result of the ensuing furore, Nadelman withdrew it, pointing out that it was strange that among all the nudes on view, it was only his fully dressed woman that the public found offensive!

Two years later, he compounded his impertinence by showing at a New York gallery other representations of contemporary figures, carved in wood and painted. "Is Nadelman serious?" demanded one critic. "Are these things art, or only insolence? Where does plastic beauty end, and decadence begin?" Another asserted flatly: "This artist . . . is a joke, and he clothes his figures with the grotesque and the bizarre. . . . Certain of his symbolizations are realistic enough, but he works with crudity, and not one of his numbers even remotely suggests aestheticism."

Among the prototypes for these and other later representations by Nadelman were wooden dolls—generalized, impersonal types, the simulacra of human beings but without brains. In using this theme, Nadelman was within a tradition that has included such disparate examples as Olympia in *The Tales of Hoffmann*, Giorgio de Chirico's manikin paintings of 1914 and 1915, Fernand Léger's wedding-gown dummies in the film *Dreams That Money Can Buy*, and Hans Bellmer's erotic articulated dolls. Nadelman also based many sculptures on his large collection of photographs of circus, vaudeville, and concert-hall performers, ballroom dance teams, and Ziegfeld Follies beauties. Another primary source was folk art. Nadelman was among the first collectors of Pennsylvania German *fraktur* (see page 36) and other kinds of American folk art, and his house at Riverdale-on-the-Hudson became a museum in which he showed American examples together with others illustrative of their European sources. It is easy to see the likeness between *Tango*, his masterpiece in painted wood, and such a work as the anonymous mid-nineteenth-century *Bootmaker's Sign* (page 67).

High in favor as a ballroom dance, the tango had recently been immortalized by Rudolph Valentino in the film *Four Horsemen of the Apocalypse*. As Lincoln Kirstein has said, Nadelman portrayed it not as a folk dance from the Argentine pampas but "as an ironic echo of resort hotels or spas where international high society consoled itself by taming any savagery in folk expression." He worked out the forms through successive drawings showing the pair first in profile, then frontally, until this final version in which they "stand separate yet locked, together yet discreetly apart, a conclusive framing of all formal encounters, divisions, and rejoicing in their dance."

The wit in Nadelman's sculptures often either outraged viewers or prevented them from perceiving his plastic sensibility. But a high quantum of humor has been a characteristic of much modern painting and sculpture, in contrast to that of previous periods in which a sharp distinction was usually drawn between serious, "high" art and the allegedly lower categories of genre, caricature, and illustration.

If there is irony in Nadelman's view of humanity, there is tragic irony in his own career. Attaining success early, he had numerous patrons, from Mme Helena Rubinstein, who bought quantities of his heads to adorn her beauty salons, to Americans who during the 1920s kept him and three full-time studio assistants busy fulfilling their commissions. His marriage to a wealthy woman enabled him to live extravagantly and acquire an enormous collection of many thousands of items of folk art. Their fortune was lost in the 1929 crash, however, and Nadelman was obliged to sell his folk-art collections, the best of his American paintings going to the Abby Aldrich Rockefeller Folk Art Collection in Williamsburg, Virginia, and the greater part of his European and American dolls and toys to The New-York Historical Society. For twenty-five years he lived in seclusion, but not in idleness, creating small ceramic figurines that he hoped could be mass-produced. He had no one-man exhibitions between 1927 and the posthumous retrospective at The Museum of Modern Art in 1948. First highly favored, then long out of fashion, Nadelman's art has recently been revalued and is now seen to be a highly original contribution to the development of modern sculpture.

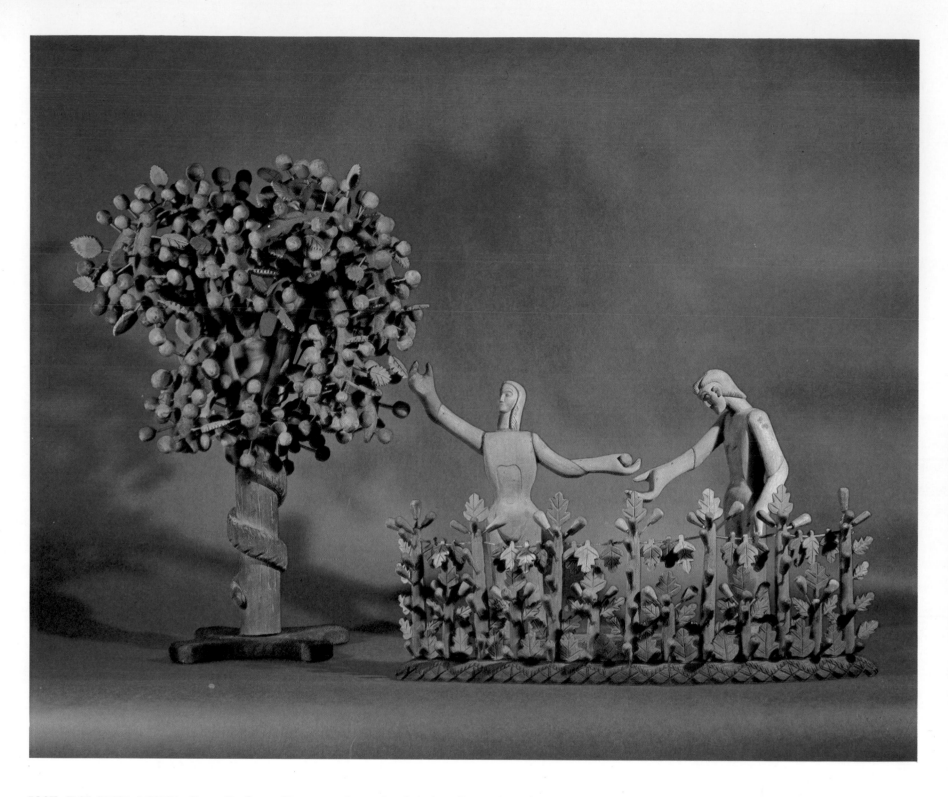

JOSE DOLORES LOPEZ. Born Cordova, New Mexico, c. 1880; died there c. 1939. *Adam and Eve and the Serpent.* c. 1930. Cottonwood, tree 24⅞″ high, figures 13″ and 14″ high, garden 8½″ × 21¼″. The Museum of Modern Art, New York (Gift of Mrs. Meredith Hare).

Adam and Eve and the Serpent is a sculpture that might well have had a dual appeal for Elie Nadelman—as an example of folk art and because of its articulated, doll-like wooden figures. José Dolores Lopez was a member of a family that had carried on the tradition of wood carving for four generations. He learned the carpenter's trade from his father and made furniture in the Spanish Colonial style, while whittling out for his own amusement figures of animals—pigs, dogs, cats, squirrels, and birds—before he was persuaded to revive the old tradition of carving religious figures for the Church.

Lopez lived in the village of Cordova, not many miles from Georgia O'Keeffe's house in Abiquiu. He was a member of the Third Order of Franciscans, the *Penitentes,* and this sculpture is an expression of the same devout form of Spanish Catholicism that O'Keeffe celebrated in *Black Cross, New Mexico* (page 112). The earlier practice in Spain and Spanish America was to make such images as realistic as possible by covering them with gesso and paint, adding artificial hair and glass eyes, and dressing them in cloth garments. Lopez, however, left the soft cottonwood surface unadorned, and stylized his figures instead of attempting realism. Adam and Eve are not differentiated by sexual characteristics; both have the same narrow waist, broad hips, and abstract treatment of rib cage and pelvic region. The subject of the Fall of Man is important theologically as the first act in the drama leading to salvation through the

Crucifixion and Resurrection. Here the hands, instruments of the forbidden sin of plucking fruit from the Tree of Knowledge, are made expressionistically large.

Besides its nonnaturalistic approach, this group has another characteristic that allies it with the work of some contemporary artists. Traditionally, sculpture in the round has concentrated on representing figures, giving scant attention to accessories. In *Adam and Eve and the Serpent* Lopez has provided his actors with an entire environment—the garden with its flowering plants, the tree with its fruit. He has created a kind of tableau, closely comparable to some works by the nineteenth-century Pennsylvania carver Wilhelm Schimmel.

Lopez died as the result of being struck by an automobile. Following his wish, he was buried in the churchyard of an old mission, under a carved and painted cross he had made for himself.

JOHN B. FLANNAGAN. Born Fargo, North Dakota, 1895; died New York City 1942. *Jonah and the Whale (Rebirth Motif)*. 1937. Sandstone, 30½″ high. Collection of Mr. and Mrs. Milton Lowenthal.

Among the several reactions to Rodin's art manifested by sculptors in Europe and America was the doctrine of "truth to materials." As defined by Robert Goldwater, this held that whether the artist worked in wood, bronze, or stone, he "had to respect the nature of his medium, be guided by its inherent qualities, and allow its character to be in constant evidence. In practice this meant closed rather than open form, stasis rather than movement, mass rather than animated surface, and as a result (in contrast to Rodin) a preference for carving over modeling." Constantin Brancusi and Jacob Epstein provided the chief examples abroad; in America, one of the leading exponents of direct carving was John Flannagan.

Flannagan began as a painter, studying at the Minneapolis Institute of Arts; from 1917 to 1922, he served in the merchant marine and traveled in Europe and South America. While working as a farmhand in upstate New York for the artist Arthur B. Davies—a dedicated proponent of modernism who had been one of the chief organizers of the Armory Show—Flannagan began to make sculpture in wood. His first carvings in stone were done in 1926, and he soon gave up wood altogether in its favor. Too poor to buy quarried blocks, he used native field stone—the rough fragments of glacial boulders—developing an almost mystical attitude toward this material. "To that instrument of the subconscious, the hand of a sculptor," he declared, "there exists an image within every rock. The creative act of realization merely frees it." In a letter of 1929 Flannagan wrote: "My aim is to produce a sculpture . . . with such ease, freedom and simplicity that it hardly feels carved, but rather to have always been that way. That accounts for the preference for field stone. Its very rudeness seems to me more in harmony with simple direct statement."

Usually Flannagan began with an idea for a sculpture and searched for a stone of the appropriate size and shape in which to execute it. In the case of his *Jonah and the Whale* it was the silhouette of the large slab of sandstone that first attracted

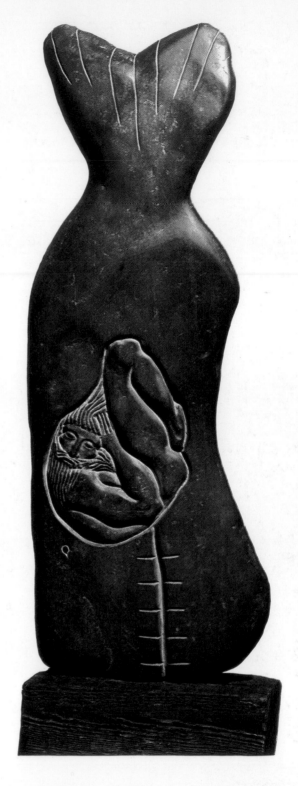

him, and he kept it for two years before working it. The subject is allied to other sculptures in which Flannagan dealt with the theme of birth: *Triumph of the Egg, I* (The Museum of Modern Art), done in granite in the same year as *Jonah* and showing a chick breaking out of its shell; a later version of the same subject in sandstone, of 1941; and a 1941 bronze, *The Beginning*—the image of a newborn child. As Flannagan's title for *Jonah* indicates, the concept here is that of regeneration. "Even in our own time," he wrote, "we know the great longing and hope of the ever recurrent and still surviving dream, the wishful rebirth fantasy, *Jonah and the Whale—Rebirth Motif*. It's eerie to learn that the fish is the very ancient symbol of the female principle."

The sinuous form of the whale stands upended, with only some incised lines defining its tail above and the powerful clenched jaws below. Within the

beast's belly, Jonah lies curled up like a fetus. The stylized, low-relief carving of his hair, beard, and features is reminiscent of Romanesque sculpture. "I have taken considerable liberties with the literal," Flannagan said, "but I think that in that deep verity of the symbolic it is right." He admired medieval art not only for its nonrealistic idiom, but also because he believed that the relation between the anonymous artist and society was the correct one; it was not the craftsman's personality but his work that was important. Although modern in his commitment to abstraction, Flannagan thought it must be made to "come alive by the use of living form. Warm the cold geometry of abstraction with a naturalism in which the artificial and accidental have been eliminated by their union with pure form. . . . Retain it always in a state of becoming . . . completed each according to his own psyche by whoever has eyes to see."

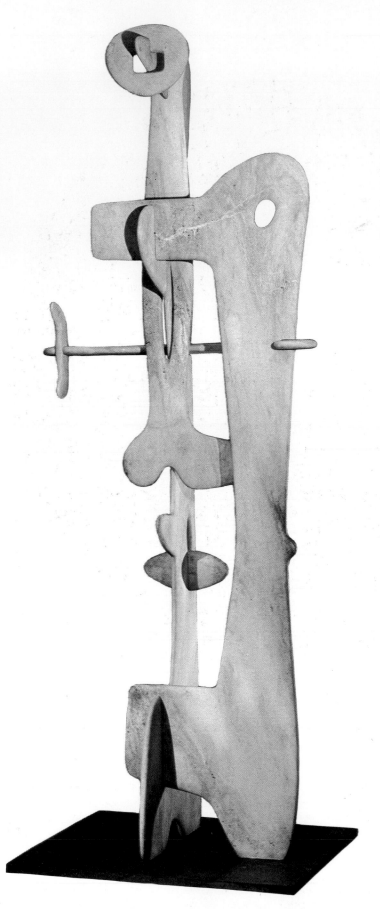

sculpture is for me the perception of space, the continuum of our existence. All dimensions are but measures of it. . . . Movement, light and time itself are also qualities of space. . . . I say it is the sculptor who orders and animates space, gives it meaning."

Noguchi was born in Los Angeles, the son of a Japanese poet and an American mother of Scotch-Irish and American Indian descent. The family moved to Japan when he was two, and he was educated there until sent back to the United States when he was fourteen. In 1922 he was briefly apprenticed to Gutzon Borglum, who is probably best known for his huge presidential portraits carved from the living rock on Mount Rushmore. Discouraged by Borglum from becoming a sculptor, Noguchi began to study medicine at Columbia University but quickly reverted to the idea of being an artist. He entered art school, took a studio in Greenwich Village, and frequented Alfred Stieglitz's new gallery, An American Place. Deeply impressed by an exhibition of Constantin Brancusi's sculpture, he left for Paris on a Guggenheim Fellowship in 1927 and for two years worked as an assistant to Brancusi while attending art schools at night. But although he admired his master, Noguchi felt that Brancusi's art was too abstract and lacked involvement with life. On returning to the United States, he made his living by carving and modeling naturalistic portraits but soon left for several years of travel, visiting China and Japan. Several years later he went to Mexico, and worldwide travel has continued to be an essential part of his way of life.

Following a period during World War II when he was voluntarily interned as a nisei at a relocation camp, Noguchi returned to New York. He wanted to work in marble, and economic reasons led him to the use of slabs, such as make up the *Kouros:* "About 1944, I came to realize that the most available form of marble in New York was in slabs, since most of it is cut that way for surfacing buildings. . . . Marble in slab form was relatively cheap in New York. . . . I found marble to be a stable and beautiful material, too beautiful perhaps. The nature of its stability is crystalline, like its beauty. It must be approached in terms of absolutes. . . . The stone had thickness too—an element of volume. This involved carving. . . . The resultant work was an enclosure of space. . . . Each sculpture had only to be completed in the eye of the spectator. I took a particular satisfaction in its fragility, arguing the essential impermanence of life, much as in the Japanese poem. Like cherry blossoms, perfection could only be transient—a fragile beauty is more poignant."

Noguchi's *Kouros* is a translation into modern terms of the type of sixth- and fifth-century B.C. Greek marble statues depicting youths, from which it takes its name. It is an assemblage of biomorphic forms fitted together on the mortise-and-tenon principle used in constructing wood furniture. A highly original work, its closest analogies are to some of the sculpture of Alberto Giacometti's Surrealist period, and the hybrid forms in paintings by Arshile Gorky—a friend of Noguchi's, with whom he drove across the continent in 1940. Like David Smith's *Hudson River Landscape* (page 133), this work is essentially frontal and linear, with the open spaces as telling as the solid marble slabs.

ISAMU NOGUCHI. Born Los Angeles, California, 1904. *Kouros.* 1944–1945. Pink Georgia marble on slate base, 9′ 9″ high, base 3′ 6″ × 2′ 10⅛″. The Metropolitan Museum of Art, New York (Fletcher Fund).

Isamu Noguchi may be regarded as a continuator of the doctrine of "truth to materials" (see page 129), for although he has worked with aluminum, magnesite, ceramic clay, bronze, cast iron, and steel, the preponderance of his sculpture has been in wood or stone. "Sculpture may be made of anything and will be valued for its intrinsic sculptural materials," he has said. "However, it seems to me that the natural mediums of wood and stone, alive before man was, have the greater capacity to comfort us with the reality of our being. They are as familiar as the earth, a matter of sensibility." Yet Noguchi does not conceive of sculpture in terms of volume and mass, but of space: "The essence of

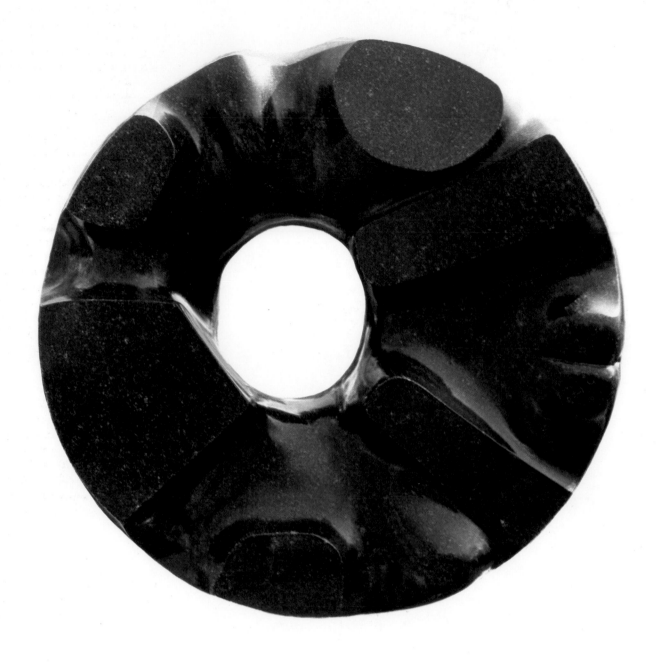

ISAMU NOGUCHI. Born 1904. *Black Sun*. 1960–1963. Black Tamba granite, 30″ diameter. Collection of the Hon. Nelson A. Rockefeller.

A virtuoso in many mediums, Noguchi has always experimented with the properties of materials. His activity has included, besides sculpture, designs for furniture, lamps, playgrounds, gardens, bridges, and theatre sets—notably those for Martha Graham's dance troupe. For a while, he explored the quality of weightlessness in sculpture, using the lightest materials he could find—aluminum and balsa wood. Reacting from this, however, he returned to stone in the 1960s. "My regard for stone as the basic element of sculpture is related to my involvement with gardens," he says. (As a child in Japan, he had had his own garden by the time he was eleven.) "I should like stone to be treated like a newly discovered medium. Both concepts and execution could then be re-examined. . . . The nature of stone is weight. . . . The deepest values are to be found in the nature of each medium. How to transform but not destroy this."

Noguchi's concern with the formal qualities of his art never overshadows his involvement with content; like Barnett Newman (page 149), he has wanted to create art that would function as myth. His collaboration with the architectural firm of Skidmore, Owings & Merrill in a garden outside the Beinecke Rare Book and Manuscript Library at Yale University (1960–1964) gave him the opportunity to construct a large complex expressing cosmic symbolism in abstract terms. The basic idea for its form was a synthesis of the sand mounds found at Japanese temples, the astronomical gardens of India, and the paved piazzas of Italy; its material is white marble. Within its sunken rectangular area are three elements: the sun as life-giving force, the pyramid as symbol of earth and matter, and the cube, poised on one of its corners and signifying the human condition—dependent, like the roll of a die, on chance.

Black Sun, carved in Japan, evolved out of Noguchi's studies for this garden. He has said that in one of its aspects, the circular disk is a ring of energy, the ever-accelerating force that is the source of life. Alternatively: "The circle is zero . . . or the zero of nothingness from which we come, to which we return. The hole is the abyss, the mirror, or the question mark. Or it may be the trumpet that calls youth to its challenge—from which a note has sounded."

Single elements related to the Beinecke garden have been enlarged as public monuments: the cube stands outside a large office building at 140 Broadway, New York, which was also built by Skidmore, Owings & Merrill; and another version of the *Black Sun*, more than three times the size of its prototype, was commissioned with the aid of a matching grant from the National Endowment for the Arts and is installed near the Seattle Art Museum.

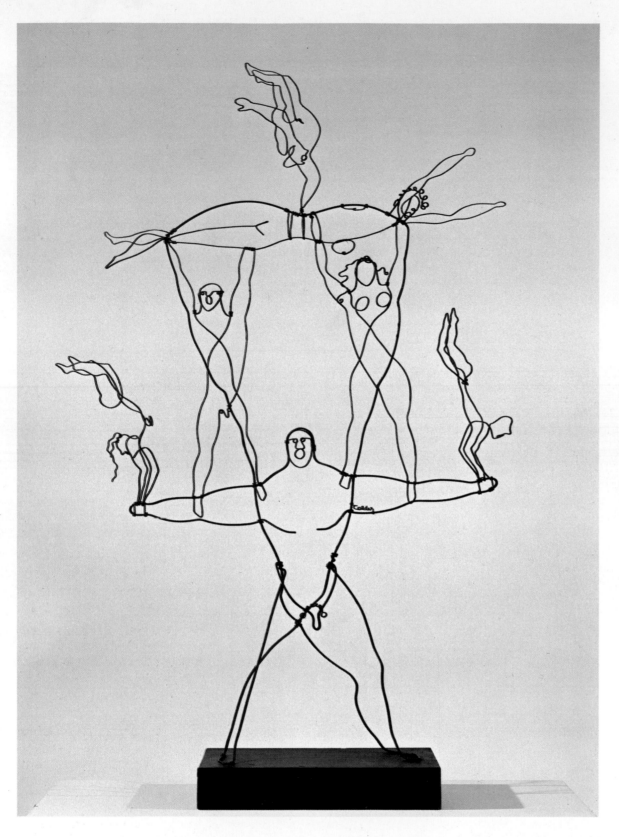

Constructivist ideas, which also influenced the open-form sculpture of Pablo Picasso, Julio Gonzalez, and Alberto Giacometti. It should be noted, however, that the Constructivists' works were all completely abstract, whereas those of Picasso, Gonzalez, Giacometti, and Calder adhered in varying degrees to representation.

A Calder wire sculpture, it has been said, can be looked at as if the background paper of a drawing had been cut away; conversely, the related ink drawings can be read as if they were wire sculptures flattened out on sheets of paper. These drawings actually were *based* on the wire sculptures, made in the late 1920s, while the wirelike drawings —most notably the series of circus subjects (1931–1932)—were done several years later. Calder drew them exactly as if the wire were his pen, and nothing is drawn in a way that could not have been twisted out of wire.

The Brass Family, which is over five feet high, has a close counterpart in a drawing called *Tumbling Family,* one of the large 1931 circus series. Juxtaposed in reproduction (as in *Calder's Circus* by Jean Lipman with Nancy Foote, New York, Dutton Paperbacks, 1972, pp. 54–55), the actual wire lines of the sculpture and the wirelike lines of the drawing look almost interchangeable. The most interesting difference is that for the sculpture Calder used two different gauges of wire; the heavier, as can clearly be seen, makes a strong, wavy triangle above the legs of the bottom figure (whose entire contour is also of heavy wire), serving both as a functional and a compositional support for the pyramidal group above. Another major difference is that, unlike the drawing, the sculpture is not strictly frontal and is much less static; although the depth is shallow, there are multiple suggestions of movement into space—another cardinal principle of the Constructivist manifesto: "Depth is the unique form by which space can be expressed."

Twists of wire, used as needed at support spots, emphasize the poise of the figures; we view their precarious but successful balance much as we would in watching actual performers. The composition is stable, symmetrical, but with enough variation to avoid rigid frontality or any possibility of monotony; notice, for instance, the faces—some blank, some with features. Everything is presented in lively and entertaining shorthand, from a lady acrobat's flying hair and hefty hips to the strong man's powerful chest muscles and impressively displayed male organ. As in Nadelman's *Tango* (page 127) and his other carved figures, humor is an essential component of *The Brass Family.* It's all playful—and monumental.

ALEXANDER CALDER. Born Lawnton (now Philadelphia), Pennsylvania, 1898; lives Roxbury, Connecticut, and Saché, France. *The Brass Family.* 1929. Brass wire, 64″ × 41″ × 8½″. Whitney Museum of American Art, New York (Gift of the artist).

At the opposite pole from Lachaise's emphasis on weight and mass or from Flannagan's insistence on direct carving is Alexander Calder's *Brass Family.* Traditionally, sculptors have thought in terms of mass and volume, achieved through the techniques of carving or modeling. First to challenge these assumptions were the Russian Constructivists

Naum Gabo and Antoine Pevsner, who, influenced by Cubist and Futurist ideas, declared that time and space were the two elements composing real life. "Therefore," they asserted in their Realistic Manifesto of 1920, "if art wishes to grasp real life, it must, likewise, be based on these two fundamental elements. . . . We deny volume as an expression of space. . . . We reject physical mass as an element of plasticity." To make the void visible, they created constructions of metal bands, rods, and wire, thin sticks of wood, and transparent materials such as glass or plastic.

Living in Paris during the 1920s and 1930s, Calder met some of its leading artists and was aware of

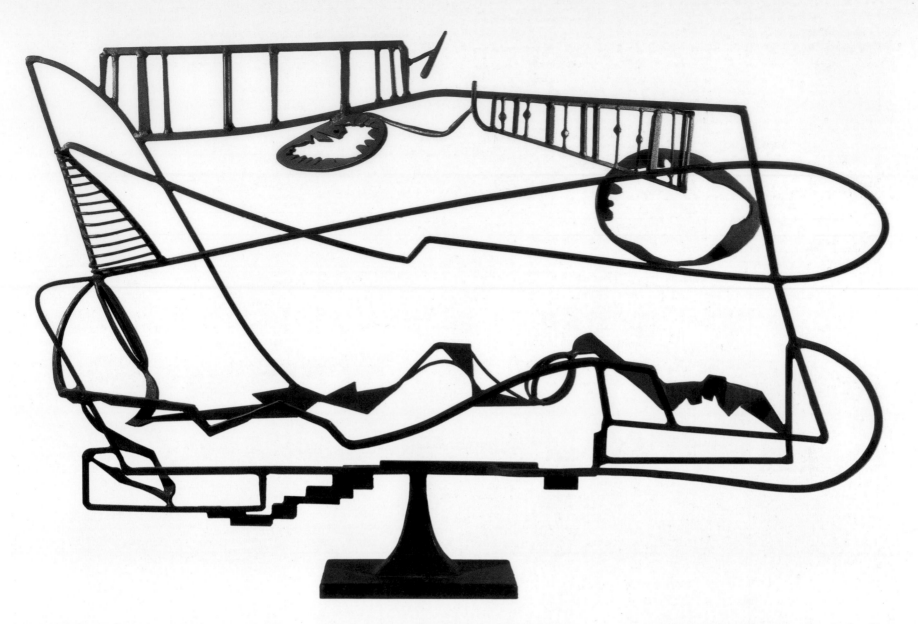

DAVID SMITH. Born Decatur, Indiana, 1906; died near Bennington, Vermont, 1965. *Hudson River Landscape.* 1951. Painted steel, 4′ 1½″ × 6′ 3″ × 1′ 6½″. Whitney Museum of American Art, New York.

In this "drawing in space," David Smith drew with welded metal in somewhat the same way that Calder had drawn with wire some two decades earlier; but there are closer relationships with Cubist constructions and Stuart Davis's linear paintings of the 1930s. Smith had learned the technique of welding when working as a riveter at the Studebaker plant in South Bend, Indiana, in 1925 and was inspired to apply it to sculpture when, about 1931, he saw in a magazine reproductions of some of Picasso's welded-metal pieces. As he later said, "This was the liberating factor which permitted me to start with steel which . . . until now only meant labor and earning power for the study of painting." From 1934 to 1940 he rented studio space for working and welding at the Terminal Iron Works in Brooklyn, New York; during World War II he did defense work at the American Locomotive Company in Schenectady, New York.

Smith's only formal training had been as a painter, and throughout his entire career, from the time that he made his first construction in 1932, he continued to explore such pictorial ideas as the function of color in relation to sculpture and the primacy of the picture plane as a point of departure for structures in space. Creating a landscape in sculpture (something he first attempted in 1946) is in itself an extraordinary fusion of the properties of that medium with those of painting.

Smith himself described *Hudson River Landscape* as "a matter of drawing"; and in fact it is very close to the preliminary sketch, which is inscribed: "River Landscape DS 1951/Hudson River from NYC tracks spring snow partially melted." The following year, he explained the genesis of the work: "The sculpture called HUDSON RIVER LANDSCAPE came in part from drawings made on a train between Albany and Poughkeepsie. A synthesis of drawings from ten trips over a seventy-five mile stretch; yet later when I shook a quart bottle of india ink it flew over my hand, it looked like my landscape. I placed my hand on paper—from the image left I traveled with the landscape to other landscapes and their objects—with additions, deductions, directives which flashed past too fast to tabulate but elements of which are in the sculpture. Is 'Hudson River Landscape' the Hudson River or is it the travel, the vision, or does it matter? The sculpture exists on its own, it is an entity. The name is an affectionate designation of the point prior to the travel. My object was not these words or the Hudson River but the existence of the sculpture. Your response may not travel down the Hudson River but it may travel on any river or on a higher level, travel through form response by choice known better by your own recall. I have intensified only part of the related clues, the sculpture possesses nothing unknown to you. I want you to travel, by perception, the path I traveled in creating it."

This description makes it clear that some element of chance and accident entered into the creative process, reminiscent of Smith's adaptation of certain Surrealist ideas during the 1940s. Beyond that, as the viewer looks through the open spaces of the piece he may be exposed to such transient events as seeing people walking by on the other side. This changes the visual context of the sculpture's environment in the way that the transparency of its material modifies Duchamp's "Large Glass" (see page 108).

The shallow calligraphic composition of *Hudson River Landscape* implies a flattening out of sculptural depth. Its roughly rectangular contour recalls the confines of a sheet of paper (although the pedestal emphasizes the piece as a sculpture). We might also recall the framing by the train window through which Smith viewed the actual landscape that he re-created in semiabstraction. The rock formations along the banks, the river, clouds in the sky, all are seen in flowing movement, almost as if we were watching with the artist as the scene flashed by.

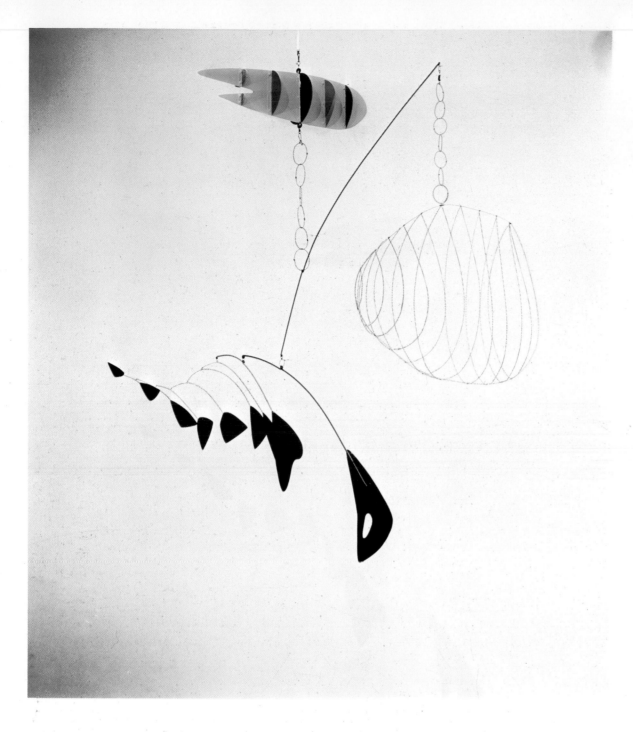

ALEXANDER CALDER. Born Lawnton (now Philadelphia), Pennsylvania, 1898; lives Roxbury, Connecticut, and Saché, France. *Lobster Trap and Fish Tail*. 1939. Steel wire and sheet aluminum, painted, 8′ 6″ × 9′ 6″ diameter. The Museum of Modern Art, New York (Commissioned by the Advisory Committee).

A logical corollary to conceiving sculpture in terms of dynamic time and space, rather than as static mass and volume, is the introduction of actual movement. In fact, the Constructivists' Realistic Manifesto (see page 132) declared: "We affirm . . . a new element of the kinetic rhythms as the basic forms of our perception of real time." About 1920 Naum Gabo and Marcel Duchamp had experimented with motorized constructions, but Alexander Calder arrived at the idea independently in 1930 through a somewhat surprising source of inspiration—a visit to the Paris studio of Piet Mondrian. "I was very much moved by Mondrian's studio," he later said, "with the walls painted

white and divided by black lines and rectangles of bright colour, like his paintings. It was very lovely . . . and I thought at the time how fine it would be if everything there *moved,* though Mondrian himself did not approve of this idea at all. I went home and tried to paint. But wire, or something to twist, or tear, or bend, is an easier medium for me to think in." At first, Calder tried making crank-driven or motorized constructions, to which Duchamp gave the name "mobiles"—which has since entered the language as a generic term. He soon abandoned this type of mechanical motion for that produced by natural forces—currents of air. The principle is similar to that of sails: an air current will cause a vertical piece to move horizontally and a horizontal one to rise. The complexity and duration of movement in the mobiles depends on the number of elements and the manner in which they are hung. Since he had been trained as a mechanical engineer before he became an artist, Calder was familiar with technology and systems of creating balance and counterbalance.

Lobster Trap and Fish Tail is one of his earliest hanging mobiles and the first to reveal the basic characteristics of the genre that launched his enormous international reputation and popularity. The variety of elements and the scale of the piece are attributes of many great mobiles that he made in later years, but none has surpassed the originality and quality of this one as a dazzling, innovative sculpture.

Despite its abstraction, *Lobster Trap,* like many of Calder's works, has references to things in nature. As described by H. H. Arnason, "The topmost element is a curious-looking, torpedo-shaped object which could be the lobster cautiously approaching the trap, represented by a delicate wire cage balanced at one end of the crossbar. Around the other end is clustered a group of fan-shaped metal plates suggestive of a school of fish." Looking at this mobile hanging in the stairwell of The Museum of Modern Art, we note the remarkably varied color patterns as the simple elements, painted red, black, orange, and yellow, turn in response to air currents. There is an inexhaustible play of shadows on the nearby wall, and a triple contrast of shapes and weights—the solid crustacean at the top, the delicately woven wire trap, and the lively "fish" swimming below and forming a complete mobile in themselves.

Making mobiles that are subject to currents of air instead of being mechanically driven introduces the factor of chance or accident—an important idea among the Surrealists, whose movement was dominant in Paris in the 1930s. Many of the freely curving units that compose Calder's mobiles are also related to the "biomorphic" forms, suggesting shapes found in natural organisms, which occur in works by Calder's friends Joan Miró and Jean (Hans) Arp.

GEORGE RICKEY. Born South Bend, Indiana, 1907. *Three Red Lines*. 1966. Stainless steel, lacquered, 37′ high. Hirshhorn Museum and Sculpture Garden, Smithsonian Institution, Washington, D.C. (Partial gift of the artist).

George Rickey's kinetic sculptures derive from the same Constructivist ideas about movement in time and space as Calder's mobiles, and their motion similarly depends on currents of air. But whereas Calder uses free-form, organic shapes, the units making up Rickey's constructions are simplified and geometric, and the underlying principle of their operation is not that of a sail but of the pivot and pendulum. They do not suggest nature as it appears to the eye but as it is manifested in the laws of physics. It is worth noting that Calder, the son and grandson of sculptors, began as a student of mechanical engineering; and that Rickey's grandfather had been a clockmaker, his father a mechanical engineer, and he himself came late to his career as sculptor. He took degrees in modern history at Balliol College, Oxford, studied painting in Paris with the Cubist artist André Lhôte from 1929 to 1930, taught history at Groton in Massachusetts, and later pursued graduate studies in art history at the Institute of Fine Arts, New York University. He has also traveled widely in Europe and Mexico, held teaching and administrative positions in several colleges and art institutions, and written a book on Constructivism.

Rickey was forty-two when he made his first kinetic works, which were of glass. During the 1950s, through research and experimentation, he investigated different kinds of movement as they might apply to sculpture. Some of his early constructions were complex machines, influenced by Calder's mobiles, with vestigial references to organic forms. The turning point that led to such a work as *Three Red Lines* came in 1961. Rickey began exploring the intersecting movement of vertical, oscillating blades or "lines," as he calls them, each consisting of "a hollow spar of thin sheet metal folded into a triangular section and tapering to a point at the top. The counterweight was of lead cast directly into the spar, below the bearing. The bearing was an arm of steel projecting at right angles to the spar at the point of balance. . . . The motion was through an arc in the vertical plane, or, if the bearing was mounted on gimbals (universal joint), the motion was random through a wide cone of space whose apex was at the bearing. These rigid lines . . . tapered to give some of the change of density of a pen stroke, offered a great variety of possibilities."

Rickey has sometimes used as many as twenty-

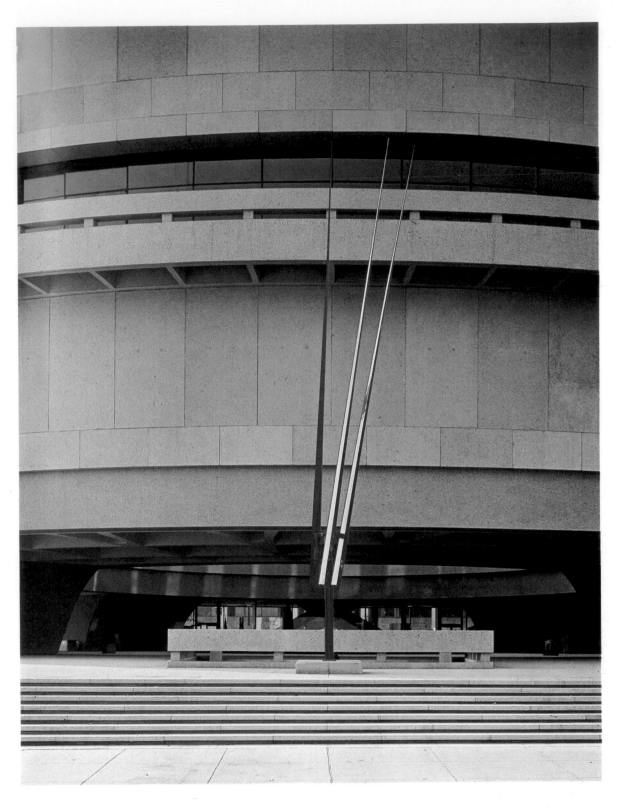

four blades (as in the construction he made in 1962 for the Kunsthalle, Hamburg) or as few as two (like that made for "Documenta III" in Kassel in 1964 and which now belongs to The Museum of Modern Art, New York). Scale has ranged from six inches to the thirty-seven-foot-high *Three Red Lines*. "In relation to movement," he explains, "change of scale is more than change of size. Time is always a factor of movement. Movement slows as dimension grows [the speed of a pendulum being in inverse proportion to its length]. . . . Ventures into large scale are also ventures into retarded time." Adjustment in the speed of swing can also be made by adding or subtracting weight, for decreasing the counterweight slows the movement. In this construction the arc of swing is controlled so that the blades do not hit the ground. The red

color, Rickey says, "is arbitrary and for visibility rather than for sensual satisfaction. It is the movement which is declaratory."

If Calder's kinetic constructions seem more the products of spontaneous intuition, and Rickey's of rational analysis and mathematical calculation, it would be erroneous to overstate the case. Knowledge of the mechanics of movement, understanding of the principles of balance, and precise craftsmanship are equally essential to the work of both artists. Furthermore, for all the seeming detachment of Rickey's scientific description, it is impossible to believe that for him, as for other viewers, there is not a strong emotional response when watching the giant blades, vivid in color and reflecting light, inscribe their lines of movement against the blue sky or white museum walls.

RICHARD LIPPOLD. Born Milwaukee, Wisconsin, 1915. *Variation within a Sphere, No. 10: The Sun.* 1953–1956. Gold wire, bronze-filled, 11′ × 22′. The Metropolitan Museum of Art, New York.

Richard Lippold is the arch-romantic among Constructivists. "It is to space that I have given most of my heart," he declared in 1953, and his works, like his writings, are lyrical incantations to that love. Like George Rickey (page 135), he was the son of a mechanical engineer. After studying at The Art Institute of Chicago, he became an industrial designer but gave up that career to teach at the University of Michigan—the first of several teaching positions he has held. The following year he began making constructions in wire. His ideas of "space and silence" (influenced by contact with the musician John Cage) took shape in the summer of 1948 while he was an artist-in-residence at Black Mountain College, North Carolina, where he created on a small scale the first of his Variations within a Sphere.

In 1950 Lippold completed the ten-foot-high *Variation Number 7: Full Moon* (The Museum of Modern Art, New York), a construction of brass rods, nickel-chromium, and stainless steel wire held in tension. He likened it to a spider web, which is "both a jewel for the branch and a noose for the fly," meant to capture space by the use of seductive materials. That same year, impressed by the grandeur and dimensions of one of the large galleries at

The Metropolitan Museum of Art in which hung dark, richly colored Oriental rugs, he wrote to propose creating a construction for that room. Three years later the museum acted on this suggestion by giving Lippold the first such commission it had ever awarded an artist.

Lippold worked for three years on *Variation within a Sphere, No. 10: The Sun,* the companion piece to the *Full Moon*—two spent in its planning and one in actual construction. Its two miles of twenty-two-carat gold wire, strengthened with an inner bronze core, had to be fabricated to his specifications, and he then electrically welded each segment into place by hand. The construction is built on a modular system: its central core, the sun, is made up of nine full disks, surrounded by quarter disks and outer forms for the corona. The piece, held in tension by invisible wires that attach it to the floor, the ceiling, and the gallery walls, is subtly lit by invisible sources of illumination. As the center slowly revolves, the observer, in Lawrence Campbell's words, "becomes aware of mysterious densities, of planes, disks, radiating lines, endlessly changing patterns. . . . It is like looking into a furnace." Although wire is Lippold's material, his actual medium here is light, with which he draws his lines in space; it is the shimmer of light, rather than the component wires, that the eye perceives.

Two critics praised *The Sun* for its "radiant geometry" and "massively delicate composition,"

but others found it a manifestation of technical wizardry rather than of sculptural sensibility. In the harsh critical climate of the 1950s *decorative* had become a term of opprobrium—a fact that would have astounded many earlier artists, not least among them Henri Matisse, who used this adjective in the title of several of his sculptures and paintings. Architects, on the other hand, have welcomed Lippold's understanding of space and given him many commissions, including those in New York for the *Orpheus and Apollo* in the lobby of Lincoln Center's Avery Fisher Hall and *Flight* in the lobby of the Pan Am Building.

In an article of 1959 Lippold wrote of "some words of Gertrude Stein which were sent to me in the midst of the five or six years which I spent on only two pieces of sculpture, two variations of a concept which I subtitled, *The Sun* and *Full Moon;* six years of *anxious* anonymity, *compulsive* construction, *obsessive* observation and *fear* of failure. I still have this tacked to the door of my studio:

'It is a moon Sunday
And Monday it is a moon Monday. It is a moon
Monday it is a sun Sunday it is a sun
Monday it is a moon Sunday. It is a
 moon Monday. It is a moon Sunday.
It is a sun Monday. It is a sun Thursday
It is a sun Wednesday. It is a sun Sunday.
It is a sun Monday.' "

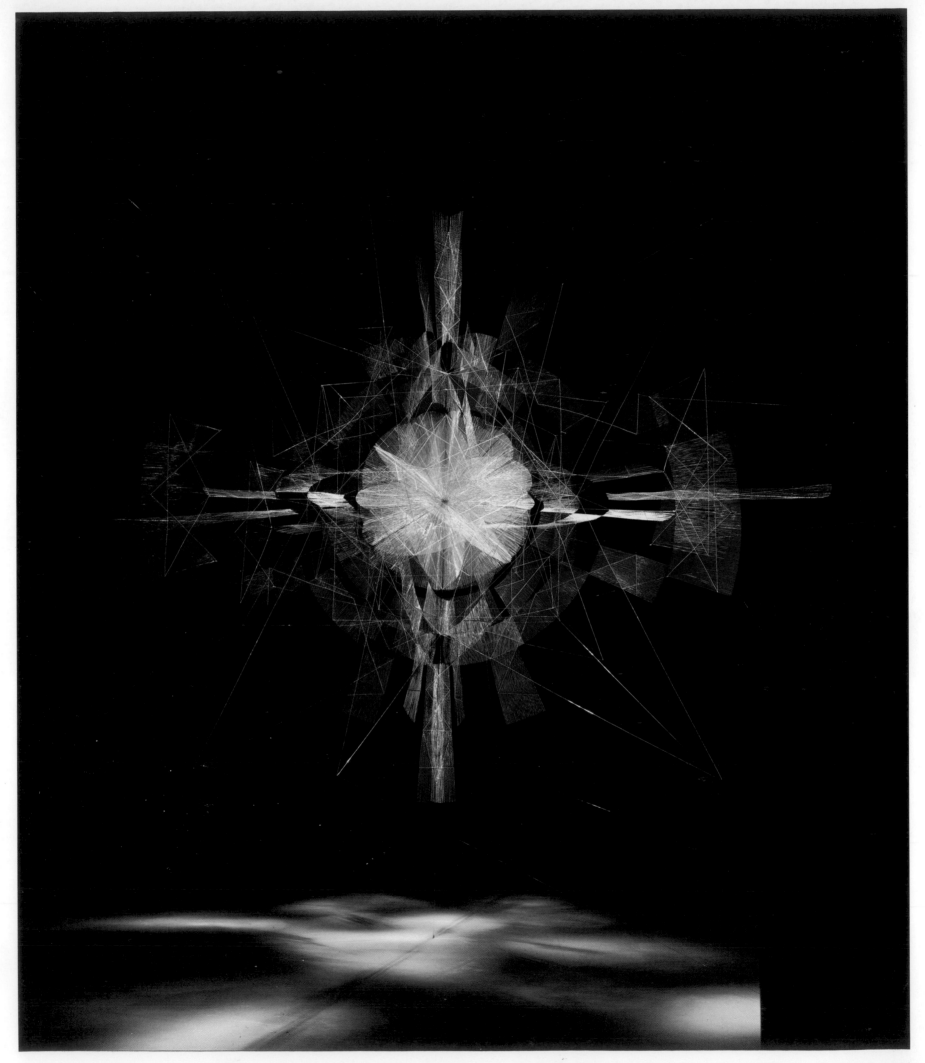

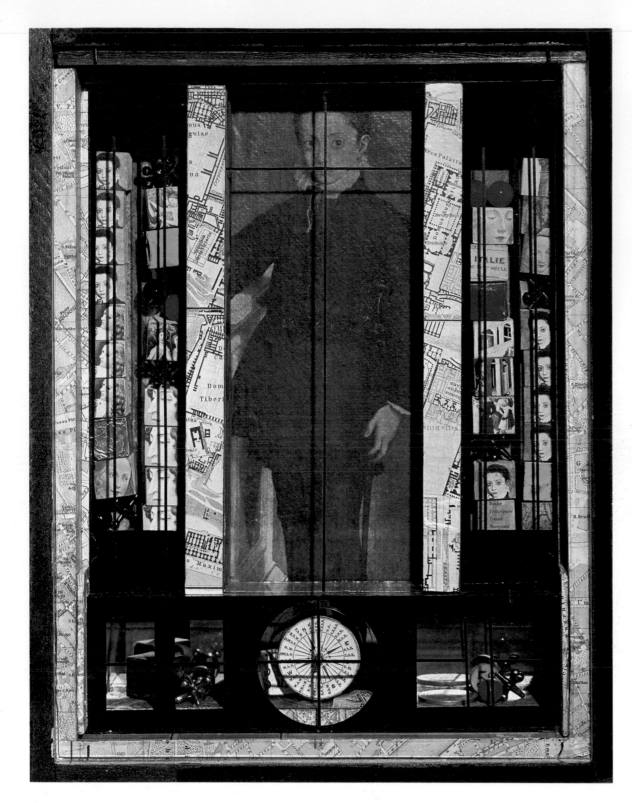

with irrationality, evoked the dreamlike and the marvelous; and so, too, do Cornell's constructions.

Recalling the toy stages he had played with as a child, Cornell constructed shadow boxes that, as he said, "become poetic theatres or settings wherein are metamorphosed the elements of a childhood pastime." The workshop of his house in Flushing, Long Island (on Utopia Parkway!) was filled with all sorts of trivia, carefully sorted and placed in labeled boxes: seashells, both real and plastic; soap-bubble pipes; wineglasses and fragments of glass and mirrors; parts of clocks and watches; eggs, feathers, and stuffed birds; pressed flowers; maps and charts; reproductions of paintings by old masters; photographs of film stars. Many of these objects had nostalgic associations with the past, and especially with poetry, music, and the dance; Cornell had worked for a time with the magazine *Dance Index* and collected memorabilia of ballerinas. He was also interested in the film, which he liked for its repeated images and the possibilities it afforded for abrupt shifts in subject, sequence, and time.

Selecting from these unlikely raw materials those having, by free association, some correspondence in his mind, Cornell composed them within small glass-fronted boxes, carefully painted or stained to provide an appropriate setting. *Medici Slot Machine* is one of his acknowledged masterpieces. Although he always refused to interpret his works, and their magic cannot be explained, some of the elements in this construction can be identified. In Diane Waldman's analysis: "The image of the young boy, Moroni's *Portrait of a Young Prince of the Este Family*, in the Walters Art Gallery, Baltimore, is viewed as if through a gun-sight or lens. . . . The spiral at his feet evokes multiple associations . . . symbolic of life repeating itself in a cycle of seasons and a cycle of generations, it is also an abstract form. . . . The complex play of imagery, sequentially strung out . . . like a series of film clips, with the implication of movement both in time and in space, reconstructs the history of a Renaissance prince and juxtaposes these images of his imaginary childhood (diagrams of the Palatine fashioned from pieced-together Baedeker maps, etc.), with current objects (marbles and jacks) so that the Renaissance child becomes a very real and contemporary child. . . . The objects are brought into reality with color, while the monochromatic images recede into the past. . . .

"Space is cubistically fragmented into small facets which co-mingle, separate and fuse again in kaleidoscopic effect. The black lines which criss-cross the surface . . . create a sense of order and calm. . . . The numbers on the side wall of the box refer to the title of the construction and to the element of play."

The title of this work and the brightly colored balls at the lower left allude to pinball machines. Like the die in the lower right compartment, this game is, of course, governed by the laws of chance, so dear to the Surrealists.

JOSEPH CORNELL. Born Nyack, New York, 1903; died Flushing, Long Island, New York, 1972. *Medici Slot Machine*. 1942. Construction of compartmented wooden box with pasted reproductions and miscellaneous objects, 15½″ × 12″ × 4⅜″. Collection of the Reis Family.

Joseph Cornell was not officially a member of the Surrealist group, although he sometimes exhibited with them and was influenced by their ideas. A self-taught artist who never left the United States, he found the catalyst for his art in a 1931 exhibition of Max Ernst's collages. Collage (from the French word *coller*, to paste) had been invented by Pablo Picasso and Georges Braque, the co-founders of Cubism, when in 1912 they began to affix fragments of paper, cloth, and other substances to their pic-

tures to enrich the surfaces and assert the reality of the work of art as an object in its own right, not the illusionistic representation of something else. In the mid-1920s Arthur Dove had created so-called abstract collage "portraits" by selecting and arranging into compositions materials that had some association with their subjects. By contrast, Ernst's collages used cutout bits of printed images—engravings from old illustrated books or linecuts from catalogues—which he combined in a way that deliberately *dissociated* them from their original context, thus effecting their poetic transformation. Giorgio de Chirico in his "metaphysical" paintings (see page 85) had similarly sought to speak directly to the subconscious mind by the incongruous juxtaposition of objects wrenched out of their normal setting. The Surrealists, replacing logic

KAY SAGE. Born Albany, New York, 1898; died Woodbury, Connecticut, 1963. *Quote, Unquote.* 1958. Oil on canvas, 28″ × 39″. Wadsworth Atheneum, Hartford, Connecticut.

Kay Sage was closely associated with the Surrealists, many of whom were her friends and colleagues; in 1940, she married the Surrealist painter Yves Tanguy, whom she had met in Paris in 1939 and helped to immigrate to the United States at the outbreak of World War II. Born in Albany, the daughter of a New York state senator, she lived in Europe, chiefly Italy, during most of her childhood; she returned to Italy after World War I and remained there until 1937. It was while she was in Paris throughout the next two years that she came to know the Surrealists. She and her husband collected many of their works, nearly a hundred of which she bequeathed to The Museum of Modern Art, New York.

Sage was largely self-taught as an artist. The interest in architecture manifest in many of her paintings was probably due to her years in Italy, and their scaffoldlike structures and evocative deep space suggest the influence of Giorgio de Chirico. James Thrall Soby has said: "Kay Sage was a painter in the romantic tradition. She loved far vistas, atmospheric ambiguities and enigma in the

many guises which give it its name. Yet she also hated such excesses of the romantic spirit as its delight in sorrow and the morbid, its obeisance to the picturesque. There was a strong discipline behind her tastes and preferences. . . . Perhaps it was this underlying control which gave her art its conviction and force."

Typical of her orderly, enigmatic images is this painting, *Quote, Unquote.* At the left, beneath a smoky greenish gray sky, a light brown plain, covered with meandering curves and broken into irregularly oblong segments of eroded soil, stretches to the distant, dim horizon. A platform rises at the right; its shallow paving blocks, tilted and overlapping, repeat the rectangular shapes that cover the plain. From this base rise slender poles, pointed at the top. Some stand alone, others support screenlike panels, and two are hung with folds of drapery. The diagonal recession into space of these units is accentuated by crisply defined shadows cast by some unseen source of light located beyond the picture's lower left corner. The muted colors—grays darkening almost to black, browns ranging from yellowish tan to walnut, and a similar gamut of dull greens—enhance the ominous quality of this mysterious composition.

Sage never explained the titles she gave her works or offered any interpretation of them, saying

they must speak for themselves. Silence is also intrinsic to her paintings, which are devoid of any sign of life. The poetic description Mr. Soby has written of them is particularly applicable to this memorable picture: "Her structures rise in a setting which is neither park nor garden, but somewhere, deep in memory, their like. These are the pavilions of dreaming. They stand in boundless space. They are uninhabited except by shadows. . . . The buildings themselves are delineated with extreme precision and yet with warmth. . . . Around this enchanted architecture an arid landscape follows a curious geometry, toward infinity and luminous skies."

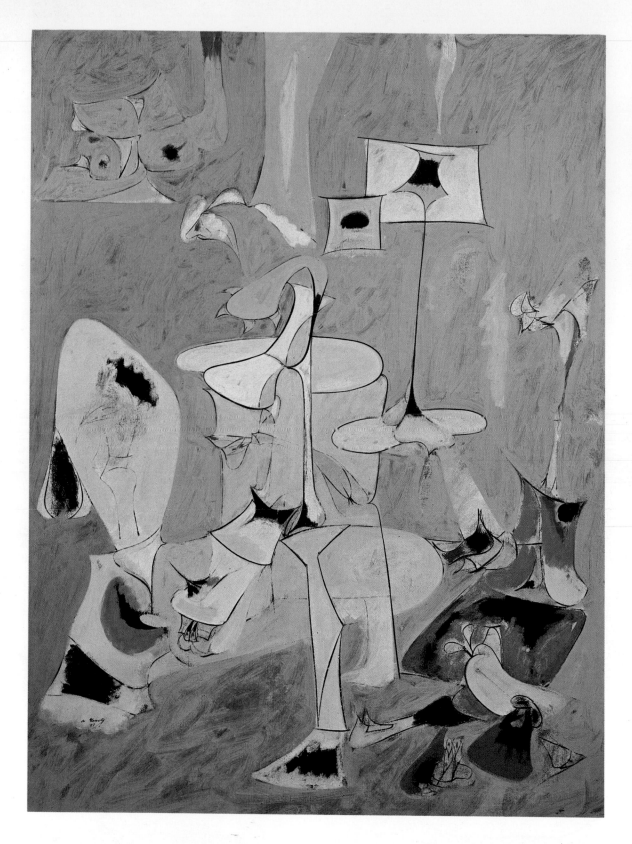

provisations of 1912 and 1913, and the erotic, psychological "Inscapes" of his friend Matta—paintings filled with hybrids that equated the human body with landscape and merged images perceived in the natural world with those born in the artist's mind.

Automatism was a basic tenet of the Surrealists; in fact, in 1924 in the First Surrealist Manifesto, Breton defined Surrealism as "Pure psychic automatism by which one seeks to express . . . the real workings of the mind. Dictated by the unconscious, in the absence of any control exercised by reason." Although some Surrealists produced illusionistic pictures that Dali called "hand-painted dream photographs," others adhered to the principle of spontaneity. Under the liberating stimulus of this concept, Gorky's imagery became more subjective, his painting increasingly fluent, and his color more varied and opulent.

The Betrothal, II is one of Gorky's most beautiful works. Its taut black lines, drawn with a special thin, long-haired brush used by sign painters, enclose painted shapes that move against a background of pale yellow, with a dark red underpainting allowed to show through. As the title indicates, this was the second version of a composition for which several studies also exist. The central theme of a rider on horseback had interested Gorky as early as 1924. The horse and rider recur frequently in Kandinsky's early paintings, but the germinal idea for this picture came from The Battle of San Romano by the fifteenth-century Florentine Paolo Uccello, a reproduction of which Gorky kept pinned to the wall of his studio. (It should be noted that Uccello was the old master most admired by the Surrealists.) The horse moves to the left, his tail pointing to the right; the featureless rider seems to wear a helmet topped by a white plume. In the background to the right, a standing figure is reduced to a polygonal head connected to pedestal-like feet by an attenuated line for a body; banners float nearby. The dark form at the lower right perhaps represents a fallen warrior. But in looking at Gorky's paintings, we should avoid making specific interpretations and be guided by Breton, who called Gorky "the eye-spring"—the first painter not to reflect the outer world passively, like a mirror, but to combine the spectacle of nature with "a flux of childhood and other memories . . . the observer being gifted to a rare degree with the grace of emotion." He declared: "Truly the eye was not made to take inventory like an auctioneer, nor to flirt with delusions and false recognitions like a maniac. It was made to cast a lineament, a conducting wire between the most heterogeneous things. . . . Easy-going amateurs will come here for their meager rewards: in spite of all warning to the contrary they will insist on seeing in these compositions a still life, a landscape, or a figure instead of daring to face the hybrid forms in which all human emotion is precipitated."

A year after completing The Betrothal, II, Gorky committed suicide. His painting has been considered transitional to that of the Abstract Expressionists (see page 141); but he had no immediate followers, and his influence was transmitted principally through Willem de Kooning.

ARSHILE GORKY. Born Khorkom Vari, Turkish Armenia, 1904; to United States 1920; died Sherman, Connecticut, 1948. The Betrothal, II. 1947. Oil on canvas, 50¾″ × 38″. Whitney Museum of American Art, New York.

New York suddenly replaced Paris as the art capital of the world when, with the outbreak of war, many leading artists came from Europe to live and work in the United States. Among them were the Surrealists André Breton, Max Ernst, André Masson, Marcel Duchamp, Salvador Dali, Yves Tanguy, and their younger associate from Chile, Sebastian Matta Echaurren. Their ideas affected a number of American painters, but none more profoundly than

Arshile Gorky, who came to be hailed by the Surrealists as one of their own.

Surrealism was only one of several influences that Gorky had undergone. He was virtually self-taught as an artist and had struggled to develop his own style by deliberate imitation of masters he admired—among them Cézanne, Matisse, and Picasso. William Rubin has said: "For Gorky . . . the recapitulation of various stages of European painting was not simply a series of identifications, subsequently rejected, . . . it was a series of lessons about the possibilities of painting." His personal style did not begin to emerge until the early 1940s, under the dominant influences of Joan Miró's biomorphic forms, Wassily Kandinsky's im-

WILLEM DE KOONING. Born Rotterdam, the Netherlands, 1904; to United States 1926. *Woman, I*. 1950–1952. Oil on canvas, 6′ 3⅞″ × 4′ 10″. The Museum of Modern Art, New York.

In an important article of 1952, "The American Action Painters," Harold Rosenberg defined the aims of the Abstract Expressionist vanguard: "With traditional aesthetic references discarded as irrelevant, what gives the canvas its meaning is . . . the way the artist organizes his emotional and intellectual energy as if he were in a living situation. . . . The tension of the private myth is the content of every painting of this vanguard. . . . Art as action rests on the enormous assumption that the artist accepts as real only that which he is in the process of creating. . . . The artist works in a condition of open possibility. . . . The test of any of the new paintings is its seriousness—and the test of its seriousness is the degree to which the act on the canvas is an extension of the artist's total effort to make over his experience."

Willem de Kooning's art has always been deeply rooted in his experience and an open-ended exploration of pictorial possibilities, which often, like modern life itself, involve ambiguities and contradictions. Solidly trained by eight years of study in night classes at the Rotterdam Academy of Fine Arts and Techniques while apprenticed to a commercial art firm, he came to the United States at the age of twenty-two. For several years he supported himself as a house painter and then as a free-lance commercial artist. He soon became acquainted with a number of New York artists, notably John Graham and Arshile Gorky; the latter became a close friend and an important influence on de Kooning's development. He participated in a number of group exhibitions in the 1940s but did not have a one-man show until 1948; almost immediately, he was recognized as a major innovator. Many considered him a foremost champion of abstraction, but de Kooning has always been impatient with those who take doctrinaire positions. In 1963, speaking of the fact that, ten years before, some of his associates and admirers had regarded his Woman series as a return to figurative painting and hence as a betrayal of abstract art, he declared, "Certain artists and critics attacked me for painting the *Women*, but I felt that this was their problem, not mine."

Ideology apart, when confronted with one of these paintings, the spectator's initial response, as to the figures in Picasso's *Demoiselles d'Avignon* of 1907 (The Museum of Modern Art), is to exclaim, "How ugly!" Obviously, neither artist was portraying an ideal of female pulchritude. Picasso's proto-Cubist canvas was, in the words of Alfred H. Barr, Jr., "a battlefield of trial and experiment," in which natural forms were broken up and fitted into a semi-abstract, overall design of tilting and shifting planes compressed within a shallow space, produc-

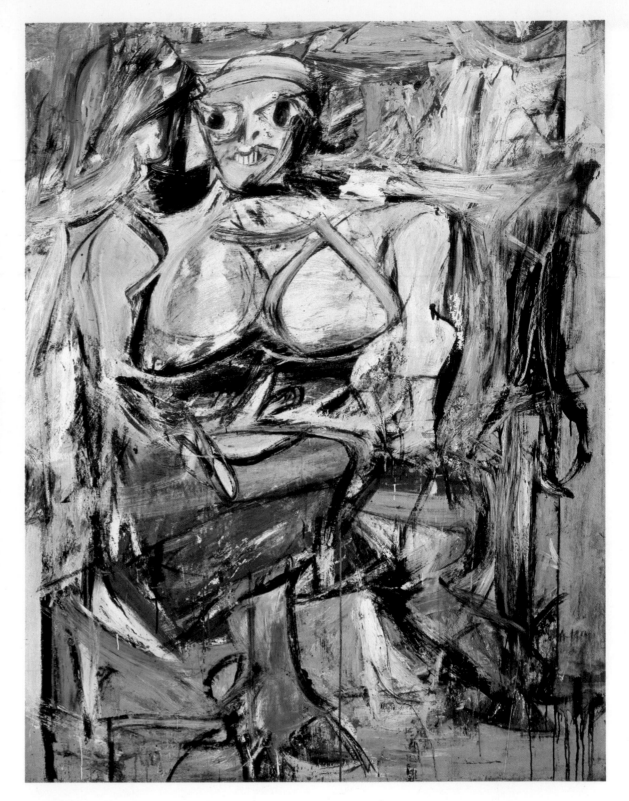

ing a painting charged with explosive energy. In *Woman, I,* de Kooning was concerned both with his subject and with a number of pictorial problems. These included the tension between the figure's three-dimensional form and the flatness of the canvas; the relation of the figure to the unidentifiable environment in which it sits; the relationships among the shapes, which are frequently overlapping; and the handling of the paint medium —with accidental effects that coexist with others deliberately planned, and with gestural, Abstract Expressionist brushstrokes that seem to obey dynamic rhythms of their own instead of outlining the forms or modeling them in a conventional way. De Kooning worked on the picture for over two years before he considered it finished, and at the last moment he

added a strip to the right side of the canvas so that the figure would be off center.

Irrespective of his involvement with seeking solutions to formal problems, in this and other paintings of the Woman series the subject itself was a major preoccupation for de Kooning. He declared that his concept "had to do with the female painted through all the ages." Besides having in mind the long classical tradition of the woman as "the idol, Venus, the nude," he also incorporated references to such contemporary icons as pinup girls and the banal stereotypes of billboard and magazine advertisements—large ogling eyes, overdeveloped breasts, and toothy grins. He was disappointed that everyone responded immediately to the figure's aggressiveness but few recognized it as hilarious.

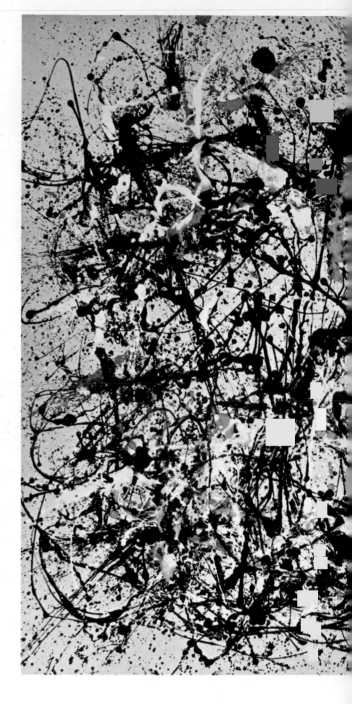

JACKSON POLLOCK. Born Cody, Wyoming, 1912; died East Hampton, Long Island, New York, 1956. *Autumn Rhythm* (*Number 30, 1950*). Oil and enamel on canvas, 8′ 10½″ × 17′ 8″. The Metropolitan Museum of Art, New York (George A. Hearn Fund).

In such a work as Jackson Pollock's *Autumn Rhythm* automatism reached a culmination never foreseen by the Surrealists—in its grandiose scale, the expressive energy of its interwoven lines, and its total commitment to abstraction, with no vestigial references to either natural or imaginary forms.

In 1944, replying to a question about the European artists then resident in the United States, Pollock said: "I accept the fact that the important painting of the last hundred years was done in France. American painters have generally missed the point of modern painting from beginning to end. (The only American master who interests me is Ryder.) Thus the fact that good European moderns are now here is very important, for they bring with them an understanding of the problems of modern painting. I am particularly impressed with their concept of the source of art being the unconscious. This idea interests me more than these specific painters do, for the two artists I admire most, Picasso and Miró, are still abroad."

The singling out of Ryder is significant, for it places Pollock within the tradition of American Romanticism, and of Romanticism's concern with the primacy of each individual's emotions. For modern man psychoanalysis has been one means of plumbing the unconscious to discover the sources of those emotions; and beginning in 1939, Pollock underwent Jungian analysis, which differs from Freudian in its emphasis on myth. He filled his early paintings with totemic symbols vaguely derived from classical mythology or from primitive cultures (as did some of his contemporaries in the 1940s, for example Mark Rothko and Adolph Gottlieb) and gave them such evocative titles as *Guardians of the Secret* and *Night Ceremony*.

Born in Wyoming, Pollock lived in Arizona and California before coming to New York to study with the Regionalist Thomas Hart Benton (see page 118). This training he later declared was "im-

portant as something against which to react very strongly," but he also took from his teacher an inclination for expressive distortions, dramatic rhythms, and strong dark-and-light contrasts. Among the Mexican muralists active in the United States in the 1930s Pollock admired the expressionistic José Clemente Orozco and David Alfaro Siqueiros; their work probably also inspired his desire to go beyond easel painting, which he considered "a dying form," in order to paint "large movable pictures which will function between the easel and mural."

The decisive break in Pollock's style came in 1947 when, purging his art of any imagery, he began to place his canvases on the floor and adopt his "drip" technique. He explained this by saying that "this way I can . . . work from the four sides and literally be *in* the painting. This is akin to the method of the Indian sand painters of the West. . . . I prefer sticks, trowels, knives and dripping fluid paint or a heavy impasto with sand, broken glass and other foreign matter added. When I am *in* my painting, I'm not aware of what I'm doing . . . the painting has a life of its own. I try to let it come through."

Many critics and members of the public focused on the method and not on the results, dubbing Pollock "Jack the Dripper." They failed to perceive that, although born in ecstasy and created by flinging or dripping paint rather than applying it with a brush, such a painting as *Autumn Rhythm* manifests throughout the artist's control of the direction, thickness, and continuity of his rhythmic lines and drips. Note, for example, how the labyrinthine skeins of pigment do not run off at the edges of the canvas but respect its top, bottom, and sides, turning with sweeping curves at the corners. The interlacing lines that fill the entire surface with an allover pattern are organized along definite horizontal and vertical axes. In contrast to some of Pollock's paintings that mingle metallic pigments with bright reds, blues, and greens, the color in *Autumn Rhythm* is almost entirely restricted to black, white, and tan against an ecru ground. The bare canvas beneath the overlapping network of lines imparts a mysterious suggestion of light and space; the total effect is at once dramatic and lyrical.

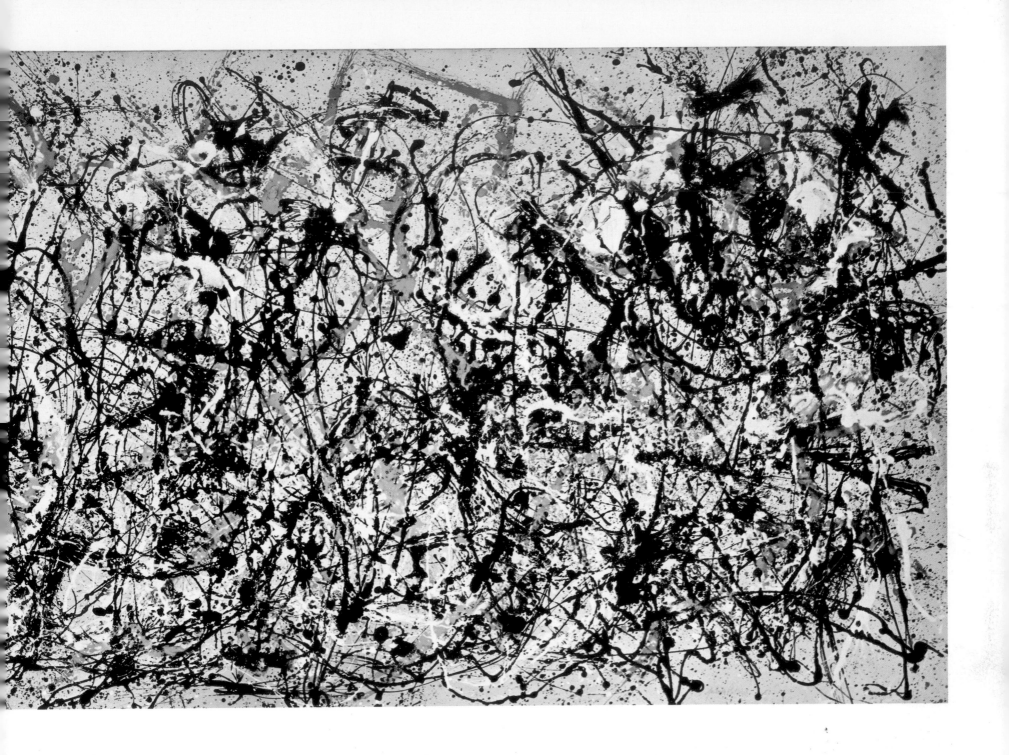

ROBERT MOTHERWELL. Born Aberdeen, Washington, 1915. *Elegy to the Spanish Republic, XXXIV*. 1953–1954. Oil on canvas, 6′ 8″ × 8′ 4″. Albright-Knox Art Gallery, Buffalo, New York (Gift of Seymour H. Knox).

In contrast to Jackson Pollock's intuitive approach to painting, that of Robert Motherwell is intellectual, although his predilection for rational analysis has never been at the expense of warm emotional involvement and sensuous delight in his materials. Whereas Pollock, despite his debt to Picasso, Miró, the Surrealists, and the Mexican muralists, was always rooted in the American experience, Motherwell has consistently been among the most internationally oriented of our modern painters. He once said that in the 1940s, when what was soon to burgeon as Abstract Expressionism or "the New American Painting" was germinating in the studios and discussion groups of New York artists, he and most of his associates "felt that our passionate allegiance was not to American art or in that sense to any national art, but that there was such a thing as modern art: that it was essentially international in character, that it was the greatest painting adventure of our time, that we wished to participate in it, that we wished to plant it here, that it would blossom in its own way here as it had elsewhere, because beyond national differences there are human similarities that are more consequential."

Motherwell came to art by way of philosophy; his other special interests have included music, psychoanalytic theory, and the Symbolist poets, particularly Mallarmé. Entering the Department of Art History and Archaeology at Columbia University in 1940, he was encouraged to devote himself to painting rather than to scholarship by Professor Meyer Schapiro, who introduced him to some of the Surrealist artists-in-exile in New York. Motherwell became especially friendly with Matta and was deeply influenced by the Surrealists' theories about automatism, but differed from them in his commitment to abstraction. He declared in 1951: "I think that abstract art is uniquely modern . . . in the sense that [it] represents the particular acceptances and rejections of men living under the conditions of modern times. . . . I should say that it is a fundamentally romantic response to modern life—rebellious, individualistic, unconventional, sensitive, irritable. . . . One might truthfully say that abstract art is stripped bare of other things in order to intensify it, its rhythms, spatial intervals, and color structure. Abstraction is a process of emphasis, and emphasis vivifies life."

The short-lived cooperative school that Motherwell founded in 1948 with several other artists (including Mark Rothko, page 151, and Barnett Newman, page 149) was called "The Subjects of the Artist," to emphasize that abstract painting, although nonrepresentational, has subject matter. In that same year he found the theme that he was to develop in more than a hundred paintings over the course of almost three decades in the series of Elegies to the Spanish Republic. In the late 1930s the Spanish Civil War had precipitated a moral crisis somewhat like that induced by the Vietnam War thirty years later; Motherwell, however, did not intend these pictures to have a topical significance: "The 'Spanish Elegies' are not 'political,' but my private insistence that a terrible death had happened that should not be forgot. They are as eloquent as I could make them. But the pictures are also general metaphors of the contrast between life and death, and their interrelation."

Like other paintings in this series, the monumental *Elegy to the Spanish Republic, XXXIV* is composed of irregularly edged biomorphic shapes in matte black, abutting one another and offset against white and colored vertical rectangles of various widths. The large black shapes have implicit sexual connotations, phalluslike verticals alternating with female ovoids; but they have also been read as the bulls' tails and testicles hung on the arena wall after a *corrida*. The general configuration of the forms, the relationships among them, and their arrangement on the flat surface are carefully controlled, although there are also some of automatism's accidental drips. Color is used for both its symbolic and its aesthetic importance: "Black is death, anxiety, white is life, éclat. Done in the flat, clear Mediterranean mode of sensuality, but 'Spanish' because they are austere." Motherwell has also said: "My use of color is quite 'naturalistic.' . . . My blue is the blue of the sky, or the sea . . . my greens are tree, flower, and plant greens; my browns are earth browns. . . . My colors already exist in nature, even if I intensify them."

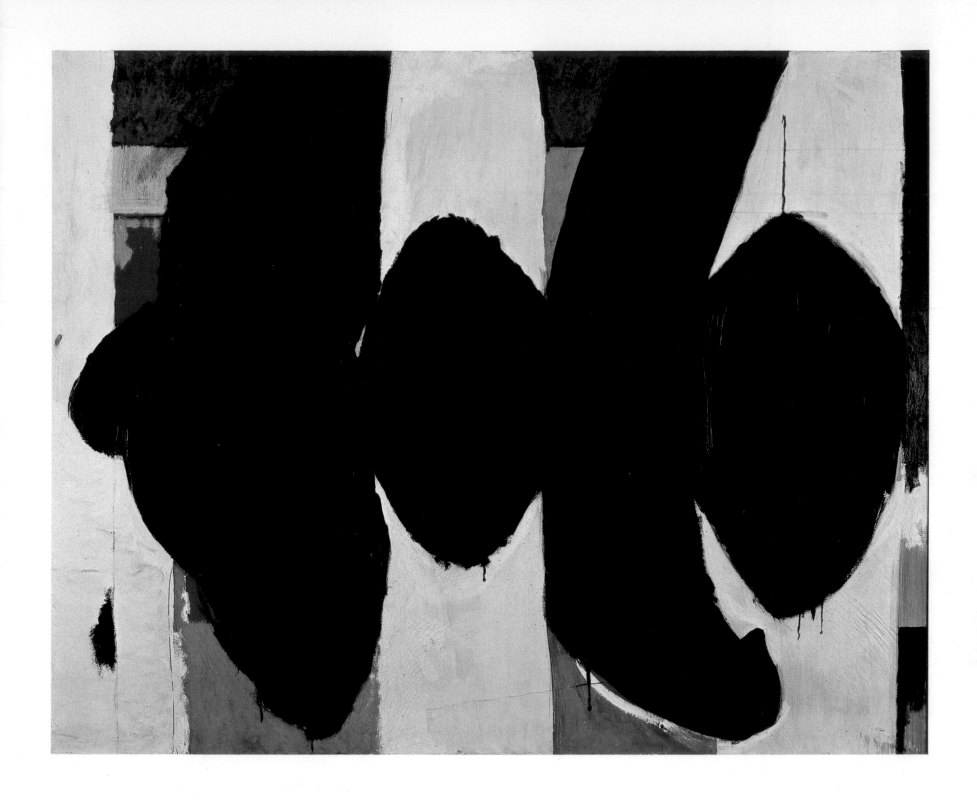

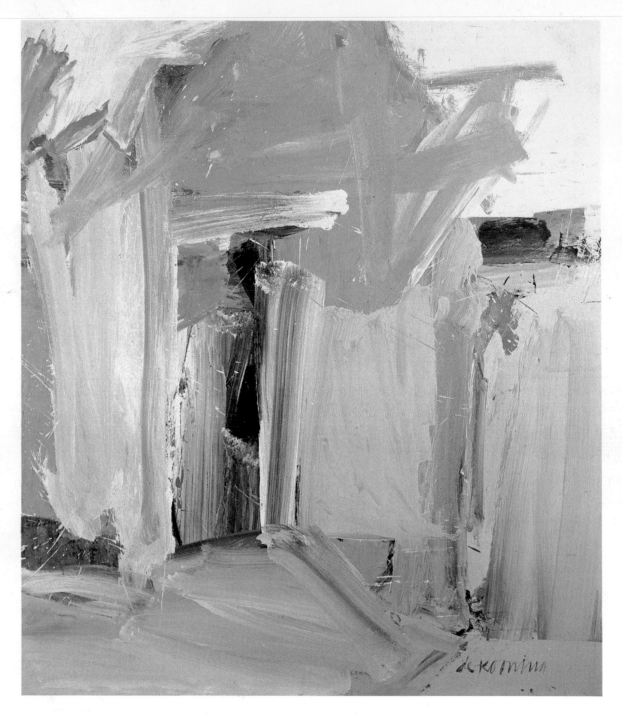

WILLEM DE KOONING. Born Rotterdam, the Netherlands, 1904. *Door to the River*. 1960. Oil on canvas, 6′ 8″ × 5′ 10″. Whitney Museum of American Art, New York (Gift of the Friends of the Whitney Museum of American Art, and Purchase).

De Kooning observed that the form of his *Woman, I* (page 141) reminded him strongly of "a landscape—with arms like lanes and a body of hills and fields, all brought up close to the surface, like a panorama squeezed together"; and he even gave one of his paintings the title *Woman as Landscape*. Beginning in the late 1950s, he spent an increasing amount of time out of New York and in 1963 left the city to settle in Springs, Long Island. In an interview of that year he said that most of the pictures he had done since the Woman series were "emotions. . . . Most of them are landscapes and highways and sensations of that, outside the city— with the feeling of going to the city or coming from it." "Forms ought to have the emotion of a concrete experience," he declared. "For instance, I am very

happy to see that grass is green." Gradually the urban themes in his pictures were supplanted by those derived from the countryside, and his colors became a reflection of green grass, sunlit yellow beaches, blue skies, blue-green ocean, and brown earth.

Although painted in New York in 1960, *Door to the River* already reveals this change in de Kooning's palette. Like *Woman, I*, it is only semiabstract, for it seems to encapsulate a view of a closed-off pier at the end of a Manhattan street. Beyond the wooden pilings appear glimpses of water and the line of the farther shore under a whitish sky. As in many of de Kooning's pictures of this period, the forms are larger and less fragmented than in *Woman, I*, corresponding with this tendency toward simplification, the brushstrokes are broader, the colors fewer. They are also more intense and are keyed to the dominant yellow, which ranges from the large bright area above and to the right of the door to a lemon color just to its left, a pale yellow mixed with much white adjacent

to that, and a darker ocher at the extreme left. The few touches of bright blue contrast with the grays and light pinkish browns in the foreground, center, and right side of the painting, and with the darker brown area at the center right. Layers of pigment are applied one over another, with the underpainting showing through, and the streaks made by the passage of the brush clearly apparent.

Notable in this painting, and running counter to the prevailing tendency in modern art, is a return to illusionism. De Kooning challenges the modernist imperative to flatness by creating a strong sense of recession in depth, which converges on the door in the center. But at the same time, the evidence of his gestural strokes, involvement with the material itself, and the many drips and splashes of paint not only impart vibrancy and dynamism to the surface but also make us constantly aware that we are not looking at a view of the world of nature but at an artificial construct—a painting. We are also conscious of the artist's self-revelation, inasmuch as the evidences of process allow us to participate vicariously in the choices and decisions he made while executing the picture. Such an attitude, which emphasizes the individual's emotion and response to his environment, clearly lies within the tradition of Romanticism.

But confronted with so beautiful a work as the *Door to the River*, we should be wise to recall a statement by Charles Demuth: "For the painter, paintings are, wet or dry, just paintings. They are not arguments. They are not signs on the way to that supposed Nirvana: Culture. . . . Paintings must be looked at and looked at and looked at— they, I think, the good ones, like it. They must be understood and that's not the word either, through the eyes. No talking, no writing, no singing, no dancing will explain them. They are the final, the 'nth whooppee of sight. A watermelon, a kiss, may be fair, but after all have other uses. 'Look at that!' is all that can be said before a great painting, at least, by those who really see it."

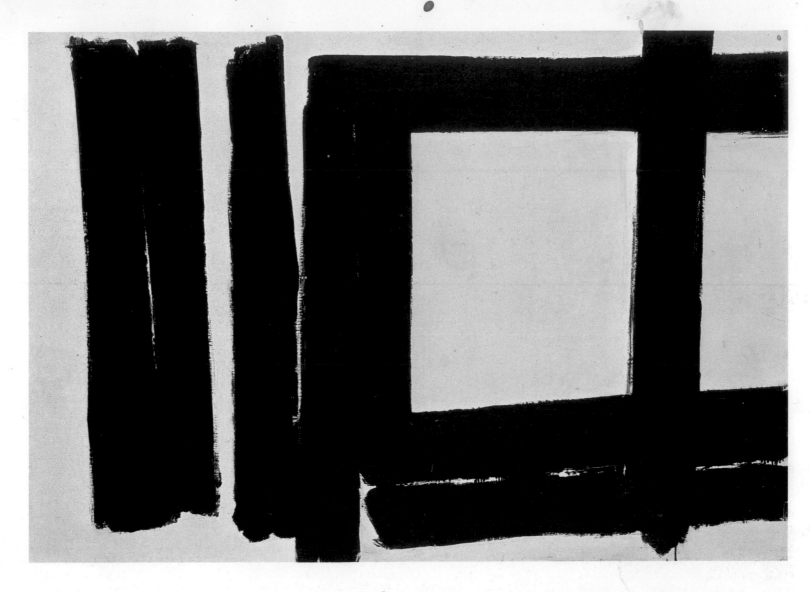

FRANZ KLINE. Born Wilkes-Barre, Pennsylvania, 1910; died New York 1962. *Painting #7*. 1952. Oil on canvas, 4′ 9½″ × 6′ 9¾″. The Solomon R. Guggenheim Museum, New York.

In such a work as Franz Kline's *Painting #7*, with its monumental size and bold abstract forms created by powerful brushstrokes, gestural painting reached its apogee. The picture appears completely spontaneous, but Kline actually worked from preparatory sketches, although his final execution was rapid. He used the large brushes of house painters and favored commercial enamels for their quick-drying properties and the possibilities they afforded of contrasting their gloss with the matte surface of the canvas.

Kline did not come to abstraction until he was about forty. He had received a thorough art training in Boston and London and admired traditional forms and styles, particularly those of Velázquez, Rembrandt, Daumier, and Ryder. Settling in New York in 1939, he continued to work in a representational style, painting portraits, seated figures (usually in rocking chairs), and recollections of the Pennsylvania landscape in which he had grown up, and of the trains that carried coal from the mines. His stepfather had operated a roundhouse, and even after Kline turned to abstraction he gave many of his paintings the names of places in Pennsylvania or of locomotives remembered from his youth, for example *Chief* and *Cardinal*.

His personal style emerged about 1947, as an outgrowth of his constant practice of drawing, and for the next several years increased in forcefulness as he enlarged his canvases and brushstrokes. Several other artists—among them Willem de Kooning, Robert Motherwell, Jackson Pollock, and Barnett Newman—were also experimenting with restricting themselves to black and white at about this time; but as Frank O'Hara has said, "Kline's was an entirely different approach. . . . The forms are stark and simple, the gesture abrupt, rough, passionately unconcerned with finish. All the finesse so ardently acquired from the masters has been set aside for a naked confrontation with the canvas and the image." Kline made it clear that his use of this idiom "wasn't a question of deciding to do a black-and-white painting. I think there was a time when the original forms that finally came out in black and white were in color, say, and then as time went on I painted them out and made them black and white. And then, when they got that way, I liked them, you know." In the mid-1950s he reintroduced color into his works—brilliant reds, yellows, oranges, and purples, as well as browns and grays.

Kline's black-and-white pictures have sometimes been compared to Oriental calligraphy, from which, however, they differ in important respects. To begin with, from a technical standpoint the configurations are not drawn with black strokes on a white ground as the eye first tends to read them. Closer inspection reveals that the white areas frequently cut into and over the black, creating a constant tension. Kline pointed out that this technique was in fact firmly based on Western tradition, "the tradition of painting the areas which, I think, came to its reality here through the work of Mondrian—in other words, everything was equally painted—I don't mean that it's equalized, but I mean the white or the space is painted."

Secondly, for all their abstraction, these pictures nevertheless invoke suggestions of machinery, or of the girders of bridges or buildings under construction. Kline joyously accepted the urban environment, delighting in New York both visually and also because it enabled him to meet frequently with fellow artists and engage in discussions with them. "If you're a painter," he said, "you're not alone. There's no way to be alone. You think and you care and you're with all the people who care. . . . You don't paint the way someone, by observing your life, thinks you *have* to paint, you paint the way you have to in order to *give*, that's life itself . . . it has nothing to do with knowing, it has to do with giving. . . . When you've finished giving, the look surprises you as well as anyone else. Of course, this must be an American point of view. . . . Hell, half the world wants to be like Thoreau at Walden worrying about the noise of traffic on the way to Boston; the other half use up their lives being part of that noise. I like the second half."

147

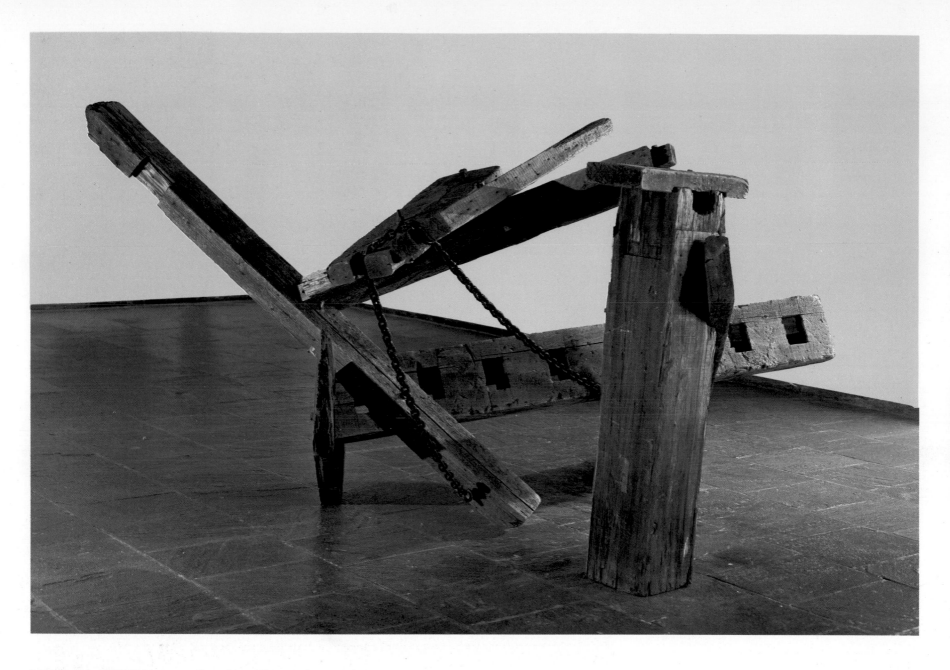

MARK DI SUVERO. Born Shanghai, China, of Italian parentage, 1933; to United States 1941. *Hankchampion.* 1960. Wood and chain construction, 9 units, 6′ × 10′. Whitney Museum of American Art, New York (Gift of Mr. and Mrs. Robert C. Scull).

The similarity between Mark di Suvero's sculptures, such as *Hankchampion,* and Franz Kline's paintings (page 147) has often been remarked; and, in fact, di Suvero was deeply impressed by an exhibition of the older artist's work that he saw in 1953. Common to both is the feeling for forceful gesture and an acceptance of the modern industrial environment. The references to beams and girders that are only hinted at in Kline's imagery become explicit in di Suvero's assemblages, which are composed of the waste products of the machine age—discarded timbers of ruined buildings, chains, unused I or L beams—bolted rather than welded together. "The crane is my paintbrush," he has said.

Di Suvero's training in California had been in an expressionist sculptural style with a certain infusion of the Futurists' sense of dynamic "lines of force." Soon after coming to New York he became interested in the cast-off materials found on the streets of the Bowery and in timbers and bolts picked up

from the docks. He began to collect this detritus and to combine it in large-scale works that parallel Abstract Expressionist paintings, especially those of Kline. But the roots of such an art lie in earlier movements: the Dadaists' antiart espousal of the "found object" (notably exemplified in the Readymades of Marcel Duchamp, who declared that by *choosing* such an object as a snow shovel or a bottle rack, the artist thereby elevated it to the status of a work of art); the collages of Kurt Schwitters, composed of worthless trivia—bits of paper and other scraps picked up on the streets or salvaged from trash cans and wastebaskets; the romanticism attached by association to old and weathered things, as in William Harnett's trompe-l'oeil pictures (see page 84). But in one of di Suvero's assemblages, as Robert Goldwater reminds us, "its style (in which large scale is essential) is of a later time. Its open composition through which space flows, its strongly linear elements crossing each other, its concentrated blacks massed against uneven whites, all these reveal the proximity of abstract expressionism, whose irregular edges and drips seem here to have their wooden counterparts."

In a perceptive article on di Suvero's sculpture Max Kozloff quotes Hyatt Mayor's description of the *Imaginary Prisons* by the eighteenth-century

Italian Giovanni Battista Piranesi: "those beams draped with tons of chains, those gang planks teetering from arch to arch, these pieces that stand like beacons for exploring loftiness and light." Like Piranesi's engravings, di Suvero's constructions create an environment. The spectator becomes involved in a spatial dialogue with the work. There is no one fixed point from which it is best viewed; the relationships among the elements, the angles they form, the contrast between solids and open spaces, constantly change as the spectator walks around the piece. Di Suvero combines such intractable units as metal beams, those made of the more pliant material, wood, and others, like chains, that have a potentiality for movement; but although actual motion plays a part in some of his pieces—most importantly, his recent monumental, play-oriented works that invite kids to rock, climb, or swing on them—it is not a primary element as it is in Calder's mobiles (page 134) or Rickey's constructions (page 135). *Hankchampion* (named for the artist's younger brother Henry, who assisted in assembling it) derives its expressive power from the tension, suspension, and pivoting among its parts. Essentially linear in conception, like Kline's brushstrokes, its aesthetic depends upon the artist's skillful balancing of asymmetrical components.

BARNETT NEWMAN. Born New York City 1905; died there 1970. *Broken Obelisk*. 1963–1967. Corten steel, 25′ 5″ high, on base 10′ 6″ square. The Rothko Chapel, Houston, Texas. (Other casts: The Museum of Modern Art, New York; University of Washington, Seattle.)

Besides such action painters as Jackson Pollock, Willem de Kooning, and Franz Kline, Abstract Expressionism included other artists, such as Clyfford Still, Mark Rothko, and Barnett Newman, who chose color rather than shapes or calligraphic lines as their principal means of expression. Newman, steeped in the Jewish traditions of the Bible, the rabbinical lore of the Talmud, and the mystical writings of the Cabala, was the scholar among these color-field painters as Motherwell was among those of the gestural tendency. During the 1940s Newman painted biomorphic abstractions with mythic connotations, inspired in part by primitive cultures. From 1948 until his death he concentrated on the line—or "zip," as he called it—by which he divided his paintings into rectangular areas of flat color. Despite the rigid ordering of elements within these compositions (page 17), Newman totally rejected what he called "this death image, the grip of geometry." The line symbolized for him the first act of Creation, the gesture God traced in the void when separating light from darkness. The artist in a sense repeats this action, "not only . . . handling the chaos of the blank picture plane but also . . . handling the chaos of form. In trying to go beyond the visible and known world he is . . . engaged in a true act of discovery in the creation of new forms and symbols that will have the living quality of creation . . . the ordered truth, that is the expression of his attitude toward the mystery of life and death." In some of his 1949 paintings Newman used a horizontal line as if to separate earth from sky in an abstract landscape, but he soon turned to vertical stripes exclusively. As with Rothko (page 151), it is the color of the large areas that becomes the primary vehicle of expression; but unlike Rothko, Newman applied his paint flatly, with no variations of surface or suggestions of atmosphere —the abnegation of materiality reinforcing the spiritual implications.

Newman made only half a dozen works in sculpture, all developed out of his drawings and paintings and expressing the same concepts. The largest and best known is the *Broken Obelisk*. Made of Cor-ten steel, which gradually weathers to a rusty brown, it consists of a pyramid on a shallow square plinth, topped by an obelisk set upside down, with its inverted base irregularly "broken." These geometrical elements in combination bear a striking but probably fortuitous resemblance to a 1934 painting, *Blue Triangle*, by the nonobjective artist Rudolph Bauer (The Solomon R. Guggenheim Museum); but Newman's intentions, as in his paintings, were not formalistic but symbolic. Lawrence Alloway has

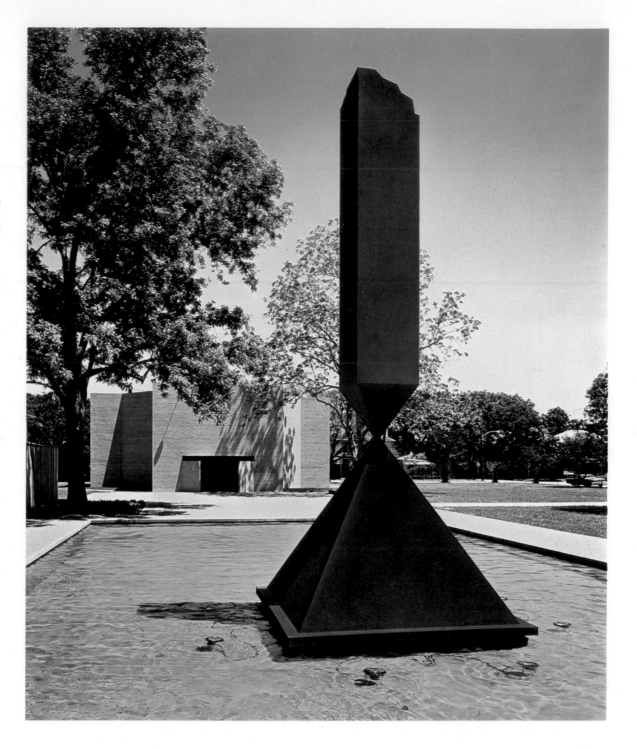

suggested that since Newman thought of "the grip of geometry" as an image of death, inverting the obelisk and breaking its form was for him an affirmation of life. He owned copies of a British Museum publication that pointed out that, for the ancient Egyptians, the pyramid was neither a symbol of death nor a funerary monument but the "Place of Ascent" from which the dead king arose to sail to join the sun-god Ra, with whom he would live throughout eternity. The Egyptian obelisk, tipped with polished gold to catch the first light of dawn, represented the sun's rays and was thus an emblem of life and its miraculous renewal.

In Thomas B. Hess's interpretation: "The main drama of *Broken Obelisk* lies in the point of contact between the two masses, in the spark-gap of energy where pyramid meets and sends aloft the shaft of the obelisk. . . . They meet at a point of maximum contraction and push in toward it with all their energy. That is, between the pyramid and the obelisk is Newman's re-enactment of the drama of

. . . the instant of Creation"—the same theme that recurs in his paintings.

Newman had the concept for this sculpture in his mind for several years but could not carry it out structurally until the steelworks firm of Lippincott, Inc., in North Haven, Connecticut, undertook to collaborate in its fabrication. The artist followed every detail of the process, working first with cardboard models and then with full-scale plywood mock-ups, drawing the broken outline he desired for the obelisk, and directing the flame-cutting of the base to give it a rough, sensuous texture. This cast of the *Broken Obelisk* stands outside the chapel that contains Mark Rothko's last cycle of mural paintings. Newman wrote the donor, John de Menil, that his work was "concerned with life and I hope I have transformed its tragic content into a glimpse of the sublime." The chapel, sculpture, and surrounding plaza were dedicated to the memory of Martin Luther King in February 1971—seven months after Newman's death.

CLYFFORD STILL. Born Grandin, North Dakota, 1904. *1951 Yellow*. 1951. Oil on canvas, 9′ 1½″ × 7′ 8¼″. Collection of Mr. and Mrs. Frederick R. Weisman.

The innovators of color-field painting—Clyfford Still, Mark Rothko, and Barnett Newman—were more purposefully intent than the gestural painters on creating an art completely independent of previous traditions in Western painting, even those of the European modernists. Still wrote in 1952: "We are now committed to an unqualified act, not illustrating outworn myths or contemporary alibis. One must accept total responsibility for what he executes. And the measure of his greatness will be in the depth of his insight and his courage in realizing his own vision." Correspondingly, it is only by dismissing all preconceptions that the observer can feel the implications of the work. The color-field artists disparaged the gestural painters' insistence on revealing individuality by strokes of the brush or other traces of the process of execution left on the canvas. As Still later declared: "I held it imperative to evolve an instrument of thought which would aid in cutting through all cultural opiates, so that a direct, immediate, and truly free vision could be achieved, and an idea be revealed with clarity. . . . No shouting about individualism, no capering before an expanse of canvas, no manipulation of academic conceits or technical fetishes can truly liberate. . . . Especially it became necessary not to be trapped in the banal concepts of space and time."

Thus, as defined by Irving Sandler, the intentions of this group "were visionary; they aimed to create an abstract art suggestive of the sublime, of transcendence, of revelation." The concept of the Sublime, like that of articulating in art man's individual emotional responses, is rooted in Romanticism. Several critics have pointed out the extent to which the ideas formulated by Edmund Burke in 1757 in his *Philosophical Enquiry into the Origin of Our Ideas of the Sublime and the Beautiful* are reflected in Abstract Expressionist paintings: the sense of boundlessness to produce an "effect of infinity"; the belief that "greatness of dimension is a powerful cause of the sublime." Similarly, Immanuel Kant in the *Critique of Judgment* (1790) postulated that "the Sublime is to be found in a formless object, so far as in it, or the occasion of it, *boundlessness* is represented."

Still was born in North Dakota but developed his style on the West Coast, where he was an influential teacher at Washington State University and later at the California School of Fine Arts. During the 1940s he made frequent trips to New York and lived there from 1950 to 1961. He began by painting landscapes of the American West, but in the early 1940s created paintings with a mythic content, not unlike those being done simultaneously by a number of New York artists (see page 142). About 1947 he began to paint the kind of abstractions for which he is best known. Generally, as in *1951 Yellow*, they are large pictures, in which jagged vertical areas form a continous expanse that spreads to the edges of the canvas and even seems to extend beyond it. The illusion of pictorial space is annihilated; there is no background, there are no boundaries. In Still's works of the late 1940s and early 1950s black predominates, interspersed with streaks of brilliant color or white that are like equivalents of light. The paint is laid on in a heavy impasto enlivened with marks made by the brush or palette knife. His subsequent paintings, like this example, are more lyrical; the colors are high in key, and black is used only as a kind of grace note. The underpainting is allowed to show through the lighter texture of the pigment, and the matte surface is streaked and varied in density.

In spite of his aversion to interpretation, Still has given this explanation of the symbolic imagery latent in his abstract forms: "When I was a young man I painted many landscapes—especially of the prairie and of men and the machines with which they ripped a meager living from the thin top soil. But mostly the paintings were records of air and light. Yet always and inevitably with the rising forms of the vertical necessity of life dominating the horizon. For in such a land a man must stand upright, if he would live. Even if he is the only upright form in the world about him. And so was born and became intrinsic this elemental characteristic of my life and my work."

DAVID SMITH. 1906–1965. *Cubi XXI*. 1964. Stainless steel, 9′ 11½″ high. Collection of Howard and Jean Lipman.

In the last four years of his life, David Smith created the twenty-eight monumental abstract and architectural works of his Cubi series. They are the distillation of ideas with which he had been concerned for at least twenty years, but more especially since his discovery in the 1950s of the properties of stainless steel. It is fascinating to compare his drawings for the linear-pictorial works of the early 1950s, such as *Hudson River Landscape* (page 133), with the strikingly sculptural ones for the stainless-steel pieces. These quick studies were made by arranging assemblages of forms—crescents of watermelon rind, rectangles of cardboard, metal rods—on sheets of paper and "fixing" their shapes with metallic color sprays, which Smith said would suggest "a metallic frame of reference." He called these preliminary stencil drawings "think pieces" for the arrangement of his forms; but with their softened outlines and atmospheric subtlety, they also predict how the finished steel sculptures would appear in dazzling sunlight.

"My reference image was the Cubist construction," Smith said in a note on his work. Although a friend of many of the Abstract Expressionists in New York, he chose to live upstate at Bolton Landing in relative isolation from them—yet making frequent trips to the city—and to use his own earlier works as the point of departure for the formulation of his ideas, finding new solutions to problems he had confronted earlier in his career.

Cubi XXI is a deceptively simple assemblage of heavy geometric volumes—cubes, cylinders, and rectangles. The cantilevered balance, however, contradicts the effect of heaviness. Again, as in *Zig IV*, we encounter the wheel. Here it suggests a movement that implies the rotation of the two cubes, joined by their cylindrical axle, around the upright support, shaped like an inverted L. This idea of movement is implemented by the quarter turn of the lower cube, and by the way in which the cubes and wheel are set off center in relation to the cylinder in an imbalance that denies rigidity and suggests counterclockwise rotation. The top cube is not the same size as the lower one but several inches larger—a negation of perspective, as one looks up, that keeps the two in a light, even balance and adds to the mobility of the lower cube. It seems to have moved a quarter turn around the larger one at the top, while the wheel, in effect, completes the turn. The rectangular post is set back a bit so that one feels the bottom cube could slide past it without colliding.

Smith did not finish his Cubi in the spontaneous style of Action painting or with decorative surface patterning. He gave the stainless steel a brushed sur-

face that absorbs light and color and seems to dissolve solid mass and formal outlines. He said that these pieces were "conceived for bright light, preferably the sun, to develop the illusion of surface and depth." Seeing *Cubi XXI* in strong sunlight is an extraordinary experience; there is an astonishing trompe-l'oeil illusion of light emanating from deep within the metal. The scrubbing reads as if it were not on the surface but, instead, *inside* the form—tangles of neon-bright wire that fill the cubes, run loosely up through the rectangular support, spiral up the cylinder, and circle inside the wheel.

Like the painting of *Zig IV*, the scrubbing of the steel surface emphasizes the contrasts between the geometric shapes but at the same time blends the whole sculpture subtly with its surroundings. Smith wrote about his treatment of stainless steel as an optically ambiguous material: "I like outdoor sculpture and the most practical thing for outdoor sculpture is stainless steel, and I made them and I polished them in such a way that on a dull day, they take on the dull blue, or the color of the sky in the late afternoon sun, the glow, golden like the rays, the colors of nature."

155

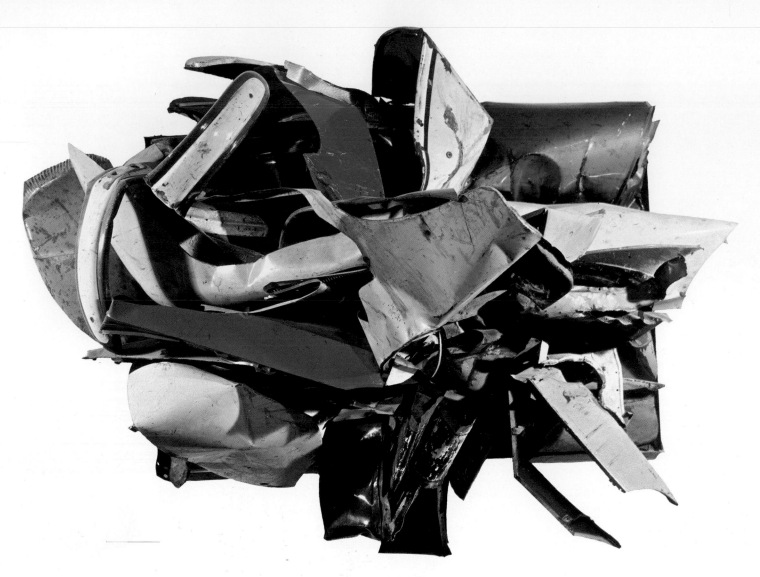

JOHN CHAMBERLAIN. Born Rochester, Indiana, 1927. *Dolores James.* 1962. Painted steel, 6' 7" × 8' 1' × 3' 3" deep. The Solomon R. Guggenheim Museum, New York.

John Chamberlain's sculptures, with their curving shapes of colored metal that overlap and interpenetrate, have been likened to the Abstract Expressionist paintings of Willem de Kooning and Jackson Pollock, much as Mark di Suvero's constructions with beams like forceful brushstrokes have been compared to Franz Kline's pictures. Chamberlain's use of welded steel and of color in his sculpture also relates to the work of David Smith, although lacking Smith's pictorialism. He concentrates on mass and volume, producing densely compressed unitary pieces rather than works built up of discrete elements.

Chamberlain studied at The Art Institute of Chicago, but it was at Black Mountain College, North Carolina, from 1955 to 1956, several years after he completed his wartime service in the navy, that he found the intellectual stimulus to think afresh about the problems of sculpture. After moving to New York, he began to work with discarded auto parts, which he said he liked because they were both commonplace and readily available. Such use of found objects, which the artist transforms into something quite different, goes back to Dada and to Cubist collage. There could hardly be a greater contrast than that between Joseph Cornell's adaptation of this tradition in his small shadow boxes that enshrine delicate fragments of the natural world and nostalgic souvenirs of bygone days (page 138) and Chamberlain's violent destruction and reconstruction of salvaged scrap metal. In his structures, as in Abstract Expressionist painting, there is an intuitive mastery of accident; he declares that the final form never results from a preconceived idea of "composition," but rather from his discovery in the course of execution of "how the parts fit and where they stand and what kind of balance and rhythms they give off as vibration . . . close to a kind of partnership" between the artist and his materials.

Although his first works made of crushed automobile parts were freestanding, the *Dolores James* is a relief. Set against a two-dimensional wall, its energetic thrust projects outward toward the spectator. Chamberlain's account of its completion in 1962 makes clear the part played by chance in his works and the criteria by which he judges the results: "I started it in the country and then I moved to the city and I put it up on a wall. I painted the wall one color and I didn't like that and I put it on another wall with another color. Nothing worked. . . . One time I came back really drunk and stood about 25 feet away and threw an eight-pound sledge at it. It went right into it like a knife—only three inches of the handle stuck out. All the pieces went chink, chink, chink. It did just that. It's how the parts lock together—the idea of the squeeze and the compression and the fit. . . . You have to transcend the material and see how it works for you." As to his use of color, he says: "I never thought of sculpture without color. Do you see anything around that has no color? Do you live in a world with no color?"

Chamberlain has never implied that there is any latent symbolism in his choice of materials, but others have seen intentional irony in his use of the wreckage of that supreme embodiment of the American dream—the automobile. The crushed and twisted metal parts, with the bright body paint of their surfaces scarred and eroded, inevitably bring to mind associations with car crashes (a theme that concerned James Rosenquist in the 1960s). The critic Barbara Rose, however, has protested that emphasis on Chamberlain's sculpture as social comment has obscured perception of its abstract plastic qualities and exceptionally expressive use of color. She terms his sensibility Baroque, noting that his works make "irresistible demands on plastic space—violating, cutting through, breaking, embracing or infecting the external ambience with powerful masses and sharp, undulating curves. . . . Interior space is enclosed as well as exterior space is broken. This enables Chamberlain to surprise by the unexpected flexibility of material we presume to be intractable." Donald Judd, a fellow artist whose own aesthetic could hardly differ more from Chamberlain's (see page 190), concurs in seeing this likeness to the Baroque; he also draws a comparison with Pollock's paintings: "The diversity and the unity occur and recur; the work explodes and implodes. . . . The order is not one of control or distillation, but of continual choices, often between accidents."

RICHARD STANKIEWICZ. Born Philadephia 1922. *Sculpture.* 1961. Scrap steel, 67″ × 38″ on base 16¼″ square. Collection of Mr. and Mrs. Burton Tremaine.

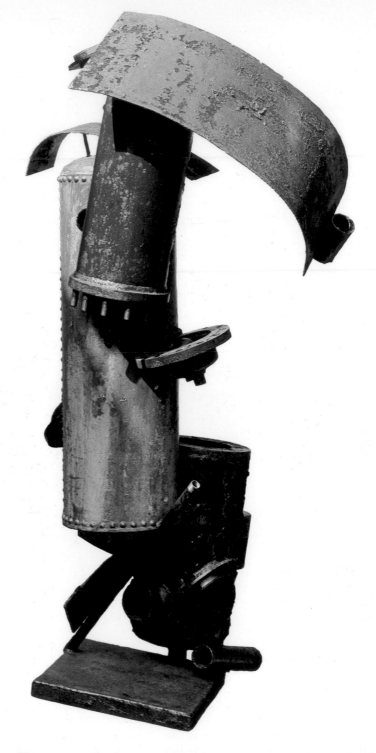

Richard Stankiewicz's assemblages of discarded machine parts welded together have various antecedents in modern art. In 1918 the Philadelphia artist Morton Schamberg, influenced by Marcel Duchamp's Readymades and the interest he and Francis Picabia had in machines, juxtaposed a miter box and a plumbing trap, blasphemously calling the resulting construction *God* (Philadelphia Museum of Art). In contrast to this Dadaist, antiart approach, Picasso in 1943 joined the handlebars and saddle of a discarded bicycle to create his *Bull's Head.* When cast in bronze, although the forms of these elements were unaltered, they became so transformed by their combination into a representational image that the viewer at first fails to recognize their origin.

In such a work as Stankiewicz's *Sculpture* the component pieces of industrial scrap retain their identity: they are neither submerged into a new image, as in the *Bull's Head,* nor compressed into a compact, if complex, unit like the automobile parts in Chamberlain's *Dolores James.* In a sense, the idea of "truth to materials" (see page 129) obtains, for the mechanical, prefabricated origin of the individual parts is not disguised or obliterated in Stankiewicz's constructions. As Robert Goldwater has said: "The tension between what they once were and what they now are remains essential." Similarly, Stankiewicz said: "I let the pieces rust because it is their nature to do so. In this way I can give them a life of their own."

The vitality inherent in Stankiewicz's work has been stressed by the painter and critic Fairfield Porter: "His sculpture, using junk, is a creation of life out of death, the new life being of a quite different nature than the old one that was decaying on the junk pile, on the sidewalk, in the used-car lot. In its decay there is already a new beginning before Stankiewicz gets hold of it. At his best he makes one aware of a vitality that is extra-artistic. His respect for the material is not a machinist's respect, but the respect of someone who can take a machine or leave it, who respects even the life of things, which is more than mechanical."

Following his father's death, Stankiewicz and his family moved to Detroit when he was six years old. They lived next door to a foundry dump, and as a child he made his toys from bits and pieces he scavenged there. "A childhood of play in the alluvium of an industrial city—Detroit—would have conditioned me to an especial and sympathetic awareness of manufactured forms in the same way that a child of another place would be stimulated by 'natural' forms during his most impressionable age," he explained. During six years of service in the navy, he traveled widely; while in the Aleutians, he began to carve in bone and caribou horn, and in Hawaii in wood. After attending Hans Hofmann's School of Fine Arts in New York, he went to Paris in 1950, studying first in Fernand Léger's atelier and then becoming an apprentice to the sculptor Ossip Zadkine. A few years after his return to New York, Stankiewicz began making constructions of welded junk; as he said: "The use of discarded metal and machine parts followed the perception that frequently ready-made forms, properly used, are more provocative than invented effects. Also visual puns, mechanical analogies and organic resemblances in machinery provide a large and evocative vocabulary for sculpture." Many of his works, like this example, suggest human forms, although the anthropomorphic references are implied rather than explicit; however, in one kinetic piece, *The Apple,* 1961, he created a motorized robot that had a swinging arm and emitted a raucous noise. His later pieces were less concerned with personification, for they were composed of fewer and simpler elements, while becoming progressively more abstract.

Despite his use of unconventional materials, Stankiewicz is a traditionalist in his approach to sculpture. Unlike Chamberlain, he allows no element of chance to enter into his works, for he believes in carefully controlled organization. The pipes, boilers, bolts, wheels, and so forth impose their own conditions, but the artist makes the choices and decisions as to their disposition. "The found forms suggest ideas, both expressive and formal," he says, "and the demands of the emerging sculpture make a discipline for the materials."

LOUISE NEVELSON. Born Kiev, Russia, 1900; to United States 1905. *Tide I Tide*. 1963. Wood, painted black, 9′ × 12′ × 10″. Albert and Vera List Collection.

As a child, Louise Nevelson collected and carved scraps of wood from her father's lumberyard in Rockland, Maine, much as Richard Stankiewicz (page 157) fashioned toys from metal salvaged from the foundry dump next door. Her creative energies as a young student in New York were directed to voice, dramatics, and painting. In 1931 she went to Munich to study with Hans Hofmann, and after his school was closed by the Nazis, she had a brief career in films. On returning to the United States, she served for a time as assistant to Diego Rivera; this experience with murals was chiefly valuable in giving her a sense of monumental scale. Traveling extensively in the United States and abroad, she became a collector of African and American Indian art, and her first sculpture show also revealed some pre-Columbian influences. She met Louis Eilshemius (see page 101) about 1931, considered him the greatest painter in America, and acquired a large number of his paintings.

Nevelson began to make assemblages in the early 1940s, almost by accident, when because of illness she temporarily lacked the strength to execute heavy pieces. It was not until the following decade, however, that she embarked on the large compartmented structures that have been her distinctive contribution to modern sculpture. For her 1958 exhibition, "Moon Garden Plus One," she created a total environment of the assemblages she called Sky Cathedrals—stacked boxes filled with newel posts, balusters and finials, moldings, and other found objects of turned wood. They were painted black, and under the dim illumination that she arranged revealed themselves only slowly to the viewer. Reviewing this exhibition, Hilton Kramer wrote that Nevelson's works "violate our received ideas on the limits of sculpture . . . yet open an entire realm of possibility. . . . The Sky Cathedrals seem to promise something entirely new in the realm of architectural sculpture by . . . postulating a sculptural architecture." The next year, she created an all-white environment, Dawn's Wedding Feast, containing a number of pieces, and followed this with an exhibition of gilded pieces called Royal Tides; in each case her use of black, white, or gold, respectively, served to unify the works making up the whole.

In Nevelson's walls each shallow compartment of the large cellular structure, filled with accretions of found wooden objects, is different, yet rhythmically related to the others by the multiplication of similar elements across the surface of the sculpture. In the tripartite *Tide I Tide* recurring motives of spools, circular disks, and turned or carved furniture parts give the whole composition a baroque richness that is a feature of her gilded pieces but rare among her great black sculptures. The compartments are held together by gravity, without nails; so neatly are they aligned that it is impossible not to respect the rigorous architecture of the overall structure, at the same time that we are lured into the mysterious dark substructures of each of the forty boxes. "My work is delicate," she has said; "it may look strong but it is delicate. True strength is delicate."

The contents of Nevelson's boxes are reminiscent of Picasso's collage sculptures of the Cubist period (it is worth noting that she has recently been producing major series of paper collages). Their positive and negative forms also imply the shallow space of Cubism. Her utilization of objects dissociated from their original context and juxtaposed in unexpected ways goes back to Dada. To the extent that Nevelson's walls are intended to be seen only from a frontal position, they relate to painting as much as to sculpture, especially to the large, mural-type works of Clyfford Still, Barnett Newman, and Mark Rothko—who once likened his paintings to "facades."

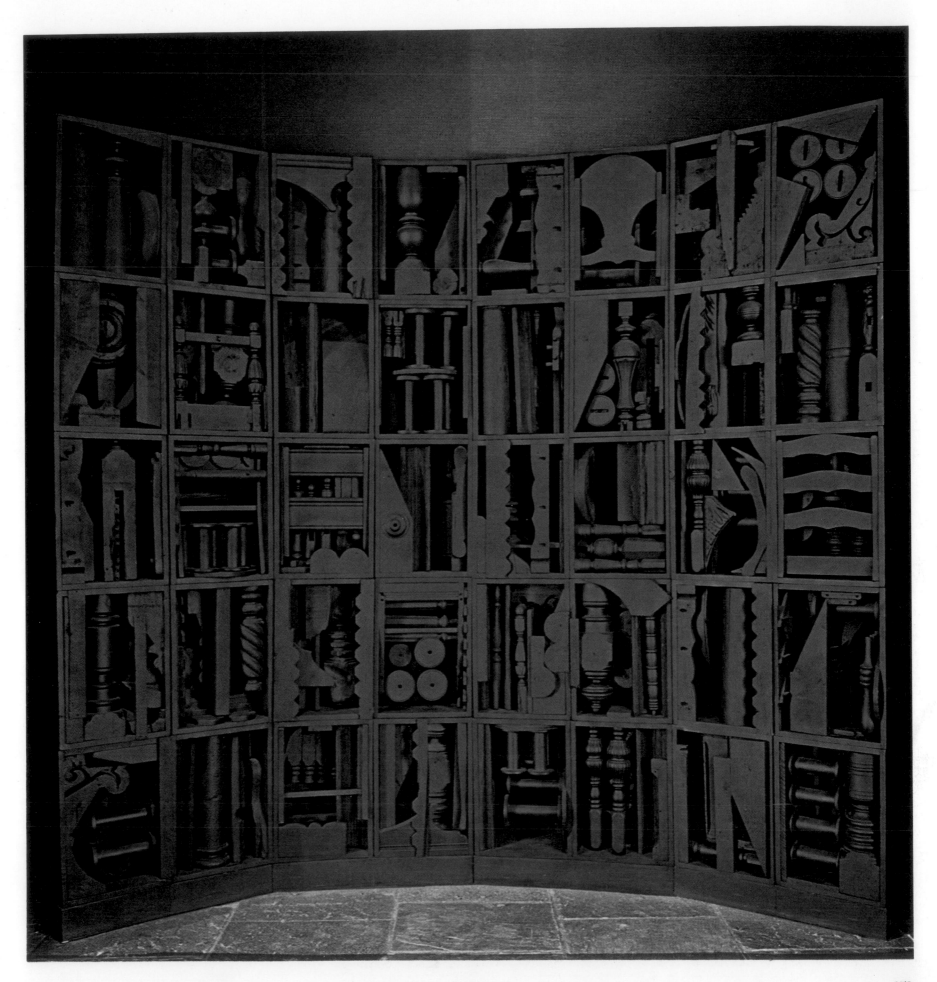

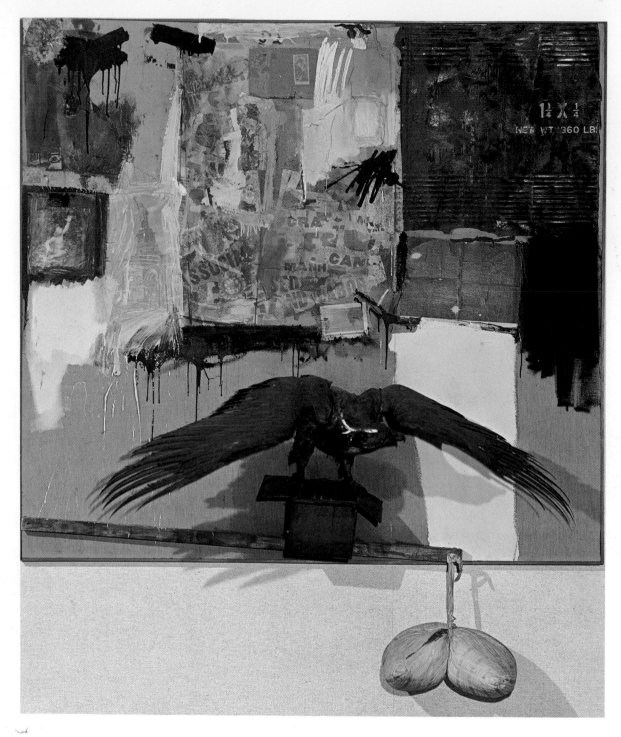

chenberg's work: "There is no more subject in a *combine* than there is in a page from a newspaper. Each thing that is there is a subject. It is a situation involving multiplicity."

The artist and critic Andrew Forge has made a detailed analysis of *Canyon:* "The outstretched eagle . . . seems to hang on the canvas . . . perched on a black box and below . . . is a piece of wood from which a pillow dangles. In the top half of the picture there are three rectangular divisions, the first filled with a brown flattened metal drum and the center filled with torn scraps of poster—red, blue, white—in which fragments of words can be made out. . . . In the third division, to the left, there is a color photograph of the Statue of Liberty . . . and an old studio photograph of a baby boy. . . . Liberty is painted over with milky-white paint. The poster scraps . . . form a tattered flag. The eagle is a commanding presence and its jagged, black, outspread wings seem to rule over the field of the canvas. . . . One can imagine its beak striking the metal surface, clanking, rattling, against its corrugations. . . . The upper half of the picture now resolves itself as an enclosure, a fortress within which the child is protected. The eagle hangs motionless in front of it, its guardian . . . macabre and deathly as well as protective. . . . The child's photograph is ringed in black. . . . A painted cross is like a brusque cancellation. The eagle throws a deep shadow outside the bounds of the picture. Within, blackness reads as shadow below the tattered posters, a ruinous opening. The dangling pillow . . . signals defeat. It is impotent, flaccid, and its drooping profile mocks the drooping wings which seem now to sail heavily over the carrion of ruined empire. . . . But the juxtaposition of black bird and black-ringed child releases a further cycle. . . . It is Ganymede, whose beauty was so extraordinary that Zeus sent an eagle to carry him off, and who . . . grew up to be Zeus' cupbearer and the giver of rain to mortals, charming all." Forge is careful to emphasize that these may be only his personal interpretations, crystallized in retrospect: "But in front of the work itself, the answer is with the viewer and . . . his willingness to . . . reverse or suspend the hierarchies of his viewing. It must also depend on . . . the texture of associations that he brings with him."

Rauschenberg's fluent brushwork with its accidental drips and splatters derives from Abstract Expressionism. But his concern is not with gestural painting as a means of expressing emotion or with the creation of a myth. Instead, he focuses on the object, on free acceptance of materials as varied and unpredictable as they are in life itself, and on the involvement of the work with the environment and the spectator. In a much-quoted dictum he said: "Painting relates to both art and life. . . . (I try to act in that gap between the two.)"

ROBERT RAUSCHENBERG. Born Port Arthur, Texas, 1925. *Canyon.* 1959. Combine-painting of oil on canvas on painted wooden boards, pasted printed matter, posters, newsprint, photographs, metal, stuffed eagle, pillow tied with cord, 6′ 1″ × 5′ 6″ × 2′ ¾″. Collection of Mr. and Mrs. Michael Sonnabend.

With its heterogeneous elements and aggressive extension of a stuffed eagle and pillow outward into the spectator's space, Robert Rauschenberg's *Canyon* could hardly seem more dissimilar from Louise Nevelson's self-contained construction *Tide I Tide* (pages 158–159), with its unifying black paint and shallow recession in depth. What they have in common is their use of the assemblage technique and a desire to create an environment—characteristics of much American art since the mid-1950s.

Rauschenberg and Jasper Johns were close associates and had studios in the same building from about 1955 to 1960, exchanging their ideas on art as they developed. Both were deeply influenced by the composer John Cage, whose work and teaching stressed randomness in composition, open acceptance of the contemporary environment, and the integration of art and life. Some of these ideas had been adapted from Zen Buddhism. His compositions incorporate "accidental" sounds like passing street noises and differ in structure from traditional music by eliminating climax and resolution. Rauschenberg was exposed to Cage's ideas in 1952 while he was an artist-in-residence at Black Mountain College, North Carolina, where he had previously studied with Josef Albers, whose entirely different influence Rauschenberg acknowledged by saying: "Years later . . . I'm still learning what he taught me. . . . He didn't teach you how to 'do art.' The focus was always on your personal sense of looking."

A free acceptance of multiple kinds of objects and materials from the world of reality distinguishes Rauschenberg's "combine-paintings," of which his *Canyon* is a prime example. Cage wrote of Raus-

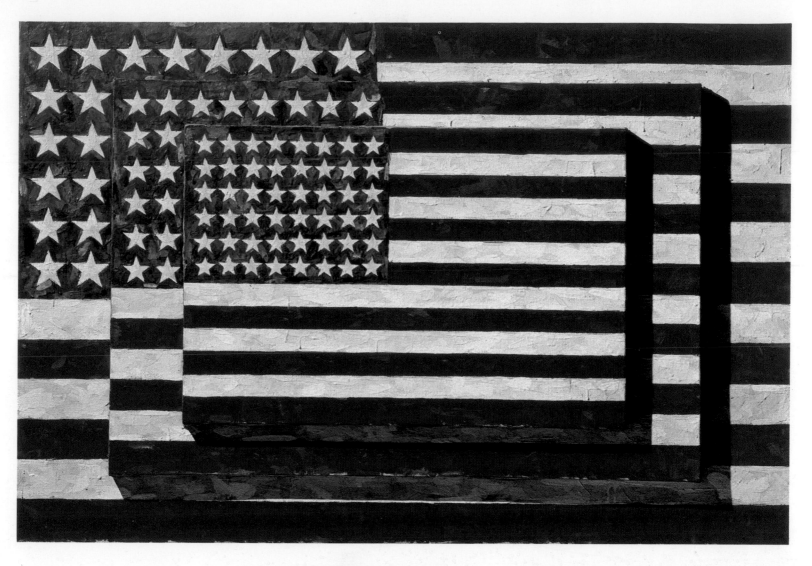

JASPER JOHNS. Born Augusta, Georgia, 1930. *Three Flags*. 1958. Encaustic on canvas, 30⅞″ × 45½″ × 5″. Collection of Mr. and Mrs. Burton Tremaine.

In contrast to the bewildering multiplicity of impressions that impinge on our consciousness when viewing Rauschenberg's *Canyon*, Jasper Johns's *Three Flags* presents an almost monolithic image, and one so familiar as to seem banal. Common to both works, nevertheless, is their focusing of attention on the object; moreover, *Three Flags*, built up in stepped planes that project outward, like the eagle and pillow in Rauschenberg's combine-painting, invades the space occupied by the spectator.

At his first one-man exhibition in 1958 Johns showed a number of paintings of completely flat objects—targets and flags. Among the latter, *Flag*, 1954 (The Museum of Modern Art), was even simpler than this example because it consisted of a single image that filled the entire area of the canvas. He explained that "using the design of the American flag took care of a great deal for me because I didn't have to design it," and selecting "things the mind already knows . . . gave me room to work on other levels." The viewer is likewise freed, because confronted by "objects so familiar . . . the spectator can cease to think about them and concentrate on the poetic qualities of the picture itself."

Paramount among these qualities is the rich, sensuous paint surface. Johns used encaustic—a medium exceptional in modern times—which mixes pigments in melted wax; he applied it with fluent, broken brushstrokes like those of the Abstract Expressionists to create a varied and uneven texture that contradicts the flatness of his subject. Secondly, by making the area of the flag coextensive with that of the canvas, with no background, he destroyed every vestige of illusionism; this is not the representation but the presentation of an object. As in trompe l'oeil, the artist is playing a kind of game with the viewer, but the situation is exactly reversed; Johns's purpose is not to fool the spectator into believing that he is looking at an actual flag, but, on the contrary, to eradicate his notions of a familiar symbol and force him to contemplate the created object as a new reality. A tension is set up by the ambiguous relationship between the well-known emblem with its customary associations and the painterly treatment that requires it to be seen in an unaccustomed way. Commenting on this ambivalence, the critic Alan R. Solomon said: *"Three Flags . . .* strangely asserts the physical character of the picture as an object, since it consists of three canvases of different sizes superimposed on one another, each with its own flag. One of [Johns's] most brilliant conceptions, it confuses the image because of the repetition of the stars and stripes at different scales; at the same time, it reenforces the flag idea in a strange way." The terraced depth of the canvas creates shadows that further complicate the design and enhance the flickering effect of the uneven surface and broken brushstrokes.

There is also an element of Dada irony in the concept, particularly of the sort exemplified by Marcel Duchamp, whom Johns admired for his "wit and high common sense, . . . the mind slapping at thoughtless values, . . . his brilliantly inventive questioning of visual, mental, and verbal focus and order." This playfulness is evident in the *Painted Bronze* Johns made in 1960. Responding to Willem de Kooning's comment that the dealer Leo Castelli could sell anything, even two beer cans, Johns promptly created two painstakingly hand-painted Ballantine ale cans. Because it simulated commonplace manufactured objects, this work has often been regarded as an archetype of Pop art. There is much confusion about this term, and about the artists and works to which it applies. It is agreed, however, that it originated in England around 1958 with reference to popular culture and products of the mass media, and in the early 1960s began to be applied to the fine arts. As generally used, it characterizes paintings or sculptures that depict—sometimes with tongue-in-cheek humor—articles of wide popular consumption (at times, products of the preceding generation), often greatly enlarged in scale. Words, numerals, or other signs are frequently incorporated into the pictorial images. The inclination of public and critics alike to focus on subject matter has tended to obscure the nature and extent of the respective artists' transformation of their sources, although this, and the success of their efforts, are the criteria by which Pop—or any other kind of art —can be considered art at all. Johns and Rauschenberg provided a bridge to Pop art, even though their painterly handling differs from the cool impersonality characteristic of that style.

161

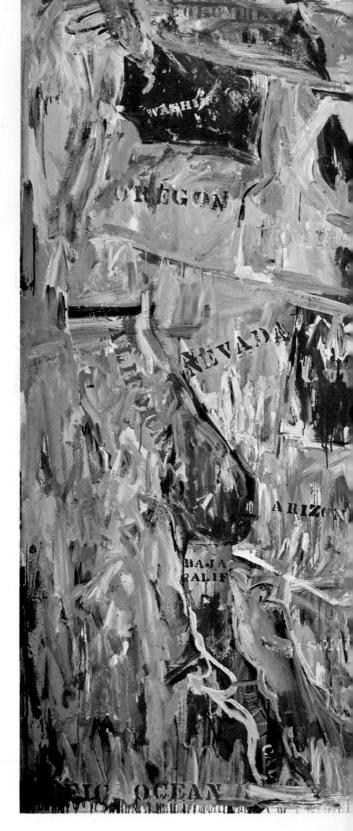

JASPER JOHNS. Born Augusta, Georgia, 1930. *Map.* 1961. Oil on canvas, 6′ 6″ × 10′ 3¼″. The Museum of Modern Art, New York (Gift of Mr. and Mrs. Robert C. Scull).

In Jasper Johns's *Map* the ambiguous relationship between the object represented and its painterly treatment is carried even further than in his *Three Flags* (page 161). Reverting to the traditional medium of oil rather than encaustic, Johns has covered the entire surface of the large canvas with bright colors, applied with broken, overlapping brushstrokes derived from Abstract Expressionism. In the Flag paintings the familiar emblem is immediately recognizable, but in looking at this picture we must make visual and mental adjustments in order to realize that it is the representation of something equally familiar—a map of the United States.

Once we have recognized the subject, we find that all our preconceptions of it are shattered, our normal expectations frustrated. A map is a diagram for conveying information and employs accepted conventions in order to be readily understood: lines marking boundaries are clearly drawn; areas within those boundaries are legibly named; each area is differentiated from those adjacent by distinctive tinting; shading, unless meant to indicate relief, is eliminated; blue is used to distinguish water from land. Here, every one of these cartographic practices is contravened. Although states and bodies of water are in their correct positions, and their limits are maintained, the colors and the brushstrokes sweep across them at random. Some, not all, of the states are labeled, but the stenciled letters are par-

tially obliterated. The overlapping colors create shading that has nothing to do with mountains and valleys. The bright blue that should be reserved for lakes and oceans makes it appear that the entire continent has been flooded. Contrasting with this predominant blue is its complementary, orange—sparingly used in itself, but induced elsewhere as the eye merges its components, red and yellow.

This painting, although highly original, is nevertheless indebted to several preceding styles. Most obvious is the influence of Abstract Expressionism in the handling of the paint. The shifting, overlapping planes of the states suggest Cubism, as does the retention of a subject that remains recognizable despite the fragmentation of its constituent parts. The chief influence, however, is that of Marcel Duchamp, for the entire concept bears the stamp of an ironic wit and love of paradox akin to his.

Map, like the Flag paintings, has no background but expands across the entire field of the canvas, producing a unitary effect. But the image itself is a complex one, characterized by Johns's customary ambiguity. In Leo Steinberg's words, Johns sets up "situations wherein the subjects are constantly found and lost, seen and ignored, submerged and recovered again." The pleasure that a picture of this kind offers the spectator, therefore, is intellectual as well as aesthetic. He will enjoy it to the degree that he is willing to engage in the artist's game of hide-and-seek, which is based on the interplay between what the eye discerns and ideas that are normally taken for granted but are here called into question.

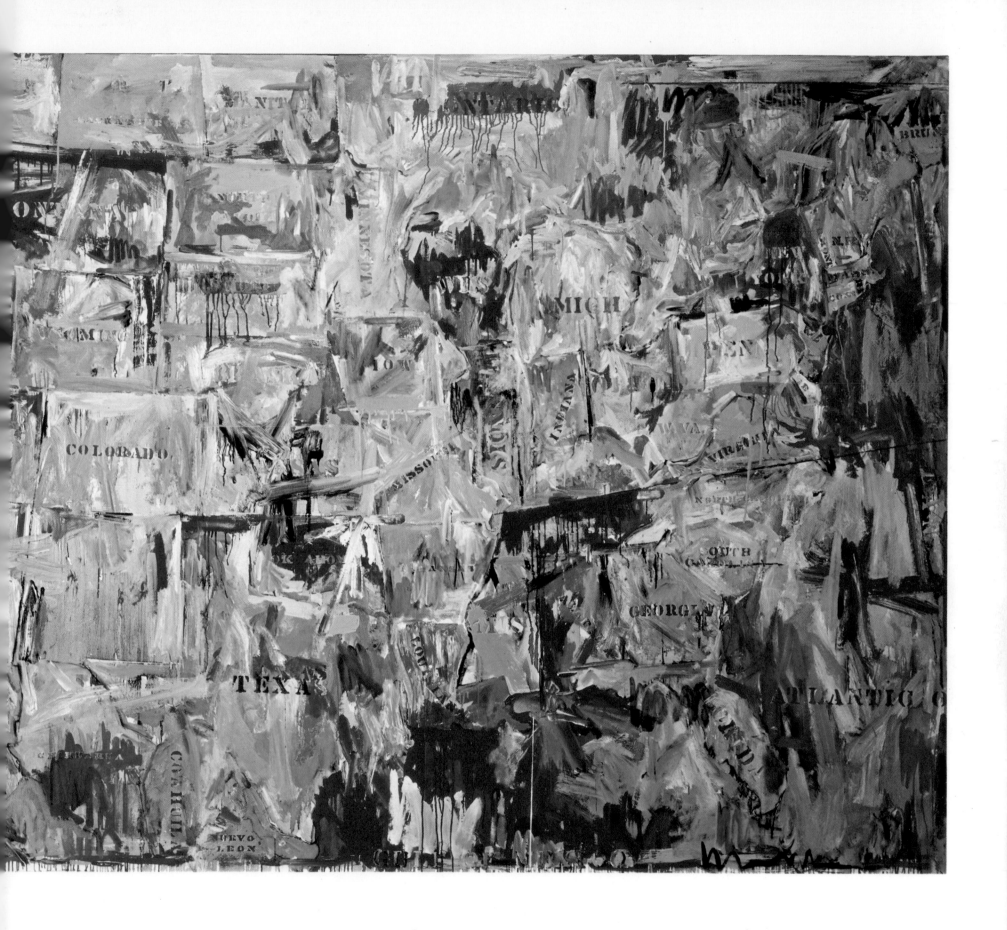

formances, with the participants responding spontaneously to absurd and unexpected predicaments.

In 1960 Oldenburg created The Street, an environmental exhibition developed out of sketches made along the Bowery and elsewhere on the Lower East Side. It included figures, signs, and objects constructed from discarded junk and other fragile materials, such as paper bags. The Store, which he opened the following year in a rented storefront on East Second Street that he also used as a studio, carried his intention of portraying what he called "city nature" a step further. Among other things, it was an effort to remove art from its Establishment museum and gallery setting and return it to the milieu of daily life. Oldenburg kept a detailed inventory of the "stock" of The Store; it consisted of reliefs depicting merchandise available in the shops of his slum neighborhood—women's stockings, girls' dresses, tights, shoes, foodstuffs—together with advertisements and signs like 7-Up. Freestanding or suspended so that they were visible from both sides, the pieces were brightly painted with enamel to make them as alluring to the eye as the articles displayed in Peto's *Poor Man's Store* (page 85). In the 7-Up sign there are only four colors—bright red, bright green, dark blue, and white. The painterly surfaces derive from Abstract Expressionism; as Barbara Rose has pointed out: "with their wrinkled, torn, and creased surfaces, their undulations and incrustations, [these objects] are the exact opposite of factory duplicates. Their most salient characteristic, in fact, is probably their unreproducibility. Paint is not only splashed, splattered, and dripped, but also speckled, spotted, flecked, and dotted to produce the richest possible surface." The edges of the fragmented signs are ragged as if they had been torn out of a larger area. Oldenburg said: "An advertisement, or part of one, ripped from a newspaper, was taken to correspond to a glance at the plane of vision. . . . The fragments are . . . 'torn' from reality." (Compare this with the synoptic vision of images taken from many sources in Rauschenberg's *Canyon*, page 160.)

Like many other young artists at this time Oldenburg was reacting strongly against Abstract Expressionism by repudiating its nonrepresentational stance, solemn rhetoric, and personalized myth-making. A credo he wrote in 1961 begins: "I am for an art that is political-erotical-mystical, that does something other than sit on its ass in a museum. I am for an art that grows up not knowing it is art at all, an art given the chance of having a starting point of zero. I am for an art that embroils itself with the everyday crap & still comes out on top. I am for an art that imitates the human, that is comic, if necessary, or violent, or whatever is necessary. I am for an art that takes its form from the lines of life itself, that twists and extends and accumulates and spits and drips, and is heavy and coarse and blunt and sweet and stupid as life itself." The long litany that follows, bringing to mind Stuart Davis's list of the things in the American environment that stimulated him (see page 116), includes the assertion: "I am for Kool-art, 7-UP art, Pepsi-art, Sunshine art, 39 cents art, 15 cents art . . . Now Art, New Art, How art . . ." Instead of turning his back on the vulgar products of contemporary America, Oldenburg welcomes them and enhances them by an enrichment of their surfaces and colors.

CLAES OLDENBURG. Born Stockholm, Sweden, 1929; to United States 1929. *7-Up*. 1961. Muslin soaked in plaster over wire frame, painted with enamel. 55″ × 37″ × 5½″. Collection of Mr. and Mrs. Burton Tremaine.

Claes Oldenburg's Store, from which this *7-Up* sign comes, is a striking manifestation of an attitude that, like Robert Rauschenberg's (see page 160), is predicated on an openness to every kind of experience life has to offer, and on a sense of the reciprocity between art and the environment, particularly the urban scene. Like Johns's *Three Flags* (page 161), it also poses the question of the relationship between "reality" and the art object. After graduating from Yale, Oldenburg took courses at The Art Institute of Chicago, served as a newspaper crime reporter, did illustrations, and supported himself with a variety of odd jobs before moving to New York in 1956. He soon came in contact with a number of young artists whose reaction against Abstract Expressionism took the form not only of paintings and assemblages but also of Happenings —an improvisational kind of theatre that extended Cage's ideas (see page 160) into unplanned per-

CLAES OLDENBURG. Born 1929. *Giant Soft Drum Set*. 1967. Vinyl and canvas, stuffed with shredded foam rubber, painted wood, metal, on wood base covered with Formica, 7′ × 6′ × 4′. Collection of John and Kimiko Powers.

The year after creating The Store, Oldenburg had the first exhibition in which he showed his "soft" sculptures—large-scale objects, such as giant ice-cream cones and hamburgers, made of cloth and stuffed like pillows with kapok or foam rubber. Presented at the Green Gallery on New York's prestigious Fifty-seventh Street—the heart of the Establishment art world—it marked the initial widespread recognition of Pop art as a cultural phenomenon. Many critics focused on its vulgar subject matter, which they regarded as a capitulation to philistinism, a passive acceptance of the worst features of America's consumer-oriented society.

Now that more than a decade has passed, we have gained a broader perspective. To begin with the most obvious aspect of these works, their subject matter: Like the objects in The Store, they revealed an affirmative attitude to the contemporary environment, rather than one of rejection. On philosophical grounds it would, in fact, be hard to say why ice-cream cones and hamburgers should be less appropriate objects for representation than the fish, fruit, or flowers depicted in traditional still lifes.

As to scale: The enlargement to colossal proportions, especially in a milieu dominated by sky-scrapers, was not without precedent. Among such inflated images we might mention the enlarged flowers painted by Martin Johnson Heade and Georgia O'Keeffe (see pages 77 and 112). "I have always been fascinated by the values attached to size," Oldenburg has said. "Considerations of size are a way to ask into the reality of vision; what is perspective, and is size completely subject to the will." As in Jasper Johns's Flags (page 161), the representation of objects in such an unexpected way challenges the viewer to examine his preconceptions about art and reality.

Next, the medium: Oldenburg's soft objects represent one of the two most radical innovations in twentieth-century sculpture—the other being Alexander Calder's mobiles (page 134). Dissimilar as these two inventions are, they share a basic concept, for both depend on chance and change. Counter to the classical outlook, which venerates the eternal and the immutable, the recognition of transience and unpredictability characterizes many fields of modern thought, from the "uncertainty principle" postulated by the atomic physicist Werner Heisenberg to the art of the Surrealists. The mobiles depend on air currents, the soft sculptures on gravity, which Oldenburg has called "my favorite form creator"; he declares: "The possibility of movement of the soft sculpture, its resistance to any one position, its 'life' relate it to the idea of time and change." He is impatient of those who do not recognize that they can intervene in manipulating these pieces: "The built-in changeableness of the work demands of its owner . . . a sense of the work's possibilities and a sense of the factors that can cause change, and decisions on the position."

Finally, content: Metamorphosis (the transformation of an object's physical properties) and metaphor (the analogies and kinships among objects, especially as suggested by free association) are central to Oldenburg's creative processes. The *Giant Soft Drum Set*, one of his most complex works (composed of 125 pieces), is an outstanding example. It relates to his summer as artist-in-residence at the Aspen Center of Contemporary Art in Colorado in 1967: "The set would not have developed as it did without my experience of the mountain. . . . I recall identifying the startlingly pure white shades of the thunderheads illuminated along the ridges of the hills around in night storms, with drums (to the accompanying sound) and the sight of Red Butte along the sunsets, which inspired the placing of the pedal there, to strike against the technicolor sky. . . . The drum set may be compared to architecture. Wooden sticks then become poles and spun metal cymbals become roofing. . . . The colossal version of the Drum Set is rationalized as a pleasure palace for concerts, circuses, etc. . . . My first and only musical instrument was a set of drums . . . bought when I was fifteen. . . . The Drum Set is the image of the human body. It is a body of both sexes, a bisexual object. . . . Because of the softness of the drums, the broken sticks, and the large amount of unruly detail . . . the piece never seems to achieve stability or order. . . . It is a state of nature, a condition, that I want to represent above all—the large formal realm of softness, which one's own body suggests."

JAMES ROSENQUIST. Born Grand Forks, North Dakota, 1933. *The Light That Won't Fail, I*. 1961. Oil on canvas, 6′ × 8′. Hirshhorn Museum and Sculpture Garden, Smithsonian Institution, Washington, D.C.

Like Oldenburg's giant sculptures (pages 165 and 193), the blown-up images in James Rosenquist's paintings derive from the insight that gross enlargement can alter our perception of things, making us question the nature of our vision and the assumptions we make about reality. After having studied painting and drawing at the University of Minnesota, Rosenquist came to New York in 1955 and enrolled at the Art Students League. From 1957 to 1960, while attending drawing classes at night, he made his living as a sign painter. Perched high on scaffolds above Times Square as he painted huge advertising billboards, he discovered that the fragment of a gigantic image, seen close to, is completely unrecognizable; losing its meaningful identity, it becomes an abstract form. He also noted that modern man is constantly being bombarded by messages: "I'm amazed and excited and fascinated about the way things are thrust at us, the way this invisible screen that's a couple of feet in front of our mind and our senses is attacked by radio and television and visual communications, through things larger than life, the impact of things thrown at us, at such a speed and with such a force that painting and the attitudes toward painting and communication through doing a painting now seem very old-fashioned."

In contrast to the multiplicity and diversity of elements in Robert Rauschenberg's *Canyon* (page 160), the objects that Rosenquist represents are relatively few, and each one, although fragmented, is depicted with great clarity. A picture such as *The Light That Won't Fail* is composed like a collage or a montage of film clips, made up of commonplace things because the observer is not meant to focus on their meaning but on their shapes. Rosenquist decided to use commercial objects because they were not emotion laden: "It wasn't meant to be present, passionate imagery—it was meant to be no image, nothing image, nowhere." A similar intention underlay his choice of the blanched gamut of colors he used in his paintings from 1960 to 1962, the very opposite of advertisements' garishness; the smoky grays, pale yellow, and offwhite in this work are typical. "I started painting really in grays. Occasionally adding a color, but usually in gray because I didn't want my paintings to be gorgeous. It had to do, like my choice of imagery, with not wanting to look contemporary."

Rosenquist's purpose in using ordinary, immediately recognizable objects that are not intended to have any symbolic significance is similar to Johns's aims in painting targets and flags (see page 161). By changing the context of such an object, Marcia Tucker explains, Rosenquist "forces us . . . to perceive it abstractly, and thus to sense or feel it, to find out about it, without preconceptions about its use or form. . . . By virtue of a formal abstraction (that is, changing the object's scale, color, form and perspective in order to isolate what is in it) his images become real rather than representational." Rosenquist himself declared: "If I use a lamp or a chair, that isn't the subject, it isn't the subject matter. The relationships may be the subject matter, the relationships of the fragments I do. The content will be something more, gained from the relationships. If I have three things, their relationship will be the subject matter; but the content will, hopefully, be fatter, balloon to more than the subject matter. One thing, though, the subject matter isn't popular images, it isn't that at all."

The title *The Light That Won't Fail* was used for two of Rosenquist's early paintings. It is based on a personal association and, like the objects portrayed, is devoid of symbolism—even though, like them, it may trigger the viewer's own associations. In 1960 Rosenquist married and, having quit his sign-painting job, was collecting unemployment compensation. His new studio, he recalls, "was all crackled plaster. There was no decoration; it was very stark, a coal stove. . . . I had no art materials in there, just a pencil, and after several days . . . I began to write things down on the wall. I wrote down 'the light that won't fail' and other phrases."

Departing from his stance of total detachment, in 1965 Rosenquist painted his huge mural *F-111* (Collection of Robert C. Scull). In its fifty-one aluminum panels, the fuselage of the U.S. Air Force's jet fighter-bomber is juxtaposed with other images in an epic commentary on the interaction between technology and people in contemporary American society.

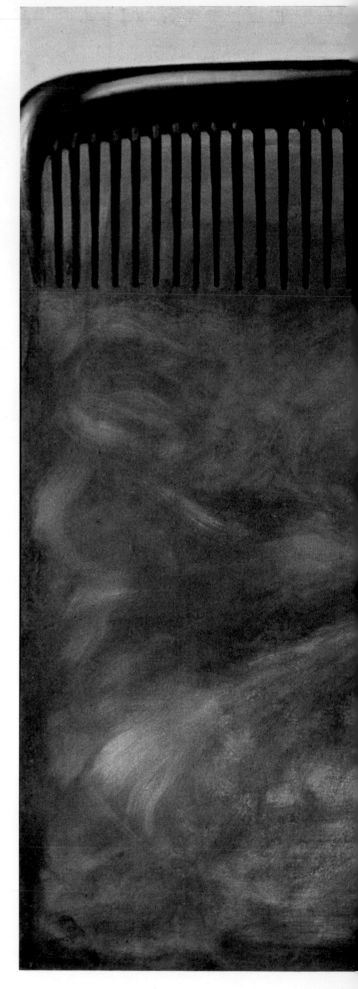

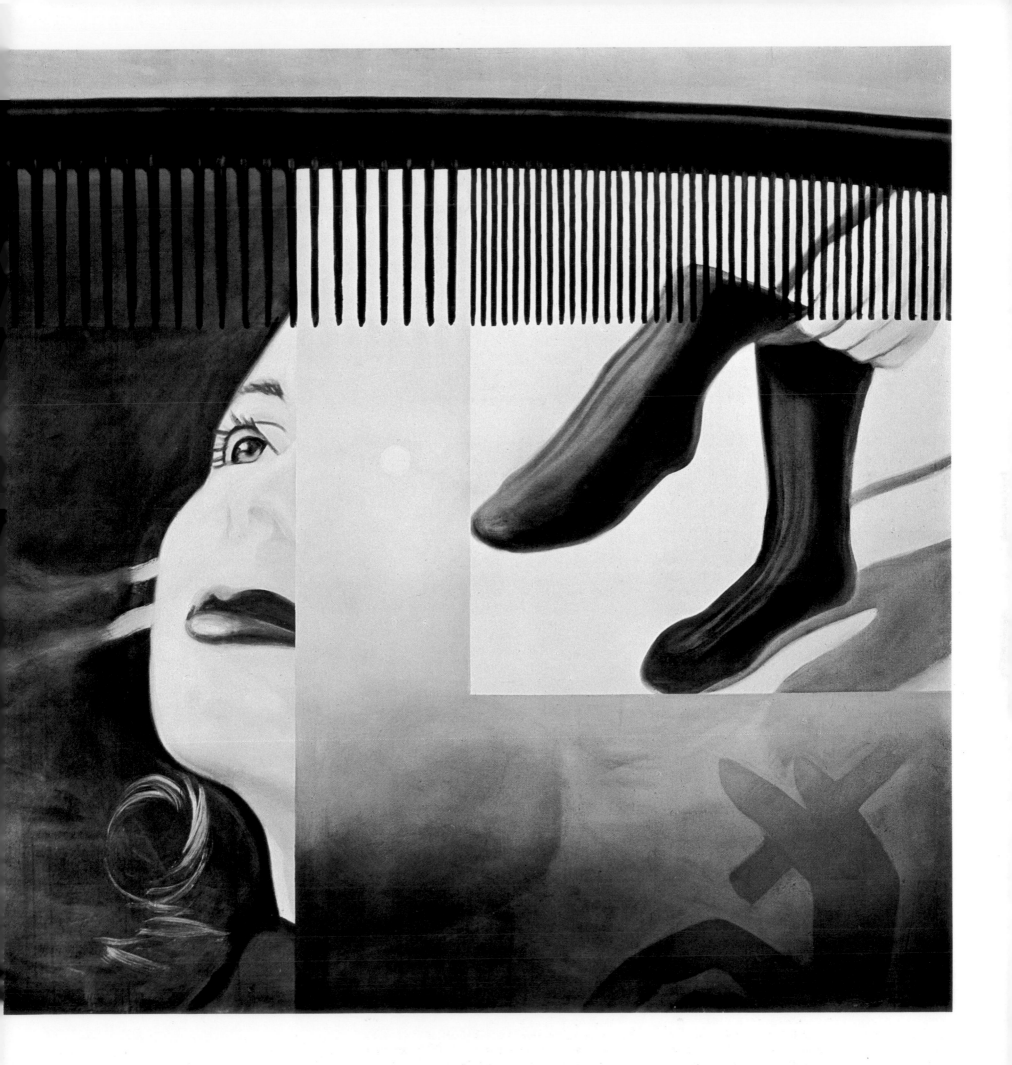

ROY LICHTENSTEIN. Born New York City 1923. *Big Painting # 6*. 1965. Oil and Magna acrylic on canvas, 7′ 8½″ × 10′ 9″. Kunstsammlung Nordrhein-Westfalen, Düsseldorf.

In Roy Lichtenstein's *Big Painting #6* gigantic scale is once again a significant factor. A segment of overlapping Abstract Expressionist brushstrokes, accompanied by the accidental drips characteristic of that style, has been isolated from any context within a painting and enormously enlarged so that it not only fills the more than ten-foot-wide canvas but even seems to extend beyond it. The succulent pigment and uneven surface of the model have been flattened, and the gestural artist's self-revelation depersonalized by heavy outlines filled in with flat color areas, set against a background simulating the benday dots used as shading tints in cheap commercial printing.

Earlier, Lichtenstein himself had painted in an Abstract Expressionist style but broke with it completely in 1961. His pictures of that year, based on isolated frames from comic strips, greatly enlarged and utilizing commercial-art techniques, presented a radical challenge to accepted ideas of art. In the shocked reaction to his subject matter, the extent to which he had transformed his motifs in the interest of formal, abstract qualities was completely overlooked. Like other Pop artists, Lichtenstein chose everyday images familiar to all; besides the comic strips, there were such ordinary objects as a ball of twine, a schoolchild's composition book, a golf ball. Subsequently he turned from adaptations of the "low" art of the comics to similar renderings of "fine" art, including paintings by Picasso, Mondrian, Monet, Matisse, and others, as well as classical architecture.

Whatever his source, Lichtenstein abstracts and stylizes it by strong outlines filled in with areas of flat, primary colors, and benday dots—which, as he has noted, can be read either as plane or, in large areas, as "atmospheric and intangible—like the sky." By cropping his images and carefully positioning them within his canvas, he sets up a tension between the figure and the ground, and also between the viewer's recognition of the source motif and its transformation into a new image.

Lichtenstein chose Magna acrylic as his medium because it is soluble in turpentine; when wiped off the surface, it leaves no trace of changes made in the course of execution. This is the antithesis of the Abstract Expressionists' practice of leaving on the canvas a clear record of their act of painting it. Regarding his limited color, Lichtenstein said: "I picked out four contrasting colors that would work together in a certain way . . . a kind of purplish blue [not used in *Big Painting #6*], a lemon-yellow, a green, . . . a medium standard red, and, of course, black and white. . . . I use color in the same way as line. I want it oversimplified."

The series of brushstroke pictures, he stated, "started with a comic-book image of a mad artist crossing out, with a large brush stroke 'X,' the face of a fiend that was haunting him. . . . Then I went on to do paintings of brush strokes alone. . . . The very nature of a brush stroke is anathema to outlining and filling in as used in cartoons. The brush strokes obviously refer to Abstract Expressionism." They were made by applying loaded brushstrokes of black Magna color to acetate; after the paint had shrunk and dried, the sheets were overlapped to find a suitable image, which was then projected onto the canvas and redrawn; the benday dots of the background were left to be filled in by assistants. Lichtenstein declared: "The meaning of my work is that it is industrial, it's what all the world will soon become. Europe will be the same way soon, so it won't be American; it will be just universal." When sold at auction in 1973, *Big Painting #6* was purchased for a European museum—at a record price that equaled any previously paid for a work by a living American painter (a distinction shared with Harnett in the nineteenth century!).

Much modern art has made allusion to other art, from which it derives a piquant or ironic humor (see, for example, Nadelman's *Man in the Open Air*, page 126). Some of the artist's intention is lost should the spectator fail to recognize these allusions, just as acquaintance with their literary antecedents is needed for a full understanding of Eliot's *The Waste Land* or Joyce's *Finnegan's Wake*. Lichtenstein's paintings assume that a sophisticated, knowledgeable public will get the point of his parodies of Abstract Expressionism, Picasso, Matisse, and others whose works he has adapted, and also the less overt references to Hokusai's waves, Art Nouveau's whiplash curves, Art Deco's geometric conventions, and—in the benday dots—to Seurat's pointillism. In other words, the viewer is expected to have a frame of reference that includes imagery from the world of art as well as familiar objects like the ale cans simulated by Johns or the hamburgers transmogrified by Oldenburg. To this extent, Pop art may be as elitist as the Abstract Expressionism against which it rebelled.

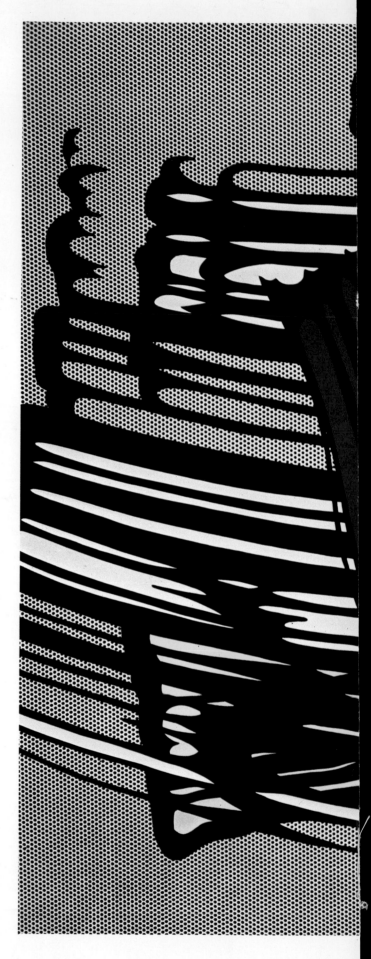

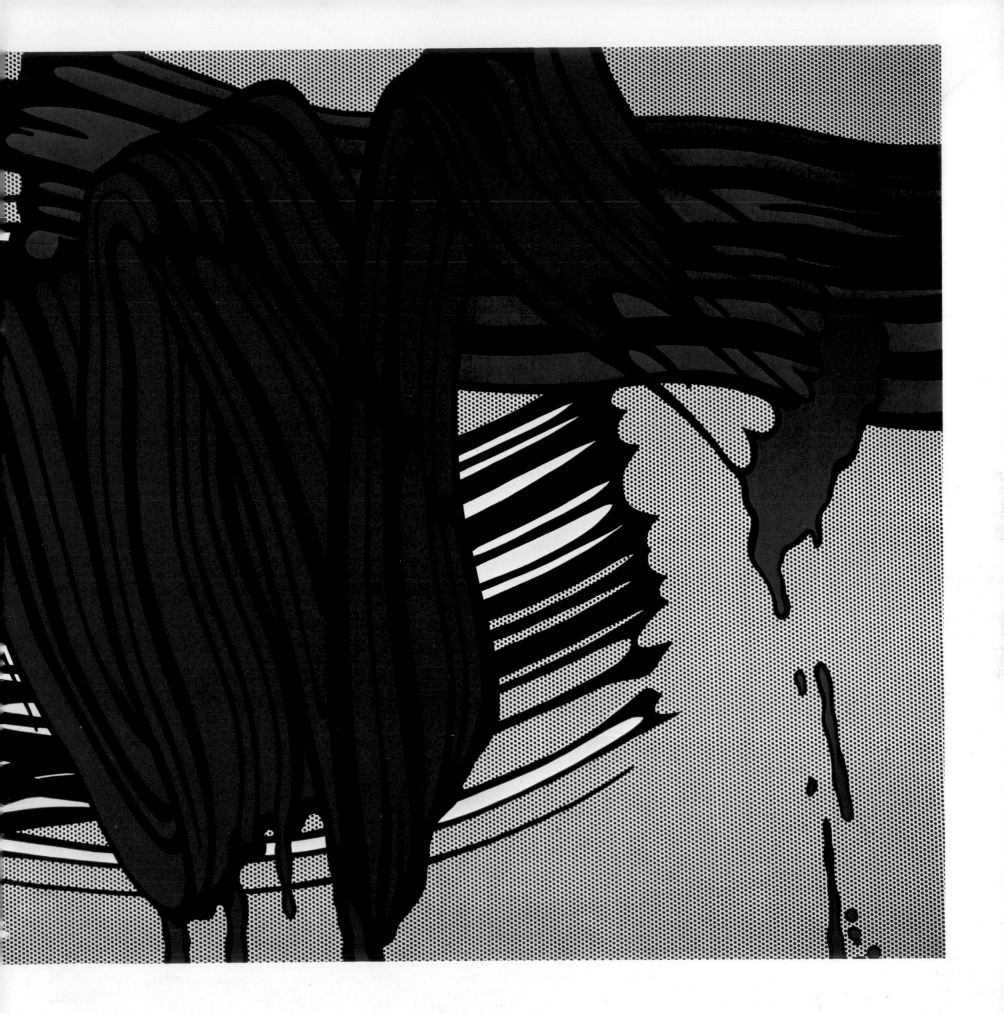

ANDY WARHOL. Born Pittsburgh, Pennsylvania, 1925. *Self-Portrait*. 1966. Synthetic polymer paint and enamel silk-screened on six canvases, each 22⅝" square. The Museum of Modern Art, New York (The Sidney and Harriet Janis Collection).

In Andy Warhol's paintings, the choice of banal subjects, depersonalization of the work of art, and dependence on commercial art for imagery and technique are carried to an extreme. After coming to New York in 1949, Warhol throughout the next decade had a highly successful career as an illustrator and commercial designer. Not inconsequentially, he views America as a consumer-oriented society, glutted with mass-produced objects and experiencing much of life at secondhand, from newspaper and magazine reproductions and images on the television screen.

In his early paintings Warhol, like Lichtenstein (see page 168), painted comic-strip characters (Mickey Mouse and Donald Duck), but he soon turned to the silk-screen technique and the representation of consumer products—his many pictures of Campbell's Soup cans being among the best known. Popular idols, among them Marilyn Monroe and Jackie Kennedy, were treated as if they, too, were articles for mass consumption. His portraits, including those of himself, are never done from life but always through the intermediary of a previously existing photograph, which is then still further removed from the living model by enlargement and silk-screening. Warhol usually leaves the printing, and often the coloring, of the resultant image to an assistant, thus negating both the individuality of the subject and the individuality of the artist who creates the finished work.

In some of his paintings Warhol takes an object or a known personality and presents it as a blown-up, isolated image. At other times, as in this *Self-Portrait*, the image is repeated on the canvas, with or without variations, anywhere from twice to one hundred times. In the first category, the object becomes an icon, a venerated idol; in the second, the repetitiveness and sameness are an implicit comment on the mechanization and dehumanization of modern society, conducive to alienation and ennui. (In some of Warhol's films, endlessly repeated images are projected at such an excruciatingly slow speed that boredom becomes a positive attribute.)

"I think it would be terrific if everybody was alike," Warhol has said. "The reason I'm painting this way is because I want to be a machine." This statement can hardly be taken at its face value; it is belied by, among other things, Warhol's notoriously exhibitionist behavior. To begin with, the making of multiple images, as in this *Self-Portrait*, is hardly a mindless, wholly mechanical procedure. As Richard Morphet points out: "Requiring selection, masking, processing, enlargement, transposition and application, in conjunction with decisions on canvas size, placing, colour and handling, it means that the finished painting is a complex and calculated artifact, which is not only unique, but strikingly different from any that another individual

might have produced." Secondly, although Warhol has said, "I like painting on a square because you don't have to decide whether it should be longer-longer or shorter-shorter or longer-shorter: it's just a square," he alleviates the monotony of the repeated image and format by using a different color and tone for each frame. Ann C. Vandevanter has noted (with reference to the related nine-panel *Self-Portrait* in the collection of David Whitney): "the changes of light and color within the flattened likenesses create a sense of time and movement and the tension between the static image and these subtle changes spells a demanding confrontation for the viewer, intensified by the scale of the whole work." Moreover, in this version Warhol has signed and dated five of the six panels on the reverse, thereby, so to speak, repersonalizing the depersonalized work. Finally, it is noteworthy that of all the possible photographs of himself that he might have selected, he chose one in which the hand is brought up before the mouth, as if an act of will were required to mask or control the potential expressiveness of that most mobile feature of the face.

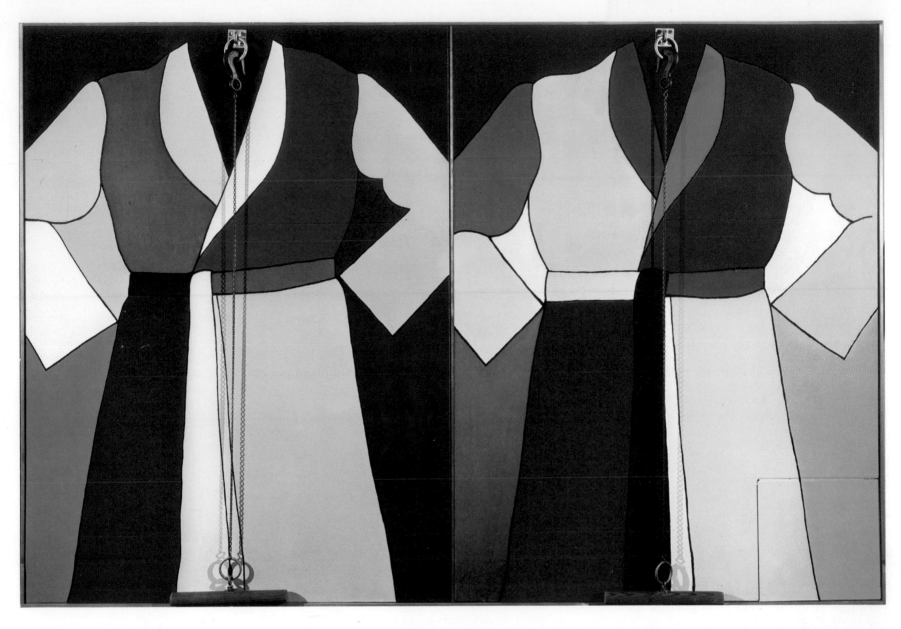

JIM DINE. Born Cincinnati, Ohio, 1935. *Double Isometric Self-Portrait* (*Serape*). 1964. Oil on canvas, metal, wood, 4′ 8⅞″ × 7′ ½″. Whitney Museum of American Art, New York (Gift of Mrs. Robert M. Benjamin, in memory of Robert M. Benjamin).

Soon after coming to New York from Cincinnati in 1958, Jim Dine met a number of artists interested in Allan Kaprow's ideas about Happenings and environments (see page 174), and when Claes Oldenburg had his first environmental exhibition, The Street, at the Judson Gallery in 1960 (see page 164), Dine simultaneously presented its counterpart, The House, also constructed of junk materials. Dine's interest in environments waned, however, as he became increasingly preoccupied with using his works—as Lucas Samaras did his objects (see page 178)—as a means for discovering his own identity. The same quest led him to undergo psychoanalysis from 1962 to 1966. In his chameleonlike shifts in styles and materials Dine seems to be trying out as many modes as possible in his efforts toward self-discovery; and certain recurrent images in his art, such as tools, palettes, and a bathrobe, have all been chosen for the personal significance they hold for him.

The tools go back to recollections of his Polish grandfather's prowess in woodworking, and of the articles sold in his store and in the one owned by Dine's father. His grandfather's tools, he has said, "were always available for me to play with. From the time I was very small I found the display of tools in his store very satisfying. . . . My father also had a store. He sold paint (house) and tools and plumbing supplies. From the age of nine till I was eighteen I worked in these stores. . . . Commercial paint color charts were real jewel lists for me too." In the palette theme Dine identifies himself specifically with his role as an artist. As for the bathrobe, he relates: "I found an ad for a red bathrobe in the Sunday Magazine of the New York Times sometime in 1963. It was headless and it seemed like my body was in it. I had searched for some time for a vehicle to label 'self-portrait.' The value of doing self-portraits for me has always been the reaffirmation that I do exist."

After Rodin received the commission to execute a sculpture of Balzac in 1891, he spent seven years working out his conception. One of the first decisions to be made was whether to show the figure nude or clothed, and if so, how. Eventually Rodin decided to show Balzac in the dressing gown he habitually wore when working; among the more than forty studies for the sculpture are some of this garment alone, which seems invested with its owner's personality. It is characteristic of Pop art that Dine, by contrast, should have selected his image

of a robe from an advertisement; but he personalized this originally anonymous, mass-produced article—which he always showed empty, with arms akimbo—by treating it in a variety of colors and mediums, and sometimes providing it with accessories. Occasionally the robe became three-dimensional, and in a seven-color lithograph of 1969 it became a landscape, with grass below and a cloud-filled sky above.

In the *Double Isometric Self-Portrait* (*Serape*), the robe is as flat as if it were meant to clothe a paper doll. Its outline, sleeves, lapels, and sash are identically repeated in both halves of the symmetrically divided canvas, but corresponding segments are given different colors in each of the dual representations: in the left-hand robe, for example, one lapel is pink, the other yellow, whereas in that on the right, one lapel is deep orange and the other blue. The subtitle of the painting suggests that the color scheme was taken from Mexican textiles. Black lines subdivide the color areas, giving the design the appearance of cloisonné enamel. The paint is as flat as on sample paint chips or commercial color charts. The only three-dimensionality is provided by the chains in front of the robes on either side, each hooked to a ring above and stretched to a wooden bar below. The picture is like an icon portraying twin presences, implacable and austere despite the striking colors.

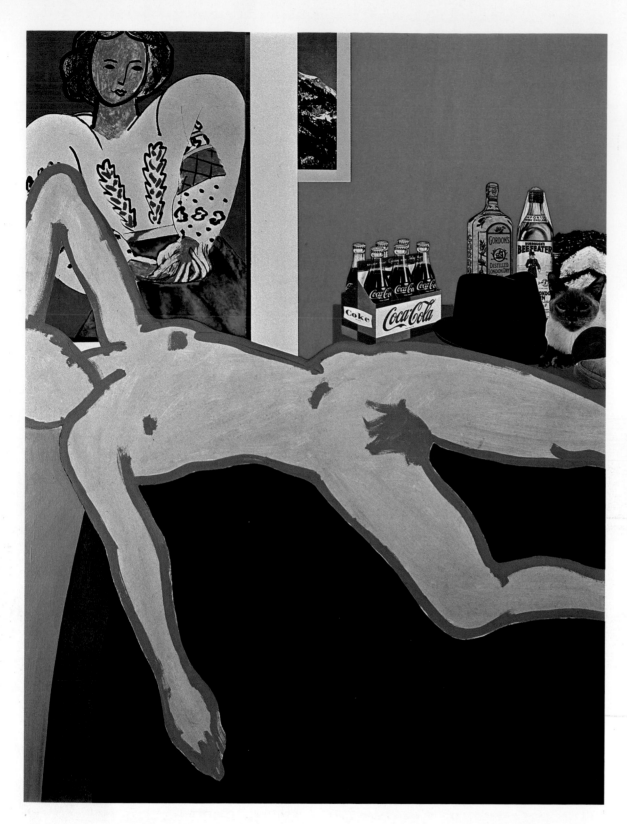

ors must work against each other in a dynamic way. All colors must advance. Competition rather than harmony is desired. (3) Keep space shallow or deny it altogether. (4) Try to disintegrate the central images and disperse them around the canvas." Wesselmann first began by working out his ideas in small collages; he said he liked this medium because "you can use anything, which gives you that kind of variety; it sets up reverberations in a picture from one kind of reality to another."

In the *Great American Nude 26*, which can be seen to fulfill each of Wesselmann's four objectives, he used collage together with oil paint. He explained this mixture of mediums by saying: "A cigarette ad and . . . a painted apple . . . are two different realities and they trade on each other. . . . This kind of relationship helps establish a momentum throughout the picture—all the elements are in some way very intense . . . all the elements compete with each other."

The subject of the reclining nude has been favored by Western artists from the time of such Italian Renaissance masters as Giorgione and Titian, through Ingres, Manet, Modigliani, and Matisse, to name only a few. While subsuming all these precedents, Wesselmann makes even more direct reference to that contemporary idol, the erotic nude of pinups and centerfolds. In this picture the body and face are left blank within the heavy outline, except for the erogenous zones—nipples, navel, and pubic hair (in some works in the series, the mouth is also shown). Deployed on a dark blue cloth, with one hand upraised beneath her head in a pose originated in antiquity to indicate sleep, the shocking-pink figure is brought up to the frontal plane and is cropped at the edges of the canvas as in a film close-up. Behind her at the upper left is a reproduction of Matisse's painting *The Rumanian Blouse,* 1940 (Musée National d'Art Moderne, Paris), the model's demure posture and modest costume contrasting wittily with the flamboyant shamelessness of the nude. Such visual quotations of earlier works are frequent within twentieth-century art; here, Wesselmann pays homage to a master he particularly admired.

Besides a fragment of collage landscape, which can be read either as a view through a window or part of another picture on the blue wall, the upper right quadrant of the painting contains a miscellany of objects that make up a still-life composition in collage, similar to those Wesselmann was producing at this period. The banal cutouts from advertisements—especially the bottles of Coca-Cola, the paradigm of American "kulchur" both here and abroad—are part of the familiar Pop vocabulary. Their use in conjunction with the replica of Matisse's painting and the highly stylized nude, however, and the manner in which these elements are dispersed throughout the picture, are flagrant violations of the classic precepts of unity, coherence, and emphasis. In Mario Amaya's words, these heterogeneous elements "are all competing for our attention and inviting us to adjust our methods of receiving visual messages with one aesthetic framework. . . . There is no predetermined condition of medium or technique and one is in a constantly changing aesthetic focus."

TOM WESSELMANN. Born Cincinnati, Ohio, 1931. *Great American Nude 26.* 1962. Oil and collage on canvas, 48″ × 60″. Collection of Mrs. Robert B. Mayer.

Tom Wesselmann's Great American Nude series is another instance of an artist's adoption of a theme that he repeats with variations throughout a large number of works in order to explore its formal possibilities. Begun in 1961 and continued until 1973, the series includes one hundred examples. Wesselmann has said that the idea came to him in a dream of the red, white, and blue of the American flag.

In part, Wesselmann's analytical approach may be due to his having come to painting relatively late. After serving in the army, he studied first at the Cincinnati Art Academy and then at Cooper Union in New York, from which he was graduated in 1959. He admired four very different artists for specific qualities in their work: Hans Memling for his isolation of single figures within an architectural setting; Willem de Kooning for his active, allover surfaces and respect for the edges of the painting; Piet Mondrian for the simplicity and tension of his compositions; and Henri Matisse for his compositions and simplified color. In 1960 Wesselmann proposed for himself several objectives: "(1) Keep the picture plane in front of the canvas plane. Lift the image off the canvas, get the painting as close to you as possible. Tie the painting to the front, not the back. (2) A painting must be competitive. Col-

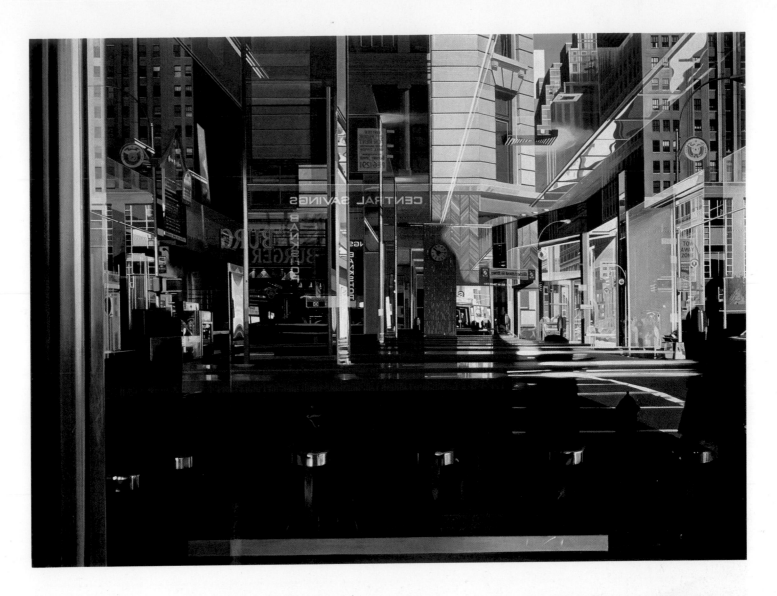

RICHARD ESTES. Born Evanston, Illinois, 1936. *Central Savings*. 1975. Oil on canvas, 36″ × 48″. William Rockhill Nelson Gallery of Art—Atkins Museum of Fine Arts, Kansas City, Missouri (Gift of the Friends of Art).

In the late 1960s the American predilection for sharply delineated realism reasserted itself in a movement known variously as Super Realism, Radical Realism, and Photo-Realism. In common with Pop art, paintings in this style take as their subject the most banal aspects of the modern environment and make use of preexisting images. Reproducing slides, photographs, and picture postcards in enlarged scale, the artists adhere so faithfully to their models that they have been accused of outright plagiarism. In contrast to Pop art, the human figure is usually absent from these pictures, and ironic humor is supplanted by cold detachment.

Earlier artists such as Fitz Hugh Lane (page 74), Thomas Eakins (page 92), and Ben Shahn (page 120) had made use of photography, but they had selected, synthesized, and transformed the visual data obtained by the lens. The precisionist Charles Sheeler—a professional photographer as well as a painter—imposed a classical, abstract order on his pictures (page 15). Even industrial subjects like automobile plants or railroad wheels and pistons were so devoid of traces of polluting grime or human toil that the term "Immaculate" was sometimes applied to his style.

Although almost equally lacking in dirt or the human presence, Richard Estes's *Central Savings* differs radically from one of Sheeler's paintings. Its profusion of overlapping visual information defies us to sort out exterior from interior, objects from reflections. The strong verticals, horizontals, and diagonals, and the focus that is equally sharp throughout, irrespective of distance, do not help us to measure space but only intensify our bewilderment.

Like Pop, Op, and Minimal art (see pages 161, 182, and 190), this kind of painting is concerned with perception. It poses a challenging question about the interaction between our retinal responses and our mental concepts, and the extent to which the latter modify our notions of reality. As the critic Leon Shulman notes: "In a normal situation of reality the viewer tends to pass over . . . given phenomena or information such as the reflections on glass, mirrored images, architectural ornaments and the multiplicity of events occurring at the same time. It is not that Estes is attempting to heighten the viewers' awareness of these urban phenomena . . . but more so for himself is he realizing retinal excitement on a . . . two-dimensional surface. His concerns are primarily formal."

Estes begins by taking color slides and blowing them up so that he can see details with great clarity. "The idea occurs and is involved with the photograph," he explains. "But I don't like to have some things out of focus and others in focus because it makes very specific what you are supposed to look at, and . . . I want you to look at it all." Over an acrylic underpainting he applies glazes of oil paint, giving the surfaces a delicate, sensuous texture that mitigates the icy precision of the images. (In this picture, another personal—and amusing—touch is his signature neatly printed in reverse above the Ballantine symbol.)

Because of his choice of subject, Estes has often been likened to Edward Hopper (page 117), who said he found the American city "hideous"; Estes would like to "tear down most of the places I paint," but says, "I enjoy painting it because of all the things I can do with it." The resemblances between the two artists are in fact only superficial. Estes's preference for ambiguous visual statements, his flattening of space, and his entire sensibility (or what Ivan Karp in a 1963 article on Pop painting called "anti-sensibility") are characteristics of a younger generation. With Frank Stella (pages 188–189) and Kenneth Noland, he shares a desire to have every inch of a painting function equally. This presupposes Jackson Pollock's allover patterning (pages 142–143), but Estes totally rejects the Abstract Expressionists' aim of projecting their personalities onto the canvas. "I think you can be more interesting and more mysterious if you use what's out there in the world; you just don't try to create it out of your head," he says. "What we select from the real world gives a pretty good indication of where we're at. . . . I couldn't do these pictures 50 years ago because none of this existed 50 years ago."

GEORGE SEGAL. Born New York City 1924. *Cinema*. 1963. Plaster, illuminated Plexiglas, metal, 9′ 10″ × 8′ × 2′ 6″. Albright-Knox Art Gallery, Buffalo, New York (Gift of Seymour H. Knox).

In contrast to the insouciant humor with which Pop artists depict the American environment, four sculptors—George Segal, Edward Kienholz, Lucas Samaras, and Ernest Trova—express, each in a different way, the alienation of modern man. Segal studied at Rutgers University under Allan Kaprow, the guiding spirit of Happenings (see page 164), and participated with Claes Oldenburg, Jim Dine, Lucas Samaras, and others in many performances; in fact, a number of picnic-Happenings took place at Segal's chicken farm in New Jersey.

Segal began as a painter of large pictures that showed expressionistically gesturing personages. In an effort to get away from the flatness of the picture plane and, as he said, to test the space, he built life-size figures of burlap dipped in plaster over a wire-mesh armature, somewhat like the technique that Oldenburg invented for his Store reliefs (page 164). He evolved his characteristic method of casting from the human body when one of his students brought him a newly developed type of wet, plaster-soaked bandages. Using his friends as models, Segal took castings by posing them in a desired attitude and then wrapping them in the bandages; when these were removed, he reassembled the parts to form the whole figure. What we see in the finished works is not a casting taken f.om the negative, true-to-life impression, but the exterior.

All extraneous details are suppressed, the face and costume remaining as generalized as the momentary, frozen action is specific. "I choose to use the exterior," Segal explains, "because in a sense it's my own version of drawing or painting. I have to define what I want, and I can blur what I don't want. . . . It bears the mark of my hand; but it bears not the work of my hand so much as the mark of my decisions in emphasis." Thus, as in Abstract Expressionist painting, choices made in the course of execution remain clearly apparent in the finished work; the texture of the plaster is varied by drips and by allowing some of the underlying net casing to show through.

His experience with Happenings had sharpened Segal's sense for the drama inherent in gesticulating figures surrounded by appropriate props. In the Happenings, however, as in the Theatre of the Absurd, the situations are unpredictable, whereas Segal represents ordinary people engaged in commonplace activities. He is as skillful as Edgar Degas in capturing an occupational gesture and making it powerfully expressive. Many of the situations he portrays reflect the blighted landscape and industrial jungle along the New Jersey Turnpike—a limbo neither urban nor suburban, littered with gas stations, buses, luncheonettes. Segal says that the idea for *Cinema* came to him one night when he was driving home from New York and saw a man, high up on a ladder and alone, changing the title on the marquee of a drive-in movie. In the real scene the figure was lit by spotlights across the street, but in his re-creation of it, a wall of fluores-

cent light was functionally integrated into the tableau, serving, he says, "to chew up the man's edges, to emanate." Segal never uses light, as Dan Flavin does (page 192), as a medium in itself, but only when it is essential to the feeling or idea he wishes to project.

The realistic accessories accompanying Segal's figures aggravate their surreal, ghostlike appearance. Kaprow has called them "vital mummies" and likened them to the inhabitants of Pompeii trapped in mid-action by lava erupting from Mount Vesuvius. In this work the setting is austere and composed of only a few elements. The smooth, translucent Plexiglas panel is framed and divided in two by strips of silvery metal; each half is subdivided into four equal compartments by three horizontal strips behind the plastic. Set back in a slightly recessed band, the large, bright letters of CINEMA, framed in metal and lit from within by bulbs, contrast with the smaller black R below, toward which the workman reaches.

The nature of his subjects and the mood of alienation evoked by his lonely, everyday figures going about their daily tasks have frequently caused Segal to be compared with Hopper (page 117). When asked about this, he replied: "There could be a kind of temperamental affinity. He's very much a sensual puritan. I guess I am too. We're both American, like large, unembellished spaces, some kind of austerity and severity of architecture. . . . I can see certain connections; they were never conscious."

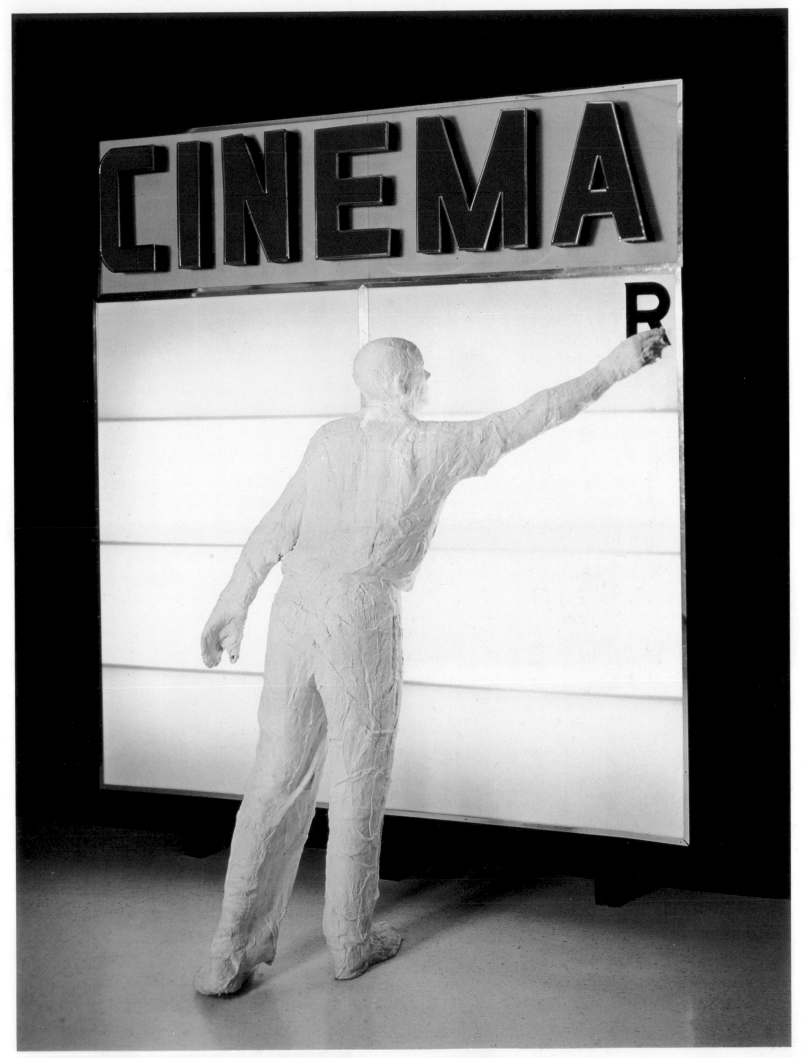

EDWARD KIENHOLZ. Born Fairfield, Washington, 1927. *The Wait*. 1964–1965. Epoxy, glass, wood, found objects, 6′ 8″ × 12′ 4″ × 6′ 6″. Whitney Museum of American Art, New York (Gift of the Howard and Jean Lipman Foundation, Inc.).

The contrast between the multiplicity of objects making up Edward Kienholz's *The Wait* and the austere economy of means in George Segal's *Cinema* (page 175) is as great as the two artists' difference in approach. Segal's comment on modern man and his environment is, oblique, the mood induced gently elegiac; Kienholz's is direct, violent, and moralistic. He has given this explanation of the work:

"I consider this particular lady as someone living today, very old and close to death. Modern times have passed her by and she lives only in the memory of her past life. The jars around her neck begin with her childhood on a farm and move on to girlhood, waiting for her man, marriage, bearing children, being loved, wars, family deaths and then senility, where everything becomes a hodgepodge.

"Her body is built from cow bones, as human bones would have been too small. The large diameter of these bones gives the impression of living flesh. One eye has a cataract and one is clear. The skull is inside the glass head, and the picture on the front is how she thinks of herself. As she has aged, she has refused to accept the physiological changes of age. She remembers herself as a young, attractive woman. Beside her are pictures of family and friends.

"She pets her cat, which I found at a taxidermist and which I· think of as being living. It was important to make the tableau concerned with imminent death, so I needed to put a live bird in the cage to show the contrast between life and death. The wainscoting is authentic, the plug in the wall is authentic. The wallpaper I did myself, and then aged it. I had a lot of trouble fiberglassing the work to retain the color of the dress and shawl. Her sewing basket, a souvenir from Atlantic City, is a beautiful sort of basket like we had on the farm. Her needlework, which was given to me, was started by a woman who laid it down thirty-four years ago and never picked it up again."

Before Kienholz turned to sculpture, he attended several universities, and then, as he said, "moved around the Western United States, sort of like Kerouac . . . worked in a hospital as surgeon's orderly. I've seen suffering . . . worked in a mental hospital . . . worked for a foreign car agency in Reno . . . opened a gambling club in Las Vegas." When he came to Los Angeles in the mid-1950s, Kienholz operated a succession of art galleries and began making wooden construction reliefs. These soon turned into assemblages of people—or fragments of people—combined with articles of their environment, which gradually became increasingly detailed and true to life. The common denominator of his nightmare tableaux (which, paradoxically, derive from the simple Sunday school tableaux that impressed him as a child) is human suffering—sometimes physical, more often psychological. He

has said: "All the things we do and call positive are because of our own fear of death—most things can be explained by the fear of death. It goes through all our expressions." *The Wait* not only anticipates mortality but represents a death-in-life.

Combined with objects painstakingly selected to establish the authenticity of the old-fashioned setting are others given a new meaning by their combination: the deer's skull and cow's bones making up the woman's head and body, the framed photograph that replaces her face, the symbols of her memories enshrined like sacred relics in the glass jars around her neck. Kienholz has ironically surrounded the woman with real objects and clad her in appropriate garments; only she herself is artificial. By such juxtapositions of disparate elements, William C. Seitz has pointed out, "in thought-provoking ways assemblage is poetic rather than realistic, for each constituent element can be transformed. Physical materials and their auras are transmuted into a new amalgam that both transcends and includes its parts. When, as in a primitive cult object, a shell becomes a human eye because of its context, the accepted hierarchy of categories (as the surrealists delighted in pointing out) is disrupted. . . . The assembler, therefore, can be both a metaphysician and . . . a poet who mingles attraction and repulsion, natural and human identifications, ironic or naïve responses. . . . Figuratively, the practice of assemblage raises materials from the level of formal relations to that of associational poetry."

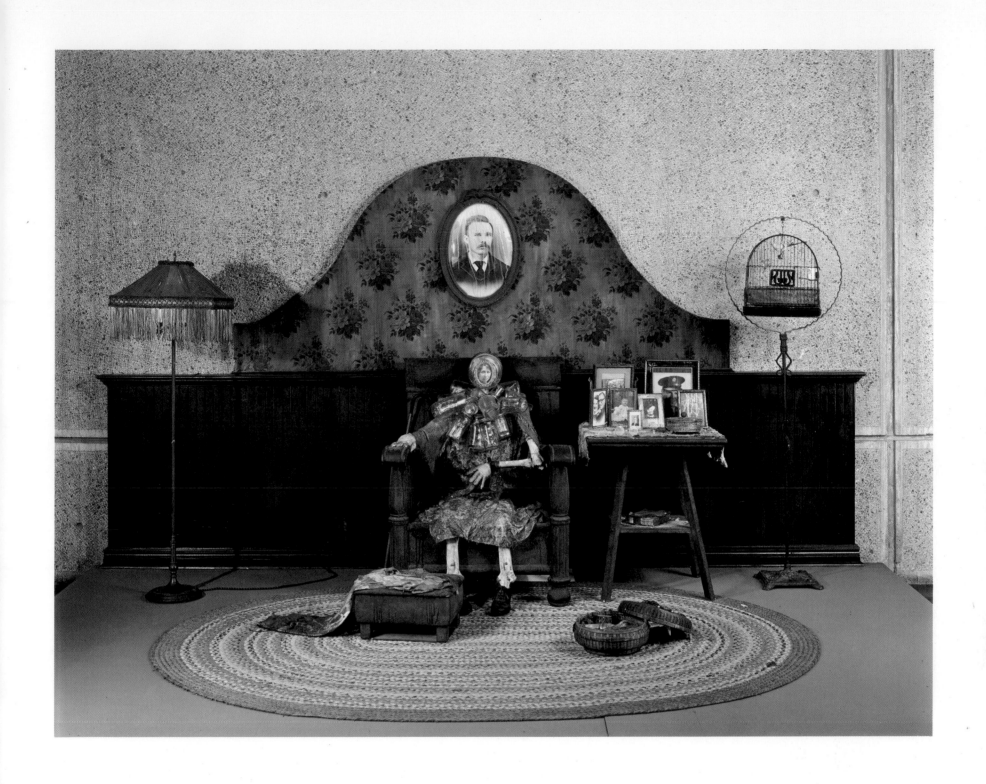

LUCAS SAMARAS. Born Kastoría, Greece, 1936; to United States 1948. *Chairs.* 1965. Pins and yarn on wood, 35½″ × 61″ × 20″. Walker Art Center, Minneapolis, Minnesota (Art Center Acquisitions Fund).

Alienation entails a tendency to dehumanize people and regard them as things; a natural corollary is to regard things as people, or at least as surrogates for them. Lucas Samaras makes emotionally charged objects that, like poetic metaphors, communicate feelings to the viewer in a very direct way. He was a student of Allan Kaprow's at Rutgers University and through him came in touch with Claes Oldenburg, George Segal, and other artists with whom he participated in Happenings, some of which took place in Oldenburg's Store (see page 164) after the exhibition there closed.

Samaras turned from making abstract pastels to creating objects. He made a series of boxes, some covered with soft stuffs, such as fur, or rainbow-colored wool yarn like the chair to the left in this work, and others covered with pain-inducing things, such as razor blades, bits of broken glass, or pins like the right-hand chair. The use of concentric strands of multicolored yarn to form a pattern is common to the folk art of several countries; the effect is not dissimilar to some of Samaras's stripe-design pastels.

"When I was a child in Greece," Samaras recalls, "we didn't have toys. Consequently we made up toys or else . . . I used . . . spools or whatnot, and they became people. So that objects were somehow either personifications of people, or symbols of people." As an artist, his objects became for him not only people in general, but were particularly a way of articulating his emotions and seeking his own identity. "I suppose some of the reasons, psychologically, why I do things, or objects," he has explained, "are because I don't relate in a conventional way with people, so that, let's say, the lack of a relationship I have with people gets into my use of materials, or the way I make works. Sometimes I feel that I want to eliminate people, so that I can just live by myself with things and memories. . . . Often, I suppose, I put dialogues that I have made with myself into the things that I make, but I don't call them that. I mean, for example, I made these two chairs, one leaning against the other—sure, it's like, you know, one person sort of leaning against another person. But I don't call it *Two People* and I don't even call them *Chairs.* [The work, like many others, was originally untitled.] I don't want people to be concerned with the fact that they're chairs. I want them to be concerned with—not words. I don't think that when they look at an art work they should be concerned with words. It should be visual: visual-emotional, not verbal-emotional."

The contrast between the two chairs is both tactile and visual—the softness and bright coloring of the wool in the one, the bristling and silvery gray of the pins in the others. As the catalogue of the Walker Art Center notes: "The atmosphere evoked is one of instability and aggression, but, paradoxically, the chair which boasts the more aggressive texture is the passive partner of the frozen drama. This inversion of roles is typical of the ambiguities to be found in Samaras' work." But even the hostile-seeming pins express the ambivalence of a love-hate relationship, for Samaras says: "When I began using . . . aggressive materials, I suppose I thought of them as being painful . . . and touching them or having them in my presence was a disturbing thing, but after I began using them . . . they were not aggressive. They were seductive, maybe, but at the same time they had a certain quality, so that if you were really so seduced that you had to touch them, then they would assert themselves somehow, so that your senses would be . . . played with . . . a kind of positive-negative . . . touch, or not touch, the quality of seducing-repelling."

Beyond the specifically sadomasochistic eroticism these objects convey, their more general significance has to do with transformation, which, Samaras declares, "is a spectacular idea. . . . My transformations negate the possibility of a single Platonic ideal acting as measure for any physical thing; instead many different ways of physically depicting a thing are selected and shown." This concept has analogies with Oldenburg's frequent creation of the same object in different scales and in hard, soft, and "ghost" versions.

ERNEST TROVA. Born Saint Louis, Missouri, 1927. *Study: Falling Man.* 1964. Chrome-plated bronze, 59″ high. Collection of Mr. and Mrs. Richard H. Solomon. (Other casts: The St. Louis Art Museum; The Museum of Modern Art, New York; Vera and Albert List Foundation; Phoenix Art Museum, Phoenix, Arizona.)

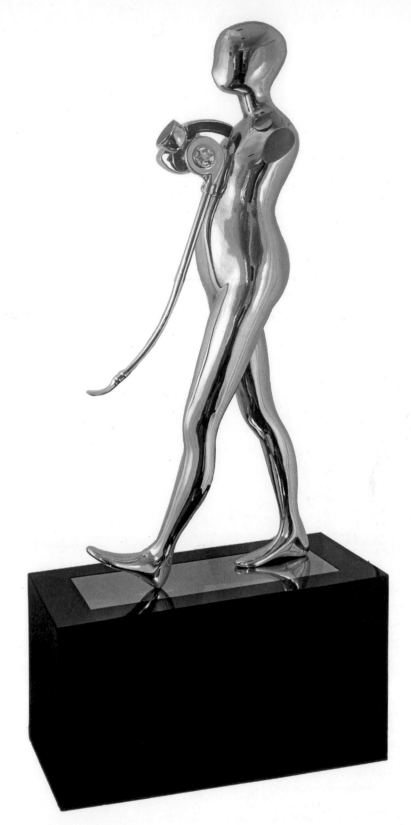

To express the modern human condition Ernest Trova invented a stereotyped image—a faceless, armless, sexless figure that he calls Falling Man. Beneath the roughened white plaster of George Segal's castings (pages 174–175), we always discern an individual engaged in a specific action; Trova, instead, presents an anonymous, machine-like automaton—a generalized sign. He has repeated this humanoid, in different situations and mediums, in an extensive series of works, each constituting a unit within an encyclopedic whole. "The sculptures are like a frame out of a film series," he has explained. "The scenario of the Falling Man. Each sculpture is a *study for a work.* . . . The Falling Man itself is definitely a man in tights reduced to an essential shape. . . . The form pleases me. The lines of the back and stomach are beautiful and right for me. He doesn't need arms because I am still experimenting with him the way he is. . . . He is definitely a man, but I feel no need to accentuate his sexuality. His face has no expression because he is not yet completed."

Trova has given his manikin a flat chest and protruding belly because he does not wish him to be ideal or heroic, but average. In this example the mechanical apparatus—cast from an agricultural spray—is like a misplaced, artificial male organ, and it also functions as a probe exploring the space toward which the figure is walking. Hundreds of Trova's works since 1963 bear the same title, *Study: Falling Man.* According to Lawrence Alloway, the word *study* does not indicate hesitation, but "human limits are acknowledged by the qualifying term"; he also suggests that the title relates to the Fall of Man, denoting a flawed, imperfect, yet somehow dignified creature, whose situation is psychological or moral, rather than physical, since many of the works (including this one) do not show the figure off balance.

Trova, a self-taught artist, began as a painter with a preference for expressionistic figures. He was greatly impressed by the exhibition of Willem de Kooning's Woman pictures (page 141), which he saw on a visit to New York in 1953, and he continued to be influenced by them for several years. He subsequently produced junk assemblages that had some analogies to the early works of Segal and Oldenburg. The Falling Man theme first appeared in Trova's paintings of the early 1960s and was soon elaborated in three-dimensional works. Using the resources of a Saint Louis department store, the Famous-Barr Company, Trova with the assistance of skilled workmen constructed figures out of the many materials used for making displays. His working procedure for the Falling Man sculptures consists of creating a constant pattern for the figures, in various sizes; finding sundry mechanical accessories in surgical supply stores, medical instrument shops, and the like; having a sand casting of the Falling Man made in a foundry, in a specified size; trying out the objects and their spatial relationships by experimentation; then, after the objects

have been screwed into place, having the entire assemblage plated. Like Barnett Newman in the fabrication of the *Broken Obelisk* (page 149), Trova controls all the successive industrial stages by constant consultation, checking, and necessary adjustments; but the finished product is totally devoid of the intervention of his own hand, seeming, as Alloway has said, as detached as if it were the result of a collaboration between surgeons and engineers. Trova has created the Falling Man in many other mediums besides painting and chrome-plated bronze: marble, plastics, toys, silk-screen prints, and jewelry. Some of the pieces are small environments.

The decision to adopt an image that could be used as a sign symbolizing man in many situations and environments was influenced not only by de Kooning's Woman series but also by Mickey Mouse. Trova, who owns a large Mickey Mouse collection, regards Walt Disney's brainchild as the most ideally successful, immediately recognizable, international symbol. He also believes Disney's method of developing the creative artist's invention with the collective aid of many technicians is the best procedure for a modern artist to emulate (compare Roy Lichtenstein and Andy Warhol, pages 168 and 170). Each Mickey Mouse film, however, is self-contained, and its dramatic situation is resolved; whereas each *Study: Falling Man* is only part of a continuous whole. The sequence of events through which the figure moves is ambiguous, and there is no denouement.

MORRIS LOUIS. Born Baltimore, Maryland, 1912; died Washington, D.C., 1962. *Floral*. 1959. Synthetic polymer paint on canvas, 8′ 5″ × 11′ 10″. Collection of Mr. and Mrs. Irwin Green.

In the various reactions against Abstract Expressionism that began in the late 1950s, the Pop artists utilized recognizable subject matter while working out a number of formal problems; by contrast, other artists continued to explore the possibilities inherent in total abstraction. Color was the primary means of expression for many of them, although their approaches to it were very different.

Morris Louis was born in the same year as Jackson Pollock and had been working in a modified Cubist style when he and a friend, the younger artist Kenneth Noland, made a trip to New York in 1953. They were impressed by an exhibition of works by Helen Frankenthaler, who had modified Pollock's method of dripping paint onto raw canvas by thinning her pigments with large quantities of turpentine, so that instead of lying on the surface the paint soaked into the cloth as a stain. Illusionistic space and the tactile quality of the medium were thus negated; what remained was pure color and an emphasis on the flat picture plane in which it was embedded. Louis was also influenced by the theories of the critic Clement Greenberg, who articulated the aim of modernist painting as the creation of works that made the flat surface of the canvas an open field for purely optical color areas.

At first, Louis used thinned-down oil paint as his medium, but beginning in 1957 he worked with a special type of synthetic polymer paint fabricated to his requirements by the firm of Bocour. It could be diluted almost to the consistency of watercolor and yet retain its transparency even when several layers were superimposed. Like Pollock and Frankenthaler, Louis spread his canvas on the floor so that he could work on it from all sides. Instead of using a brush, he poured his pigments directly onto the canvas. He controlled the flow by tilting the canvas until he obtained the effect he desired, although to a limited degree the procedure involved

automatism. In his so-called Veil paintings he allowed successive waves of pigment to flow into and over one another, producing irregular, overlapping shapes that occupied almost the entire field with little of the bare canvas visible, much as Pollock had organized his allover compositions. Since gravity was the controlling factor in this series of works, their configurations were vertically oriented.

Floral is one of a series known by that name, which Louis began in 1959 and continued into the following year. The verticality of the Veils was replaced by a new centralized focus, as the colors were poured inward to the middle of the field. The shapes, although still overlapping, were more clearly isolated as individual units than in the Veil paintings. The title—like those of Louis's other series—was not provided by the artist but by critics, who saw in these works a suggestion of the petals of some gigantic flower surrounded by areas of bare canvas; Louis himself had no representational intent whatsoever.

Until his death in 1962 Louis, a prolific artist, continued in successive series to experiment further with the technique he had devised. In the Alephs, he poured paint away from the center instead of toward it; in the Unfurleds, he left the center of the canvas bare and moved the shapes—no longer overlapping—toward the periphery; in the Stripes, which preoccupied him just before his death, vertical bands of color, varied in thickness, were bunched toward the center, the edges of the canvas being left bare at the sides and either above or below (he was indifferent to the direction in which the works were hung). As Mr. Greenberg has emphasized, whatever format Louis adopted, "The configurations . . . are not meant as images and do not act as images; they are far too abstract. They are there to organize the picture field into eloquence. . . . They are there, first and foremost, for the sake of feeling, and as vehicles of feeling." In Louis's paintings color becomes as nearly disembodied as it is possible for anything produced by material substances to be, asserting itself as an independent optical reality.

180

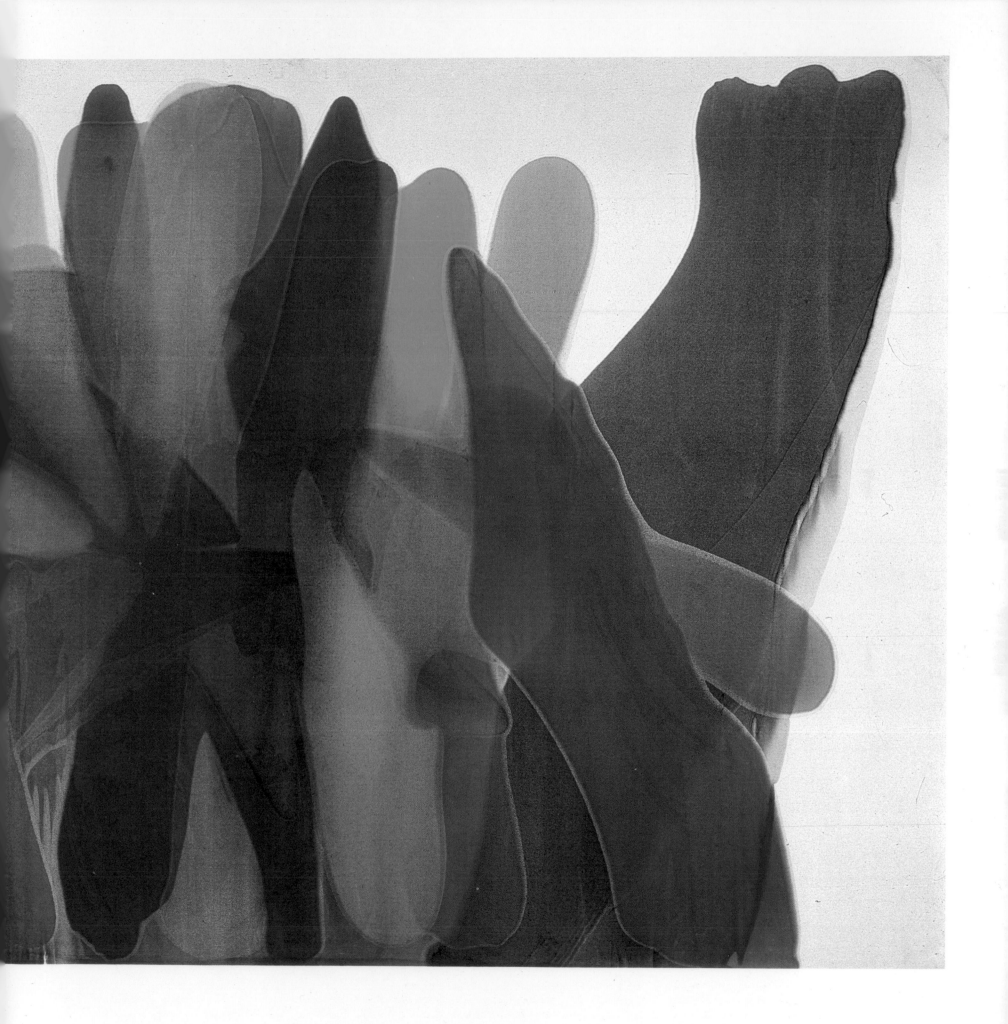

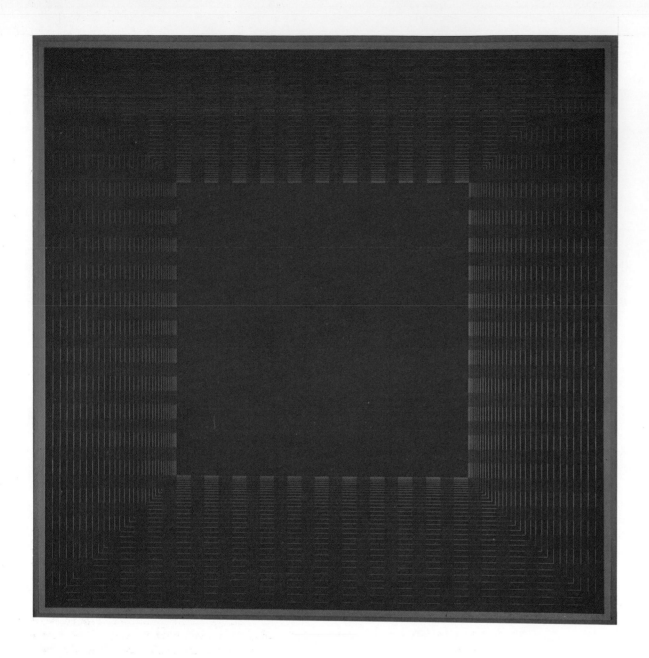

RICHARD ANUSZKIEWICZ. Born Erie, Pennsylvania, 1930. *Sol, I*. 1965. Acrylic on canvas, 7' square. Hirshhorn Museum and Sculpture Garden, Smithsonian Institution, Washington, D.C.

By contrast to Morris Louis's procedures in experimenting with the autonomy of color and his use of fluent, errant shapes, Richard Anuszkiewicz adopts a scientific attitude and adheres to the strict discipline of geometric abstraction. From 1954 to 1955 he studied at Yale University with Josef Albers, whose Homage to the Square series, begun in 1949 and continued until his death in 1976, was an ongoing process of research into the interaction of color. The square-within-a-square format that Albers retained was a survival of his earlier work as a student and professor at the Bauhaus, the pioneering school of design that operated in the 1920s and early 1930s successively at Weimar, Dessau, and Berlin. When it was closed by the Nazis in 1933, Albers came to the United States, where—like another refugee, Hans Hofmann—he became one of this country's most influential teachers, first at Black Mountain College and then at Yale.

Basing themselves on the color theories of Michel-Eugène Chevreul and other nineteenth-century scientists (see page 109), successive generations of artists from the Impressionists on have been interested in the ways in which juxtaposition of colors affect perception. Nonobjective perceptual art, however, draws on many sources in both science and art. No longer concerned with representation, as the Impressionists were, it often focuses on the illusion of movement, corresponding with a general twentieth-century interest in kinetic art. No one has been able to establish precisely the respective roles that physiological and psychological factors play in creating the effects of so-called optical painting—which, by analogy with Pop, quickly became known in the 1960s as Op art. According to Albers, it is the artist's unique function to exploit just this "discrepancy between physical fact and psychic effect" in order to evoke a rich variety of imagery through color.

There are important differences between Anuszkiewicz's paintings and those of his teacher. In *Sol, I* he has taken Albers's square format and made it still more symmetrical by organizing it evenly around the center. Instead of the stability that would normally result from such a classical scheme, however, the entire picture has become dynamic. In place of the close-valued colors often favored by Albers, Anuszkiewicz has intensified the bright green and medium blue, which lie close to each other in the spectrum, by making them border the large inner area of brilliant red. This is consonant with a statement he made in 1963: "My work . . . has centered on an investigation into the effects of complementary colors of full intensity when juxtaposed and the optical changes that occur as a result." Irrespective of theory, such investigations remain to a great extent empirical—chiefly because, since vision varies from one observer to another, some degree of subjectivity is involved.

Looking at this work, the eye is dazzled. Our normal perception of "hot" colors as advancing, and "cool" ones as receding, is confused by the scheme of concentric lines with diminishing spaces between them, which creates the illusion of a perspective recession converging toward the central square. Yet because of its color, this framed square seems to advance instead of being further away in depth. We are baffled in determining what constitutes the picture plane; the entire surface therefore becomes virtually dematerialized, and color—apparently independent of any support—exists as the sole reality, suggesting light rather than substance. The picture's title corroborates this idea, for when we look at the sun, we perceive it as an emanation of radiance rather than as a solid sphere.

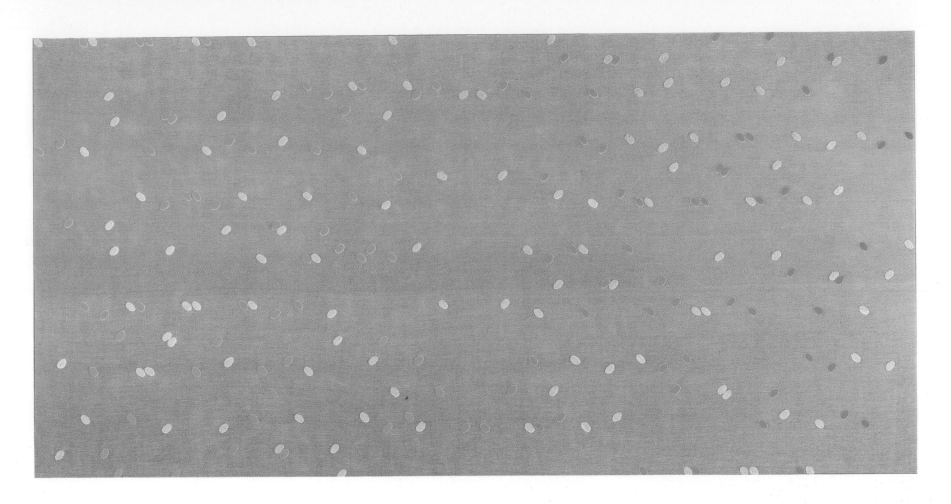

LARRY POONS. Born Tokyo, Japan, 1937, of American parents; to United States 1938. *Han-San Cadence*. 1963. Acrylic and fabric dye on canvas, 6′ × 12′. Des Moines Art Center, Des Moines, Iowa (Nathan Emory Coffin Fine Arts Fund).

Larry Poons, like Richard Anuszkiewicz, is concerned with optical effects, particularly as they relate to color; yet his *Han-San Cadence* is very different from Anuszkiewicz's *Sol, I*. The formal structure of the latter work, symmetrical and geometric, is immediately apparent; the diagrammatic scheme that underlies Poons's composition is far less obvious. Before turning to art, Poons had studied at the New England Conservatory of Music. His earliest paintings were attempts to realize musical structure in a visual medium, influenced by the rhythmic, geometrical abstractions of Piet Mondrian and Theo van Doesburg, co-founders in 1917 of the movement known as De Stijl ("The Style"). Although his later works have fewer analogies to music, the relationship persists: in the shape of the round or elliptical dots, which resemble musical notes; in their horizontal orientation across the face of the canvas, which can be read like a score; in the importance given to the intervals between the dots; and in the musical terms used in some of his titles, as in *Han-San Cadence*.

Poons's method of composition in these paintings was influenced by Jackson Pollock's allover style (pages 142–143), but instead of the latter's linear network he used multiple small, disconnected dots—some clustered, and others more widely scattered. He gave particular importance to space relationships, saying: "The edges define but don't confine the painting. I'm trying to open up the space of the canvas and make a painting with a space that explodes instead of going into a painting." He has al-

ways regarded color as inseparable from form and used it in a sensuous rather than in a scientific way.

In *Han-San Cadence* the unsized canvas is dyed a bright ocher. Oval dots in two colors have been applied to this ground. The brilliant turquoise units lie flat upon the surface, but those in grayish-blue have been poured onto the canvas so that in the drying process the acrylic paint has blistered, leaving a slightly raised, cupped edge. This tactile variation enhances the flickering effect, like tiny blinking electric lights, produced by the different intensities of the dots and the ground, and the afterimages they induce—the visual equivalents of overtones in music. Counterpointing this staccato beat is the wavelike movement of the dots, which flow up, down, and across the face of the painting.

In planning his dot compositions (which he continued to make through 1966), Poons began by drawing a grid on graph paper and rigorously working out the placement of the dots; enlarged and transferred to the canvas, the grid was sometimes allowed to show through faintly. His use of such a module relates him to other artists of the 1960s and 1970s whose art has a systemic basis (for example, Frank Stella, pages 188–189, and Donald Judd, page 190). In the course of execution, however, Poons departed from his orderly scheme to work intuitively, giving free rein to lyricism and sensuousness at the expense of the purely rational. Poons regards such antitheses as an evidence of vitality: "I believe in ambiguity, but there is a positive and negative side to it. Ambiguity is a feeling. . . . If you rule out the possibility of failure in esthetic or other ways, you end up with an object with nothing more to it than death. . . . What is important about painting is the contradictions of choices, decisions, believing in choices and allowing yourself to make choices."

ROBERT MOTHERWELL. Born Aberdeen, Washington, 1915. *Geneva Collage*. 1974. Collage, 6′ × 3′. Collection of Mr. and Mrs. Robert H. Shoenberg.

Since its invention by Braque and Picasso in 1912 in the course of their development of Cubism, collage has had many practitioners. With the exception of the large cut-and-pasted papers that Matisse did in the last years of his life, most works in this medium have been rather small; but in recent years, Robert Motherwell has created collages, such as this six-foot-high example, that rival in size many contemporary American paintings.

Motherwell began working with collage in 1943 when Peggy Guggenheim, director of the influential New York gallery Art of This Century, invited him, Jackson Pollock, and William Baziotes to participate in an international collage exhibition. It was that experience, he has said, which gave him his first understanding of the structural basis of Cubism. Although Motherwell has been among the most innovative of American artists, the formal structure of his art (like that of his friend David Smith; see page 155) is rooted in Cubism, just as its content—allusive rather than descriptive—reflects the influence of Symbolist poetry. For all his intellectual attainments, Motherwell is deeply sensuous in his approach to art. He delights in color and texture and has said that what he especially likes about collage is that it involves him in a very direct way with his materials: "We feel through the senses, and everyone knows that the content of art is feeling; it is the creation of an object for

sensing that is the artist's task; and it is the qualities of this object that constitute its felt content. . . . It is natural to rearrange or invent in order to bring about states of feeling that we like. . . . The sensation of physically operating on the world is very strong in the medium of the *papier collé* or collage, in which various kinds of paper are pasted to the canvas. One cuts and chooses and shifts and pastes, and sometimes tears off and begins again. In any case, shaping and arranging such a relational structure obliterates the need, and often the awareness, of representation. Without reference to likenesses, it possesses feeling because all the decisions in regard to it are ultimately made on the grounds of feelings."

Whereas Motherwell's somber Elegies to the Spanish Republic (pages 144–145) deal with a monumental theme and convey a tragic sense of life and death, his collages reveal another aspect of his personality: "The papers in my collages are usually things that are familiar to me, part of my life," he has said. "Collages are a modern substitute for still-life. . . . My paintings deal in large simplifications for the most part. Collage in contrast is a way to work with autobiographical material. . . . I do feel more joyful with collage, less austere." Since making this statement in 1963, however, Motherwell's more recent collages—although still autobiographical—have, like his works in oil of the same period, also dealt with "large simplifications" and are closely related to the development of American color-field painting. The *Geneva Collage* of 1974 has analogies to the pictures of the Open series that Motherwell began in 1967, of which he said: "The

'Open' series is less aggressive than my older paintings. I have placed more emphasis on the format and the color in them. In most of them, color plays a dominant role, whereas in my earlier work, color was not at all favored over other structural elements. I must add that the 'Open' paintings make a subtle but genuine reference to one of the most classic themes of modern art: the window, or French door, through which one looks outward from an interior."

In the paintings of the Open series the window or door is indicated by a U-shape, squared at its base and inscribed against a field of color. The blue element in *Geneva Collage* is somewhat similar in shape, although it is a solid area instead of being delineated graphically. Its sea- or sky-blue is set against its complementary color, an intense orange that fills the entire background. White and cream are sparingly used to outline the edges of the shapes or to provide flat, bright accents against the dull brown of the crumpled paper, whose slight projection subtly suggests the three-dimensional package from which it came. This paper with its handwritten address, the letterhead which also relates to Provincetown, the customs label, and the airmail sticker are characteristic of the kinds of materials having personal associations that Motherwell began to incorporate into his collages in the 1960s. Like the titles of the works, these materials frequently refer to his travels; since 1972, he has made frequent visits to Switzerland, and the blue area in this collage probably refers to Lake Geneva.

ELLSWORTH KELLY. Born Newburgh, New York, 1923. *Red Blue*. 1964. Oil on canvas, 7′ 6″ × 5′ 6″. Collection of Mr. and Mrs. Morton J. Hornick.

Ellsworth Kelly's *Red Blue* differs from Robert Motherwell's *Geneva Collage* (pages 184–185) in being a wholly self-contained work that bears no reference to associations outside itself, in having a flatly painted surface devoid of textural variations, and in being composed of simple shapes with clean, rather than irregular, contours. In his monograph on Kelly, Eugene C. Goossen has suggested that the artist's wartime experience in a camouflage unit of the U.S. Army trained his eye to see things in terms of flattened shapes and shadow patterns. After the war, Kelly attended the School of the Museum of Fine Arts in Boston for two years; then, dissatisfied with its expressionistically oriented instruction, he decided to use his benefits under the GI bill to return to Paris and enroll at the Ecole des Beaux-Arts.

During the six years from 1948 to 1954 that Kelly spent in France he haunted museums and made numerous trips throughout the country, visiting monuments he had studied in his art history courses. He was particularly attracted to Romanesque paintings and reliefs, in which figures are fitted into shapes other than the conventional rectangle. He also frequented the library of the Byzantine Institute in Paris, admiring Byzantine art for its abstract, architectonic qualities, the flatness and frontality of its images, and its contouring of shapes with sensuous, continuous outlines. Even more important for his development than this exposure to the art of the past was his observation of the en-

vironment. Unlike the artists of the Ashcan School (see pages 102 and 103), Kelly was not interested in scenes of city life but in the minutiae of inanimate things: details of arched doorways and mullioned windows, combinations of building materials on walls, and patterns made by shadows and stains. He noted these down in drawings and transformed them into paintings so drastically simplified that they seem like geometric abstractions unrelated to anything seen in the real world.

Kelly began to work in brilliant colors for the first time when he went from Paris to the light-filled atmosphere of Sanary on the Riviera. He was also impressed by the clean, flat surfaces of indigenous Mediterranean architecture and those of Le Corbusier's modern apartment house, L'Habitation, at Marseilles. His interest in shapes led him to make sculptures by bending flat sheets of metal, and also to pioneer in the creation of "shaped canvases"—works whose format departs from the conventional rectangle or circle to accommodate itself to the configuration it presents.

Besides distilling into simplified forms things that he observed in nature, Kelly has worked with a vocabulary of arbitrarily selected shapes, sometimes ovoids and rhomboids, at other times ones that are less geometrically definable. In contradistinction to earlier geometric abstractions with their separable and often multiple elements, the term *hard-edge* was invented to describe nonfigurative works that, in Lawrence Alloway's words, "combine economy of form and neatness of surface with fullness of color. . . . The whole picture becomes the unit; forms extend the length of the painting or are restricted to two or three tones . . . the spatial effect of figures on a field is avoided."

Kelly's *Red Blue* belongs in this category. He has painted some works that range through many hues of the spectrum and others that use three colors, or only two, as here. He nevertheless regards shape as his primary means of expression. To avoid illusionism he replaces traditional dark-light contrasts with contrasts between hues of equal value and intensity; thus, in this painting, both shapes can be read as either figure or ground.

Mr. Goossen has pointed out that Kelly gives his pictures interest and variety through tension—sometimes by having shapes act against each other within the confines of the canvas, at other times by having "the shapes put pressure outward against the constrictions of the space in which they are trapped. . . . In . . . *Red Blue*, round curve . . . meets straight line, this time the edge of the canvas. . . . Here Kelly breaks an old rule laid down in the days of representational illusionism: 'A shape must be either in the rectangle or convincingly mostly out of it—but never tangential to a side.' The rule and Kelly's exception to it are exactly the difference between the old and the new schools. The old rule was based on the experience of a fact; if a form or shape is tangent to the edge of the rectangle, it destroys the illusion of depth and creates a lateral tension, drawing the eye to the surface. In this case . . . he wants his shape to lie on or above the surface. . . . This lateral pressure against the edge, supported by incipient pressure in the lower left, increases the whole 'surfacing' of the picture so that the sensuousness of the colors and the line is analogized again in the literal touching of the limiting edge."

FRANK STELLA. Born Malden, Massachusetts, 1936. *Empress of India.* 1965. Metallic powder in polymer emulsion on canvas, 6′ 5″ × 18′ 8″. Collection of Irving Blum.

Frank Stella belongs to a still-young generation of abstractionists whose approach to art is that of systematic problem solving. Often effectively articulate in defining their own aims, these artists have also incited a large body of formalist criticism. Stella's development has been by a progression through successive series of works, each series manifesting a central concern that preoccupied him at the time.

After graduating from Princeton University in 1958, Stella moved to New York City. His early paintings were both influenced by and reactions against Abstract Expressionism. He disliked its romanticism and rhetoric, and the open-ended attitude that made some of the artists—Willem de Kooning especially—express uncertainty about when they should consider a painting finished. On the other hand, he admired Jackson Pollock's all-over compositions (pages 142–143), although not their complexity and their vestiges of Cubist space; Barnett Newman's frontal paintings, with their minimizing of visual incident and their evenness of surface; and Mark Rothko's symmetrically arranged, simplified, yet expressive shapes (page 151). Stella was also impressed by the flag and target pictures he saw in Jasper Johns's first one-man show (see page 161): "The thing that struck me most was the way he stuck to the motif . . . the idea of stripes—the rhythm and interval—the idea of repetition."

Stella soon began to make paintings with repeated stripes as their motif. During his first six months in New York, while working several days a week as a house painter, he used for his own pictures house-painters' broad brushes and cheap, out-of-fashion decorator colors; shortly thereafter, he confined himself to commercial black enamel and simplified his designs still further. His Black series executed in 1959 and 1960 consisted of parallel black bands, two and a half inches wide, separated by very narrow strips of unpainted canvas. He sketched the schemes out beforehand but laid the stripes on freehand to avoid the machinelike precision of geometrical abstraction, and he painted over each stripe several times to detach it slightly from the textured canvas. To accentuate this surface quality still further he used a three-inch-deep stretcher that lifted the painting, as a two-dimensional object, perceptibly off the wall. The stripes were arranged in absolutely symmetrical patterns,

running parallel to the framing edge in the earlier works, and parallel to the picture's diagonal axes in the later ones. Since he wanted the entire painting to be instantly apprehended as a visual whole, Stella said that he "tried for an evenness, a kind of all-overness, where the intensity, saturation, and density remained regular over the entire surface."

In his next series, the Aluminum paintings, Stella used metallic paints that reflected light slightly differently, according to the direction of the brushstrokes, and so created a sense of rippling movement. He also began to shape his canvases by cutting out small notches in the areas "left over" from the design, where the stripe patterns met the framing edge.

Empress of India belongs to a still later series dating from 1964 and 1965, the Notched V paintings. This huge picture is painted in four tones of metallic paint, unified by the luminous sheen of light they all radiate. The work is composed of four juxtaposed V-shaped sections facing in different directions, each segment containing evenly spaced bands arranged in concentric chevrons. With inexorable logic the literal shape of the support and the depicted shapes of the stripes become mutually interdependent patterns. Stella has spoken of the paintings in this series as "flying wedge" pictures;

as the critic Robert Rosenblum has pointed out, they imply dynamic movement and velocity—implied also by the titles of the works in this series, which are taken from British clipper ships. "The wedge-shaped canvas, with its swift ascent of convergent (or descent of divergent) stripes," Mr. Rosenblum notes, "is almost a twentieth-century symbol for abstract, mechanized speed, whose lineage could be traced through the streamlining in commercial machine design of the 1920s and 1930s . . . back to the 'lines of force' in Italian Futurist art." The mechanical effect is enhanced by the industrial colors, like those of automobile bodies.

In subsequent series Stella has produced polychromed works using fluorescent and polymer paints and has explored a wide variety of shapes and patterns, such as the Irregular Polygons, and the Protractor series in which for the first time he used curved forms, their intricate interlacings restoring a degree of illusionism. Stella's aims have nevertheless remained much as he defined them in a 1964 interview: "My painting is based on the fact that only what can be seen there *is* there. . . . You can see the whole idea without any confusion. . . . What you see is what you see. . . . It's really something if you can get a visual sensation that is pleasurable, or worth looking at, or enjoyable . . ."

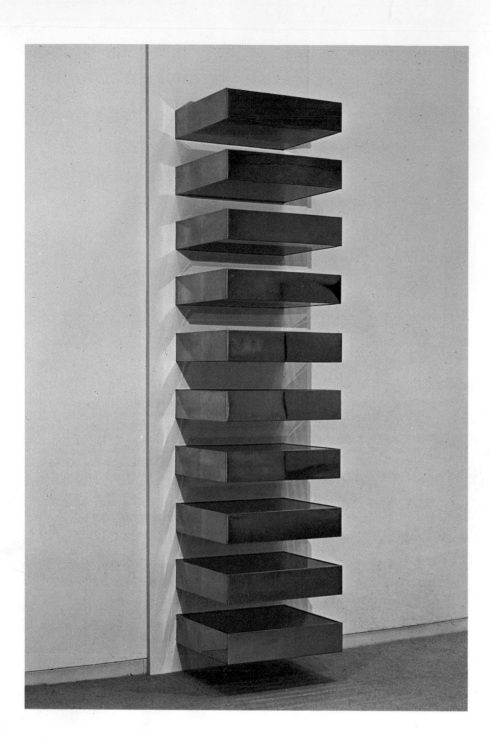

DONALD JUDD. Born Excelsior Springs, Missouri, 1928. *Untitled*. 1969. Brass and red Plexiglas, 10 units, each 6″ × 27″ × 24″. Hirshhorn Museum and Sculpture Garden, Smithsonian Institution, Washington, D.C.

Donald Judd, like Robert Morris and Dan Flavin (pages 191 and 192), is not only a leading practitioner but also an outstanding theoretician of Minimal art. The concept of a reductive art that purges itself of all references to the outside world to find expression in radically simplified, universally comprehensible forms goes back to Kasimir Malevich, who called his nonobjective compositions, such as *White on White*, 1918 (The Museum of Modern Art), "Suprematist" to signify "the supremacy of pure feeling in creative art" and proclaimed Suprematism "the new realism in painting." Present-day Minimalists dislike the term *reductive*, which they believe gives negative emphasis to what they reject instead of stressing the positive criteria they seek to affirm. They declare that for every value in traditional art that they seek to do away with in

their work, they substitute another, equally valid. This can be indicated by tabulating certain polarities (in the listing below each value of traditional art, set in roman type, is immediately followed by a value of Minimal art, set in italics):

Continuity of the European tradition.
 Exploration of new approaches.
Reference to things in the outside world.
 Creation of completely self-contained, nonreferential objects.
Creation of illusionistic "realism."
 Creation of an object that is "real" in itself.
Composition through the balance of constituent parts, arranged in a hierarchical order.
 Insistence that the object be unitary—immediately apprehensible as a whole, with equal and symmetrical parts.
Indication of the artist's personality through evidences of his handling of the material.
 Detachment, anonymity; use of industrial, "non-art" materials.
Variety, complexity.

 Repetition, serialization, simplification.
Ambiguity; possibility of alternative, subjective interpretations.
 Clarity; literal, unequivocal statements.
Self-sufficiency of the creative work, irrespective of the beholder.
 Involvement of the beholder by confronting him with an object or "presence" that stimulates his awareness of its shape and scale, with reference to his own body and to space in the environment he and the object occupy.

However different in appearance, Minimal art thus shares with the coeval movements Pop and Op a concern with perception—how the viewer's experience of an object is determined, modified, or controlled.

In making what he calls "specific objects," Judd fulfills in three dimensions the goal Frank Stella said he strove for in his paintings: "What you see is what you see." The components of this untitled work, and similar ones with seven, eight, or nine units, are not differentiated but identical, so that the whole structure is immediately comprehensible as a single visual experience. The principle of organization is not that of balancing one part against another, but of stacking—a principle David Smith had explored in two works of 1956, *Four Units Equal* and *Five Units Equal*, and which Judd began to use in the mid-1960s. The box-shaped units are separated by intervals equal to their height. Theoretically, such an undifferentiated sequence of repeated, modular forms could imply indefinite extension, as in Constantin Brancusi's ninety-six-foot-high cast-iron *Endless Column*, 1937 (Tirgu-Jiu, Romania), but Judd limits the number so that the viewer may relate the work both to the gallery space and to his kinesthetic sense of his body. Cantilevered outward with no visible attachment to the wall, the object invades the viewer's space and also makes him aware that the intervals between the units are as important as the solid volumes. The materials—brass and Plexiglas—are industrially fabricated and fitted together with machinelike precision. "I don't like sculpture with a handled look," Judd has said, "just as I don't like the evidence of brushwork in painting. All of that implies expressionism, implies that the artist is involved with the work as he goes along. It's a particular attitude that comes out of the European tradition. I want the material to be material when you look at it."

Although Minimal art depends on conceptualization, it differs from recent Conceptual art, which stresses the importance of an idea or piece of information rather than the necessity for its realization in concrete visual terms (see page 200). Minimal art emphasizes the physicality of the created object. In Judd's words: "Even if you can plan the thing completely ahead of time, you still don't know what it looks like until it's right there. . . . You can think about it forever in all sorts of versions, but it's nothing until it's made visible." In this example, despite the austerity of its form, there is obvious sensuousness in the gold color of the brass contrasted with the cerise Plexiglas. The front edge of each unit takes on a more orange tonality because of the reflection cast by the gold metal above it; to that extent, illusion plays a part even in this rigidly structured object.

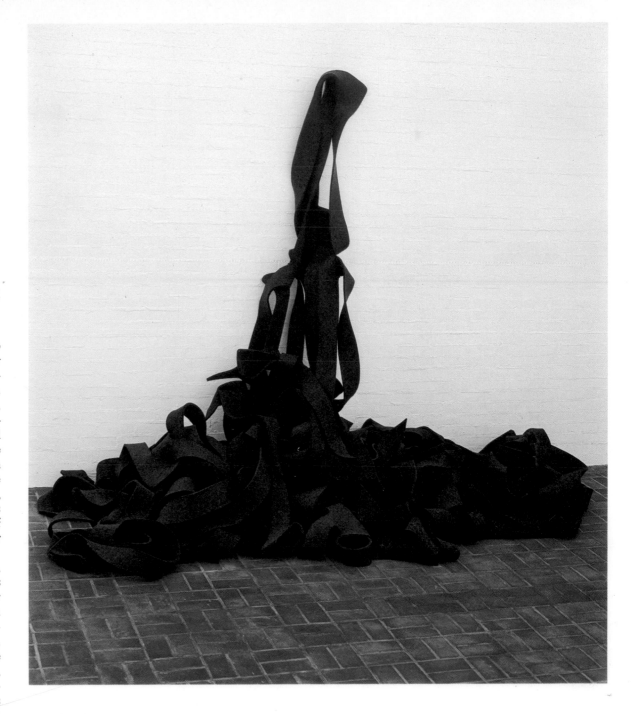

ROBERT MORRIS. Born Kansas City, Missouri, 1931. *Untitled*. 1967–1968. Charcoal gray felt, ⅜″ thick. Collection of Philip Johnson.

The unitary objects that Robert Morris began to construct and exhibit in 1961 were so drastically simplified that they seemed like theorems, or models for experiments in a course on psychology. Trained both as an artist and as an art historian, Morris has written numerous didactic and polemical essays that set forth the propositions of Minimal art's new aesthetic. He has carried to the extreme of logical conclusion ideas previously enunciated in the nonobjective art of Kasimir Malevich and the Russian Constructivists (see pages 132 and 134), in the antiart stance implied by Marcel Duchamp's Readymades, and in the openness and spareness of Barnett Newman's compositions (without their metaphysical content).

By placing large, simple shapes of plywood, such as cubes and L-beams, in various positions throughout a gallery, Morris obliged the beholder to confront them as phenomena within his own space. Set in various positions on the floor, suspended from the ceiling or hanging on the wall, leaning against a wall or straddling a corner, these pieces were meant to evoke the viewer's immediate, kinesthetic response. In the belief that color emphasizes optical rather than physical qualities, Morris used only neutrals so that there might be maximum focus on scale, proportion, shape, mass, and the incidence of light on the object. "The better new work," he wrote in his essay "Notes on Sculpture" in 1966, "takes relationships out of the work and makes them a function of space, light, and the viewer's field of vision. . . . One is more aware than before that he himself is establishing relationships as he apprehends the object from various positions and under varying conditions of light and spatial context." This involvement of the spectator relates to Morris's interest in the dance. Once married to the dancer Yvonne Rainer, he has himself been both a performer and a choreographer. The scale of his objects, although large, is keyed to that of the human body: the pieces should not be so small as to be private and "intimate," nor so enormous as to be overwhelming and "monumental." This also reflects his conviction that art should be seen in a more public way than heretofore.

"Simplicity of shape does not necessarily equate with simplicity of experience," Morris declared. There is a tension between the mind's immediate apprehension of a regular or irregular polyhedron (seeing it from any point, one can logically deduce the shape of the whole) and one's actual perception of it, which constantly changes as one moves around it. In order to force the viewer's awareness of how he physically experiences such contradictions as inside/outside, surface/interior, hanging/resting, tangible/intangible, visible/invisible, Morris has used other materials instead of plywood—perforated metal mesh, transparent Plexiglas, pliant rope—and has sometimes combined flexible and rigid substances.

Departing from the implacable severity of these works, Morris began making felt pieces in the summer of 1967, when he, like Claes Oldenburg, was an artist-in-residence at the Aspen Center of Contemporary Art (see page 165). He was impressed by Oldenburg's soft sculptures with their dependence on gravity, their unpredictability, and their capacity for change. The basis of the felt pieces, like that of Morris's solid objects, is geometric; they are constructed of one or more pieces of rectilinear felt, which are slashed with slits or cut into ribbon-like strips. In some examples, hung outspread on a wall, the original shape is immediately apparent; in others, such as this untitled work, the form is impossible to read and is subject to endless rearrangements, which forces the owner into active involvement with it. In a 1968 essay, "Anti Form," Morris mentioned Jackson Pollock's dripping and pouring of paint and Oldenburg's use of nonrigid materials as processes yielding results that could not be projected in advance. In the felt pieces, "Random piling, loose stacking, hanging, give passing form to the material. Chance is accepted and indeterminacy is implied since replacing will result in another configuration." Since "good" or "bad" arrangements depend entirely on the owner's subjective judgment, these pieces also subvert the idea that quality is inherent in a work of art. "Under attack is the rationalistic notion that art is a form of work that results in a finished product," Morris has written. "What is revealed is that art itself is an activity of change, of disorientation and shift, of violent discontinuity and mutability, of the willingness for confusion even in the service of discovering new perceptual modes."

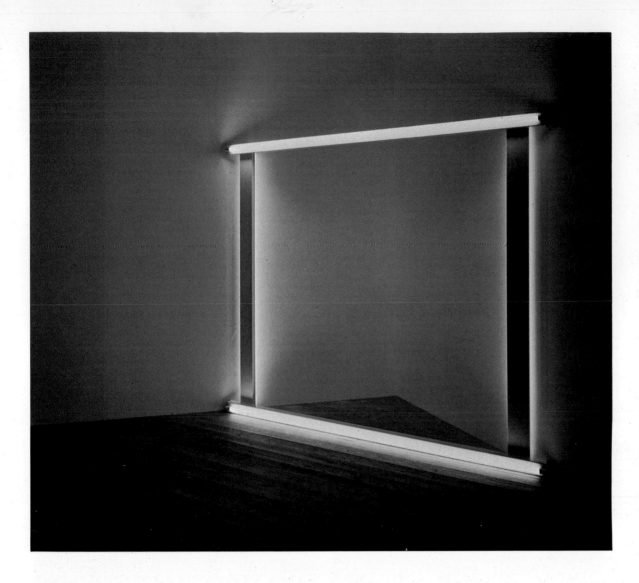

DAN FLAVIN. Born Jamaica, Long Island, New York, 1933. *untitled (to the "innovator" of Wheeling Peachblow)*. 1966–1968. Pink, gold, and daylight fluorescent light, 8′ square. The Museum of Modern Art, New York.

Like other Minimal artists, Dan Flavin uses a few simple, industrially fabricated elements as modules with which to involve the spectator in an awareness of his spatial environment. But instead of defining this space by reference to solid, geometrically shaped units and the intervals between them, Flavin discovered in 1963 when making *the diagonal of personal ecstasy* that the eight-foot strip of colored fluorescent light had quite different properties: "The entire interior spatial container and its components—wall, floor, and ceiling—could support a strip of light but would not restrict its act of light except to enfold it. Regard the light and you are fascinated—practically inhibited from grasping its limits at each end. While the tube itself has an actual length of eight feet, its shadow cast from the supporting pan, has but illusively dissolving ends. This waning cannot really be measured without resisting consummate visual effects. Realizing this, I knew that the actual space of a room could be disrupted and played with by careful, thorough composition of the illuminating equipment. For example, if an eight-foot fluorescent lamp be pressed into a vertical corner, it can completely eliminate that definite juncture by physical structure, glare, and doubled shadow. A section of wall can be visually disintegrated into a separate triangle by placing a diagonal of light from edge to edge on the wall; that is, side to floor, for instance." Having made this discovery, Flavin went on to explore the possibilities of fluorescent light, using modules of standard lengths in daylight white or commercially available colors, singly or in combination, which he positioned differently with relation to each other and the structural features bounding the room. Although the walls, floor, and ceiling remain perceptible, they become so transformed as to be virtually dematerialized; what the viewer is aware of is color and totally enveloping, incommensurable space.

Flavin calls his works "situational"; if the elements are disassembled and installed in their same respective positions elsewhere, the result will be modified by the different proportions of the new location, the volume of space encompassed, the texture of the surrounding surfaces, and the admixture of light coming from other sources. Flavin himself cannot always predict the effects. Thus, when *untitled (to the "innovator" of Wheeling Peachblow)* had its first showing at the Dwan Gallery, New York, in 1968, he wrote to Philip Leider, who was preparing an article on the exhibition: "The corner installation was intended to be beautiful, to produce the color mix of a lovely illusion, to render the wall junction above the 'fact' of the floor triangle less visible than in usual lighting. I did not expect the change from the slightly blue daylight tint on the red rose pink near the paired tubes to the light yellow mid-way between tubes and the wall juncture to yellow amber over the corner it-self. When asked about the 'gold' light somewhat unfortunately available beside the vertical lamps because of the uneven plaster work of the walls, I complained that the phenomena was approximately what the drip must have been for de Kooning—an unavoidable incident of media use."

This work is composed of horizontal, single-strip eight-foot fixtures with daylight fluorescent lamps, attached at top and bottom to two eight-foot vertical fixtures containing yellow outer, and pink inner, lamps. The square corner installation is a structure the artist often uses to produce a subtle and mysterious mixture of colors that contrasts with the severity of the framing elements. Flavin, who usually gives his works subtitles with some personal associations for him, explained the dedication of this piece as having been suggested by the colors, which somewhat resemble a particular type of late-nineteenth-century art glass. He cited a book's description of this ware: "Peachblow . . . was produced by the Mount Washington Glass Company in New Bedford; Hobbs, Brockunier & Company of Wheeling; and the New England Glass Company at Cambridge. It was given its name because of a resemblance in coloring to the Chinese porcelains called Peachblow. Of these porcelains the most famous example is the Morgan vase . . . which brought $18,000 at the sale in New York, in 1886. . . . At Wheeling, William Leighton, Jr., of Hobbs, Brockunier & Company, copied the vase in the new 'Peachblow' glass . . . the darker coloring, a deep red shading to greenish yellow . . . characterizes the Wheeling Peachblow."

CLAES OLDENBURG. Born Stockholm, Sweden, 1929; to United States 1929. *Giant Saw—Hard Version*. 1969. Laminated wood, aluminum filled with polyurethane foam, 12′ (hinged) × 3′ 4″ × 6½″; blade 1″ thick. The Vancouver Art Gallery, Vancouver, British Columbia (Other cast: Stedelijk Museum, Amsterdam.)

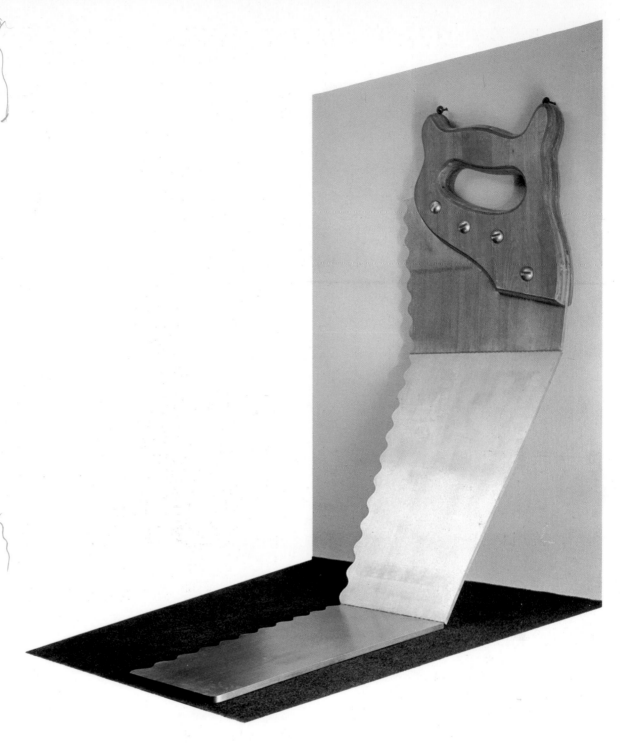

In contrast to Tony Smith (pages 194–195), who has stated categorically that he does *not* wish to make monuments, Claes Oldenburg has been preoccupied with projects for monuments since 1965. The huge scale of a new studio into which he moved at that time, combined with recollections of travel, suggested to him "the idea of placing my favorite objects in a landscape—a combination of still-life and landscape scales. By rendering atmosphere and the use of perspective, I made the objects seem 'colossal.' . . . The project began as a play with scale, and that's what it seems to be about—the poetry of scale." Drawn with consummate skill, his proposals for monuments were an outgrowth of his earlier interest in giant objects (see page 165). A satirist who habitually cloaks his serious intent in comic guise, Oldenburg explained his departure from previous types of heroic monuments by saying: "The object is chosen because in some way it fits the shape, the conditions and the associations of the site. The giant frankfurter [for Ellis Island] has a shape like the ships that pass it, going up and down the Hudson. The ironing board over the Lower East [Side] echoes the shape of Manhattan island and also 'shields' the vanishing ghetto, commemorating the million miles of devoted ironing."

Oldenburg's proposals were executed only as drawings until 1966, when he went to Stockholm for a retrospective exhibition of his work at Moderna Museet. "In Stockholm I got a lively response to my proposals, which were presented in the papers," he said. "Swedes believe in technology. They seemed to think my monuments could actually be built some day."

The prototypes for the *Giant Saw—Hard Version* were a *Saw—Soft Version,* made of flag cloth, and a pencil drawing, *Proposed Colossal Monument for Långholmen, Stockholm*—one of six proposals presented as photo-enlargements on a billboard in the center of town. Like most of Oldenburg's concepts, the saw as an appropriate emblem for Stockholm originated in free association and involved the metamorphosis of one form into another. He recalls that one Sunday evening, while he was visiting relations on an island outside Stockholm, his cousin Uno lowered the flag at sundown and then "left the room and returned with what looked like a violin case, but in the shape of a saw. He opened it and it was a saw, a fine saw, which had never sawn wood. He put the saw between his knees and began to bow the saw. His wife sat down at the piano," and together they played several tunes (beginning with "Santa Lucia"). Several days later Oldenburg told the director of Moderna Museet, Pontus Hultén, that he wanted to make flags for the poles outside the museum in the pennant version (*vimpel*) of the Swedish flag. "In my design, I combined the form of the saw which was on my mind with that of the 'vimpel.' . . . One flag was hung inside the museum where it functioned very well, moving slightly in indoor breezes." His related pencil drawing for a proposed monument showed "A colossal version of the saw . . . set across an island west of Stockholm, as if sawing it in half. The saw is a tilted version of the bridge which binds the island to the mainland."

Giant Saw was produced as a three-dimensional object for a group show at The Vancouver Art Gallery in 1969. For its outline Oldenburg used the large-scale drawing he had made when designing the pennant for Moderna Museet: "The hinge divisions were where the cardboard sections of the original drawing ended. . . . Vancouver is a saw-shaped word and it fills a pennant very well." As Barbara Rose has pointed out in her monograph on the artist, this work is more closely related to the abstract object sculpture of the Minimalists (see pages 190 and 191) than to Pop art; it is a large, three-dimensional floor piece, "a single image that must be seen as a whole unit and not as made up of discrete parts. What is stressed in such work is, above all, physicality, concreteness, and presence." We respond to the impressive form, to the shape of the three-part blade with its serrated and straight edges and the massive handle above, and to the contrast between shining metal and laminated wood, before realizing the paradox of a *hinged* saw. This patent absurdity relates the work to Man Ray's Dada *Gift* of 1921—a flatiron with its sole-plate studded with metal tacks—and that classic example of Surrealist irrationality, Meret Oppenheim's *Fur-Covered Cup, Saucer, and Spoon* of 1936. It also has latent anthropomorphic suggestions, translating into nonfigurative terms *The Big Man* in Oldenburg's 1960 exhibition, The Street (see page 164)—a huge figure seated on the floor and leaning against a wall.

This was the first of Oldenburg's works to be industrially fabricated. In an increasing involvement with technological processes, he has since created many three-dimensional models for monuments, as well as multiples and several large outdoor sculptures.

TONY SMITH. Born South Orange, New Jersey, 1912. *Cigarette*. 1961–1968. Cor-ten steel, 15′ × 26′ × 18′. Albright-Knox Art Gallery, Buffalo, New York (Gift of the Seymour H. Knox Foundation, Inc.). (Other casts: The Museum of Modern Art, New York; Collection of the Hon. Nelson A. Rockefeller.)

Tony Smith's large, angular pieces have often been associated with Minimal art but are actually based on quite different premises and procedures. From 1933 to 1936 Smith worked as a toolmaker and draftsman in a factory while studying painting at night at the Art Students League. He subsequently served as an apprentice to Frank Lloyd Wright, assisting as draftsman and supervisor on several projects, and at that time became interested in Wright's system of modular planning. Although never formally trained as an architect, between 1940 and 1960 Smith designed several residences and projects for unexecuted monuments. During those years he also held a number of teaching positions, continued to paint, and became a close friend of many of the emerging Abstract Expressionists, among them Jackson Pollock, Clyfford Still, Mark Rothko, and Barnett Newman. His own painting differed from theirs, however, in being based on modules, like his architectural projects.

After reading some theoretical articles and seeing kites, towers, and other structures made by Alexander Graham Bell in 1901, Smith began to experiment with more complex, less symmetrical modular units—polyhedra with four faces (tetrahedra) or with eight (octahedra). "While the axes normal to the surface of a cube are three," he has explained, "those perpendicular to the planes of a space-lattice made up of tetrahedra and octahedra are seven. This allows for greater flexibility and visual continuity of surface than rectangular organizations. Something approaching the plasticity of more traditional sculpture, but within a continuous system of simple elements, becomes possible." He found himself moving "farther and farther from considerations of function and structure toward speculation in pure form. . . . Architecture has to do with space and light, not with form; that's sculpture." By the mid-1950s, he had also become disenchanted with painting, which seemed to him anachronistic, too pictorial, too "busy," and totally irrelevant to his concern with scale, monumentality, and the environment.

The first public exhibition of Smith's structures was in a group show at the Wadsworth Atheneum, Hartford, Connecticut, in 1964; his one-man show there two years later established him as one of America's most influential sculptors. He said of his faceted pieces in that exhibition, which were made of plywood, painted black: "They may be seen as interruptions in an otherwise unbroken flow of space. . . . I don't think of them as objects among other objects; I think of them as being isolated in their own environments."

Smith's work differs from that of the Minimalists in significant ways. His approach is not programmatic, like theirs; "they are aiming at certain results," he has said, "while my work is the product of processes which are not governed by conscious goals." He does not make preliminary drawings, "because I don't have any sense of how a piece is going to turn, or even if it is going to turn out, until the end." Working from three-dimensional maquettes rather than from sketches, he says his structures "almost come into existence by some kind of spontaneous generation," a process he identifies with Surrealist automatism, which also influenced the Abstract Expressionists. Like them, too (and unlike the Minimalists), Smith is interested in myth, and in the associations his pieces conjure up in his own mind and in that of the observer. He does not wish them to be clear, unitary objects that can be immediately apprehended but thinks of them as presences, inscrutable and mysterious. He prefers them to be seen in an outdoor setting rather than in a confined, measurable architectural interior, so that "trees or plants, rocks, can combine with the piece in forming space around it."

For *Cigarette* Smith first made a thirteen-inch-high maquette (1961), which served as the basis for plywood models in half- and full-size (1966), from which the Cor-ten steel structure was fabricated (1967–1968). The version shown, left unpainted, has weathered to a warm brown; the other two have been painted black, like most of Smith's works. He has written of its genesis: "I had set out to make a serious piece of sculpture, and thought I had done so. Upon seeing the smooth plaster model, I realized that I had been taken in by the irregularities of the paper one. The piece was redundant, and had the look of a war memorial. Stripping away everything but the spine, I wound up with a cigarette from which one puff had been taken, before it was ground out in the ashtray." Seen from any one viewpoint, its asymmetrical form, thrusting aggressively into space, is unpredictable; it can be experienced fully only by walking around or through it.

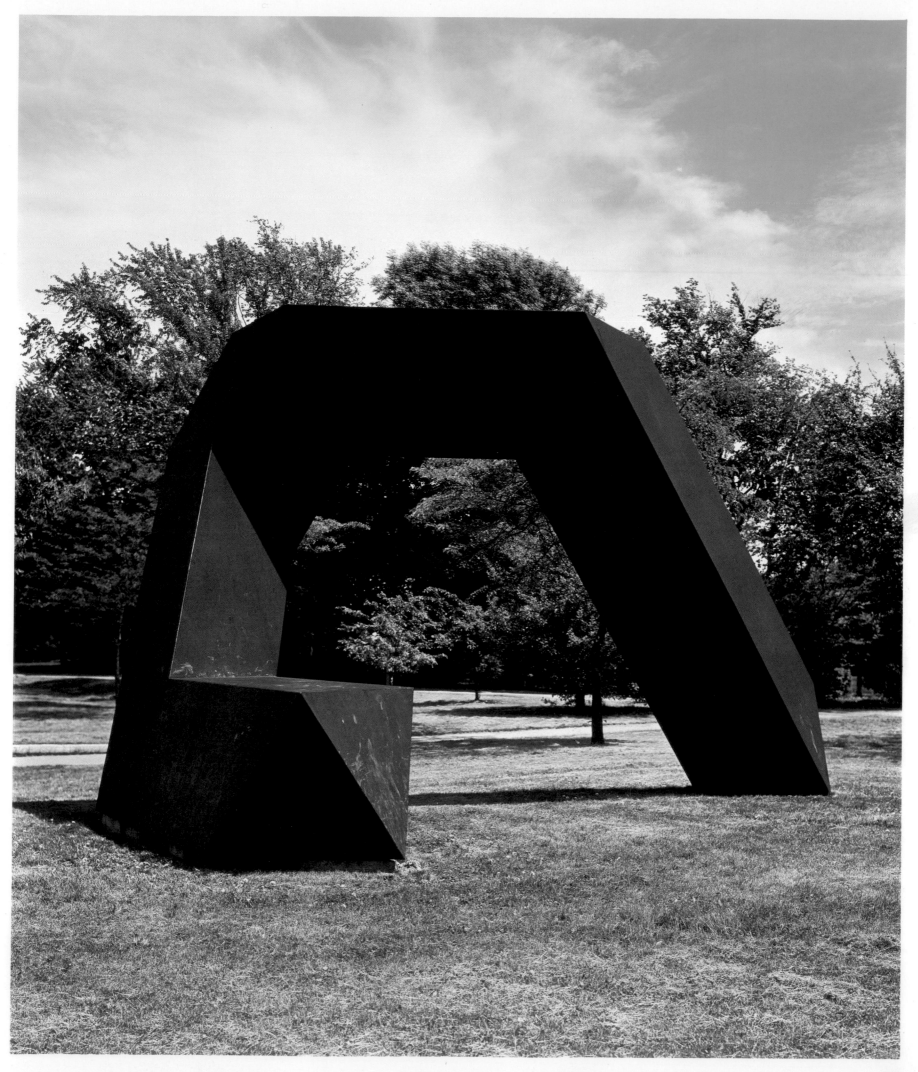

ALEXANDER CALDER. Born Lawnton (now Philadelphia), Pennsylvania, 1898; lives Roxbury, Connecticut, and Saché, France. *Le Guichet*. 1965. Sheet steel painted black, 14′ × 22′ × 22′ 2″. Lincoln Center for the Performing Arts, New York (Gift of Howard and Jean Lipman).

Alexander Calder's kinetic constructions were given the name "mobiles" by Marchel Duchamp; it was another fellow-artist, Jean (Hans) Arp, who called his abstract standing constructions "stabiles." Although Calder had begun experimenting with them as early as 1940, he made his first large outdoor steel stabiles in 1957. As he developed this genre, he began to make the works monumentally massive, yet designed to rest easily on the ground with relatively few points of support. He resorted to having them fabricated in foundries to solve the technical problems of constructing and bolting together the heavy metal elements; his decision therefore was not based on any philosophical principle of anonymity and the use of industrial processes, such as that postulated by the Minimalists (see pages 190–192). *Le Guichet*, like many of his large sculptures since 1962, was made at the Etablissement Biémont, a foundry in Tours near Calder's home in Saché. From the maquettes that he provides, and under his supervision, skilled workmen make mathematical enlargements, cut templates for the metal sheets, then cut the sheets, bend them to shape, and bolt them together.

This is one of the most firmly grounded of Calder's large stabiles, yet it rises lightly to the triangular peak. Its powerful design is tempered with grace. The sculpture is purely abstract, simply a physical presence; its name was given after the fact, when Calder saw the open space in the largest element as a ticket window (*guichet*), but this association makes it singularly appropriate for its present location in the plaza at Lincoln Center. Like Tony Smith, Calder develops his forms intuitively; in 1951, he said: ". . . when I use two or more sheets of metal cut into shapes and mounted at angles to each other, I feel that there is a solid form, perhaps concave, perhaps convex, filling in the dihedral angles between them. I do not have a definite idea of what this would be like, I merely sense it and occupy myself with the shapes one actually sees." The metal is painted flat black so that no color or surface reflections can distract attention from the massive shapes.

As with Tony Smith's works, also, the form of the whole cannot possibly be predicted from any one viewpoint. In a stabile the movement that is integral to a mobile becomes instead a function of the spectator's action. As he walks around *Le Guichet*, the entire composition seems to change at every few steps, dramatically opening up new relationships between the solid elements and the spaces they enclose; but the balance between the slender ribbed legs, the large central arch, and the broad unit perforated by the open "window" remains firm, and voids and solids are kept in constant equilibrium when seen from any aspect.

Calder's interest in monumental scale, his collaboration with technicians, and his creation of large sculptures placed outdoors like presences, which require the spectator to experience them physically by his own action, ally him firmly with the concerns of younger artists. His enormous *Teodelapio* (almost sixty feet tall), produced by an Italian shipyard in 1962, straddles an intersection at the entrance to Spoleto, where trucks and buses pass easily beneath its arched opening.

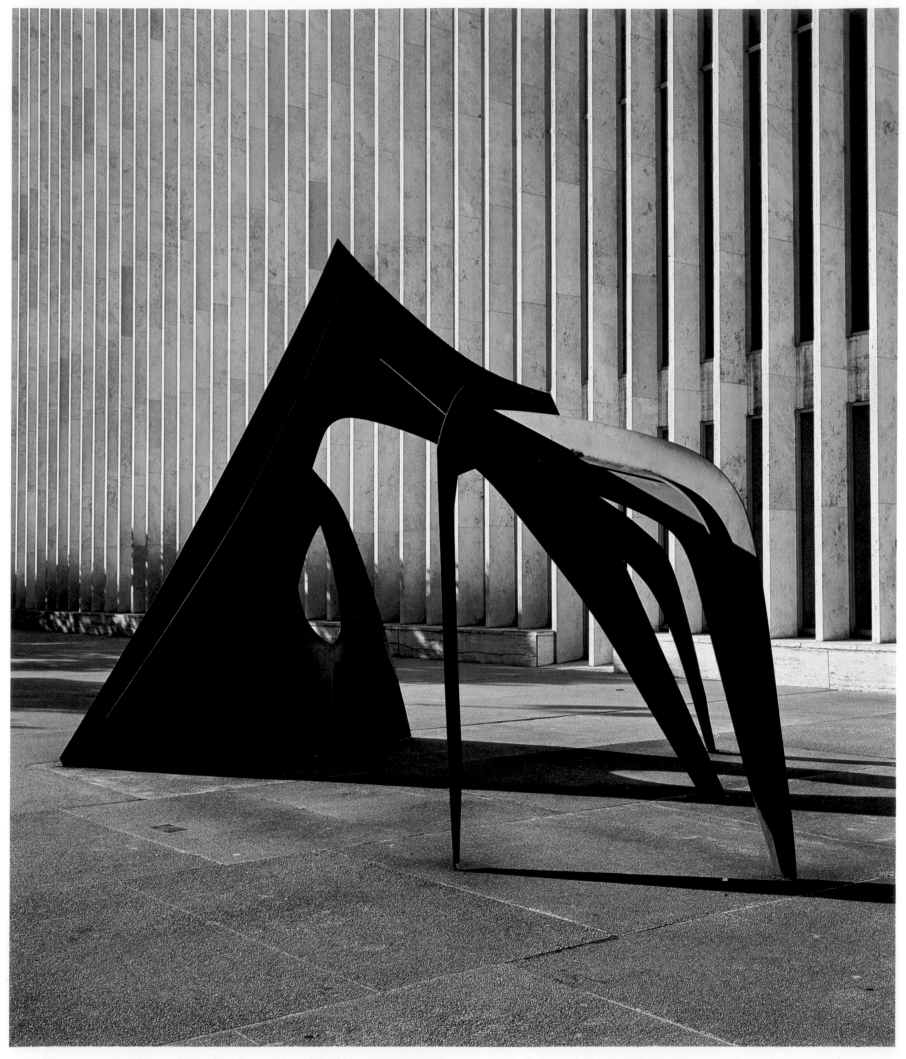

LOUISE NEVELSON. Born Kiev, Russia, 1900; to United States 1905. *Atmosphere and Environment XIII: Windows to the West.* 1972. Cor-ten steel, 14′ × 14′ 7½″ × 5′. City of Scottsdale, Arizona.

In a statement written for the exhibition "Nature in Abstraction," held at the Whitney Museum of American Art in 1958, Louise Nevelson said: "My total conscious search in life has been for a new seeing, a new image, a new insight. This search not only includes the object, but the in-between place." Always innovative and eager to discover the possibilities offered by different materials, she became interested in making fabricated works in 1965, when on a trip to Saint Louis she visited the company that produces Trova's Falling Man studies (page 179) and became fascinated with the idea of fabrication. She began to explore the lightweight and reflective properties of black-enameled aluminum, and of black and clear Plexiglas. Instead of blocking the viewer's vision with a massive wall divided into compartments with shallow recession (pages 158–159), she created transparent, skeletal structures open to the space beyond. She found geometrical shapes—concentric arcs and squares— more appropriate to the new medium than the swelling, baroque forms that fill the boxes of her wooden constructions.

The transparent sculptures were small in scale, but Nevelson reverted to monumentality in 1969 when Princeton University commissioned her first large piece in Cor-ten steel. The interior forms of her works in this medium are fewer than heretofore, and the open spaces assume significance equal to that of the solid shapes.

Windows to the West is the culminating masterpiece of a series called Atmosphere and Environment, which originated in the smaller black fabricated pieces. Nevelson has explained this generic title by saying: "The landscape is the *atmosphere* that fills the spaces of the steel *environment;* the two together are the sculpture." She said of this work: "We look through the inside mass to see a multitude of paintings and photographs. The mountains, the trees, and the skies of Arizona." The relationship between the atmospheric landscape and the steel environment is in constant flux; the entire complex structure appears to change as the light changes, breaking and shadowing the forms and casting shadows seemingly as solid as the steel plates. As the viewer walks past the sculpture, the interlocking arcs seem to rotate, the rectangular "windows" to slide open or close. Only the staccato patterning of the bolts remains constant. Her dealer and biographer, Arnold Glimcher, notes that in this piece, "Nevelson extends her vocabulary of found forms to include the surrounding landscape. Unlike the closeted secrecy of her wooden 'walls,' she opens these boxes to focus on the ritualization of natural forms subject to constantly changing light and shadow." Geometric and abstract, rather than linear and descriptive like David Smith's *Hudson River Landscape* (page 133), Nevelson's *Windows to the West* has in common with it, nevertheless, the quality of frontality, and the exploitation of the changing interplay between the created work of art and the natural background seen through and beyond it. Surprise has always been important to Nevelson: in her wooden walls, it is the rich content of the individual boxes and their formal relationships; here it is the fluidity of the geometrically structured forms and their unexpected interaction with the landscape.

Subsidized by matching funds from the National Endowment for the Arts and the citizens of Scottsdale, whose mayor dedicated it in 1973, this is one of a growing number of works by advanced American sculptors that have recently come into being and been set up in public places throughout the United States as commissions from municipal, state, or federal agencies.

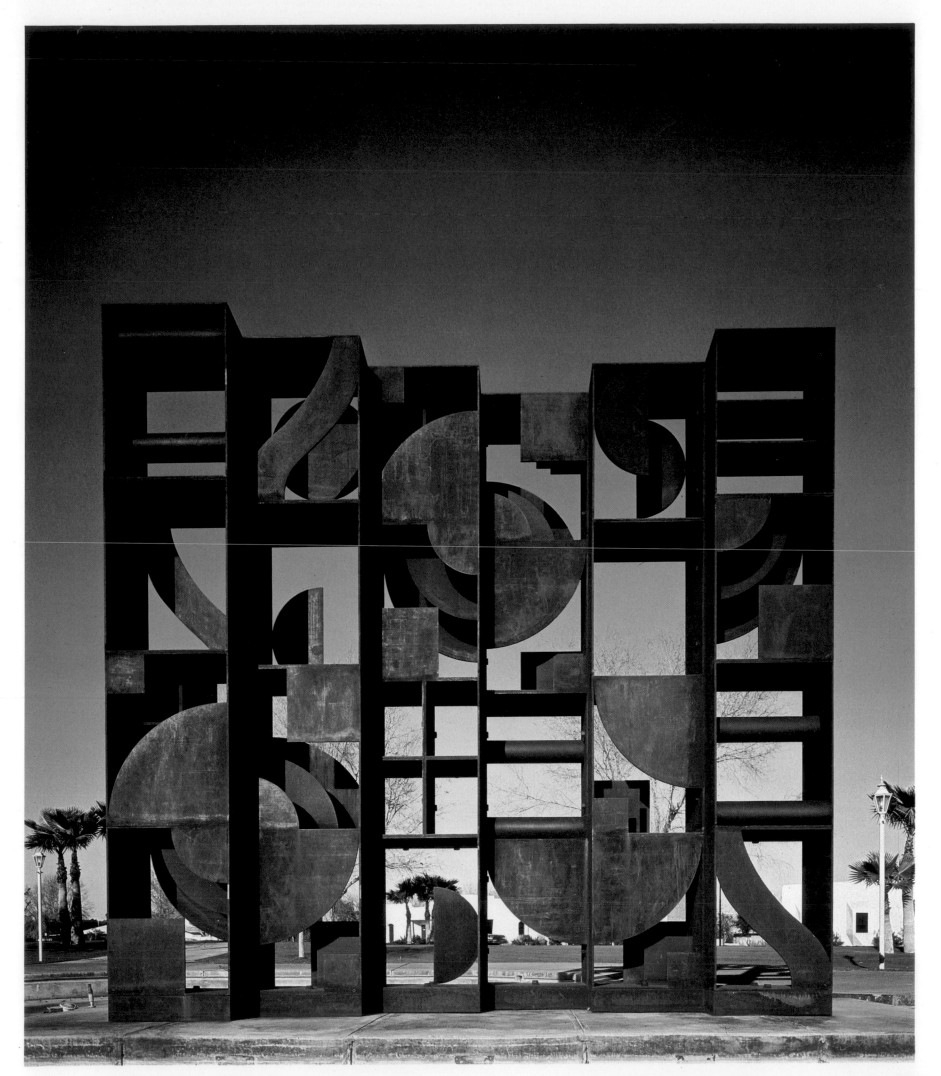

ROBERT SMITHSON. Born Passaic, New Jersey, 1938; died near Amarillo, Texas, 1973. *Spiral Jetty*. 1970. Black rock, earth, salt crystals, water; coil approximately 1,500′ long × 160′ wide. Great Salt Lake, Boy Elder County, Utah.

The *Spiral Jetty* is the second of three earthworks created by Robert Smithson; the third, the *Amarillo Ramp*, was completed posthumously after he was killed in a plane crash near its Texas site. Although he was only thirty-five at the time of his death, his works and theoretical writings had already made him an influential figure in the art world.

Earthworks, an offshoot of the international movement known as Conceptual art, began to be developed in the second half of the 1960s. They reflect the concern with ecology and the anti-Establishment attitude widespread among the young in America during that turbulent decade; they are also a culminating expression of the interest in large scale and in the environment manifested in much recent art, together with an acceptance of chance and change.

Disdaining the commercialization of art as a commodity, and carrying out Marcel Duchamp's dictum that artists should create ideas rather than "visual products," the Conceptualists seek the total elimination of the work of art as a physical entity—an object produced for a consumer by an artist-craftsman who gives his material a tangible, permanent form that can be judged according to critics' standards of style and quality. They propose that art, instead of being a product, is a process—a form of energy; and that what constitutes art is the artist's intention and activity. His concept need not find concrete expression but can remain an abstraction, set forth as a verbal proposal rather than in visual terms; if, however, it leads to some activity or occurrence, this is documented by written records, photographs, or film. Paralleling recent developments in science, in which formerly discrete disciplines tend to merge, Conceptual art makes connections with the natural and physical sciences, technology, electronics, and philosophy, as well as with poetry, film, and the performing arts.

Earthworks, which use the elements and processes of nature as the artist's materials, have precedents in several primitive cultures. Examples include the geometrical markings in the Nazca Valley of Peru, about A.D. 500, which extend as much as two-and-a-half miles in length and were perhaps made for astronomical calculations; the Great Serpent Mound in southern Ohio, thirteen hundred feet long, built by Indian tribes for burial and religious and social purposes; and the enormous ninth-century figure incised in chalk on White Horse Hill, Berkshire, England. Like the *Spiral Jetty*, their structures become fully intelligible only when viewed from the air.

In 1966 Smithson turned from painting and the making of objects to work with materials taken from urban sites and quarries. He first conceived an earthwork when hired as artist-consultant by an architectural engineering firm that was designing the Dallas–Fort Worth Airport; although this project was never carried out, Smithson gained valuable experience in surveying and working with maps. For the next several years, he traveled widely throughout the United States, Canada, the Yucatán, Great Britain, and Europe, familiarizing himself with the geology of those areas and the scars made by man's encroachments, such as mines and quarries. "The earth is built on sedimentation and disruption," he wrote in 1968. "A sense of the earth as a map undergoing disruption leads the artist to the realization that nothing is formal or certain." He asserted that rusted metal and burned-out slag, the refuse of technology, are as much a part of this process as the earth's erosion through natural causes, which takes places over long periods of time. In his earthworks and in works he showed in galleries—such as his Non-sites, samplings of substances taken from the ground and exhibited in bins —he sought to establish a dialectic between nature, with its continual processes of generation, destruction, and renewal, and the reciprocal interaction of those processes with human intervention through technology.

For the *Spiral Jetty* Smithson used heavy construction machinery to structure natural elements into a form that expressed a complex of interrelated ideas. In keeping with Conceptual precepts he documented the work with a film that explains his intention, shows the process of its realization, and presents aerial views after its completion. Thrusting outward from the shore into the Great Salt Lake, the vast spiral is formed of compacted black rock, mud, and sand; its counterclockwise coil, rimmed with white salt crystals, encircles water tinged by red algae, contrasting with the intense blue of the surrounding expanse of the lake and of the sky above. The spiral is a form that recurs continuously in nature and also in the art of many cultures ever since prehistoric times. The intricate blend of scientific and mystical ideas in the *Spiral Jetty*, elaborated in the film's images and narration, has been summarized by Bruce Kurtz: "The form and structure of the *Spiral Jetty* was determined by the banks of the Salt Lake; the fact that salt crystals form in spiral patterns; the legend that there was a whirlpool in the Salt Lake; the intense heat in relation to the spiral structure of gases emitted from the sun; the pre-history of the site and spiral nebulae of stars and planets as they form in the universe; and the fact that the site suggests endlessness coupled with the endlessness of the spiral."

A paramount example of the "Abstract Sublime" (see page 150), the *Spiral Jetty* is a highly romantic creation, made more poignant by Smithson's tragic death only three years after its completion in a manner reminiscent of Icarus's fall from the skies. Together with its accompanying film, it is a beautiful, imaginative, and poetic statement. The last of our Bright Stars, it has many characteristics we have encountered in previous examples. These include the American artist's innovation and refusal to be bound by tradition; his involvement with the physical reality of his materials, and an inventiveness in using them; together with a predilection for the specific, a romanticism manifested in a reverence for nature and an exaltation of individual sensibility in confronting it; a mingling of science and art; the adaptation of machinery and technology for creative purposes; and the use of abstraction as an expressive means for conveying a content that is often symbolic or metaphysical.

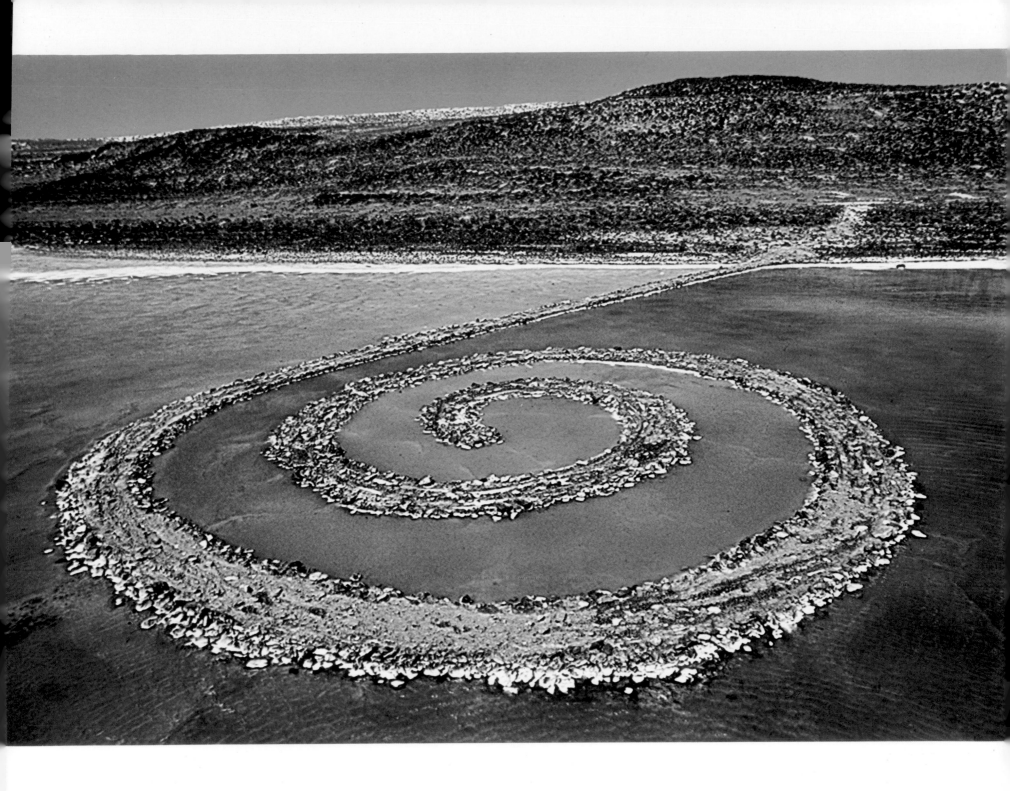

Sources

Quotations in the comments accompanying the color plates come from the sources listed below and are cited in the order in which they appear on the respective pages indicated:

p. 28. John Galt, *Life and Studies of Benjamin West, Esq. . . . Prior to his Arrival in England,* compiled from materials furnished by himself, Philadelphia, Moses Thomas, 1816, p. 131 f.—West, letter of 1805; quoted in Alfred Frankenstein and the Editors of Time-Life Books, *The World of Copley, 1738–1815,* New York, Time-Life Books, 1970, p. 123.

p. 35. Matthew Harris Jouett, "Notes Taken on Conversations on Painting with Gilbert Stuart," 1816; quoted in James Thomas Flexner, *The Light of Distant Skies: American Painting 1760–1835,* New York, Harcourt Brace, 1954; paperback edition, New York, Dover Publications, 1969, p. 75.

p. 36. Paul Svinin, "The Observation of a Russian in America: A Glance at the Liberal Arts in the United States," 1829; quoted in English translation by Abraham Yarmolinsky, *Picturesque United States of America, 1811, 1812, 1813, . . . ,* New York, William Edwin Rudge, 1930, p. 34.

p. 38. Mrs. Jacob M. Kaplan, unpublished letter, August 1974.—Tom Armstrong, Acoustiguide tape for the exhibition "The Flowering of American Folk Art: 1776–1876," New York, Whitney Museum of American Art, February 1–March 24, 1973.

p. 39. Douglas Davis, review of the exhibition "The Flowering of American Folk Art," *Newsweek,* February 11, 1974, p. 56.

p. 42. Peale's autobiography; quoted in Charles Coleman Sellers, *Charles Willson Peale,* New York, Scribner's Sons, 1969, p. 204.—Peale to West, December 16, 1807; quoted in exhibition catalogue "The World of Benjamin West," Allentown (Pennsylvania) Art Museum, 1962, pp. 81–82.

p. 43. Audubon to Governor Miller of the Arkansas Territory, 1820; quoted in exhibition catalogue "19th-Century America: Paintings and Sculpture," New York, The Metropolitan Museum of Art, April 16–September 7, 1970, no. 33.—John James Audubon, *Ornithological Biography,* Edinburgh, Adam & Charles Black, vol. IV, 1848, pp. 539–540.

p. 44. Catlin, letter written on arrival at mouth of the Yellowstone River, Upper Missouri, 1832; quoted in Ellwood Parry, *The Image of the Indian and the Black Man in American Art, 1590–1900,* New York, George Braziller, 1974, p. 83.—George Catlin, *Life Amongst the Indians,* 1861; quoted in John C. Ewers, "George Catlin, Painter of Indians and the West," *Annual Report of the Smithsonian Institution, 1955,* Washington, D.C., U.S. Government Printing Office, 1956, p. 484.—Catlin, letter, 1832, *ibid.*—George Catlin, *Notes of Eight Years of Travel Amongst the North American Indians,* 1841; quoted in Thomas Donaldson, *The George Catlin Indian Gallery in the U.S. National Museum (Smithsonian Institution), Smithsonian Report, 1885,* Part II, Washington, D.C., 1887, pp. 328–331.

p. 45. George Catlin, *Last Rambles Amongst the Indians of the Rocky Mountains and the Andes,* London, Sampson Low, Son, and Marston, 1868, pp. 279–280, 283–285.

p. 46. Gravestone of Abigail Barber, 1797; quoted in Allan I. Ludwig, *Graven Images: New England Stonecarving and Its Symbols, 1650–1815,* Middletown (Connecticut), Wesleyan University Press, 1966, p. 223.

p. 47. Benjamin H. Latrobe, oration before the Society of Artists of the United States, Philadelphia, 1811; quoted in Henri Marceau, *William Rush, 1756–1833: The First Native American Sculptor,* Philadelphia, Pennsylvania Museum of Art, 1937, p. 19.—Quoted in *ibid.,* p. 58.

p. 51. Conversation with Powers recorded by the American Consul in Genoa, C. Edwards Lester, *The Artist, the Merchant, and the Statesman,* New York, Paine & Burgess, 1845, vol. I, pp. 64–66.—Conversation with Powers recorded by the Rev. Henry W. Bellows, published in *Appleton's Journal,* 1869; quoted by Albert T. Gardner, "Hiram Powers and 'The Hero,'" *The Metropolitan Museum of Art Bulletin,* n.s. II, October 1943, p. 108.—Powers, quoted in Sylvia E. Crane, *White Silence: Greenough, Powers, and Crawford,* Coral Gables (Florida), University of Miami Press, 1972, p. 221.—Nathaniel Hawthorne, quoted in *ibid.,* p. 257.

p. 52. Morse to his parents, May 2, 1814; quoted in *Samuel F. B. Morse: His Letters and Journals,* edited and supplemented by his son, Edward Lind Morse, Boston & New York, Houghton Mifflin, 1914, vol. I, p. 132.—Morse to his wife Lucretia, February 8, 1825; quoted in *ibid.,* vol. I, p. 261 f.—Morse, quoted in *ibid.,* vol. I, p. 272.—Morse, quoted in Flexner, *The Light of Distant Skies,* paperback edition, p. 234.—Morse to James Fenimore Cooper, November 20, 1849; quoted in *Samuel F. B. Morse: His Letters and Journals,* vol. II, p. 31.

p. 54. Sargent to Trumbull, unpublished letter, September 21, 1821, in the Archives of American Art, Washington, D.C.—John Neal, *Randolph, A Novel,* 1823; reprinted in *Observations on American Art: Selections from the Writings of John Neal (1793–1876),* edited with Notes by Harold Edward Dickson, State College (Pennsylvania), The Pennsylvania State College Press, 1943, pp. 7–8.

p. 55. Washington Irving (under the pseudonym Geoffrey Crayon), *Tales of a Traveller,* London, John Murray, 1824, vol. II, part IV, "The Money Diggers . . . Wolfert Webber, or Golden Dreams," pp. 378, 365.

p. 56. Rembrandt Peale, "Reminiscences," *The Crayon,* vol. III, January 1856, p. 5.—Henry R. Stiles, *A History of the City of Brooklyn,* 1869; quoted in J. Hall Pleasants, "Four Late Eighteenth Century Anglo-American Landscape Painters," *Proceedings of the American Antiquarian Society at the Meeting Held in Worcester October 21, 1942,* Worcester (Massachusetts), 1943, pp. 239–300.—Broadside issued by the Shakespeare Gallery, New York, 1820, "Description of the Brooklyn Snow Piece in the Gallery of Paintings. 11 Park."

p. 58. Stanley Kunitz, "Words for the Unknown Makers," *Craft Horizons,* vol. XXXIV, February 1974, p. 33 (published by kind permission of the author).

p. 61. Letter of Seifert's granddaughter, printed in its entirety in Jean Lipman and Alice Winchester, *Primitive Painters in America,* New York, Dodd Mead & Co., 1950, pp. 149–152.

p. 62. Hicks to Dr. Joseph Watson, September 23, 1844, letter in the Abby Aldrich Rockefeller Folk Art Collection, Williamsburg, Virginia.

p. 63. Oliver W. Larkin, *Art and Life in America,* New York, Rinehart & Company, 1949, pp. 230–231.

p. 64. Esther Sparks, "Olof Krans, Prairie Painter," *Historic Preservation,* October–December 1972, p. 9.

p. 65. *History of Mendocino County, California,* San Francisco, Alley, Bowen & Co., 1880, p. 414.

p. 66. Kunitz, "Words for the Unknown Makers," p. 30 (published by kind permission of the author).

p. 68. William Cullen Bryant, Preface to *The American Landscape,* New York, Elam Bliss, 1830, pp. 2–3.—Thomas Cole, "Essay on American Scenery," *The American Monthly Magazine,* n.s. I, January 1836; quoted in John W. McCoubrey, *American Art 1700–1960, Sources and Documents,* Englewood Cliffs (New Jersey), Prentice-Hall, 1965, p. 105.

p. 69. William Cullen Bryant, *A Funeral Oration occasioned by the death of Thomas Cole delivered before the National Academy of Design,* New York, May 4, 1848, p. 37.—John Keats, sonnet, "To Solitude," 1815; quoted in exhibition catalogue "A. B. Durand, 1796–1886," Montclair (New Jersey) Art Museum, October 24–November 28, 1971, p. 59.—Cole to Bryant, June 15, 1840, letter in Manuscript Division, The New York Public Library.—Asher B. Durand, "Letters on Landscape Painting," *The Crayon,* vol. I, June 6, 1855, p. 354.

p. 70. Town to Cole, May 1840, letter in New York State Library, Albany, New York; microfilm in the Archives of American Art.—Cole to Durand, May 26, 1840; quoted in exhibition catalogue "Thomas Cole 1801–1848, One Hundred Years Later," Hartford (Connecticut), The Wadsworth Atheneum, November 12, 1948–January 2, 1949, New York, Whitney Museum of American Art, January 8–30, 1949, pp. 30–31.

p. 72. Mount to Charles Lanman, November 17, 1847; quoted by Alfred Frankenstein in exhibition catalogue "William Sidney Mount, 1807–1868," circulated 1968–1969 by the International Exhibitions Foundation, © 1968 by The Suffolk Museum at Stony Brook, Long Island, New York, p. 37.—Undated manuscript notebook (1844–1850), Suffolk Museum and Carriage House, Stony Brook, Long Island; quoted in Barbara Novak, *American Painting of the Nineteenth Century: Realism, Idealism, and the American Experience,* New York, Praeger Publishers, 1974, p. 307, n. 16.—Mount, quoted in Marshall B. Davidson and The Editors of American Heritage, *The American Heritage History of The Artists' America,* New York, American Heritage Publishing Company, 1973, p. 115.

p. 73. Washington Irving, *Astoria,* Philadelphia, Carey, Lea, & Blanchard, 1836, vol. I, pp. 142–143.

p. 74. John I. H. Baur, "American Luminism," *Perspectives USA,* no. 9, 1954, p. 91.—John Wilmerding, *Fitz Hugh Lane,* New York, Praeger Publishers, 1971, p. 60.

p. 76. *National Academy of Design—Exhibition of 1868,* New York, D. Appleton, 1868.

p. 77. Theodore E. Stebbins, Jr., *The Life and Works of Martin Johnson Heade,* New Haven & London, Yale University Press, 1975, p. 142.—*Ibid.,* p. 138.

p. 78. Alexander von Humboldt, *Cosmos: A Sketch of a Physical Description of the Universe,* translated from

the German by E. C. Otté, New York, 1850–1859; quoted in exhibition catalogue "19th-Century America, Paintings and Sculpture," no. 106.—Henry T. Tuckerman, *Book of the Artists: American Artist Life*, New York, G. P. Putnam & Son, 1867, p. 383.

p. 80. Directories of Bridgeport, Connecticut, 1862, 1868, 1869–1870; quoted by Jean Lipman, *Rediscovery: Jurgan Frederick Huge (1809–1878)*, New York, Archives of American Art, 1973, p. 4.

p. 82. Mark Twain and Charles Dudley Warner, *The Gilded Age*, New York, Harper, 1873, chapter 8.

p. 84. Alfred Frankenstein, *After the Hunt: William Harnett and Other American Still Life Painters, 1870–1900*. Revised edition. Berkeley and Los Angeles, University of California Press, 1969, p. 54.—William Harnett, interview in the *New York News*, 1889 or 1890; quoted in *ibid.*, p. 55.

p. 85. Giorgio de Chirico, *Memorie della mia vita*, Rome, 1945; quoted in English translation by James Thrall Soby, *Giorgio de Chirico*, New York, The Museum of Modern Art, 1955, p. 110.

p. 86. Maud Valona Elmer, "Edwin Romanzo Elmer as I Knew Him," *The Massachusetts Review*, Autumn–Winter 1964/65.—Alfred Frankenstein, "Edwin Romanzo Elmer," *Magazine of Art*, vol. XLV, October 1952, p. 272.

p. 89. Jules Antoine Castagnary, "Le Salon de 1863," "Le Salon de 1868"; quoted in English translation by John Rewald, *The History of Impressionism*. Fourth, revised edition. New York, The Museum of Modern Art, 1973, pp. 149–150

p. 90. Henry James in *The Galaxy*, July 1875; quoted in Albert Ten Eyck Gardner, *Winslow Homer, American Artist: His World and His Work*, New York, Clarkson N. Potter, p. 195.

p. 91. *Boston Sunday Post*, November 2, 1902; quoted in exhibition catalogue "American Paintings & Historical Prints from the Middendorf Collection," Baltimore, The Baltimore Museum of Art, July 9–September 24, 1967, New York, The Metropolitan Museum of Art, October 4–November 26, 1967, no. 43, p. 60.—Howard J. Cave, "Alexander Pope, Painter of Animals," *Brush and Pencil*, vol. VIII, 1901, pp. 109, 112.

p. 92. Lloyd Goodrich in exhibition catalogue "Thomas Eakins," New York, Whitney Museum of American Art, September 22–November 21, 1970, p. 12.—Eakins, letter, quoted by Lloyd Goodrich, *Thomas Eakins, His Life and Work*, New York, Whitney Museum of American Art, 1933, p. 18.

p. 93. Achille Segard, *Un Peintre des enfants et des mères, Mary Cassatt*, Paris, 1913; quoted in English translation by Rewald, *The History of Impressionism*, p. 409.—A. Mellerio, "Mary Cassatt," *L'Art et les Artistes*, November 1910; quoted in English translation by Adelyn D. Breeskin in introduction to exhibition catalogue "The Paintings of Mary Cassatt," New York, M. Knoedler & Co., February 1–26, 1966.

p. 95. Adams to Richard Watson Gilder, October 14, 1896; quoted in *The Reminiscences of Augustus Saint-Gaudens*, edited by Homer Saint-Gaudens, New York, Century Co., 1913, vol. I, p. 363.—*The Education of Henry Adams: An Autobiography*, Boston and New York, Houghton Mifflin, 1918, p. 329.—Saint-Gaudens to Wayne MacVeagh, February 26, 1906; quoted in Louise Hall Tharp, *Saint-Gaudens and the Gilded Era*,

Boston, Little, Brown, 1969, p. 225.—George Heard Hamilton, "Realism and Idealism in Late 19th-Century American Art: Augustus Saint-Gaudens and Thomas Eakins," *Stil und Überlieferung in der Kunst des Abendlandes*. Akten des 21. Internationalen Kongresses für Kunstgeschichte, Bonn, 1964, vol. I, p. 250.—*The Reminiscences of Augustus Saint-Gaudens*, p. 356 f.—Hamilton, "Realism and Idealism," p. 254.

p. 96. Whistler to Henri Fantin-Latour, Fall 1867; quoted in Rewald, *The History of Impressionism*, p. 160.—Stéphane Mallarmé; quoted by Frederick A. Sweet in exhibition catalogue "James McNeill Whistler," The Art Institute of Chicago, January 13–February 25, 1968, p. 28. John Ruskin in *Fors Clavigera*, July 2, 1877; quoted by Whistler in Prologue to *The Gentle Art of Making Enemies*, New York, G. P. Putnam's Sons, 1890.—Whistler at the Ruskin libel trial, November 1878, quoted in *ibid.*—Whistler, lecture, "The Ten O'Clock," February 20, 1885; "The Red Rag," *The [London] World*, May 22, 1878; *ibid.*; "Proposition No. 2," 1898; all four quoted in *Artists on Art from the XIV to the XX Century*, compiled and edited by Robert Goldwater and Marco Treves, New York, Pantheon Books, 1945, pp. 347, 349–351.

p. 97. Stevenson, quoted by Davidson in *The Artists' America*, p. 188.—Stevenson to Will H. Low, October 22, 1885; quoted in catalogue of the Stevenson Sale, New York, Metropolitan Art Association, November 24, 1914.—Henry James, "John S. Sargent," *Harper's Monthly Magazine*, vol. LXXIX, September 1889, pp. 683, 689.

p. 98. Elihu Vedder, *The Digressions of V.*, Boston, 1910; quoted by James Thrall Soby, *Romantic Painting in America*, New York, The Museum of Modern Art, 1943, p. 29.—*New-York Daily Tribune*, June 4, 1864, "National Academy of Design: The Thirty-Ninth Exhibition. Sixth Article . . . No. 297."

p. 99. Ralph Waldo Emerson, "Brahma," *Atlantic Monthly*, vol. I, 1857; reprinted in Ralph Waldo Emerson, *Complete Writings*, vol. 9, *Poems*, New York, William H. Wise & Co., 1926, p. 195.—*Ibid.*, "Notes," p. 464.

p. 100. Ryder to Thomas B. Clarke, April 1885; quoted by Lloyd Goodrich in catalogue "Albert P. Ryder Centenary Exhibition," New York, Whitney Museum of American Art, October 18–November 30, 1947, p. 18.—John Dos Passos, "Art and the Writer: A Narrative Painting," *Art in America*, vol. XLVII, no. 2, 1959, p. 48.—A. P. Ryder, "Paragraphs from the Studio of a Recluse," *Broadway Magazine*, vol. XIV, September 1905; excerpted in John W. McCoubrey, *American Art 1700–1960. Sources and Documents*, pp. 186–187.—Ryder, quoted in Frederick Fairchild Sherman, *Albert Pinkham Ryder*, New York, 1920, p. 43.—Ryder, "Paragraphs from the Studio of a Recluse," p. 187.—Anonymous critic, 1890, quoted by Goodrich, "Albert P. Ryder Centenary Exhibition," p. 28.

p. 101. Unsigned review, *Studio*, 1932, quoted in notation on photograph mount, The Frick Art Reference Library.—Marcel Duchamp, comment written in 1943, included in *Yale University Art Gallery, Collection of the Société Anonyme: Museum of Modern Art 1920*, New Haven (Connecticut), 1950, p. 154.

p. 102. Robert Henri, *The Art Spirit*, Philadelphia and New York, J. B. Lippincott, 1923; paperback edition, 1960, p. 218.—*New York Herald*, 1907, quoted in Charles H. Morgan, *George Bellows, Painter of America*, New York, Reynal & Co., 1965, p. 83.—George Bellows in *Touchstone*, 1917; quoted in *ibid.*, pp. 209–210.

p. 103. Luks, quoted in exhibition catalogue "George Luks, 1866–1933," Utica (New York), Munson-Williams-Proctor Institute Museum of Art, April 1–May 20, 1973, p. 6.—Guy Pène du Bois, "George B. Luks and Flamboyance," *The Arts*, vol. III, February 1923; reprinted in Barbara Rose, ed., *Readings in American Art since 1900: A Documentary Survey*, New York, Frederick A. Praeger, 1968, pp. 44–46.

p. 104. Quoted in Davidson, *The Artists' America*, p. 270.—Perry T. Rathbone, Preface to exhibition catalogue "Maurice Prendergast, 1859–1924," Boston, Museum of Fine Arts, October 26–December 4, 1960, p. 12.

p. 105. Arthur G. Dove, Foreword to catalogue of one-man show, An American Place, New York, 1927; quoted by Alan Solomon in exhibition catalogue "Arthur G. Dove, 1880–1946," Ithaca (New York), Andrew Dickson White Museum of Art, Cornell University, November 1954, p. 8.

p. 106. Man Ray, *Self Portrait*, Boston and Toronto, Little, Brown and Company, 1963, p. 55.—*Ibid.*, pp. 66–67.—André Breton quoted by Sanche de Gramont, "Remember Dada—Man Ray at 80," *New York Times Magazine*, September 6, 1970, p. 27.—Jules Langsner, "About Man Ray: An Introduction," in exhibition catalogue "Man Ray," Los Angeles County Museum of Art, October 27–December 9, 1966, p. 9.

p. 108. Marcel Duchamp, comment in *Yale University Art Gallery, Collection of the Société Anonyme*, p. 192.

p. 109. Henri Matisse to his students, 1908; quoted in English translation in Alfred H. Barr, Jr., *Matisse: His Art and His Public*, New York, The Museum of Modern Art, 1951, p. 552.—William C. Agee in exhibition catalogue, "Synchromism and Color Principles in American Painting, 1910–1930," M. Knoedler & Co., New York, October 12–November 6, 1965, pp. 35–37.—Bruce, quoted in *ibid.*, p. 36.

p. 110. Malcolm Cowley, *Exile's Return: A Literary Odyssey of the 1920's*. Revised edition. New York, The Viking Press, 1951, pp. 295, 289–290.—Murphy, quoted in William Rubin (with the collaboration of Carolyn Lanchner), *The Paintings of Gerald Murphy*, New York, The Museum of Modern Art, 1974, p. 14.—Rubin, *ibid.*, p. 16.—*Ibid.*, p. 30.—Fernand Léger, quoted in James Johnson Sweeney, "Eleven Europeans in America," *Museum of Modern Art Bulletin*, vol. XIII, 1946, p. 15.—Rubin, *The Paintings of Gerald Murphy*, p. 17.—Murphy to Rudi Blesh, 1955, quoted in *ibid.*, p. 11.

p. 111. William Carlos Williams, "The Great Figure," *The Collected Early Poems of William Carlos Williams*, copyright by the author 1938, 1951, New York, New Directions.—Henry Geldzahler, *American Painting and Sculpture in the Twentieth Century*, New York, The Metropolitan Museum of Art, 1965, p. 138.

p. 112. O'Keeffe, quoted by Katharine Kuh, *The Artist's Voice: Talks with Seventeen Artists*, New York and Evanston, Illinois, Harper & Row, 1962, p. 202.—Georgia O'Keeffe, "About Myself," statement in catalogue of one-person exhibition, An American Place, New York, 1939; quoted by Lloyd Goodrich and Doris Bry in exhibition catalogue "Georgia O'Keeffe," New York, Whitney Museum of American Art, October 8–November 29, 1970, p. 22.

p. 113. Spencer, statement in exhibition catalogue "A New Realism: Crawford, Demuth, Sheeler, Spencer," Cincinnati, Modern Art Society, March 12–April 7, 1941.

p. 114. Hartley, statement accompanying one-man exhibition at Stieglitz's Photo-Secession Gallery, "291," New York, 1916; quoted by Geldzahler, *American Painting in the Twentieth Century*, pp. 59–60.—Marsden Hartley, "Albert P. Ryder," *The Seven Arts*, May 1917, p. 95.

p. 115. Marin in catalogue of his one-man show, Photo-Secession Gallery, "291," New York, 1913; reprinted in MacKinley Helm, *John Marin*, Boston, Pellegrini & Cudahy in association with the Institute of Contemporary Art, 1948, pp. 28–29.

p. 116. Stuart Davis, "The Cube Root," *Art News*, vol. XLI, February 1943, p. 34.—Stuart Davis, "Modern Art and Freedom of Expression," unpublished essay, June 1941; quoted in *Stuart Davis*, edited by Diane Kelder, New York, Praeger Publishers, 1971, p. 9.—Stuart Davis, "Is There a Revolution in the Arts?," *Bulletin of America's Town Meeting of the Air*, vol. V, February 1940; quoted in *ibid.*, p. 122.—Davis, quoted in Kuh, *The Artist's Voice*, p. 52.—Davis, statement made for Alfred H. Barr, Jr., The Museum of Modern Art, November 3, 1952; reprinted in *Stuart Davis*, ed. Kelder, pp. 100–102.

p. 117. Hopper, quoted in Lloyd Goodrich, *Edward Hopper*, New York, Harry N. Abrams, Inc., 1971, p. 99. —Hopper, quoted in Kuh, *The Artist's Voice*, p. 134.— Goodrich, *Edward Hopper*, pp. 113, 142.—Hopper, quoted in William C. Seitz, "Edward Hopper, Realist, Classicist, Existentialist," *São Paulo 9, United States of America*, Washington, D.C., Smithsonian Institution Press, 1967, p. 17.—Hopper, statement in exhibition catalogue "Edward Hopper," New York, The Museum of Modern Art, 1933.—Lloyd Goodrich, *Edward Hopper: Selections from the Hopper Bequest*, New York, Whitney Museum of American Art, 1971, p. 10.

p. 118. Wood, quoted in Darrell Garwood, *Artist in Iowa: A Life of Grant Wood*, New York, W. W. Norton & Co., 1944, pp. 137–138.

p. 119. Wyeth, quoted in exhibition catalogue "Andrew Wyeth," Philadelphia, Pennsylvania Academy of the Fine Arts, October 5–November 27, 1966, p. 26.

p. 120. Ben Shahn, *The Shape of Content*, Cambridge (Massachusetts), Harvard University Press, 1957, pp. 41–42, 45.

p. 121. Jacob Lawrence, reply to artist's questionnaire in Collection files of The Museum of Modern Art.—Milton W. Brown in exhibition catalogue "Jacob Lawrence," New York, Whitney Museum of American Art, May 16–July 7, 1974, p. 12.—Lawrence, quoted by Elizabeth McCausland, "Jacob Lawrence," *Magazine of Art*, vol. XXXVIII, November 1945, p. 251.—Lawrence, statement, 1972, in *The Hirshhorn Museum and Sculpture Garden, Smithsonian Institution*, New York, Harry N. Abrams, Inc., 1974, p. 711.

p. 122. Kane, quoted in [Marie McSwigan] *Sky Hooks: The Autobiography of John Kane*, Philadelphia and New York, J.B. Lippincott, 1938, pp. 82, 101, 102, 172.

p. 123. Novak, *American Painting of the Nineteenth Century*, pp. 100–101.—Morris Hirshfield, "My Life Biography," in Sidney Janis, *They Taught Themselves: American Primitive Painters of the 20th Century*, New York, The Dial Press, 1942, p. 18.—Janis, *ibid.*, pp. 37–38.

p. 124. Gerald Nordland, *Gaston Lachaise, The Man and His Work*, New York, George Braziller, 1974, p. 82. —Lincoln Kirstein, introduction to catalogue "Gaston Lachaise: Retrospective Exhibition," New York, The Museum of Modern Art, January 30–March 7, 1935, p. 13.—*The Education of Henry Adams: An Autobiography*, p. 384; quoted by Lachaise in a handwritten autobiographical sketch in the Beinecke Rare Book Library, Yale University; cited by Nordland, *Gaston Lachaise*, p. 65 and n. 3.—Gaston Lachaise, "A Comment on My Sculpture," *Creative Art*, vol. III, August 1928, p. xxiii.

p. 126. Elie Nadelman, "Photo-Secession Notes," *Camera Work*, no. 32, 1910, p. 41.—Lincoln Kirstein, *Elie Nadelman*, New York, The Eakins Press, 1973, pp. 201–202.

p. 127. Henry Tyrell in *The [New York] World Magazine*, November 30, 1919; quoted in Kirstein, *Elie Nadelman*, p. 276—*New York Evening Sun*, quoted in *ibid.*, p. 215.—Kirstein, *ibid.*, p. 223.

p. 129. Robert Goldwater, *What Is Modern Sculpture?*, New York, The Museum of Modern Art, 1969, p. 38.— Flannagan, statement in exhibition catalogue "The Sculpture of John B. Flannagan," edited by Dorothy C. Miller, New York, The Museum of Modern Art, 1942, p. 7.—Flannagan to Carl Zigrosser, 1929, in *Letters of John B. Flannagan*, with an introduction by W. R. Valentiner, New York, Curt Valentin, 1942, p. 20.— Flannagan, statement in "The Sculpture of John B. Flannagan," p. 8.—Flannagan to Carl Zigrosser, June 1937, in *Letters of John B. Flannagan*, p. 58.—Flannagan, quoted by Carl Zigrosser in introduction to "The Sculpture of John B. Flannagan," p. 11.

p. 130. Isamu Noguchi, *A Sculptor's World*, New York and Evanston, Illinois, Harper & Row, 1968, p. 39.— Noguchi, statement for exhibition catalogue "Fourteen Americans," New York, The Museum of Modern Art, 1946.—Noguchi, *A Sculptor's World*, pp. 27–28.

p. 131. Noguchi, *A Sculptor's World*, p. 38.—*Ibid.*, p. 170.

p. 132. Naum Gabo and Antoine Pevsner, Manifesto, Moscow, 1920; quoted in English translation (from French version published in *Abstraction–Création*, no. 1, 1932) in Goldwater and Treves, *Artists on Art*, p. 454.—*Ibid.*

p. 133. Smith, lecture given March 1953 in Portland, Oregon; quoted in *David Smith by David Smith*, edited by Cleve Gray, New York, Holt, Rinehart and Winston, 1968, p. 68.—David Smith, "The Language Is Image," *Arts and Architecture*, February 1952, p. 34.

p. 134. Gabo and Pevsner, Manifesto, Moscow, 1920; English translation in *Gabo*, with introductory essays by Herbert Read and Leslie Martin, Cambridge (Massachusetts), Harvard University Press, 1957, p. 152.— Alexander Calder, "Mobiles," in *The Painter's Object*, edited by Myfanwy Evans, London, Gerald Howe Ltd., 1937, p. 63.—Calder, text by H. H. Arnason, Princeton (New Jersey), Van Nostrand Company, 1966, p. 78.

p. 135. Rickey, statement, 1972, in *The Hirshhorn Museum and Sculpture Garden*, p. 739.

p. 136. Lippold, lecture, Arts Club of Chicago, 1953; quoted in George Rickey, *Constructivism: Origins and Evolution*, New York, George Braziller, 1967, p. 154.— Rickey, statement in exhibition catalogue "Fourteen Americans," edited by Dorothy C. Miller, New York, The Museum of Modern Art, 1952.—Lawrence Campbell, "Lippold Makes a Construction," *Art News*, vol. LV, October 1956, p. 64.—Quoted by Calvin Tomkins, "Profile: A Thing among Things," *The New Yorker*, March 30, 1963, p. 47.—Richard Lippold, "To Make Love to Life," *Wayne State University Graduate Comment*, vol. III, October 1959, p. 5.

p. 138. Cornell, statement in catalogue of one-man exhibition at the Copley Galleries, Beverly Hills, California, September 1948; quoted by Dore Ashton, *A Cornell Album*, New York, The Viking Press, 1974, p. 64.—Diane Waldman in exhibition catalogue "Joseph Cornell," New York, The Solomon R. Guggenheim Museum, 1967, pp. 16–17.

p. 139. James Thrall Soby, introduction to exhibition catalogue "A Tribute to Kay Sage," Waterbury (Connecticut), Mattatuck Museum, 1965.—James Thrall Soby, foreword to exhibition catalogue "Kay Sage," Rome, Galleria dell' Obelisco, March 1953; reprinted as foreword to exhibition catalogue "Kay Sage," New York, Catherine Viviano Gallery, April–May 1960.

p. 140. William Rubin, "Arshile Gorky, Surrealism and the New American Painting," *Art International*, vol. VII, February 1963, p. 28.—André Breton, First Surrealist Manifesto, 1924; quoted in Rubin, *ibid.*, p. 34, n. 12.—André Breton, "Arshile Gorky," *Le Surréalisme et la Peinture*. 2nd edition. New York, Brentano's, Inc., 1945, pp. 196–199; English translation "The Eye-Spring: Arshile Gorky," in exhibition catalogue, "Arshile Gorky," New York, Julien Levy Gallery, March 1945.

p. 141. Harold Rosenberg, "The American Action Painters," *Art News*, vol. LI, September 1952, pp. 22–23. —Willem de Kooning, "Content Is a Glimpse," interview with David Sylvester (BBC), published in *Location*, vol. I, Spring 1963; reprinted in Thomas B. Hess, *Willem de Kooning*, New York, The Museum of Modern Art, 1968, p. 148.—Alfred H. Barr, Jr., *Picasso, Fifty Years of His Art*, New York, The Museum of Modern Art, 1946, p. 56.—De Kooning, "Content Is a Glimpse," pp. 148–149.

p. 142. Pollock, reply to a questionnaire, *Arts & Architecture*, vol. LXI, February 1944, p. 14.—*Ibid.*—Pollock, statement in application for a John Simon Guggenheim Fellowship, 1947; quoted in Francis V. O'Connor, *Jackson Pollock*, New York, The Museum of Modern Art, 1968, pp. 39–40.—Jackson Pollock, "My Painting," *Possibilities*, Winter 1947/48, pp. 78 ff.; quoted in O'Connor, *ibid.*, p. 40.

p. 144. Motherwell, television interview with Bryan Robertson, "Art, N.Y." (Channel 13), December 15, 1964; quoted in Frank O'Hara, *Robert Motherwell*, New York, The Museum of Modern Art, 1965, p. 8.— Motherwell in symposium "What Abstract Art Means to Me," February 5, 1951; published in *Museum of Modern Art Bulletin*, vol. XVIII, Spring 1951, pp. 12–13.—Robert Motherwell, "A Conversation at Lunch," transcribed by Margaret Paul, in exhibition catalogue "Robert Motherwell," Northampton (Massachusetts), Smith College Museum of Art, January 10–28, 1963.— *Ibid.*—Motherwell, interview with Irmeline Leeber, *Chroniques de l'Art Vivant*, no. 22, July–August 1971; published in English translation in exhibition catalogue "Robert Motherwell," Minneapolis, Walker Art Center, 1972, p. 14.

p. 146. De Kooning, "Content Is a Glimpse," p. 149.— *Ibid.*, p. 148.—Charles Demuth, "Across is Written Greco," *Creative Arts*, vol. V, September 1929; quoted in exhibition catalogue "Pioneers of American Abstraction," New York, Andrew Crispo Gallery, October 17–November 17, 1973.

p. 147. Frank O'Hara, introduction to exhibition catalogue "Franz Kline: A Retrospective Exhibition," London, Whitechapel Gallery, 1964; reprinted in Frank O'Hara, *Art Chronicles, 1954–1966*, New York, George

Braziller, 1975, p. 45.—"Franz Kline 1910–1960. An Interview with David Sylvester," *Living Arts,* vol. I, Spring 1963; excerpted by Maurice Tuchman in *New York School: The First Generation, Paintings of the 1940s and 1950s,* Greenwich (Connecticut), New York Graphic Arts Society Ltd., 1965, p. 89 (based on catalogue of exhibition at the Los Angeles County Museum of Art, July 16–August 1, 1965).—*Ibid.,* p. 90. —"Franz Kline Talking," interview with Frank O'Hara, *Evergreen Review,* vol. II, 1958; reprinted in O'Hara, *Art Chronicles,* p. 52.

p. 148. Goldwater, *What Is Modern Sculpture?,* pp. 99–101.—Barbara Rose, "Mark di Suvero," *Vogue,* vol. 161, February 1973, p. 162.—Hyatt Mayor, quoted by Max Kozloff, "Mark di Suvero: Leviathan," *Artforum,* vol. V, Summer 1967, p. 41.

p. 149. Newman, statement, 1958, in exhibition catalogue "The New American Painting as Seen in Eight European Countries," New York, The Museum of Modern Art, 1959, p. 60.—Barnett Newman, "The Plasmic Image, Part I, 1943–1945"; quoted in Thomas B. Hess, *Barnett Newman,* New York, The Museum of Modern Art, 1971, p. 38.—Hess, *ibid.,* p. 121.—Newman to John de Menil; quoted by Harold Rosenberg, *Barnett Newman: Broken Obelisk and Other Sculptures,* Seattle and London, University of Washington Press, 1971, p. 13.

p. 150. Still, letter of February 5, 1952; quoted in exhibition catalogue "15 Americans," New York, The Museum of Modern Art, 1952.—Still to Gordon M. Smith; quoted in exhibition catalogue "Paintings by Clyfford Still," Buffalo, Albright-Knox Art Gallery, November 5–December 13, 1959, pp. 8–9.—Irving Sandler, *The Triumph of American Painting: A History of Abstract Expressionism,* New York and Washington, Praeger Publishers, 1970, p. 150.—Edmund Burke, *A Philosophical Enquiry into the Origin of Our Ideas of the Sublime and the Beautiful,* 1757; quoted by Sandler, *ibid.,* pp. 151, 153.—Immanuel Kant, *Critique of Judgment,* 1790, I, book 2, § 23; quoted in Robert Rosenblum, "The Abstract Sublime," *Art News,* vol. LIX, February 1961, p. 40.—Still, statement, 1972, in *The Hirshhorn Museum and Sculpture Garden,* p. 752.

p. 151. Mark Rothko, "A Statement on His Attitude of Painting," *The Tiger's Eye,* vol. I, October 1949; quoted in exhibition catalogue "15 Americans."—Sandler, *The Triumph of American Painting,* p. 183.—Rosenblum, "The Abstract Sublime," p. 56.

p. 158. Hilton Kramer, review in *Arts,* vol. XXXII, June 1958; quoted in Arnold B. Glimcher, *Louise Nevelson,* New York and Washington, D.C., Praeger Publishers, 1972, p. 84.—Louise Nevelson, "Prologue," quoted in *ibid.,* p. 121.

p. 160. Rauschenberg, quoted by Andrew Forge, *Robert Rauschenberg,* New York, Harry N. Abrams, Inc., 1969, p. 69.—John Cage, "On Rauschenberg, Artist, and His Works," *Metro,* vol. I, 1961; quoted in William C. Seitz, *The Art of Assemblage,* New York, The Museum of Modern Art, 1961, p. 116.—Forge, *Robert Rauschenberg,* pp. 31–32.—Rauschenberg, quoted in Seitz, *The Art of Assemblage,* p. 116.

p. 161. Johns, quoted in *Time* magazine, May 4, 1959, p. 58.—Johns, quoted in "Five Young Artists," *Charm,* April 1959; quoted in Leo Steinberg, *Jasper Johns,* New York, George Wittenborn, 1963, pp. 8, 10.—Alan R. Solomon in introduction to exhibition catalogue "Jasper Johns," New York, The Jewish Museum, 1964, p. 8.— Jasper Johns, "Duchamp," *Scrap,* no. 2, 1960; quoted in Lawrence Alloway, *American Pop Art,* New York,

Collier Books in association with the Whitney Museum of American Art, 1974, p. 66.

p. 162. Steinberg, *Jasper Johns,* p. 10.

p. 164. Barbara Rose, *Claes Oldenburg,* New York, The Museum of Modern Art, 1970, p. 67.—Oldenburg, quoted by Rose, *ibid.,* p. 69.—Oldenburg, statement for exhibition catalogue "Environments, Situations, Spaces," New York, Martha Jackson Gallery, May 23–June 23, 1961; published in definitive form in Claes Oldenburg, *Store Days,* New York, Something Else Press, 1967, pp. 39, 41.

p. 165. Claes Oldenburg, "Items toward an introduction," in exhibition catalogue "Claes Oldenburg," organized by The Museum of Modern Art under the auspices of its International Council, London, The Tate Gallery, June 24–August 16, 1970, p. 8.—Oldenburg, statement, 1966; quoted in *ibid.,* p. 16.—Oldenburg, statement, 1968; quoted in Rose, *Claes Oldenburg,* p. 194.—Oldenburg, statement included in *Claes Oldenburg: Selected Texts for the Traveling Exhibition of 1971–73,* rewritten by the artist from his notebooks and conversations with Barbara Haskell, Pasadena (California) Art Museum, 1971, p. 8.

p. 166. Rosenquist, interview with G. R. Swenson, "What Is Pop Art?, Part II," *Art News,* vol. LXII, February 1964, p. 62.—Rosenquist, quoted by Jeanne Siegel, "An Interview with James Rosenquist," *Artforum,* vol. X, June 1972, p. 30.—*Ibid.,* p. 33.—Marcia Tucker in exhibition catalogue "James Rosenquist," New York, Whitney Museum of American Art, April 12–May 29, 1972, p. 17.—Rosenquist, interview with Swenson, "What Is Pop Art?," p. 64.—Rosenquist, quoted by Tucker, "James Rosenquist," p. 26.

p. 152. *Bahá'í World Faith,* Wilmette, Illinois, Bahá'í Publishing Trust, 1956; quoted in William C. Seitz, *Mark Tobey,* New York, The Museum of Modern Art, 1962, p. 14.—Mark Tobey, "Reminiscence and Reverie," *Magazine of Art,* vol. XLIV, October 1951, p. 230.— Sidney Janis in exhibition catalogue "Mark Tobey," New York, Willard Gallery, April 4–29, 1944; quoted in *Three Generations of Twentieth-Century Art: The Sidney and Harriet Janis Collection,* New York, The Museum of Modern Art, 1972, p. 116.—Seitz, *Mark Tobey,* p. 22.—Tobey, quoted in Denys Chevalier, "Une Journée avec Mark Tobey," *Aujourd'hui,* vol. VI, October 1961; quoted in English translation in Seitz, *Mark Tobey,* p. 23.

p. 153. Henri Matisse, "Notes d'un peintre," *La Grande Revue,* Paris, December 25, 1908; quoted in English translation in Barr, *Matisse: His Art and His Public,* pp. 120, 119.—Clement Greenberg, "Milton Avery," *Arts Review,* vol. XIV, September 22–October 6, 1962; reprinted in Clement Greenberg, *Art and Culture: Critical Essays,* Boston, Beacon Press, 1972, p. 198.—*Ibid.,* p. 201.—Mark Rothko, Memorial address delivered at the Ethical Culture Society, New York, January 7, 1965; quoted in exhibition catalogue "Milton Avery," Washington, D.C., National Collection of Fine Arts, Smithsonian Institution, December 12, 1969–January 25, 1970.

p. 154. Clement Greenberg, "David Smith," *Art in America,* vol. LIV, p. 44.—Smith, interview with Thomas B. Hess, "The Secret Letter," in exhibition catalogue "David Smith," New York, Marlborough-Gerson Gallery, October 1964, p. 9; reprinted in *David Smith,* edited by Garnett McCoy, New York, Praeger Publishers, 1973, p. 183.

p. 155. David Smith, "Notes on My Work," *Arts,* vol.

XXXIV, February 1960, p. 44.—*Ibid.*—Smith, quoted in Hess, "The Secret Letter"; reprinted in *David Smith,* ed. McCoy, p. 183.

p. 156. Chamberlain, quoted by Diane Waldman in exhibition catalogue "John Chamberlain," New York, The Solomon R. Guggenheim Museum, 1971, p. 11.— Chamberlain, quoted in Phyllis Tuchman, "An Interview with John Chamberlain," *Artforum,* vol. X, February 1972, p. 39 f.—*Ibid.*—Barbara Rose, "How to Look at Chamberlain's Sculpture," *Art International,* vol. VII, January 1964, pp. 36, 38.—Donald Judd, "Chamberlain: Another View," *Art International,* vol. VII, January 1964, p. 39.

p. 157. Goldwater, *What Is Modern Sculpture?,* p. 99.— Richard Stankiewicz in *School Arts,* vol. LX, January 1961; quoted in "Richard Stankiewicz," *Current Biography,* vol. XXVIII, 1967, p. 398.—Fairfield Porter in *School of New York,* edited by B. H. Friedman, New York, Grove Press, 1959, p. 76.—Stankiewicz, reply to questionnaire in Collection files, The Museum of Modern Art.—Stankiewicz, quoted in *Current Biography.*— Stankiewicz to Jan van der Marck, March 1963; quoted in *Twentieth-Century Sculpture: Walker Art Center, Selections from the Collection,* Minneapolis, Walker Art Center, 1971, p. 65.

p. 168. "Lichtenstein Interviewed by Diane Waldman," in Diane Waldman, *Roy Lichtenstein,* New York, Harry N. Abrams, Inc., 1971, p. 28.—Lichtenstein, quoted by John Coplans in interview, "Talking with Roy Lichtenstein," *Artforum,* vol. V, May 1967, p. 34.—*Ibid.,* p. 36. —Lichtenstein, interview with Swenson, "What Is Pop Art?, Part I," *Art News,* vol. LXII, November 1963, p. 63.

p. 170. Warhol, quoted in exhibition catalogue "Andy Warhol," Stockholm, Moderna Museet, 1968, unpaged. —Richard Morphet in exhibition catalogue "Andy Warhol," London, The Tate Gallery, 1971, pp. 17–18.— Andy Warhol, *The Philosophy of Andy Warhol,* New York, Harcourt Brace Jovanovich, 1975, pp. 148–149.— [A]nn C. [V]andevanter in exhibition catalogue "American Self-Portraits, 1670–1973," organized and circulated by the International Exhibitions Foundation, Washington, D.C., 1974, p. 204.

p. 171. Dine, statement in John Gordon, *Jim Dine,* published for the Whitney Museum of American Art by Praeger Publishers, New York, 1970, unpaged.— Dine, quoted in "American Self-Portraits," p. 218.

p. 172. Thomas H. Garver in introduction to exhibition catalogue "Tom Wesselmann: Early Still Lifes, 1962–1964," Balboa (California), Newport Harbor Art Museum, December 9, 1970–January 10, 1971, unpaged.— Wesselmann, interview with Swenson, "What Is Pop Art?, Part II," p. 41.—*Ibid.,* p. 64.—Mario Amaya, *Pop Art . . . And After,* New York, The Viking Press, 1966, p. 74.

p. 173. Leon Shulman in exhibition catalogue, "Three Realists: Close, Estes, Raffael," Worcester (Massachusetts) Art Museum, February 27–April 7, 1974.—Estes, quoted in "The Photo-Realists: 12 Interviews," *Art in America,* October–November, vol. LX, November–December 1972, p. 81.—*Ibid.,* p. 82.—Estes, quoted in "The Real Estes," interview with Robert Raymond, *Art and Artists,* vol. 9, July 1974, p. 28.

p. 174. Segal, lecture given at the Albright-Knox Art Gallery, Buffalo, New York; excerpted by William C. Seitz in "Environments USA: 1957–1967," *São Paulo 9, United States of America,* Washington, D.C., Smithsonian Institution Press, 1967, p. 103.—Segal, quoted in Phyllis Tuchman, "Interview with George Segal," *Art*

in America, vol. LX, May–June 1972, p. 81.—Allan Kaprow, "Segal's Vital Mummies," Art News, vol. LXII, February 1964, p. 33.—Segal, quoted in Tuchman, "Interview with George Segal," p. 80.

p. 176. Kienholz, quoted by Henry T. Hopkins in "Two Views of Kienholz," Art in America, vol. LIII, 1965, p. 73.—Kienholz, quoted by Frederick S. Wight in "Two Views of Kienholz," p. 71.—Ibid., p. 72.—Seitz, The Art of Assemblage, pp. 83–84.

p. 190. Kasimir Malevich, "The New Plastic as 'Abstract-Real Painting': The Plastic Means and Composition," De Stijl, vol. I, 1917; quoted in English translation in Hans L. C. Jaffe, De Stijl, New York, Harry N. Abrams, Inc., 1970, p. 54.—Donald Judd in The National Observer, February 20, 1967; quoted in Contemporary Art 1942–1972: Collection of the Albright-Knox Art Gallery, New York, Praeger Publishers, 1973, p. 296.—Judd, quoted in "Questions to Stella and Judd," p. 60.

p. 191. Robert Morris, "Notes on Sculpture. Part II," Artforum, vol. V, October 1966; reprinted in Minimal Art: A Critical Anthology, p. 232.—Robert Morris, "Notes on Sculpture. Part I," Artforum, vol. IV, February 1966; reprinted in ibid., p. 228.—Robert Morris, "Anti Form," Artforum, vol. VI, April 1968, p. 35.—Morris, statement in exhibition catalogue "Conceptual Art and Conceptual Aspects," New York Cultural Center, 1970; reprinted in Conceptual Art, edited by Ursula Meyer, New York, Dutton Paperbacks, 1972, p. 184.

p. 192. Dan Flavin, ". . . in daylight or cool white," Artforum, vol. IV, December 1965; reedited and published in exhibition catalogue "Dan Flavin," Vancouver (British Columbia) Art Gallery, November 12–December 7, 1969, pp. 18–19.—Flavin to Philip Leider, November 6, 1968; reprinted in ibid., p. 238.—George S. McKearin and Helen McKearin, "Late 19th Century Glass, Fancy Wares," American Glass, New York, Crown Publishers, 1941, p. 419; quoted by Flavin in ibid., p. 238.

p. 178. Samaras, quoted in Alan Solomon, "An Interview with Lucas Samaras," Artforum, vol. V, October 1966, p. 41.—Ibid.—Twentieth Century Sculpture: Walker Art Center, Selections from the Collection, p. 60.—Samaras, quoted by Solomon, "An Interview with Lucas Samaras," p. 41.—Samaras, statement in exhibition catalogue "Lucas Samaras," New York, Whitney Museum of American Art, November 8, 1972–January 8, 1973.

p. 179. Trova, quoted by Donald Miller, "Ernest Trova as Neo-Surrealist," Art International, vol. XIV, September 1970, p. 69.—Lawrence Alloway, Trova: Selected Works, 1953–1966, New York, The Pace Gallery, 1966, p. 13.

p. 180. Clement Greenberg in exhibition catalogue "Three New American Painters: Louis, Noland, Olitski," Regina-Saskatchewan, Norman Mackenzie Art Gallery, January 14–February 15, 1963; reprinted in exhibition catalogue "Morris Louis, 1912–1963," Boston, Museum of Fine Arts, 1965, p. 83.

p. 182. Albers, quoted by William C. Seitz in exhibition catalogue "The Responsive Eye," New York, The Museum of Modern Art, February 23–August 25, 1965, p. 18.—Anuszkiewicz, statement in exhibition catalogue "Americans 1963," edited by Dorothy C. Miller, New York, The Museum of Modern Art, May 20–August 18, 1963, p. 6.

p. 183. Poons, quoted by Lucy Lippard, "Larry Poons: The Illusion of Disorder," Art International, vol. XI, April 1967, pp. 23–24.—Ibid., p. 22.

p. 184. Robert Motherwell, "Beyond the Aesthetic," Design, vol. XLVII, April 1946; excerpted in O'Hara, Robert Motherwell, p. 37.—Robert Motherwell, "A Conversation at Lunch."—Motherwell, interview with Irmeline Leeber, 1971, p. 10.

p. 186. Lawrence Alloway, introduction to exhibition catalogue "Systemic Painting," New York, The Solomon R. Guggenheim Museum, 1966; reprinted in Minimal Art: A Critical Anthology, edited by Gregory Battcock, New York, Dutton Paperbacks, 1968, p. 45.—E. C. Goossen, Ellsworth Kelly, New York, The Museum of Modern Art, 1973, pp. 73–74.

p. 188. Stella, interview with Alan Solomon, 1966, in series "U.S.A. Artists," National Educational Television (NET), New York; transcript quoted in William S. Rubin, Frank Stella, New York, The Museum of Modern Art, 1970, p. 12.—Stella, in conversation with William S. Rubin; quoted in ibid., p. 29.—Robert Rosenblum, Frank Stella, Penguin New Art, 1. Baltimore, Penguin Books, 1970, p. 36.—Stella, interview with Bruce Glaser, "New Nihilism or New Art?," broadcast on WBAI-FM, New York, February 1964; edited by Lucy R. Lippard and published as "Questions to Stella and Judd," Art News, vol. LXV, September 1966, pp. 58–59.

p. 193. Oldenburg, interview with Paul Carroll, August 22, 1968; published as "The Poetry of Scale" in Claes Oldenburg, Proposals for Monuments and Buildings: 1965–69, Chicago, Big Table Publishing Company, 1969, pp. 11–12.—Ibid., p. 15.—Ibid., p. 16.—Oldenburg, Selected Texts for the Traveling Exhibition of 1971–73, p. 3.—Ibid.—Rose, Claes Oldenburg, p. 127.

p. 194. Smith, quoted by Samuel Wagstaff, Jr., "Talking with Tony Smith," Artforum, vol. V, December 1966, pp. 15–16.—Smith, statement in catalogue "Tony Smith—Two Exhibitions of Sculpture," Hartford, Wadsworth Atheneum, November 8–December 31, 1966; Philadelphia, University of Pennsylvania, Institute of Contemporary Art, November 23, 1966–January 6, 1967.—Smith, interview with Renée Sabatello Neu, summer 1968; published in exhibition catalogue "Tony Smith," circulated by The Museum of Modern Art, New York, September 1968–September 1969.—Smith, interview with Lucy R. Lippard, "The New Work: More Points on the Lattice," in exhibition catalogue "Tony Smith: Recent Sculpture," New York, M. Knoedler & Co., March 23–April 24, 1971, p. 20.—Smith, interview with Renée Sabatello Neu.—Smith in "Tony Smith.—Two Exhibitions of Sculpture."

p. 196. Alexander Calder in "What Abstract Art Means to Me," Museum of Modern Art Bulletin, vol. XVIII, Spring 1951, p. 8.

p. 198. Nevelson, statement in exhibition catalogue "Nature in Abstraction," New York, Whitney Museum of American Art, January 14–March 16, 1958.—Nevelson, quoted in "The Nevelson Gala," dedication program for Windows to the West, Scottsdale, Arizona, November 11, 1973.—Arnold Glimcher, unpublished comment, August 1974.

p. 200. Robert Smithson, "A Sedimentation of the Mind: Earth Projects," Artforum, vol. VII, September 1968, pp. 49–50.—Bruce Kurtz, "Abstraction and Actuality," Arts, vol. XLVIII, December 1973, p. 34.

Photograph Credits

Special photography for this book has been supplied by the following persons. Page numbers are cited. Henry Beville, Annapolis, Maryland: 105; Richard Cheek, Cambridge, Massachusetts: 48; Geoffrey Clements, New York: 76; Arthur Vitols, Helga Photo Studio, New York: 46, 53, 67, 83, 94, 95, 102, 113, 119, 126, 127, 128, 129, 130, 137, 138, 148, 153, 155, 157, 161, 164, 170, 177, 179, 187, 191, 197; National Geographic Society, Washington, D.C.: 65; Edward Peterson, Astoria, New York: 115; Eric Pollitzer, Hempstead, New York: 123; Frank J. Thomas, Los Angeles, California: 188–189; Charles Uht, New York: 131.

Notes on the Authors

JEAN LIPMAN was Editor of Art in America for thirty years, then Editor of Publications at the Whitney Museum of American Art. After studying art history at Wellesley College, she did graduate work at the Institute of Fine Arts of New York University, from which she received her M.A. She is the author of more than a hundred articles and a dozen books on various aspects of American art. Her most recent major publications are The Flowering of American Folk Art (with Alice Winchester, 1974) and Calder's Universe (1976).

HELEN M. FRANC was formerly Editor-in-Chief in the Department of Publications of The Museum of Modern Art. She majored in art history at Wellesley College and holds graduate degrees from the Institute of Art History of New York University and the Sorbonne. Before joining the staff of The Museum of Modern Art in 1954, she had been successively Assistant to the Director and Acting Curator of Drawings at The Pierpont Morgan Library, Assistant Editor of the Art Bulletin, Associate in Education at the Philadelphia Museum of Art, Managing Editor of the Magazine of Art, and Associate Editor at Harry N. Abrams, Inc. She is the author of An Invitation To See: 125 Paintings from The Museum of Modern Art (1973).

JOHN I. H. BAUR, Director Emeritus of the Whitney Museum of American Art, was previously Curator of Paintings and Sculpture at The Brooklyn Museum. He is the author of many histories and monographs in the field of American art, among them Revolution and Tradition in Modern American Art (1951) and American Art of Our Century (with Lloyd Goodrich, 1961).

Index
of Artists
and Works

Bright Stars, reproduced in color, are designated by titles and page numbers in **bold face**.

207